Black Women Legacies

WOMEN, GENDER, AND SEXUALITY
IN AMERICAN HISTORY

Editorial Advisors:
Susan K. Cahn
Wanda A. Hendricks
Deborah Gray White
Anne Firor Scott, Founding Editor Emerita

*For a list of books in the series, please see
our website at www.press.uillinois.edu.*

Black Women Legacies

Public History Sites Seen and Unseen

ALEXANDRIA RUSSELL

UNIVERSITY OF
ILLINOIS PRESS
Urbana, Chicago, and Springfield

Publication was supported by a grant from the Howard D.
and Marjorie I. Brooks Fund for Progressive Thought.

Library of Congress Cataloging-in-Publication Data

Names: Russell, Alexandria, 1986– author.
Title: Black women legacies : public history sites seen and
 unseen / Alexandria Russell.
Other titles: Public history sites seen and unseen
Description: Urbana : University of Illinois Press, [2024] |
 Series: Women, gender, and sexuality in American history |
 Includes bibliographical references and index.
Identifiers: LCCN 2024023895 (print) | LCCN 2024023896
 (ebook) | ISBN 9780252046292 (hardcover) | ISBN
 9780252088360 (paperback) | ISBN 9780252047572 (ebook)
Subjects: LCSH: African American women—Historiography.
 | African American women--Monuments. | Historic sites—
 United States. | Memorialization—United States. | Public
 history—United States.
Classification: LCC E184.65 .R87 2024 (print) | LCC
 E184.65 (ebook) | DDC 973.09/9—dc23/eng/20240809
LC record available at https://lccn.loc.gov/2024023895
LC ebook record available at https://lccn.loc.gov/2024023896

For Samantha

Contents

Acknowledgments

I was shocked to learn there are only two National Park Service Historic Sites of African American women. In September 2012, I watched the "African American Women and the National Park Service" panel from the Association for the Study of African American Life and History conference that aired on C-SPAN's American History TV. The curiosity sparked from that conversation developed into a vibrant and layered research journey that has taken me all over the United States.

The seed that acclaimed historian Darlene Clark Hine planted in me as an undergraduate student at the College of Charleston grew into my desire to become a historian of African American women. As a pioneer in the field of Black women's history, Hine has made an enormous contribution to African American and United States history through her own scholarship and compassionate mentorship of students like me. She has nurtured a passion for celebrating the histories of African American women through thorough research, collegial collaboration, and public engagement with communities of all backgrounds. I am so grateful for her personal and professional encouragement from the early conceptions of this project to the present publication.

As a graduate student at the University of South Carolina (USC) in the History Department, I developed the foundational research for this comprehensive study, which culminated in my dissertation, *Sites Seen and Unseen: Mapping African American Women's Public Memorialization*. My dissertation chair, Wanda A. Hendricks, has been an invaluably astute advisor. Her ongoing support as a mentor whose own meticulous research practices provided an exemplary model for scouring the archive, using clear syntax, and exerting an authentic authorial voice has greatly influenced this history

about the lives and legacies of African American women. The enthusiastic feedback from the other members of my dissertation committee, Melissa Cooper, Patricia Sullivan, and Allison Marsh, supported the evolution of the dissertation into a book manuscript.

While at the University of South Carolina, my research benefited from my public history practitioner experience with Robin Waites at Historic Columbia, Nancy Stone-Collum at the Richland County Conservation Commission, and Bobby Donaldson, the USC James E. & Emily E. Clyburn Endowed Chair of Public Service and Civic Engagement and Executive Director at the Center for Civil Rights History and Research. The USC Smith Richardson Travel Grant and Rose Library Research Fellowship I was awarded in Spring 2017 enabled me to travel to several public history sites and archival repositories, including the Colored Girls Museum, the Historical Society of Pennsylvania, the Schomburg Research Library, and Emory University's Special Collections. Presenting at the Association for the Study of African American Life and History's Centennial Conference in 2015 and the University of Memphis's Graduate Conference in African American History in 2018 provided supportive forums for the continued development of this research.

Archivists like Annie Nelson of the Blair-Caldwell Library in Denver, Colorado, have been instrumental in my documentation of memorials to African American women in every region of the United States. Collections and vertical files at local public libraries like the Tyler (Texas) Public Library and Oakland Public Library have supported my mapping of memorials in cities and towns to which I was unable to physically travel. In addition to local librarians and archivists at larger repositories, the museum and family collections from memorializers like Marie Adams and Rose Shiver of the Harriet Barber House have greatly enriched this publication.

After completing graduate school, I was able to expand my analytical framework of African American women's public history by collaborating with colleagues to present at the Association of Black Women Historians Symposium, the American Historical Association, Stanford University's "But What Does Wonder Do?" conference, and the Western History Association. Dean Joye Bowman's invitation to the University of Massachusetts Amherst as the Charles K. Hyde Visiting Practitioner provided an opportunity for public history discussions of this work with scholars like Marla Miller. My visit also cultivated an interest in the W. E. B. Du Bois Papers, which I examined and incorporated into this research project as a Du Bois Center Summer Research Fellow.

My research fund that accompanied my position as the Rutgers University Scarlet and Black Postdoctoral Associate in the History Department

enabled my continued expansion of research, including visits to the Harriet Tubman memorials in Cambridge, Maryland, and Auburn, New York. Mentors Deborah Gray White and Marisa Fuentes helped facilitate my larger conceptualization of the layered meaning in African American women's public history with their feedback and support, which also enhanced my public presentations of this research to audiences in the United States and England. And the Rutgers Institute for Research on Women seminar (2019–2020) was a positive and constructive venue of feedback and intellectually stimulating discussions about memorialization.

The research fund associated with my position as the Harvard and the Legacy of Slavery Research Fellow for digital humanities under the extraordinary leadership of Tomiko Brown-Nagin at the Harvard Radcliffe Institute also furthered my research. The panel "State of the Field: Black Women's Public History" at the Annual Meeting of the National Council on Public History afforded me the opportunity to celebrate this growing field with colleagues Tara White and Ashley Robertson Preston and prompted fruitful discussions of my research with Fath Davis Ruffins and Tiya Miles, two historians I greatly admire. The American Democracy Fellowship at the Warren Center at Harvard University has supported the development of the research in this publication into a free and accessible digital humanities project.

As a W. E. B. Du Bois Research Institute Hutchins Family Fellow at Harvard University's Hutchins Center for African and African American Research, I have received support to finalize this publication and valuable feedback from Executive Director Henry Louis Gates Jr. that has strengthened my Phillis Wheatley research.

My sister scholars and colleagues Nakia Parker, Kaisha Esty-Campbell, and Miya Carey-Agyemang gave helpful feedback and made informed suggestions for enriching this research in a writing group we created to help transition our dissertations to manuscript projects. The women of the Easton's Nook writing retreat created a warm space for me to revise my dissertation. And writing sessions and analytical discussions with Ronald W. Davis II made my final revising for this work a joyful endeavor.

My family's support has propelled and sustained my ability to research and write about the lives of African American women. My mother, Sandra McDowell, has been a tenacious encourager and champion for the development of this research and my career as a professional historian. Thanks, Mom! Thank you to my siblings, Portia Russell, Samantha Russell, Henry Russell, and Larrick Rose, who, along with my niece Melina Lee Russell, have given me an array of robust support. My aunt Pamela Marcano and cousins Christal McKinley and Amber Russell McDuffie as well have been

great listeners and providers of feedback on my research throughout my journey.

As a middle school teacher in Berkeley County, South Carolina, I could not have imagined that a panel on C-SPAN would impact my life so greatly. I am immensely grateful for all the support I have received over the last decade from family, friends, institutions, and local communities across the United States that has resulted in the first full-length publication of African American women's public history. The research in this book showcases that the lives and legacies of African American women not only matter but are a central aspect of Black life and culture in the United States.

Black Women Legacies

Introduction

The crater from the wrecking ball stood hollow in the center of the home at 2335 Arapahoe Street in the summer of 1983. Concerned community members scrambled to pause the imminent demolition to the home of Dr. Justina Ford, Colorado's first African American woman to become a licensed physician. They were successful in obtaining a compromise: demolition of the home would cease, but the home could not remain at its current location. In February 1984, the two-story house was removed from its foundation and transported thirteen blocks on an oversize platform to 3091 California Street in downtown Denver. Since that time, it has remained the official site of the Black American West Museum.

As one of the most renowned medical professionals in Colorado's history, Justina Ford has remained a beloved beacon of the African American community, in life and death. She was born in 1871 in Knoxville, Illinois, and her mother, who worked as a nurse, greatly influenced her desire to work in the medical field. After graduating high school in 1890, she moved to Chicago to attend Hering Medical College. While there, she met and married Reverend John L. Ford in 1892, and by 1899, she had obtained her degree. She began her career as a doctor in Chicago, but in 1902, she and John relocated to Denver, Colorado.[1]

While Ford was applying for her license to practice medicine in Colorado, a snarky clerk proclaimed that as a Black woman she had "two strikes" against her, alluding to her race and gender in a field dominated by White men. Though he assumed she would not or could not receive official authorization, Ford prevailed, making her the first licensed African American woman doctor in the state. But the realities of race and gender discrimination, including being barred from joining the Colorado Medical

Association, made practicing in Denver's hospitals impossible. In addition to dealing with the structural confines of embedded racism in society, doctors like Ford "were forced to battle not only sexism, including that of black men, but also racism, including that of white women."[2]

Ford overcame the setbacks and complexities of the two strikes against her, by opening a home medical practice in the heart of Denver's Five Points neighborhood. Known as the Harlem of the West, Five Points was a thriving African American neighborhood in downtown Denver dating back to the late nineteenth century. An economic and cultural center of the African American community, Five Points was filled with entrepreneurs, artists, musicians, and licensed educators, lawyers, and doctors.[3] As part of the African American professional class, Justina Ford intentionally used her knowledge and skills to meet the needs of African Americans, who experienced health disparities due to limited access to health care and financial resources to pay for medical services. She also extended her medical care to both poor Whites and immigrants as the go-to for anyone in need. By the time of her death in 1952, "the Lady Doctor," as she was widely known, had delivered over seven thousand babies. Generations of children proudly proclaimed being "Ford babies" or members of the "Justina Baby Club."[4] Her generosity, inclusivity, and extensive medical knowledge made her a treasured physician. Longtime resident Dr. Oswaldo Grenardo remarked:

> Dr. Justina Ford to us, to African Americans here in Colorado, was as big or as important as Dr. King, as Rosa Parks, as Jackie Robinson in terms of breaking down barriers and overcoming incredible hardship to get what she wanted, to do what she wanted, which was to serve and to be an inspiration.[5]

Ford's achievements, philanthropy, leadership, and steadfast dedication to the medical needs of her community embedded the physician in the hearts of Coloradans. In fact, it was two Ford babies, Moses and Elizabeth Valdez, father and daughter, who catalyzed the memorial movement to save her home and practice almost a century after it was built in 1890.[6] They contacted memorializer Paul Stewart, who was instrumental in saving the house to honor Ford's legacy.

Stewart had not begun his public history journey with commemorating Justina Ford, however. He began in a barbershop. Though born in Iowa, Stewart made Denver, Colorado, his home after moving there in the 1960s and opening a barbershop. Having seen a host of White cowboys in his favorite westerns, he realized after encountering an actual Black cowboy for the first time as an adult that the "history books had deliberately left black people out."[7] Fascinated by the cowboy, Stewart became enthralled

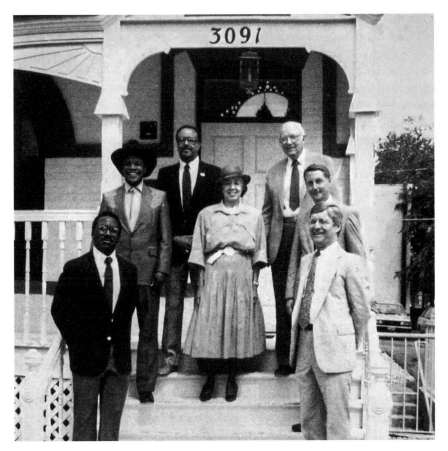

FIGURE 1. Members of the Justina Ford Medical Society with memori-alizers Paul Stewart (middle left) and Geraldine Stepp (center) standing on the steps of the Black American West Museum opened in the newly renovated home of Dr. Justina Ford at 3091 California Street in down-town Denver, Colorado. This photo appeared on the cover of Volume 86 (July 1, 1989) of *Colorado Medicine* and is reprinted with permission from the Colorado Medical Society.

with western African American culture and history. As a deliberate act of recovery, he began collecting artifacts from his customers and local com-munity members, which he prominently displayed around his barbershop. He was also known to pull out his tape recorder to conduct on-the-spot oral history interviews, even while giving a haircut. As more and more people brought in family heirlooms and stories, the barbershop became a de facto heritage center.[8] Amid clippers, razors, western memorabilia, and treasured memories, the Black American West Museum (BAWM) was born.

In 1975, Stewart transitioned from his career as a barber and made the BAWM his fulltime focus.[9] A 1977 feature in *Black Enterprise* proclaims, "What began as a hobby has become his life's work," since his roles as "curator, founder, head of research, fieldworker, administrator, spiritual mentor, janitor, art director and tour guide" required his full attention.[10] Stewart had turned his personal passion into a lasting project. Donned in his traditional cowboy attire, he lectured at universities and lobbied for public and private financial support to operate the museum.[11]

Although the BAWM became "the foremost source of historical materials and oral histories of blacks in the West," it did not maintain a permanent home because funding was always inadequate. Once the museum had outgrown the barbershop in 1971, Stewart prioritized finding a lasting space to display his vast collections for people to access. He first moved his collection to an "old Denver saloon," but urban renewal efforts destroyed the location, and he was forced to look elsewhere.[12] Clayton College donated a room for the collection, but it was cramped and difficult for the public to access on a regular basis.[13] Next, the collection was moved to a larger and more accessible building in Five Points, but the rented space was a financial burden.

In the early 1980s, when the opportunity to save Justina Ford's home presented itself, Stewart also saw an opportunity for the BAWM to enjoy a permanent location. African American community members worked with Stewart to form the Dr. Justina Ford House Committee with the dual goal of saving Ford's home and housing the museum.[14] Geraldine Stepp, an eventual director of the museum, recalled that "movers, permits, donations of materials, myriads of details and funding had to be found." The committee formed a key partnership with Historic Denver to restore, move, and maintain the home. It took three years to relocate it and place it under the official ownership of the BAWM and another three years to complete construction. Stepp called the process a "miracle," stating, "This is the first preservation project of its kind ever attempted by a black organization in the State of Colorado."[15] Indeed, it remains the only project of its kind in the western United States.

The successful campaign to preserve and restore Justina Ford's home exists as part of a larger narrative of the evolution of African American women's memorialization, or the process of commemoration. Its origins in the United States date back to the early nineteenth century, when free Black communities in the North organized festivals and parades to celebrate emancipation, promote abolitionism, and disseminate Black history. They used these public venues to also herald the contributions of Black women through commemorative oratory, trumpeting their legacies through

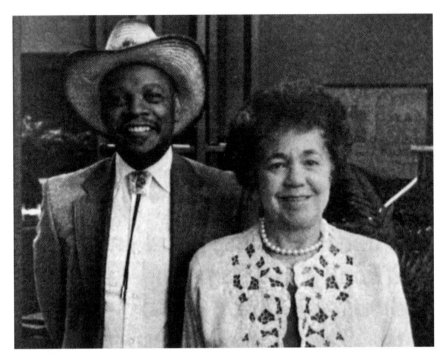

FIGURE 2. Memorializers Paul Stewart and Geraldine Stepp received the "Colorado Medical Pioneer" recognition from the Colorado Medical Society in honor of the preservation of the Dr. Justina Ford House for the Black American West Museum. This photo appeared in Volume 86 (April 15, 1989) of *Colorado Medicine* and is reprinted with permission from the Colorado Medical Society.

speeches. After the Civil War, public festivals and parades spread to the South. Commemorative texts and memorial books, too, like *In Memoriam: Catherine S. Campbell-Beckett* (1888), were used as public ways to recognize African American women. Existing research on nineteenth-century African American women's public history is limited. The documentary record reveals, however, that the era predated the substantial transformation that began in the 1880s.

African American clubwomen began creating named memorials—public memorials attached to a person's legacy—for women like Phillis Wheatley. At the dawn of the clubwomen's era, the National Association of Colored Women (NACW) was instrumental in establishing a nationwide infrastructure for named memorialization to expand in the 1890s, all while Jim Crow laws increasingly restricted the parameters of Black citizenship. At the same time, White organizations like the Daughters of the Confederacy began to

erect public monuments that supported false narratives of the Civil War and conveyed dehumanizing myths about enslaved Black people. With limited to no control of the public landscape domain, African American communities employed named memorials as strategic resistance against the erasure and caricature that existed among White public history memorials, race pseudoscience, and published historical narratives. In the absence of statues, monuments, and museums, African American women sparked the era of named memorials, which spread across the United States and manifested in domestic and Pan-African organizations, public libraries, public housing, and even commercial ventures.

As the ruling power of Jim Crow laws began to lessen in the 1960s, the prominence of named memorials ebbed as the ability to erect traditional public history sites, such as museums and statues, increased. Integration decreased the visibility of named memorials as constituencies of public buildings and African American neighborhoods began to change. Mary McLeod Bethune's Washington, DC, statue commemoration set the tone for a new era of African American women's memorialization, signaling a significant shift in *how* public spaces could be used to promote their legacies.

In the midst of the civil rights, Black Power, and Black Studies movements, African American communities had more access and negotiating power with local and national bureaucracies to influence the public history landscape. They advocated to save buildings and create new spaces to celebrate Black heritage and culture, ushering in a new era of African American traditional memorials. Though urban renewal at times galvanized memorializers to save meaningful cultural places, it irrevocably restructured African American communities. Still, by developing public and private partnerships, a new generation of memorializers, African American preservationists, and public historians and organizations resisted erasure of their communities from the physical landscape when they established the first traditional public history sites.

In the twenty-first century, memorializers' ability to create and sustain traditional memorials has only increased, with web-based technologies and social media platforms expanding memorials for African American women even further. Facebook, Instagram, and Twitter/X posts, along with Google Doodles and digital humanities projects, have become integral to how Black history is disseminated to public audiences. The internet has provided a new public history terrain shaped by memorializers of all backgrounds. Community advocacy for more visible multicultural representation has broadened the scope of museums, statues, and historical markers in locales across the United States.

African American named memorials are tied to the culture of recognition, the dual acknowledgment between namesakes and memorializers. These public recognitions simultaneously celebrated the African American women for whom memorials were named and those who relished in commemorating the women's achievements. Memorial brands, or the symbolism attached to namesakes, represent the values espoused by memorializers and crafted public memory to disseminate Black history. The dynamic duality of the culture of recognition permeated the Jim Crow era, making named memorials the primary public history medium used to honor the legacies of African American women.

African American public historians, or memorializers and public memory crafters, have made commemorative memorials a central part of Black life and culture. African American clubwomen inlaid an entire infrastructure of public history memorials into the American landscape. Without access to traditional public history mediums, like statues and historical markers, they promoted the legacies of African American women by simply saying their names. Deft memorializers like Paul Stewart often lacked professional training, held limited academic or institutional knowledge, and had restricted ability to permanently shape public spaces. As self-taught public historians and strategic preservationists, they partnered with private and public entities to influence communal spaces in African American neighborhoods through memorials, thus affecting how generations learned about the Black past. Through the decades, many of these memorializers have gone undocumented in historical canon, despite their looming influence on public history in the United States. *Black Women Legacies* chronicles their lasting legacy work by showcasing their invaluable contributions to African American women's public memorialization.

Each generation of memorializers used different mediums and venues of memorialization based on access and resource availability. Commemorative oratory and named memorials were popular mediums during the nineteenth and early twentieth centuries. They were effective in crafting public memory and required little money, if any, to create. While a couple of traditional mediums existed during the Jim Crow era, it was not until the mid- to late twentieth century that African American communities were able to develop statues, public plaques, historical markers, house museums, monuments, and National Park Service (NPS) Historic Sites.

Each venue of memorialization depended on the medium and, in some cases, could be abstract. Commemorative oratory venues were most often experienced at festivals, public celebrations, and churches. Named memorials like the Phillis Wheatley Association in Cleveland, Ohio, had a

permanent location, while the Sojourner Truth Club of Richmond, Indiana, utilized different homes as the venue for the organization's activities. Traditional memorials have set venues and mediums at specific locales, for example, a house museum or statue in a park. In the twenty-first century, digital mediums of memorialization have broadened commemoration, making the internet itself a venue. By examining the public memorials of African American women, *Black Women Legacies* traces this evolution of medium and venue through the legacy work of memorializers.

This book is the first full-length study to situate African American women's memorialization within the larger historiographies of African American history, women and gender studies, public history and preservation, and United States history. Scholars have previously focused on African American public memory, African American collective commemorative activities, and White women's preservation contributions to memorials and tourism. The specific historical dimensions of African American women's public history commemorations have gone unexamined. However, several historians have documented the significance of African American public history.

The seminal scholarship of Fath Davis Ruffins provides an overview of the intentional commitment made by African American communities to preserve and disseminate Black history. Ruffins's articles "Mythos, Memory, and History: African American Preservation Efforts, 1820—1990" (1992) and "Building Homes for Black History: Museum Founders, Founding Directors, and Pioneers, 1915—95," (2018) chronicle these efforts, while "'Lifting as We Climb': Black Women and the Preservation of African American History and Culture" (1994) provides an insightful gendered analysis.[16] Kenneth Hamilton's *Booker T. Washington in American Memory* (2017) and Ian Rocksborough-Smith's *Black Public History in Chicago: Civil Rights Activism from World War II into the Cold War* (2018) offer new insight into how public memory is translated into African American memorialization. Mabel Wilson's *Negro Building: Black Americans in the World of Fairs and Museums* (2012), dissertations such as Ashley Bouknight's "Black Museology: Reevaluating African American Material Culture" (2016), and Tara White's "History as Uplift: African American Clubwomen and Applied History" (2018) all contribute significantly to documenting commemorative traditions employed by African American organizations and public historians.[17] These scholars are incorporating the thematic elements of African American public history into the larger canon of American public history, preservation, and memory studies.

Black Women Legacies is an important addition to this body of work. By using an intersectional lens to highlight the racialized, gendered, classed, and regional aspects of the lives and legacies of African American women,

this book documents the specific parameters of the memorializers and the memorialized.[18] The culture of recognition and memorial brand theorizations provide a framework of analysis to understand the great breadth of public history that evolved from the late nineteenth to the twenty-first century. For one, this scholarship centers African American women by focusing on the memorials created in their honor. Often undocumented and unheralded, this history reveals the impact of memorializers' development on the culture of recognition and in pioneering commemorative strategies with limited resources to shape physical and cultural landscapes. By detailing distinct mediums and venues of memorialization, *Black Women Legacies* demonstrates how central these commemorative practices and memorial manifestations were to the everyday life and culture of African Americans.

With this book, I provide an expansive national analysis of African American women's public history to highlight both the representation and underrepresentation—the sites seen and unseen. These public history sites exist in every region of the United States. Each region is distinct, with the South containing the most named and traditional memorials by far, including the Maggie Lena Walker Home in Richmond, Virginia, the first NPS Historic Site created for an African American woman. African American memorializers made Southern locales the most dynamic by creating a bountiful landscape of named and traditional memorials, often claiming ownership of segregated neighborhoods through public commemoration. An interracial cadre of memorializers in the North produced the first traditional memorial of an African American woman in 1914 to honor Harriet Tubman, mounting a bronze plaque on the Cayuga County Courthouse in Auburn, New York. Regional monikers like the Black American West Museum in the Justina Ford House are less common among traditional memorials, yet they broadly highlight the African American experience in the West.

Memorializers in the Midwest have created unique memorials, including Phillis Wheatley Bread in Detroit, Michigan, and the (Madam C. J.) Walker Theatre in Indianapolis, Indiana. African American women have developed robust archival collections, such as the Indiana Historical Society's "Black Women in the Middle West," that substantially document the activities of named memorial organizations in the region. The ongoing memorialization of Mary McLeod Bethune in Washington, DC, has influenced African American women commemoration for half a century. A decade after the Bethune statue in Lincoln Park became the only one of an African American and a woman in the NPS in the capitol city, the Bethune Council House and the National Archives for Black Women's History were implemented. In 2022, Bethune became the first African American to represent a state with a statue on Capitol Hill. Her national commemorations have extended the

reach of African American public history and influenced the manifestation of memorials in every region.

Despite all the national and regional representation, significant under-representation of African American women memorials still remains. The NPS's incorporation of the Maggie Lena Walker Home in Richmond, Virginia, and the Mary McLeod Bethune Council House in Washington, DC, in the twentieth century were significant additions that signaled a major evolution in African American women's memorialization. Yet they remain the only two NPS Historic Sites centered around Black women, which is less than 1 percent of all NPS units. With the addition of the Harriet Tubman National Historic Park in 2009, the three African American women NPS units still account for less than 1 percent of all designations.

On a local level, the underrepresentation is just as glaring. In the over six hundred pages of *Black Heritage Sites: An African American Odyssey and Finder's Guide* (1996), Nancy Curtis examines local sites in the United States. Approximately thirty of the sites are centered around Black women, with over half of them (eighteen) located in the South. Barbara Tagger's 1997 analysis of the over eight hundred sites in the volume *African American Historic Places* revealed that only three had been created around the legacies of African American women.[19] Twenty-five years later, the Monument Lab's *National Monument Audit* found that of the three African Americans among the top fifty people with the most public monuments in the United States, Harriet Tubman is the only woman represented.[20]

The silence of underrepresentation and unseen memorials has been countered by the national movement of African American public memory crafters to resist erasure and cultivate historical narratives that can withstand generations. Operating with unprecedented savvy, African American memorializers have been at the forefront of establishing a national public history landscape. *Black Women Legacies* celebrates them and those they commemorated through African American women memorials.

In part 1, "Creating Their Own World: Named Memorials of African American Women during Jim Crow," chapters 1 through 4 examine the national network of named memorials curated by African American clubwomen. By cultivating their own space to celebrate themselves, they also promoted the public memory of their achievements as counternarratives against the histories that rendered them invisible or insignificant. Their determination to be remembered with pride made them successful not only in creating their own commemorative traditions but also in making named memorials the most popular medium of African American public history throughout the Jim Crow era.

Chapter 1 illustrates the expansive reach of the Phillis Wheatley memorial brand. As the most memorialized African American woman in the early twentieth century, memorials to Wheatley spanned from organizations and settlement homes to businesses and Pan-Africanism. The legacy work that began in the 1880s with African American clubwomen in the NACW influenced public history throughout the twentieth century. Wheatley's named memorialization existed among many other commemorations that celebrated the legacies of formerly enslaved Black women.

Chapter 2 examines Sojourner Truth's and Harriet Tubman's historical memorial brands, which documented the recent past of Black enslavement as well as the ongoing struggle to obtain freedom in the Jim Crow era. Sojourner Truth's commemorative symbolism evoked the distinct intersection of race and gender for African American women, while Harriet Tubman was celebrated as a freedom fighter whose commemoration represents the tenacious triumph of African American women in dire circumstances. Tubman's memorialization in Auburn, New York, chronicles the establishment of the first traditional public history medium of an African American woman in the United States.

The NACW was the most significant organization in establishing named memorials of African American women. Chapter 3 discusses how three NACW presidents were commemorated through named memorials during their lifetimes. Mary Church Terrell, Mary Burnett Talbert, and Mary McCleod Bethune were celebrated by Black clubwomen for their leadership and extraordinary achievements. Through the culture of recognition, African American women honored national leaders through their own local initiatives. Unlike most named commemorations, living named memorials allowed for personal interaction between organization members and their namesake through correspondence and special events.

Other named memorials were used as monikers of segregated space that public memory crafters used to claim ownership of their neighborhoods. Chapter 4 highlights named memorials attached to public buildings in African American communities. The Ella Reid Public Library in Tyler, Texas, the Ida B. Wells Homes in Chicago, Illinois, and the (Celia) Saxon Homes in Columbia, South Carolina, exemplify three instances of named memorials used to designate and claim Black public space through the commemoration of African American women. Memorializers collaborated with all-White power structures and local bureaucracies to create these named memorials attached to the symbolism of African American progress. This practice shifted as new generations encountered integration and urban renewal.

Part 2, "The National, State, and Local Stages: Ushering in the Golden Age of African American Women's Memorialization," explores the creation of statues, house museums, and historic sites in chapters 5 through 9. The civil rights, Black Power, and Black Studies movements created a political and social landscape for African American communities to establish public history sites using public federal and state funding. This golden age spurred the creation of a new generation of memorializers—African American preservation organizations that were deft at garnering the public and private resources needed to sustain traditional memorials.

Chapter 5 examines how Mary McLeod Bethune's incorporation into the NPS created a new precedent for African American women memorials in the United States. The National Council of Negro Women (NCNW), led by president Dorothy Height, was instrumental in erecting the Bethune statue in Lincoln Park, just a mile away from Capitol Hill. A decade later, Bethune became the second African American woman to receive a NPS Historic Site designation through the Mary McLeod Bethune Council House and the National Archives for Black Women's History. Bethune's memorial brand was used to reflect the contributions of African American women across the United States, inspiring traditional commemorations all over.

Chapter 6 tells the story of memorializers Elena Albert and Sue Bailey Thurman of the San Francisco African American Historical and Cultural Society and how they reshaped public memory of Mary Ellen Pleasant and established the first African American woman traditional site in the West. To combat the derisive dismissal of Pleasant's historical legacy, these pioneering African American public historians reclaimed her legacy as the "Mother of Civil Rights in California." Their endeavors were so effective in recasting Pleasant's public memory that they influenced a national media campaign in *Ebony* magazine.

African American historical societies like the Madam Walker Theatre Center in Indianapolis, Indiana, worked to preserve eroding neighborhoods through memorialization. Chapter 7 chronicles the memorialization of the distinct Indiana Avenue building. As urban renewal threatened permanent erasure of the African American community that once thrived on the legendary avenue, memorializers promoted Walker's memorial brand as the first woman millionaire in the United States to both stimulate the local economy and preserve the cultural heritage of the neighborhood.

In Sedalia, North Carolina, the Charlotte Hawkins Brown Historical Foundation established the first and only historic site of an African American woman that is fully operated by the state government. Chapter 8 examines the foundation's successful advocacy through the state legislature that resulted in the creation of the Charlotte Hawkins Brown Museum, a

multisite traditional memorial on the Palmer Memorial Institute campus. Brown founded the school in 1902, and her memorializers promoted her education memorial brand by renaming the entire site in her honor in their unique commemoration of her legacy.

The combination of substantial public and private funding was essential to establishing traditional memorials in the late twentieth century. Chapter 9 demonstrates the impact of collaborative funding and operational alliances in preserving house museums of two African American women of Columbia, South Carolina. African American memorializers catalyzed the creation of the (Celia) Mann-Simons and Modjeska Monteith Simkins public history sites, then parlayed their vision into lasting sustainability with Historic Columbia, a local preservation organization. Their joint venture saved homes destined for demolition and promoted the history of the African American experience through the public memory of these two women.

The conclusion examines the evolution of Maggie Lena Walker's memorialization from the Jim Crow era through the twenty-first century as reflective of the African American public history journey highlighted throughout *Black Women Legacies*. The most recent traditional memorial, Walker's exists among a new group of public history sites like The Colored Girls Museum in Philadelphia, Pennsylvania, and the Harriet Barber House in Hopkins, South Carolina, that are pushing the boundaries of how African American women are commemorated. Further expanding the reach of commemorative public space, the latest memorial venue, the internet, continues to transform and influence public memory of African American women. The extraordinary achievement of Mary McLeod Bethune's commemoration in a Capitol Hill statue affirms the continued centrality of African American women's memorialization in Black life and culture in the United States.

The legacies of Black women have been celebrated in named and traditional memorials, by generations of memorializers and public memory crafters, through a continuum of commemoration manifested in a vibrant public history landscape throughout the United States.

PART ONE

Creating Their Own World

Named Memorials of African American Women during Jim Crow

The Phillis Wheatley Brand

Phillis Wheatley was the most memorialized African American woman of the early twentieth century. One of the most widely acclaimed poets of the eighteenth century and in American history, Wheatley was born around 1753 near the Gambia River in West Africa. Kidnapped, enslaved, and bound on the *Phillis* slave ship as a child, she was purchased directly from the docks of Boston, Massachusetts, by John Wheatley. His daughter, Mary, taught her to read the Bible, and within sixteen months, Phillis had mastered the English language. She also learned Latin, Greek, and Roman mythology, which she later incorporated into her famed writings and poetry, first published in 1767. Her only volume of poetry, *Poems on Various Subjects, Religious and Moral*, published in 1773, was the first book published by a Black person in the United States. Wheatley wrote one of her most famous poems in 1775 about George Washington, which she mailed to him herself. Washington was so moved by her words he invited Wheatley to a private meeting with him at his headquarters in Cambridge, Massachusetts. Having obtained her freedom in 1773, she married a free Black man named John Peters in 1778.

Despite international fame, Wheatley's life was difficult, especially because she was unable to profit significantly from her poetry. Though she spent the last years of her life as a free woman, she lived in poverty.[1] Her writings, informed by her life experiences in the colonial era and during the formation of the United States, maintained their relevancy long after her death in 1784 and were instrumental in establishing the Black literary tradition. The *Norton Anthology of African American Literature* boasts, "No single writer has contributed more to the founding of African American literature."[2] With the 250th anniversary in 2023 of her publication of

Poems on Various Subjects, Phillis Wheatley has remained a notable figure in American literature for over two centuries.

African American women connected to Wheatley's life story by linking their experiences in Jim Crow America with her triumph over enslavement and illiteracy. The dissonance of democracy, freedom, and sovereignty she experienced in early America was still present for African Americans in the late nineteenth and early twentieth centuries. In a society that proclaimed "liberty and justice for all," African American women understood that the rhetoric of equality was not intended for them nor their communities. In the midst of constant racialized and gendered discriminations, they deliberately created distinct public spaces to celebrate their achievements, choosing Phillis Wheatley as the ultimate symbol of their capacity to be creative intellectuals and nurturing community caregivers.

African American clubwomen grasped that the symbolism of Wheatley named memorials was tied to cultural norms of social respectability and used this concept to upbuild future generations.[3] Though self-help, Christian morality, and the motto of the National Association of Colored Women (NACW), Lifting as We Climb, were central to African American women's clubs during the Jim Crow era, members also promoted a culture of recognition. By establishing a brand of Wheatley named memorials, African American women celebrated her triumphs as they were celebrating their own.[4] In African American communities, this concurrent recognition of both well-known and everyday heroines made named memorials the primary public history medium of the era.

While other African American women inspired named memorials in the early twentieth century, the memorials created in Wheatley's name are unique. The national scope and malleability of Wheatley's symbolism across diverse organizations, from commercial enterprises to Pan-African liberation causes, made her public commemoration more expansive than that of any other Black woman of the era. Wheatley named memorials are documented through a myriad of African American organizational records and newspaper sources that identify named memorials across the United States from the late nineteenth century through the twentieth century.[5] The sheer depth and range of named memorials established Phillis Wheatley's legacy as a brand signifying African American womanhood and intellectualism. By the turn of the twentieth century, clubwomen, or "Phyllis Wheatleys," as they were sometimes called, had developed a national memorial brand that prompted their public commemoration to expand to all facets of Black life and culture.

Wheatley organizations existed as early as the 1880s, but the Phillis Wheatley Club in Saint Paul, Minnesota, and the Phyllis Wheatley Circle

in Greenville, Mississippi, both founded in 1892, were among the earliest documented organizations. "Why Phillis Wheatley?" asked the *St. Paul Daily Globe*. The simple answer is, as an enslaved "negro poetess of the last century," Wheatley and her life accomplishments were admired by the women of Saint Paul, who embraced her memorial brand to highlight their community service.[6] In August 1892, they held a successful concert fundraiser for the children's building at the World's Fair, where Mae Wilkins used commemorative oratory to showcase "Phillis Wheatley's Ode to General Washington."[7] In Greenville, the Wheatley Circle began as a culture club but quickly expanded to community philanthropy. Between 1894 and 1895, the women raised around $400 to donate to local churches. By 1896, they had begun working with girls from the local school to teach them "sewing, mending, cooking, painting, and many kinds of fancy work."[8]

Schools also were named for Wheatley in the late nineteenth century, such as the Phillis Wheatley School in Oregon, Missouri. Upon the suggestion of local teacher Professor P. J. Robinson, the "colored school" was renamed in 1895, making the segregated space one of the first public buildings to recognize a Black woman with a named memorial.[9]

The most documented Wheatley naming of the late nineteenth century was the organization of Wheatley clubs in New Orleans, Chicago, and Nashville. The founding of the New Orleans Wheatley Club in 1895 garnered national attention and was reported in newspapers all over the United States.[10] Led by Sylvanie Williams, one of the first vice presidents of the NACW, the club established the Phyllis Wheatley Sanitarium and started a nursing school for Black women in 1897.[11] The NACW not only documented the histories of Wheatley organizations but they provided an infrastructure for their future growth. The notoriety of leaders like Williams helped the named memorials become distinguished organizations among the other clubs in the NACW. By 1896, the national association reported six Wheatley organizations.[12]

Among them was the Phillis Wheatley Club of Chicago (sometimes referred to as the Wheatley League), established by NACW organizational historian Elizabeth Lindsay Davis. The club was dedicated to community service projects and was a venue for social activities "but also served as a marker of social class, status, and prestige."[13] Between 1906 and 1908, the club worked with the Illinois Federation of Colored Women's Clubs to found the Phyllis Wheatley Home for Girls, which was both the first Wheatley home and "the longest running Black settlement on Chicago's South Side during the early twentieth century."[14]

Prominent clubwoman Fannie Barrier Williams proclaims, "The most important undertaking among colored women is the establishment of the

Phillis Wheatley home. It was organized some years ago for the purpose of giving shelter and protection to the young colored women who wander into Chicago unacquainted with the snares and pitfalls of a great city."[15] Providing a safe haven for migrants was an important endeavor that African American clubwomen made a top priority across the nation. Wheatley homes were established by African American women who sought to fill the needs of vulnerable populations in their communities and commemorate their namesake. Many of the Wheatley homes were a place for young, single mothers or unmarried women. They often operated as settlement houses in northern and midwestern cities, designed for female migrants from the South and sometimes West. In other instances, homes were established for elderly and disabled people. These homes were essential, since local governments and philanthropists often neglected to include African American women, older adults, and disabled people in their budgets.

In Nashville, the Phyllis Wheatley Club was the oldest Black women's club in the city. Organized in 1897 by Mrs. C. S. Smith at the African Methodist Episcopal (AME) Church Sunday School Union, the Wheatley Club embraced the NACW's motto of self-help "to lift as we climb and to help in every way we can for the betterment of our people, especially womanhood."[16] By 1907, they had raised money to build the Phyllis Wheatley Charity Home,[17] which created "Phyllis Wheatley Day" as a designated time to collect and solicit donations for sick and impoverished people in their community.[18] In 1909, the Phyllis Wheatley Club Incorporated of New York City opened a home "to provide a place for the many young women of the race who come to New York from the south and other sections of the country, where they may prepare themselves for paying positions along the lines of domestic work and at the same time enjoy the privileges of home comforts."[19] Other prominent settlement homes included the Phyllis Wheatley Home in Detroit, Michigan, founded in 1897, and the Phillis Wheatley Association in Cleveland, Ohio, founded in 1911 by Jane Edna Hunter.[20]

Phyllis Wheatley Place was developed in 1916 "as a residential addition exclusively for black families." It flourished over the next several decades to become a premier African American subdivision in Dallas, Texas.[21] In addition to the Wheatley (Elementary) School and Park, other namesake establishments of the neighborhood were an art club and mission club, which, respectively, promoted the community's amenities and bolstered a landscape of Black cultural heritage.[22] Wheatley's commemoration in the nationally distinct memorial, "named for the 19th century American poet," made the neighborhood rare. Much more common were named memorials, like the Phyllis Wheatley Community Center in Lincoln, Nebraska,

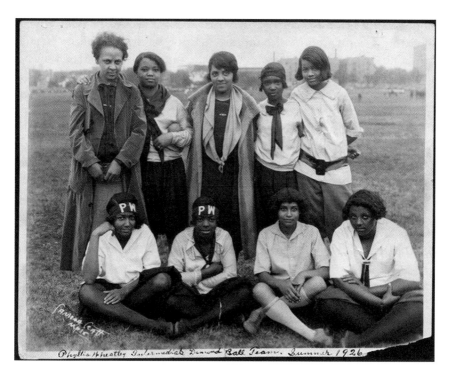

Figure 3. Leaders of the Phyllis Wheatley Home in Minneapolis, Minnesota, pose with the girls of the PW Intermediate Diamond Ball Team in the Summer of 1926. Phyllis Wheatley House Collection, Courtesy of the Minnesota Historic Society.

the Phillis Wheatley Children's Home in Wichita, Kansas, the Wheatley Rescue Club in Keokuk, Iowa, and the Ladies' Tinney Philis Wheatley Immediate Relief Association in Washington, DC, that attended to the social and philanthropic needs of local residents.[23]

The women of the Phyllis Wheatley Settlement House in Minneapolis, Minnesota, extended her memorial brand to promote youth athletic teams as early as the 1920s, which included the Phyllis Wheatley girls' "intermediate diamond [base]ball" team, along with boys' basketball and football teams, which existed as late as the 1950s.[24] The Phyllis Wheatley Center in Greenville, South Carolina, too, broadened their services to include young Black boys when they established a "boys club" in 1928.[25]

In addition to philanthropy and youth outreach, African American women used Wheatley's memorial brand to promote her public memory and poetry. Mrs. Rev. Tillman of the Phyllis Wheatley Club in Chicago recited "an original poem from her own pen, in memoriam of Phyllis

Wheatley" at a club event.[26] President Annabel Harris of the Phyllis Wheatley Club in Saint Paul "read a short sketch and delineation of the life and character of Phyllis Wheatley."[27] On some occasions, special guests were invited to give presentations on the poet, including "a man of excellent literary tastes [who] read of the life and work of Phyllis Wheatley" at the Washington, DC, Wheatley Club.[28]

In 1913, memorializer Sue Wilson Brown helped organize the Philis Wheatley Club in Des Moines, Iowa, perhaps influencing Brown's involvement in the Intellectual Improvement Club, which had "a very interesting discussion on the life and character of Phillis Wheatley" during one of their meetings.[29] A different African American women's club in Des Moines had a guest speaker presentation "on the life and character" of Wheatley, followed by a discussion among "all present with much enthusiasm in which Mrs. Wheatley was paid high tribute."[30] These public events reinforced Wheatley's significance to clubwomen as a literary figure and a positive historical representation of Black womanhood.

Wheatley art, dramatic, and reading circles, or literary organizational activities, centered around presenting literature, plays, and operas to members and local communities. In 1893, the *Cleveland Gazette*, reporting on the Wheatley Literary Club, wrote that "a bevy of the most popular young ladies that Steubenville [Ohio] can afford, treated a well filled house to one of the most interesting programmes that have been rendered in this city for a season." To purchase a new communion set for Quinn Memorial AME Church, the young women presented a "head handkerchief jubilee concert," which paid homage to enslaved women through Negro spiritual selections.[31] The Wheatley Dramatic Club in Davenport, Iowa, also performed plays at a local church.[32] In Charleston, South Carolina, the Wheatley Literary and Social Club was one of the most prestigious African American organizations in the state. Meetings were strictly restricted to members of the organization, except in 1921, when scholar and activist W. E. B. Du Bois attended a special birthday celebration. In 1928, they sponsored a Marian Anderson concert for an interracial audience.[33] Smaller organizations, like the Wheatley Art Clubs in Winslow, Arizona, and Kansas City, Missouri, held programs and meetings in members' homes.[34]

Even clubs with other named memorials embraced the promotion of Wheatley's public memory. At a meeting in March 1899, the Ida B. Wells Club discussed "Our Afro-American Women in Literature," a paper presented by Agnes Moody. Afterward, a dramatic reenactment of Wheatley was performed. *The Appeal* reported, "Mrs. Fannie Hall Clint characterized Phillis Wheatley, and in the garb [clothing] of the eighteenth century, looked

the part, reciting Miss Wheatley's poem to the Earl of Dartmouth and George Washington's letter in reply to a poem sent him by Miss Wheatley."[35]

Her name commonly evoked, Wheatley was a representation of Black women in literature, and it was common for clubwomen to recite her poetry as a method to teach their communities about her life and achievements. Eugenicists of the late nineteenth and early twentieth centuries insisted that pseudoscientific evidence proved Black peoples to have diminished intellectual capacity, and Jim Crow laws relegated African Americans to second-class citizenry.[36] Wheatley's accomplishments as a published poet and her interaction with George Washington defied White supremacists' conceptions of African American capabilities. Wheatley became a symbol of the intellectualism possessed by African Americans, despite her being formerly enslaved and categorized as subhuman. African American intellectuals latched onto the symbolism of Wheatley as a powerful retort to racist imagery and mythology.

Du Bois was a well-known supporter of Wheatley organizations, often sending them congratulatory messages, donating money to sustain them, serving on boards, and featuring their accomplishments prominently in *The Crisis*. His extensive support of the Wheatley brand reflected his support for the philanthropic work that Black women were doing nationwide. In 1924, he wrote to the "Phillis Wheatleys" of Charleston: "I am sure that if Phyllis herself could look in upon you today she would be uplifted beyond her wildest dreams for she must have been a very lonely little girl there in Boston with scarce a soul of her own race and blood to speak to, while if she lived today she would have all that you have and that, despite everything, is a great deal."[37] Indeed, "despite everything," African American women supported themselves through their social welfare work that sustained the Black community during Jim Crow and affirmed themselves through legacy work. Du Bois not only appreciated the historic significance attached to Wheatley organizations but he celebrated the ability of her memorial brand to refute false narratives of Black women's inferiority.

Like other African American clubwomen, Mary Church Terrell wielded Wheatley's public memory to refute negative public discourse. Her 1932 "Historical Pageant-Play Based on the Life of Phyllis Wheatley" centered the poet as an integral part of the founding of the nation. As a member of the Committee on Coordinating Activities among Colored People for the George Washington Bicentennial Celebration in the District of Columbia in 1932, Terrell found in the plays and pageants compiled that "without exception, the colored people mentioned in them were objects of ridicule." She decided to write her own pageant and chose Wheatley as the

central focus, deeming the poet a "credible representative" and lifting up the writer as one "whose career our young people would have reason to be proud."[38] Wheatley's life story was acted out in a series of dance and dialogue scenes that emphasized her African heritage and famed communication with George Washington. Terrell, a deft public memory crafter and memorialized Black woman herself, understood the significance of promoting the public legacies of African American women. Her emphasis on Wheatley's African heritage demonstrated the diasporic lineage of African Americans. She believed Wheatley's life story would "increase the colored youth's respect for his African ancestors by showing the native ability and the brilliant literary success of an African girl stolen from her native land."[39] By noting that Wheatley was "stolen," Terrell underscored the realities of slavery's terrorism and dehumanization of Black bodies. She employed Wheatley's public memory to display both the tragedy and triumph of enslaved Black women.

Terrell also used the story of Wheatley and Washington to demonstrate that African Americans, and specifically women, were active agents in advocating for their freedom based on the founding principles of the United States. By linking the two figures, Terrell's pageant constructed Wheatley's public memory as an educational tool designed to incorporate Black women into American history. The pageant was geared toward Black children to "increase their pride in their racial group and thus strengthen their self respect."[40] The play debuted at the all-Black Armstrong High School in Richmond, Virginia, on November 19, 1932, but was performed on other occasions, including as late as 1941 by the Dunbar High School Community Center in Washington, DC. Terrell's pageant made African American women central to the bicentennial celebration and inspired the celebration of "Phillis Wheatley Day" at Lincoln Congregational Temple on June 12, 1932.[41]

Decades before Mary Church Terrell's pageant, Wheatley's public memory was promoted in print media. *The Statesmen* opined in 1910 that though "Phillis Wheatley is known by name to thousands of Americans today . . . she is to most people . . . only a name."[42] But African American writers and journalists worked diligently to bring her story to the masses. Wheatley was often written about in newspaper articles on the history of colonial America and the American Revolution during national holidays like the Fourth of July. Newspapers often paired brief biographical sketches of her life with reports of new organizations established in her name. These mini bios helped to sustain Wheatley's public memory and encouraged African American youth to emulate her success. As early as 1887, Osceola F. Gordon of the *Christian Recorder* encouraged, "Young ladies, remember Miss Phillis

Wheatley, the colored poetess, whose ambition for reading and studying should be emulated by every colored woman."[43]

Wheatley's public memory was employed as a reminder to Black communities that racial hardships could be overcome. In February 1901, the *Colored American* published a speech by Harry W. Bass in which he discussed the Black liberation struggle from the writing of the US Constitution to the Civil War. Bass made Wheatley a prominent part of his oration, reciting her poetry and centering her life journey. He stated, "Phyllis Wheatley represented a mentality peculiar to her race which slavery could not longer subdue."[44] Commemorative oratory was often employed at public festivals and church programs to teach and inspire African Americans of all ages. By printing Bass's speech, the *Colored American* reinforced the expansiveness of Wheatley's public memory for a national audience.

Radio broadcasts were another venue that African Americans used to promote Phillis Wheatley's public memory. In 1943, she was the first person featured on "Heroines in Bronze," a nationwide Columbia Broadcasting Station (CBS) radio program sponsored by the National Urban League. The *Pittsburgh Courier* reported that the episode was "the first time that the accomplishments and achievements of Negro women have been heard over the air in story and fact in the history of radio."[45] Shirley Graham's "The Story of Phillis Wheatley," a preamble to Negro History Week, debuted the night of January 25, 1949, as a thirty-minute feature show on CBS.[46] The celebrated stars of the show included "dramatic and operatic star" Muriel Smith, who was cast as Phillis.[47] The radio script chronicled Wheatley's enslavement in Boston and the difficult "public test" she endured to be legitimized and published as a writer.[48]

Chronicling Wheatley's life was only part of Graham's broader work. As a celebrated writer, Graham published pieces as a means to promote and disseminate Black history to the masses. Several months after the success of her CBS show, she published a young adult biography with the same title, *The Story of Phillis Wheatley*, featuring illustrations by Robert Burns.[49] One reviewer noted that Graham's characterization of Wheatley has "a definite emotional appeal for girls of twelve and over."[50] Having served on the executive board of the Wheatley YWCA in her hometown of Indianapolis, Indiana, Graham was a longtime memorializer of the poet's legacy. She wielded popular media and accessible publications to reflect the challenges and pinnacles of Wheatley's life onto the African American woman's experience through the culture of recognition.

Public memory crafters were so successful in promoting Wheatley that her memorial brand began to resonate with all types of public enterprises. Marcus Garvey and the Universal Negro Improvement Association (UNIA)

adopted the Wheatley brand as an international moniker of freedom. Founded by Garvey in Jamaica in 1914 and brought to the United States in 1917, the UNIA was a Pan-Africanist organization established to promote Black economic and social liberation and unity. Black women were the "backbone" of the UNIA, comprising "at least half of its membership and serving in leadership positions on the local, national, and international levels."[51] Garvey embraced women's participation in his grassroots organization and highlighted their contributions to Black history in his public commemorations.

The Black Star Line Steamship Corporation of the UNIA was launched in October 1919 with the SS *Frederick Douglass*, the first of three ships scheduled to embark. The other two were the SS *Phillis Wheatley* and the SS *Booker Washington*. Garvey explains: "The names chosen for the three ships are a happy expression of the pride in success without which no race can hope to advance in the path of progress. Frederick Douglass, Booker Washington, and Phillis Wheatley will live forever in the history of the American Negro, as a testimony to that which the race has accomplished in diplomacy, in education and in the realm of letters."[52] Named after "illustrious Negroes," the ships of the Black Star Line celebrated the political and educational legacies of Black achievement.[53] Having been enslaved, Douglass, Washington, and Wheatley each obtained their freedom and led extraordinary lives. Celebrating their accomplishments demonstrated the convergence of the Black past and future, since they symbolically steered the African diaspora to freedom and economic independence.

Known as "the Africa ship," the *Phillis Wheatley* was to sail from the United States to West Africa as its main route.[54] The UNIA had chosen a woman to lead Black Americans back to their ancestral homeland. Ultimately, though, the steamships *Wheatley* and *Washington* were never brought to fruition. The Black Star Line had solicited and sold stock for the SS *Wheatley* through advertisements sent using the United States Postal Service. Because the ship had not been purchased before the UNIA sent official correspondence about investing in the ship, the Federal Bureau of Investigation pounced on this fact as a strategy to discredit and indict Garvey on mail fraud charges. Still, Wheatley's significance as a historical representation of Black womanhood was ever growing, not only as an American brand but as an international symbol of liberty. Since the *Wheatley* and the *Washington* had never materialized, the UNIA memorialized the two historical figures through other means. The Phyllis Wheatley Hotel, the UNIA's official headquarters in New York City, housed the organization's Booker T. Washington University, opening the summer of 1922.[55]

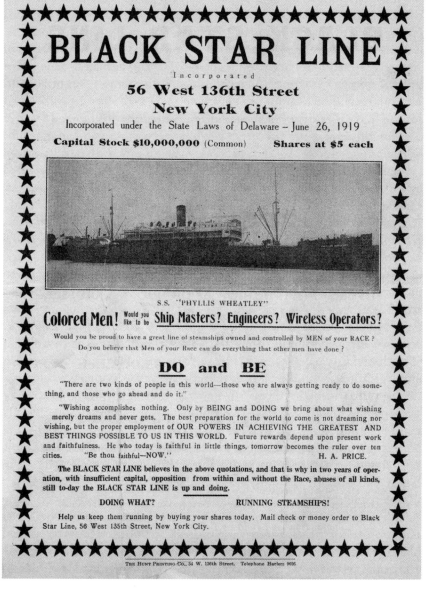

FIGURE 4. SS *Phillis Wheatley* advertisement, circa 1919–22. Broadside of the Black Star Line, Universal Negro Improvement Association. Collection of the Smithsonian National Museum of African American History and Culture.

New York was also home to another unique Wheatley named memorial in the 1920s. The Phillis Wheatley Publishing Company was established on September 1, 1925, "in honor of the Negro poet" in order "to prepare, publish and distribute reference books, text books, and other volumes of special interest and service to Americans of African descent."[56] The editor in chief Roscoe Conkling Bruce coordinated the company's central focus of producing a publication of *Who's Who in Colored America*, which was to profile notable achievements of Black Americans. Volume one was to contain the biographies of the living, while volume two was designated for historical figures.[57] Black scholars across the nation were asked to write the biographical sketches. Some of them were also among the carefully curated board of directors that Bruce had compiled of accomplished African Americans, including W. E. B. Du Bois, Mary McLeod Bethune, James Weldon Johnson, and Alain Locke.[58]

Off to a great start, the publishing company had lofty goals of expanding to "issue a series of supplementary [African and African American history] readers especially for the use of pupils in grades four, five, six, and seven in the elementary colored schools of the South."[59] Bruce set an ambitious schedule to have the first volume, reported to contain "over one thousand pages of biographical data," published by October of 1926.[60] The company was cash strapped from its inception, however, and had no means to print the volume in mass. Bruce did his best to manage the financial woes, but after consulting with over fifteen publishers, he was not able to find one that would partner with them.[61] In an attempt to salvage the project, Bruce wrote to the American Public Fund in New York to apply for a $25,000 loan. He emphasizes the significance of the company's endeavors: "*This Company is no mere commercial enterprise*. It was established . . . for the one central purpose of providing the American people, white and colored, with books giving information of an educational nature regarding the Negro.[62]

The name chosen for the company highlighted that it intended to do public good. The Wheatley memorial brand also symbolized Black achievement, which for the publishing company was exemplified by its prominent board of editors and those featured in *Who's Who*. Despite his enthusiasm and expansive network, Bruce was unable to secure the money needed to sustain the business. With the rejection of their loan request, the company ended in failure.[63] Though short-lived, the Phillis Wheatley Publishing Company remains a distinct capitalist venture that used the memorial branding that African American clubwomen had established decades earlier.

In the late 1930s, African American businessman George Friley "decided to venture into the bakery business . . . and formed the Phillis Wheatley Bread Company," the Detroit branch of the New York Bell Bakeries.[64]

Available in seven varieties (rye, whole wheat, raisin, rolls, white sesame, braniax, and tea biscuits), a sixteen-ounce loaf sold for ten cents.[65] Lillie Brooks, mother of heavyweight champion Joe Louis, was made spokesperson for the new brand. In a lengthy ad, Brooks appealed to Black mothers about the nutritional and sociological value of Phillis Wheatley Bread. Not only was it the "Finest Quality of Loaf of Bread on the Market" for "any mother who desires to keep her children strong and healthy," it was also "named after a great Negro woman and is an all race product."[66]

Wheatley Bread was marketed specifically to the race and gender consciousness of African American women because of the powerful resonance of Wheatley's brand. The Wheatley Home had existed in Detroit since 1897 and was still a vibrant philanthropic and social center for African American women in the 1930s. During Negro History Week in 1939, the *Michigan Chronicle* announced that the Booker T. Washington Trade Association would be serving "Phillis Wheatley bread" following its meeting at Hartford Avenue Baptist Church.[67] Such an announcement during a designated time to celebrate Black history demonstrates that Wheatley Bread evoked a philanthropic and social meaningfulness for African American women and community organizations that was used to encourage Black consumers to support the product.

The Phillis Wheatley Bread Company also represented career advancement for African American women. The Lewis Business College lauded the employment and promotion of graduate Mary Ellen Payne at the company in 1939. Payne's position exemplified the type of careers that its graduates could look forward to, though it was truly unique to work for a company named after an African American woman.[68] As economic tensions for Americans were beginning to ease in the late 1930s, Payne's career signified new possibilities for African Americans. It was an honor to be affiliated with the distinguished Wheatley brand because it offered a departure from popular culture caricatures and stereotypical images of African American women. These features added to the company's prestige and made Wheatley bread a desirable product for African Americans. There is little known documentation outlining the success or longevity of the Phillis Wheatley Bread Company. However, its existence reinforced the utility of celebrating the legacies of African American women through named memorials.

The visibility of Phillis Wheatley's commemoration through organizational and economic memorial branding continued to expand in every region of the United States and in at least thirty-seven states throughout the 1930s and 1940s. In rare instances, fraternal organizations embraced the Wheatley named memorial brand. In Charleston, West Virginia, there was the Phyllis Wheatley Court No. 1 of the Order of Calanthe, while the

what Joe Louis' mother Mrs. Lillie Brooks, says about PHILLIS— WHEATLEY— BREAD:

Good wholesome BREAD is important in the raising of healthy children. I have raised several boys and girls. Fortunately, one of my boys has become heavy-weight champion of the world.

I attribute his success, partly to the careful selection of his food, and the one thing that has been foremost, was the careful selection of a high quality Loaf of B R E A D.

I have tried this New PHILLIS WHEATLEY BREAD and have found it to be the Finest Quality Loaf of Bread on the M a r k e t. . . .

It has uniformity, taste and flavor.

I highly recommend PHILLIS WHEATLEY BREAD to any mother who desires to keep her children strong and healthy.

PHILLIS WHEATLEY BREAD is named after a great Negro woman and is an all race product.

I am enthusiastic about this new enterprise and I hope every mother will get behind this new race concern and help to make it a real success. We, Mothers owe it to our race to DO so

Signed —

mrs Lillie Brooks

• • • • •

The change is to **PHILLIS WHEATLEY BREAD.**

• • • • •

THE PHILLIS WHEATLEY JOBBING COMPANY

BEAUBIEN and ILLINOIS

Phone TEmple 1-1316

FIGURE 5. Phillis Wheatley Bread advertisement featuring spokesperson Lillie Brooks. "Phillis Wheatley Bread is named after a great Negro woman and is an all race product." *Detroit Tribune*, August 6, 1938. Chronicling America, Library of Congress.

Phyllis Wheatley Temple of the Improved Benevolent and Protective Order of Elks of the World was established in Red Bank, New Jersey.[69] But by and large, the national network of named memorials was bolstered through the work of African American clubwomen of the NACW.

Keen to capitalize on the popularity of Wheatley named memorials, NACW president Sallie Wyatt Stewart created an official national department in 1930.[70] Stewart asked one of the most successful leaders of a settlement house in the nation, Jane Edna Hunter, founder and president of the Phillis Wheatley Association in Cleveland, Ohio, to become the national chair of the new department. Stewart and Hunter created guidelines stating, "The purpose of the National Phyllis Wheatley Department is to establish a national network of institutions which will provide homes and a program of social service for Negro girls and women, serve as meeting centers for club women, and stand as lighthouses to all young women in their respective communities."[71]

The Wheatley name was indeed a lighthouse to communities, and her memorial brand affiliation symbolized that these organizations were among the best equipped for community and social uplift. From large cities and metropolises to small and rural towns, the Wheatley name was continuously used to memorialize and signify an association with the work being done by Black women all over the country.

By 1937, the Wheatley Department had grown to include twenty-six clubs and nine homes. Five state federations sent delegates to visit Hunter's Cleveland organization to learn how to replicate its model of success.[72] In 1939, ten districts of Wheatley organizations were affiliated with the department. Hunter continued as the department chair until the 1950s, when the NACW shifted its focus "to train the next generation of clubwomen and extend the longevity of NACW" by establishing the Phyllis Wheatley Young Women's Department.[73] Though the NACW had many clubs named in honor of other African American women, the Wheatley Department was the only instance in their history when they developed national resources to build a network of new organizations under the same named memorial.

The vast influence of the NACW made being affiliated with a Wheatley organization a distinguished honor for African American clubwomen. Beyond the NACW, Wheatley named memorials were created in other national women's organizations as well. While the Women's Christian Temperance Union chapter named for Wheatley in Harrisburg, Pennsylvania, was rare, African American branches of the Young Women's Christian Association (YWCA) named for her became standard.[74] Though founded in the mid-nineteenth century, the YWCA did not officially incorporate African American women until the early twentieth century. Under the "supervision" of White women, African American branches of "the Y" (as it

was commonly referred to) were founded beginning in the 1910s. Branches were sometimes named after their locations, by cities or streets, but the "colored" YWCA branches were named after Phillis Wheatley more than any other affiliation. Journalist Rita Robbins explains, "Phyllis Wheatley lives on, however, not only to honor with her name many YWCA branches in this country but also as a personality, a poet and notable woman in American history."[75]

YWCA branch named memorials extended the distinguished cache of the Wheatley memorial brand well into the mid-twentieth century. Most African American branches of the Y were formed from existing clubs seeking financial resources for much-needed community and social welfare services. In Asheville, North Carolina, the Phyllis Wheatley YWCA was birthed from the Employment Club. Established in 1913, the Employment Club was "committed to finding jobs and providing support for hardworking Negro women." By 1921, the club had rebranded as a Phyllis Wheatley branch and was operating under the supervision of the Asheville Central YWCA. They continued their work "as an informal employment referral agency for Negro girls."[76] Similarly, the Phyllis Wheatley branch in Seattle, Washington, grew out of the already established Culture Club in 1919 to become "the first of its kind in the Northwest."[77]

According to Rosa Loving, a small group of African American women began in 1909 to help support the housing needs of young Black women and girls who were new to Richmond, Virginia. When the women were unable to house all those in need between a rented six-room building and Loving's own home, "it was finally decided to ask the help and cooperation of the white YWCA." Loving's collaboration rendered Richmond its first African American YWCA branch and another named memorial of Wheatley.[78] In December 1914, the Central YWCA officially "accepted responsibility for the Phyllis Wheatley branch," which allowed Loving's group to utilize new resources to expand to "a more spacious residence" and fulfill the growing needs of their community.[79]

The Indianapolis Phyllis Wheatley YWCA, too, was preceded by a group of Black women offering boarding and programming for Black women and girls. The process of development began in 1895 "in a rented house, with a lounge for working girls and religious programs in factories." By 1900, the women had purchased a house, and in 1909, they dedicated a new building at the same location. In 1922, they began a "membership campaign for [the] negro branch" but did not dedicate the Phyllis Wheatley Branch until 1929. Becoming a part of the YWCA meant a steady allocation of resources and an alignment of Christian and philanthropic values the women already subscribed to in their club activities.[80]

African American branches were also assisted by the national organization in purchasing land and financing organizational headquarters. For instance, in Washington, DC, "the national association gave the local body both the land and the commodious new building which now occupies it." The women of the Phyllis Wheatley YWCA did their part to furnish and maintain the home at 901 Rhode Island Avenue with a "successful campaign for $25,000."[81] Though Black clubwomen remained the primary fundraisers for their programs and philanthropy, their affiliation with the national YWCA meant the entire financial burden was not on them alone.

The YWCA's organizational infrastructure supported African American clubwomen's efforts to create safe spaces for children and extend Wheatley's memorial brand to girls through the culture of recognition. The Brownies, Blue Triangle Girls (which evolved into Girl Reserves and, later, Y-Teens), and Industrial Girls participated in educational activities, workshops, and socials under the umbrella of YWCA programming. Youth outreach stimulated "pleasure cultures" by providing safe spaces for dances, summer camps, babysitting classes, citizenship conferences, and a variety of other rich programming.[82] Historian LaKisha Michelle Simmons argues that despite segregation, communities "organized around a geography that reinforced and recreated dominant ideologies of race, gender, and sexuality. . . . The worlds created by the YWCA, and in similar spaces inside of the black community, created different, often positive and hopeful, conversation."[83] African American clubwomen used the Wheatley memorial brand to create their own world in which African American children could flourish and experience joy.

In Albuquerque, New Mexico, named memorials were employed to identify racial and ethnic youth groups in the local YWCA. The Wheatley memorial brand distinguished African American girls in the YWCA, likely since one of the earliest documented Wheatley clubs was founded there in 1896.[84] Advised by African American clubwomen, the Phyllis Wheatley Girl Reserves were known for their programming and activities, which began as early as the 1920s. In addition to weekly meetings, the girls went camping and participated in activities with other groups in citywide and statewide conferences.[85] The Girl Reserves regularly performed and hosted well-attended plays, concerts, and dances while also raising money for "poor children," "taking baskets of food to needy families," and visiting with the "sick and shut-ins."[86] As these girls grew into young women in the 1940s, they formed the Phyllis Wheatley Big Sister Club to supervise the activities of the next generation of Girl Reserves. The new club provided a distinct space to host programs and activities for young women in their late teens and early twenties.[87] Rather than choosing a new name for the club, the Big Sisters kept the Wheatley moniker as a label of distinction.

Wheatley YWCA branches promoted their namesake's legacy as a regular part of their youth activities. The Girl Reserves Dramatic Club of the Phyllis Wheatley YWCA in Washington, DC, planted and dedicated to her a white oak tree in 1922.[88] In Richmond, Virginia, the Wheatley YWCA annually crowned a teenage girl "Miss Phillis Wheatley."[89] The young women who participated in the highly anticipated pageant were celebrated for their community service and respectable social graces. Because clubwomen heralded the symbol of Wheatley as a model for womanhood, they taught girls that representing Miss Phillis Wheatley was connected to a larger legacy of African American women's achievement.

When the national YWCA began to integrate, African American branches named after Wheatley dwindled. Though the process of integration meant increased opportunities for equality for African American women within the institutional structure, the erasure of Wheatley named memorials was an unintended consequence. Integration in Asheville, North Carolina, began in 1954, when Lucille Burton became the first African American elected to the Central YWCA board. By 1967, two years after Thelma Caldwell was hired as executive director of both the Wheatley branch and the Central YWCA, the membership rolls had been completely combined. In 1971, the two groups moved into the same building to fully integrate, the Wheatley and Central names were dropped, and the local chapter was renamed the YWCA of Asheville.[90] While some branches, like the Phyllis Wheatley YWCA in Knoxville, Tennessee, retained their named memorial well into the twenty-first century, many lost Wheatley's name as they merged with all-White chapters. The integration of the YWCA signaled a changing tide in the application of the Wheatley brand across the nation.

Though the number of Wheatley named memorials decreased through the 1950s and 1960s, Wheatley's public legacy endured. The emergence of the Black Arts and Black Studies movements in the 1970s set the stage for increased circulation, analysis, and criticism of Wheatley's poetry. Yet a new generation of African American women found Wheatley's public memory to be just as compelling as had the founders of the first named memorials in the 1890s. African American women continued to be at the forefront of her public commemoration in this era, most notably at the 1973 Phillis Wheatley Poetry Festival.

Scheduled for November fourth through the seventh, the symposium was organized by Margaret Walker (Alexander) to celebrate the two-hundredth anniversary of the publication of Wheatley's *Poems on Various Subjects, Religious and Moral* (1773), since it was the first book published by a Black person in the United States. Walker, a pioneer of the Black Studies movement, "established one of the first black studies programs in the country."

In 1968, she founded the Institute for the Study of the History, Life, and Culture of Black People at Jackson State College, now University, in Mississippi.[91] In addition to her own major achievements as a Black literary icon, Walker created space for other Black women writers to flourish. After securing a sizable grant from the National Endowment for the Humanities, she carefully selected almost two dozen of the nations' most talented African American women writers and artists to pay tribute to their literary predecessor.[92] Nikki Giovanni, Audre Lorde, Sonia Sanchez, June Jordan, Paula Giddings, Alice Walker, and Lucille Clifton, among others, agreed to participate in the symposium.

The four-day festival was centered around five poetry recitation programs, where authors read Wheatley's and their own original poems, illustrating the culture of recognition. Music was ever present in the Dansby Hall Auditorium as the Jackson State College Choir belted out Negro spirituals and Nina Simone's "To Be Young, Gifted and Black" or led the audience in James Weldon Johnson's "Lift Every Voice and Sing." Nikki Giovanni's poetry reading was accompanied by the Tougaloo College Gospel Choir, while Wheatley's work was "read to the accompaniment of eighteenth century classical music on the organ and harpsicord [sic]."[93] Festival attendees witnessed the unveiling of Elizabeth Catlett's original bronze bust sculpture of Wheatley and viewed some of Wheatley's "handwritten letters" in an "exhibition of historical documents."[94] *Jet* reported that the highlight of the festival was *Phillis Wheatley—Gentle Poet, Child of Africa: A Portrait in Nine Scenes.* The one-woman show, "staged by Broadway star Vinie Burrows," chronicled Wheatley's life from her youth in Africa through her marriage to John Peters.[95] The festival created a splendid forum to celebrate the legacy of Wheatley while giving African American women a prominent platform to share their work.

Margaret Walker thought the festival was a "tremendous success" on both fronts, and the African American press agreed.[96] *Ebony* informed readers that the festival was "an obvious result of the revived interest in Miss Wheatley and her writings." *Black World* professed it "one of the most important literary festivals organized in this country."[97] And *Freedomways* printed the most detailed article, "Ancestral Memories," with an explanation of and insightful commentary on each presentation of the festival. In the piece, authors Charles H. Rowell and Jerry W. Ward declare that the "festival will be recorded as an occasion of great distinction in the annals of Afro-American literature and culture." They also observe that "the festival recognized the creative endurance and historical contribution of the black American woman. . . . Each of the women poets was in her own way a Phillis Wheatley, or at least a spiritual daughter of Phillis Wheatley, who

expresses herself against the odds."[98] Just as Black clubwomen had been called Phillis Wheatleys decades before, the festival served as a debut for this new generation of Wheatleys who were redefining public memorialization for African American women.

African American women's admiration for Wheatley as a symbol of Black intellectualism, Black womanhood, and Black triumph in the face of oppression did not waver throughout the twentieth century. Yet maintaining the permanency of named memorials attached to clubs, YWCAs, and public buildings lessened as segregation of the Jim Crow era was being dismantled. The 1973 festival reinforced the commitment of African American women to create their own public spaces to celebrate their historical icons. At the festival, Margaret Walker notes: "America is like this—the horror is here, the corruption is here, the evil is here. / But there is also some love and some beauty as we see in this festive atmosphere."[99] Like generations of African American memorializers before, Walker's legacy work demonstrates that Wheatley was a beacon that highlighted Black women's ability to treasure the love and beauty found in creative endeavors despite the horror, corruption, and evil subjecting African Americans to second-class citizenship in the nation they were integral in conceiving and building.

A decade before the explosion of the fields of Black women's history and Black women's literature in the 1980s, the Wheatley Poetry Festival showcased Black women as adept architects of creativity. Giovanni heralds Walker as "the living personification of the spirit of Phillis Wheatley," high praise indeed. Later looking back, Walker expresses that Black women writers "are simply continuing a tradition begun by Phillis over two hundred years ago."[100] She was conscious of the obvious parallels between Wheatley's struggle to be a successful and published poet and the obstacles Black women writers faced in her lifetime. The decision to feature a scholarly discussion at the festival on the absence of Black women in textbooks drew attention to the criticisms about the absence of Black women in positions of power in academia. "I think that our coming together in 1973, ostensibly to honor and celebrate the first among us to raise her voice within mainstream America," Walker reflects, "challenged us to give shape and form to a movement which permitted even more voices to be heard."[101]

The Wheatley memorial brand was rooted in her ability to defy and endure societal expectations of Black women. Of all the presentations of the festival, Alice Walker's "In Our Mothers' Gardens" remains one of the most recognizable. In her acclaimed essay, Walker argues

> But at last, Phillis, we understand. No more snickers when your stiff, struggling, ambivalent lines are forced on us. We know that you were

not an idiot nor a traitor; only a sickly little Black girl, snatched from your home and country and made a slave; a woman who still struggled to sing the song that was your gift, although in a land of barbarians who praised you for your bewildered tongue. It is not so much what you sang, as that you kept alive, in so many of our ancestors, the notion of song.[102]

Alice Walker's eloquent words echo the looming admiration African American women continue to hold for Wheatley. Wheatley's unmatched named memorials and strategic public memory crafting, along with Walker's keen articulation of her lasting significance, defy the notion that she was relentlessly criticized and undervalued by all Black scholars at the height of the Black Arts movement.[103]

Fifty years later, the anniversary conference of the Phillis Wheatley Poetry Festival in 2023 reveals that the culture of recognition for Wheatley has shifted into a new era as her memorializers advocate for understanding the humanity of African American women. While she is still heralded as symbol of their creativity and intellectual capacity, African American women are increasingly interested in commemorating her interiority. Now commonly referred to as Phillis Wheatley Peters, her chosen married name, she is characterized as a wife, a mother, and a friend. As research unearths more about the details of Wheatley's life beyond enslavement, memorializers have increased understanding to delve deeper into her personhood, which reflects their own desire to be seen as complex people whose lives, ideals, and contributions matter.

Statues of Wheatley and historical and literary publications like Honorée Fanonne Jeffers's *The Age of Phillis*, newly brought into being in the twenty-first century, show that African American women continue still to be at the forefront in celebrating Wheatley's legacy.[104] Their dedication to their communities anchored the activities of hundreds of organizations across the nation named for Wheatley beginning in the 1890s. Through the culture of recognition, they evoked Wheatley's name to point out their own creative capabilities and significant contributions. Their public commemorations designated Wheatley as a malleable memorial brand employed in public enterprises to garner support from African American consumers. The resonance of Phillis Wheatley as a named memorial brand rendered her a central presence in Black life and culture, making her the most memorialized African American woman of the Jim Crow era.

CHAPTER 2

Commemorating Freedom

Named Memorials of Sojourner Truth and Harriet Tubman

African American women used named memorials to commemorate Black history. Sojourner Truth and Harriet Tubman were celebrated for their triumph over enslavement and their representation of women in historical events. Their memorial brands resonated with African American women who wanted their present activism to be linked to racial progress. Associating their organizations with formerly enslaved women like Truth and Tubman showcased that their present-day contributions were part of a continuum of African American women's aspirations to obtain freedom for themselves and their communities.

As one of the most notable antislavery and women's rights advocates of the nineteenth century, Sojourner Truth was commemorated by African American women to connect with their distinct experiences through the culture of recognition. Originally named Isabella, Truth was born and enslaved around 1797 in Ulster County, New York, which had a significant community of Dutch immigrants and their descendants. At fourteen, she was married to an enslaved man, Thomas, and bore five children. In 1827, she emancipated herself, supported by her religious conviction and applying state law, and moved to New York City. Pentecostal religion became a central tenet of Isabella's life, and on June 1, 1843, she changed her name to Sojourner Truth, meaning "itinerant preacher." Guided by the Holy Spirit, Truth was compelled to preach the gospel and did so throughout the Northeast. In Florence, Massachusetts, Truth joined the Northampton Association of Education and Industry, which connected her to prominent abolitionists, including Frederick Douglass and William Lloyd Garrison. By the late 1840s, she had begun to use her public platform in religious circles to address abolition, temperance, suffrage, and women's rights. Her

speeches and witty remarks paired with her tall stature and captivating voice made her a popular speaker for some thirty years. At the time of her death on November 26, 1883, Truth was one of the nation's most known African American women public lecturers.

Ironically, much of what African American women memorializers knew and celebrated about her was never written or spoken by Sojourner Truth. She has been credited with giving her most famous public address, "Ar'n't I a Woman?," in 1851 at a woman's rights meeting in Akron, Ohio. The popular question she posed has defined Truth's public memory for more than one hundred and fifty years. Historian Nell Painter separates the public image of Truth from reality in *Sojourner Truth: A Life, A Symbol*, where her groundbreaking research reveals that the public persona of Truth was carefully crafted as a symbol of resistance. Not only did Truth not write or publish the works attributed to her, Painter argues it was actually Frances Dana Gage, a White women's rights activist, who constructed the famous "Ar'n't I a Woman?" speech and fictionalized the Ohio Woman's Rights Convention.[1]

African American clubwomen based their admiration of Truth on what they knew and their ability to tie her legacy to the recent Black past. They embraced the notion that Truth was able to defy societal norms to speak publicly about her experiences and the contradictions of slavery in a free society. The desires of clubwomen to be fairly treated echoed Truth's advocacy for equal treatment for Black women. No other historical voice so forcefully articulated the distinct realities of facing race and gender discrimination. For the African American women that memorialized Truth, "Ar'n't I a Woman?" epitomized their defiance of the simultaneous racism and sexism they regularly experienced. As historian Deborah Gray White posits, "Black women can take pride in the fact that Truth's real remarks and life history obviously inspired the question "Ar'n't I a Woman?"[2] Truth's memorial brand was a historical symbol that African American women rallied behind because they related to her public persona and championed her bold public advocacy for equality and justice in the United States.

Sojourner Truth named memorials were established as early as 1896 through the Truth Home in Washington, DC, and the Truth Club in Birmingham, Alabama.[3] Within a decade, clubs bearing her name had expanded across the nation. In Los Angeles, the Sojourner Truth Club was founded in 1904 with the central purpose of creating a home for impoverished, orphaned, and older Black women.[4] Margaret "Maggie" Johnson Scott was a founder and served as the president in the early 1910s and again in the late 1920s.[5] As part of her strategy to learn best practices in developing and maintaining settlement houses, Scott conducted a research tour in New York, Chicago, and Philadelphia, where she met with Black clubwomen to

collect information and resources. When she returned to Los Angeles, she had a clear vision for how the Truth Club should move forward with the creation of the home. With contributions from the California Federation of Colored Women's Clubs, local churches, African American men's clubs, and support from White clubwomen in Los Angeles, the women of the Truth Club raised just under $14,000 to purchase a plot of land for the home. One of Scott's most inventive fundraisers was the "mile of pennies," which raised twenty cents per foot to total $1000 for their treasury.[6]

In 1913, The Sojourner Truth Industrial Home was opened, complete with "nine bedrooms, two bathrooms, kitchen, dining-room, reception hall and library."[7] Furnished with community donations, the two-story home could house at most twenty women and "was the first home of its kind in California entirely operated" by Black women.[8] The California Federation embraced the home as its Southern California project. It was "considered the first monument to the efforts of Race women in California."[9] The California Federation held Truth's memorial brand in such high regard that, as part of their 1915 annual convention, they named one day's activities "Sojourner Truth Day."[10] The Truth Club and Home became a statewide and regional hub for the club work of African American women. While providing housing to single women, the home also served as a meeting space for California Federation meetings, community workshops, and special event programming.[11] The Los Angeles Truth Club was the most prominent organization in California named in honor of Truth and was regularly reported in local and national newspapers as part of the culture of recognition.[12] Media outlets highlighted that Truth clubs not only represented African American women's modern contributions but also evoked the historical relevance of their namesake.

The Truth Home in Los Angeles used its prominence to lobby for the political needs of Black communities. The home regularly hosted local political candidates to address African American concerns, including Vincent Morgan, candidate for district attorney, who "was introduced to hundreds of his Afro-American supporters."[13] The women also opened their home in 1916 to the Los Angeles Chapter of the NAACP for their annual dinner, where Mayor Frederick Woodman was expected to be in attendance.[14] The home became a vibrant community meeting place, with guests from out of town being welcomed with teas and special parties or celebrated as noted public speakers and performers for programs.[15] Every fourth Monday, the Truth Home hosted Educational Day, where members discussed the work of African American intellectuals like Alain Locke's "The New Negro" or featured special guests like probation officer Alva L. Pulliam with his talk on "The Work of the Juvenile Court."[16]

¶¶¶ MONUMENTS ¶¶¶

¶¶¶

National Monument

Frederick Douglass Home
 National Headquarters in Washington, D. C.

§§§§

State Monuments

Sojourner Truth Home ---- Los Angeles, California

Eastside Settlement House - Los Angeles, California

Fannie Wall Home and Day
 Nursery ---------------- Oakland, California

Mme C.J. Walker Home ---- San Francisco, California

Golden West Club House ---- Bakersfield, California

Negro Women Civic Improvement Club ------------
 ---------- Sacramento, California

The Fine Art and Social Club - Merced, California

Women's Art & Industrial Club - Oakland, California

Phyllis Wheatley Club ---- Los Angeles, California

Mabel V. Gray Progressive Club - Delano, California

FIGURE 6. Page 28 in the 1965 California State Association of Colored Women's Club program booklet listing the Sojourner Truth Home as the first state monument. Other listed California named memorials include the Fannie Wall Home, Madam C. J. Walker Home, Phyllis Wheatley Club, and Mabel V. Gray Progressive Club. California State Association of Colored Women's Clubs, Inc., African American Museum and Library at Oakland, Oakland Public Library, Oakland, CA.

Besides the Truth Homes in Los Angeles and Washington, DC, others were established in New York and Seattle in 1915 and 1920, respectively.[17] In less populated locales, Truth organizations operated with different goals. In Richmond, Indiana, the twelve Black women who founded the Sojourner Truth Club on October 14, 1921, defined their mission of "social and moral uplift," including working to "visit and report all sick of our community." As the first and oldest club in Richmond to belong to the Indiana Federation of Colored Women's Clubs, the women created the Sojourner Truth named memorial to emphasize their interest in Black history. The clubwomen promoted the public memory of Frederick Douglass as well by regularly hosting commemorative oratory programs and donating money to the preservation of his home in Washington, DC.

In addition to disseminating Black history, Truth Club members provided scholarships to young collegebound women and men and used most of their resources to supplement health care for ill people and support bereaved families. The Truth Club prided itself on visiting sick women in the community and celebrated national health care initiatives like National Negro Health Week.[18] All "members were urged to visit the sick," but the Sick Committee spent the most time organizing club initiatives to provide "gowns that was [sic] donated by the club and . . . a nice basket of fruit" to ailing women. A "Greens Supper," a "Rabbit Supper," and "Chittling-Chicken Suppers" supplied the money needed for the Truth Club's social activities and local philanthropy. A significant portion of club resources was allocated for gifting flowers, sprays, and greeting cards to the often overlooked members of their community. On one occasion, when founding member "Mother Robinson" became ill, fifty cents of their limited budget was allotted to send her fruit. Their efforts were greatly appreciated. Families of those recovered from illness expressed their gratitude with thank you cards, which were regularly read at meetings.[19]

The activities of clubwomen evoked the public memory of their organizational namesakes to echo their linkages to both the Black past and to current progress. Organization named memorials of Sojourner Truth were a continuation of the typical African American women memorials of the Jim Crow era. Though they did not expand to the scope of Phillis Wheatley memorials, they were more common than most because of Truth's national notoriety.

In contrast, Harriet Tubman's dynamic memorial brand exceeded the customary practice of named memorials as the primary medium during the Jim Crow era. Indeed, Tubman became the first African American woman to have traditional public history memorials created in her honor. A forerunner of traditional memorialization for African American women,

she was celebrated with the first historical marker, unveiled in 1914—sixty years before the trend spanned the nation. Tubman defied the odds, also being recognized with a state historical marker and house museum established in the 1930s and 1950s, respectively. Through both multiracial commemorative committees and African American memorializers, Tubman's memorial brand as the perpetual "Moses of her people" made her public commemorations unlike any other woman's of the era.

The fifth of nine children, Harriet Tubman was born around 1820 on a plantation on the Eastern Shore of Maryland. She and her family were enslaved by Anthony Thompson, his second wife, Mary Pattison Brodess, and eventually her son Edward Brodess. When Edward reached his early twenties, he forced Tubman and her family to move to his farm in nearby Bucktown. Tubman was frequently hired out to work for "temporary masters," who neglected and treated her cruelly. The most brutal treatment happened in the early 1930s, when she was struck with an iron weight so hard that it fractured her skull and nearly took her life. Her injury remained with her; for the rest of her life, she endured debilitating headaches, seizures, and epilepsy.

Though Tubman suffered greatly as a hired-out laborer, she was eventually able to gain an in-depth knowledge of communication and infrastructure networks in the area, including those of Black mariners. By September 1849, she felt confident enough in her knowledge to flee to freedom. She was able to connect with an existing network of Black and White "conductors" helping enslaved people to escape to freedom—the Underground Railroad. With their help and the North Star as her guide, she reached Philadelphia, where she tasted freedom for the first time. Tubman wanted to give this gift of freedom to others. She began leading her family members and other enslaved people to freedom in December 1850 and, for ten years, kept going back until her last mission in December 1860. Tubman used disguises, clever ploys, different escape routes, and famously carried a revolver to deter any weary escapees. Successful in freeing an estimated seventy people, there was a sizable bounty on her head. In 1859, she moved with her family to Auburn, New York, to property sold to her by William Henry Seward, President Abraham Lincoln's secretary of state.

Tubman became deeply enveloped in the abolitionist movement. John Brown, so impressed with her abilities, dubbed her "General Tubman." While she was never promoted to the rank of general, her work as a nurse and spy with the Union army during the Civil War was unprecedented for a Black woman. Tubman also led over seven hundred enslaved African Americans to freedom in South Carolina as "the first woman to command an armed military raid when she guided Colonel James Montgomery and

his Second South Black regiment up the Combahee River, routing Confederate outposts, destroying stockpiles of cotton, food, and weapons." While all of Tubman's experiences were not as triumphant (she witnessed the massacre of the all-Black Massachusetts 54th Regiment in July 1863), her contributions to the war effort were unparalleled. Her freedom fighting did not end with the Confederacy's defeat in the Civil War. She continued to work as a philanthropist, suffragist, and civil rights activist as she lived out her final years in Auburn.[20]

One of her most notable philanthropic endeavors was her conception of the Harriet Tubman Home for the Aged, which she opened in 1908 to care for older African Americans. Just a few years later, she became a patient in the home because of her migraines and seizures. News of Tubman's condition quickly spread among Black clubwomen, and the Empire Federation of Colored Women's Clubs made her health a major topic of discussion at their third annual conference in 1911. They were so concerned about Tubman's wellbeing that they appointed President Mary Burnett Talbert to visit her in Auburn and report back on her condition.[21] "Aunt Harriet," as she was affectionately called by African American women, had been a part of the women's club movement since its inception in the 1880s. She was not only a "living legend" but also a revered arbiter of wisdom.

Upon returning from the visit to Auburn, Talbert reported that Tubman's "mental faculties" were intact but that she needed financial help to pay for a home care nurse and other monthly expenses. Because Tubman's pension (that she fought to receive for her contributions to the Civil War) was not enough to meet her monthly financial obligations, Talbert called upon the women of the Empire Federation to make donations to help. In addition to raising money for Tubman, the clubwomen were tasked with making her "comfortable during the close of her declining years" by providing linens and towels for her at the Home for the Aged.[22] The clubwomen acted without hesitation in response to Talbert's report. They decided to hold a "linen shower" and agreed to send $25 to Tubman every month. To raise the money, they began to lobby to members, community organizations, and churches for donations.[23] Denominational churches like Fleet Street AME Zion took up collections "for the relief of Harriet Tubman," with most donations coming from African American communities across New York and New Jersey.[24]

By 1912, donations began to wane. With such tight resources, the $25 monthly commitment was taxing on the Empire Federation's expenses, and some members began to question the utility of continuing to take on the financial burden. In response, respected African American scholar James Edward Mason of Livingston College visited Tubman in her Auburn

Home for the Aged to investigate whether such a large monthly commitment was necessary. When he returned from his trip, the *New York Age* reported the details of his visit, while also affirming that Tubman "has earned all the money she is getting and should have $50 a month more."[25] Mason commends the "splendid club women of the Empire Federation" for their philanthropy to the "worthy" Tubman. Highlighting the culture of recognition, he noted, "They are honoring themselves, doing honor to the race and exalting womanhood; in striving to make the closing months of 'the Moses of her people' comfortable." Mason donated ten dollars to the Empire Federation's efforts and encouraged others to do the same.[26] Several months later, the clubwomen reported they had been successful in sending Tubman $132, no small feat for communities with limited resources.

In February 1913, Mary B. Talbert again visited Harriet Tubman and found her "very feeble and a shadow of what she was one year ago." Nevertheless, the contributions sent by the Empire Federation "were helping to make her last days on earth comfortable," and Tubman told Talbert she was grateful for the support of Black clubwomen. Less than two weeks later, on March 10, 1913, Harriet Tubman died at ninety years old in Auburn, New York.[27] After her death, the Empire Federation began focusing on Tubman's lasting legacy.

In New York City, Marie Jackson Stuart, an executive leader in the Empire Federation, organized a special memorial service that featured songs and solemn remarks. Stuart read letters of sympathy sent from a host of prominent clubwomen like Margaret Murray Washington, Nannie Helen Burroughs, and Addie W. Hunter.[28] Just a year earlier, Stuart had established the Harriet Tubman Neighborhood Club, with the mission of creating community programs for local children. Ione Gibbs, a clubwoman from Minneapolis, Minnesota, noted that the Harriet Tubman Neighborhood Club "in its name bears a distinction which will ever be recognized as a herald of freedom, human rights and justice to all."[29] At Tubman's New York City memorial service, the members of the Tubman Neighborhood Club felt compelled to expand the mission of the organization to create a traditional memorial to Tubman "to perpetuate the memory of this noble heroine in some fitting way." By the end of the service, Stuart had collected an offering of $5.45 to begin the memorial fund.[30]

Like Mary B. Talbert, Stuart was a founding member of the Empire Federation of Colored Women's Clubs and spent much of her life as a club organizer and community philanthropist.[31] During the first decade of the twentieth century, Stuart built up her reputation as a local dramatist and helped to coordinate community service events,[32] the *New York Age* ranking her as "one of the foremost dramatic readers of Brooklyn" and describing

her as "an enthusiastic clubwoman and an elocutionist."[33] By 1913, she had established the School of Expression, Music and Dramatic Art in New York. Stuart used her talent to create venues to disseminate Black history, including her work with Charles Burroughs to present an "emancipation exposition" to celebrate the fiftieth anniversary of the Emancipation Proclamation.[34] She frequented tristate area churches and theaters as a sought-after speaker and performer. "Madam Stuart," as she was sometimes called, was so well respected that at times she was asked to perform spontaneously, and it was not uncommon for her to have "responded to an encore" request from enthusiastic audiences.[35] Though she was involved with the West Fifty-Third Street Branch of the YWCA, her most prominent contributions in the early 1900s went to sustaining the White Rose Home, a settlement home for Black women and girls in New York. Stuart's role in organizing benefit concerts for the White Rose and Frederick Douglass Homes were so successful that she was later elected as entertainment "organizer" for the Empire Federation.[36]

Stuart celebrated her own service and affinity for Black history by promoting Tubman's memorial brand through the culture of recognition. Her peers chose her to plan several memorial services and fundraisers for a Tubman monument in Auburn, including a momentous event at the Empire Federation's annual conference in July 1913.[37] Community events like "Harriet Tubman Night" and a ten-cent commitment from each organization in the Empire Federation helped the memorial fund grow.[38] However, Stuart and the Harriet Tubman Neighborhood Club's desire to erect a statue of their namesake in New York City was redirected by Talbert's decision to use the funds for a grave marker in Auburn.

Talbert had been greatly influenced by her experiences with Tubman's memorialization in the rural upstate New York town. Auburnites were proud to have Tubman as part of their community because of her national significance as a conductor on the Underground Railroad and as an extraordinary woman of achievement. Great care was taken by the Cayuga County Historical Society and the Business Men's Association, both made up of White Auburnites, to plan and erect a memorial marker in Tubman's honor. Several months after her death, they coordinated the creation of a historical marker and an unveiling program for June 1914 to feature Booker T. Washington and Talbert, who also eulogized the funeral.[39] Tubman's historical marker measures four by two feet, is cast in bronze, and has a small portrait sculpted by Allen G. Newman above a brief biography of her life. At the unveiling ceremony, Auburn mayor Charles Brister proclaimed, "Few memorials have been erected in this land to women . . . and few to Negroes. None has been erected to one who was at once a woman, a negro, and a

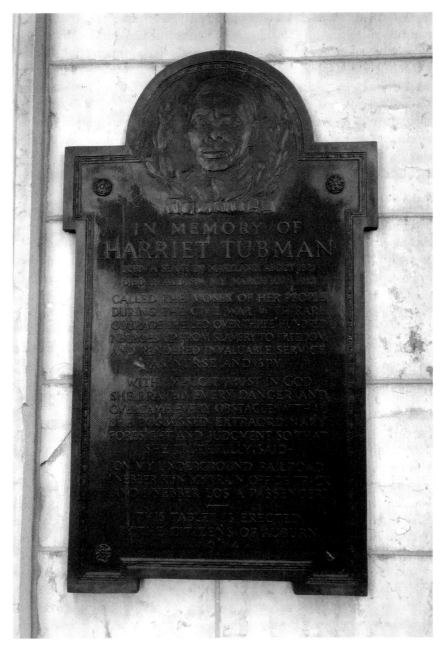

FIGURE 7. "In Memory of Harriet Tubman" bronze plaque on the Cayuga County Courthouse in Auburn, New York. Photo by A. Russell, 2019.

former slave."[40] Indeed, when Brister presided over the presentation and eventual placement of the Tubman tablet on the Cayuga County Courthouse in downtown Auburn, he was witnessing the first traditional public history memorial of an African American woman in the United States.

Though African Americans donated to the memorial fund for the tablet, the majority of donors were White citizens of Auburn. Most newspapers, such as the *Democrat and Chronicle* (Rochester), even reported that the bronze marker of Tubman "was paid for by white people."[41] This designation conveyed that the African American community had no ownership over the memorial design. Just as they had been seated in a separate section at the memorial ceremony, African American memorializers had been adjacent to the planning process. In fact, some later expressed displeasure with the "haggish physiognomy" of Tubman's sculpture on the marker. The *Baltimore Afro-American* reported, "If the artist intended to do something 'striking,' he failed," and went on to disdain the quote on the marker attributed to Tubman, which reads, "On my Underground Railroad I nebber run my train off de track and I nebber los' a passenger."[42] The attempt from the memorial planning committee to capture the dialect and cadence of Tubman's speech fell short. While there is no evidence to suggest that Washington or Talbert took issue with the tablet's imagery or tone, it was widely understood that the memorial had not come from the African American community.

The memorializer distinction was further emphasized with Talbert's remarking, "The white people of Auburn have erected a tablet in the courthouse in honor of Harriet Tubman. They are asking if the colored people are going to place anything at the grave."[43] Despite the assumption from White Auburnites, it had already been a priority for African American communities to create a traditional public history memorial. Talbert decided that the Empire Federation would collaborate with the Harriet Tubman Neighborhood Club to create a public monument to be placed at Tubman's grave in Auburn. In March 1915, the *New York Age* reported on a difference of opinion between Talbert and Marie Jackson Stuart about how to best memorialize Tubman and, more importantly, where the public monument should be erected. While Stuart and the Tubman Club wanted to place a stone marker at Tubman's grave site, they envisioned a more prominent public monument in New York City "to serve as an inspiration to the generations coming up."[44] Both Talbert and Stuart were savvy memorializers and deeply invested in crafting Tubman's public memory before and after her death. To reach a compromise, they decided to direct the entirety of the memorial fund to a grave marker in Auburn and raise additional funds for a statue in the future.[45] In July 1915, the Empire Federation held a memorial service to dedicate the new gravestone at the Fort Hill Cemetery in Auburn

in coordination with their annual meeting. Though Stuart had designed the $175 headstone, she was unable to attend the ceremony because of illness.[46]

Despite setbacks, Stuart remained committed to her vision of a New York City monument by hosting events to raise money for the memorial fund and promoting Tubman's public memory. In 1920, she collaborated with the Manhattan YWCA to celebrate "Harriet Tubman Day," where "a most inspirational address on the life of Harriet Tubman" was given in commemoration of her life.[47] But Stuart was never able to raise enough money for the statue she had conceived almost a decade earlier before she died in 1925. After her death, the leadership of the Empire Federation maintained Stuart's enthusiasm for a traditional memorial, endeavoring to memorialize Tubman by taking on the running of the Tubman Home for the Aged.

In her will, Tubman had deeded her twenty-six-acre property—which included her home, the Home for the Aged, and a brick masonry—to the AME Zion Church. Unfortunately, the upkeep was difficult for the organization to maintain. Unsatisfied with the church's care of Tubman's property, the Empire Federation launched a campaign in the late 1920s to create a settlement house for African American girls and reopen the Home for the Aged. In 1932, "unexpected legal entanglements" with AME Zion Church caused the Empire Federation to abandon their plans in Auburn.[48] They shifted their memorial plans once again and chose instead to erect a substantial monument at Tubman's grave site, which they unveiled several years later in 1937.[49] As part of the dedication ceremony, the bronze historical marker that had been placed on the Cayuga County Courthouse in 1914 "was given a thorough reburnishing."[50] The Empire Federation's support of Tubman's memorialization in Auburn reflected their longstanding ties with her legacy in life and death. By carrying out plans for a traditional memorial, they were also honoring the legacies of African American women like Stuart and Talbert, who envisioned future generations learning about the Black past through Tubman's memorial brand.

In the 1930s, White Auburnites created another public memorial in Tubman's honor. The Cayuga County Historical Society was successful in erecting a state historical marker in front of her Auburn home through the New York Division of Archives and History.[51] In 1932, the marker was erected near the edge of Tubman's property. It reads,

Harriet Tubman
Moses of Her People
Served Underground Railroad
Frequented This Site
After The Civil War[52]

Though it is unclear what had catalyzed its petition to the state, the Cayuga County Historical Society continued to champion Tubman's public memory as a significant aspect of Auburn and United States history.

Outside of New York, Tubman's memorialization expanded even further during the World War II era. Led by President Mary McLeod Bethune, the National Council of Negro Women (NCNW) lobbied for a Harriet Tubman named memorial to be attached to a US Liberty ship. While twelve African American Liberty ships had been named for African American men, the SS *Harriet Tubman* was the first named in honor of an African American woman.[53] Bethune's motivation to lobby for the prominent named memorial reflects her great belief that a war fought on the principles of liberation and freedom fit the life and legacy of Tubman as a freedom fighter, liberator, and military strategist. The NCNW led a nationwide war bond drive, "Launching for Freedom," to support the creation of the SS *Tubman*. Some organizations and businesses, such as the National Negro Insurance Association and the North Carolina Mutual Life Insurance Company, purchased millions of bonds. The enthusiasm for Tubman's named memorial was so exuberant that the NCNW surpassed its goal of selling 2 million bonds by more than 1.4 million. Black clubwomen in Georgia were reported as the most successful in selling bonds, followed by those in New Jersey, New York, Illinois, Washington, DC, Pennsylvania, Missouri, and California.[54]

On June 3, 1944, the SS *Harriet Tubman* was christened by Eva Stewart Northrup, Tubman's niece, and launched in South Portland, Maine. Venice Tipton Spraggs captured the excitement of the moment, reporting: "'The catch in your throat the first moment you got a glimpse of the foot-high white letters spelling 'Harriet Tubman.'"[55] As Black clubwomen gathered in the shipyard "beladened with furs," "small flower-laden hats," and "tailored and dressmaker suits," Mary Church Terrell posed, "'What would Harriet's former masters say to see the United States government so honor a slave?"[56] And Toki Schalk affirmed that the "thrilling occasion" saw "dreams of grandeur" realized when the ship "made a graceful dip into the ocean and carried the illustrious name into the service of our country."[57]

The christening ceremony represented the pinnacle of African American clubwomen's memorial efforts exerted over half a century. First Lady Eleanor Roosevelt sent remarks to be read that the SS *Harriet Tubman* was "a fitting honor to a distinguished woman," noting, "This Liberty Ship will carry war materials . . . where they will be used in defense of those principals [*sic*] that Ms. Tubman established."[58] Tubman's memorial brand as an emblem of American liberty continued to resonate with White and African American public memory crafters keen on utilizing the symbolism attached to her legacy as a commentary on racial progress. As Terrell had

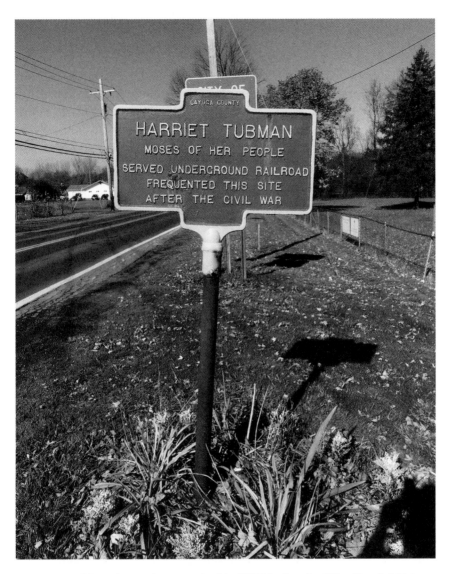

FIGURE 8. Historic marker erected in 1930 in front of the Harriet Tubman Home in Auburn, New York. Photo by A. Russell, 2019.

observed, Tubman's journey from an enslaved woman, an emancipated fugitive, and a patriot initially denied her military pension to become the ultimate symbol of freedom was a powerful public statement about the challenges and possibilities for the ongoing liberation struggle of African Americans in Jim Crow America.

Harriet Tubman's memorial brand continued to flourish as a frontrunner of African American women's memorialization in the 1950s. In 1953, her Home for the Aged, where Tubman lived until her death, became the first house museum of an African American woman. Limited financial resources had made the upkeep of Tubman's acreage difficult for the church to which she had willed her land. But that situation changed under the leadership of Bishop William Walls, who made Tubman's memorialization a major priority of his administration. The AME Zion Church renovated and operated the Harriet Tubman Home as a "national shrine" and designated space for national race and religious leaders to convene.[59] It reportedly cost the church between $20,000 and $35,000, which they raised through several conference meetings, to restore the home and transform the first floor of the two-story house into a museum.[60] The top floor was utilized by church officials and caretakers of the home until the late twentieth century.

Furnishing the restored home and museum was a community effort, and African American clubwomen contributed greatly. Beatrice Hemans donated a lounge chair and ottoman, the People's AME Zion Church in Syracuse gave "garnet velvet hangings . . . and gold draperies," Rosa Patterson gifted "an oil portrait of Harriet Tubman by Falstaff Harris," and Adelaide B. Mead donated original artwork that was hung in the home.[61]

The Harriet Tubman Boosters Club had been at the forefront of supporting the establishment of the home and then led with funding its operation. The Tubman Boosters, consisting of women in the Auburn area (most of whom were members of Thompson AME Zion), held social events and raised money for scholarships for local students,[62] but their main focus was promoting the public memory of their namesake and supporting the care of the Tubman Home. They played a central role in preparing the home for its opening and also provided refreshments at the dedication ceremony. Once the museum was opened, the Tubman Boosters continued to add memorabilia to the home while hosting visiting organizations like the AME Zion Connectional Council and the Empire Federation of Colored Women's Clubs.[63] When the house museum officially opened on April 30, 1953, African Americans traveled across the nation to journey to the home where Tubman had lived. The *Detroit Tribune* reported, "Dedicated to the memory of this champion of freedom, the Home brings alive the earnest desire of a life time of service, the desire to provide a place where all people may stop and become refreshed. As in Tubman's lifetime, the house at Auburn is again a place where courage is renewed and lives rededicated."[64]

Designated as a "pilgrimage" site, the home was used to remind and teach visitors about the pains and triumphs of the Black freedom struggle. The popularity of the house museum spread, and annual pilgrimages were

scheduled at the home throughout the 1950s for African Americans journeying from across the nation. Annual memorial services to Tubman, supported by the Thompson AME Zion Church and Tubman Booster Club, featured concerts of her favorite songs and prominent keynote speakers ranging from Black theologian Howard Thurman and his wife, the pioneering public historian Sue Bailey Thurman, to White elected officials, including Auburn's mayor.[65] Other events took place at the Cayuga County Courthouse in Auburn during the pilgrimage season to connect "the bronze tablet honoring Harriet Tubman" to her past public commemoration.[66]

Outside of New York, Tubman's public history presence was furthered by African American clubwomen's establishment of named memorial organizations across the United States. One of the most notable is the Harriet Tubman Guild in Pittsburgh, Pennsylvania, which has remained active for over a century. When twelve African American women—in solidarity with the twelve disciples of the Bible—organized the Tubman Guild on July 22, 1915, their central purpose was to provide "food and other household necessities for the Aged Minister's and Layman's Home." President Winona Idell Lincoln, who founded the organization in her home, promoted Tubman's public memory. Lincoln urged all members to "arrange with their pastors to have a short memorial service" on March 10 to commemorate the day Tubman died. The guild also celebrated Tubman's historical memorial brand through presentations, such as "Influence of the American Women on Emancipation."[67] Under their motto, "Deeds Not Words," the organizers celebrated Tubman through the culture of recognition because her "courageous and untiring deeds as a conductor on the Underground Railroad," along with her "love for her race and her activities during the Civil War" reflected their own community activism.[68] Lincoln helped establish an appreciation for the preservation and promotion of Tubman's legacy that permeated throughout the guild chapters through the rest of the twentieth century.

Often referred to as "Harriet Tubmans" or "Tubmans" by the *Pittsburgh Courier*, the guild gave philanthropic support to older and ill community members.[69] Pamela Smoot argues, "These club women worked relentlessly to provide the black community with a comfortable first-class facility to confront the problem of black convalescent care head on." In addition to attaining several buildings to house the most vulnerable members of its community, the organization helped pay for medical operations for Black patients. Members' visits to those in poor health often included "reading to patients; washing of face and hands; combing the hair; assist in giving baths; filling water pitchers." Some members even sang Christmas carols. The Tubman Guild also donated baby clothes and towels to hospitals and

provided African American women with a nursing scholarship to support their provision of health care services.[70]

One of the guild's major achievements was establishing the Harriet Tubman Terrace House for Convalescent Colored Women and Girls in 1931. The house served as the central meeting space for Tubman Guild programs, philanthropic outreach, and club activities. In 1934, the organization expanded significantly past its initial twelve-member limit by creating a nonprofit corporation with six chapters. Within just two years, the guild expanded further into fifteen chapters and convened at annual conferences called "solidarity sessions." Some chapter names were "Achievement, Congress of Negro Women, Pen and Pencil, and Tri-Boro." Most chapters were named memorials of African American women, however, including those honoring Tubman Guild founders Winona Idell, Anna Douglass, and Laura A. Brown.[71] Two youth chapters were the Hallie Q. Brown and Winona Idell Jr. Chapters.[72] These named memorials reflect the women's admiration for both NACW organizational leaders like Brown and local vanguards like Idell.

The expansion of the guild chapters illustrates the broadening of Tubman's memorial brand. In 1935, the *Pittsburgh Courier* declared, "With new chapters steadily coming in, and with all members, new and old, working for the comfort and the uplift of the unfortunate, the Harriet Tubman guild is a decided asset to the state of Pennsylvania."[73] Indeed, its members successfully aided and garnered resources for African American communities that were overlooked by state social welfare services. Under the banner of Harriet Tubman's memorial brand, their work saved and extended the lives of desolate and impoverished African Americans.

Harriet Tubman named memorials continued to be prevalent throughout the twentieth century. Outside of the medium, her commemoration was distinct since African American traditional memorials had been created to honor the legacies of men during the Jim Crow era. National public history sites like the George Washington Carver and Booker T. Washington National Monuments established in 1943 and 1956, respectively, commemorated African American men prior to the 1970s. The first African American commemorated on a US postage stamp was Booker T. Washington in 1940, followed by four additional men. In 1978, Harriet Tubman became the first African American woman memorialized on a US stamp in the Black Heritage Series, the postal service's longest running commemorative series.[74]

Tubman's inaugural commemoration in the stamp series adds another layer to understanding her barrier-breaking memorialization that included historical markers erected by the Cayuga County Historical Society in 1914

and 1932, the opening of the Harriet Tubman Museum in 1953, and the launching of the SS *Harriet Tubman* in 1944. Still a frontrunner in the twenty-first century, Tubman is the first African American woman with two National Park Service sites—in Auburn, New York, and the Eastern Shore of Maryland—dedicated to her legacy. And under President Barack Obama's administration, Tubman was slated to be the first African American woman printed on US currency. Americans of all backgrounds continue to champion her memorial brand, viewing Tubman as one of the most significant freedom fighters in United States history.

Sojourner Truth and Harriet Tubman overcame enslavement and through their effective advocacy became beacons of liberation who distinctly articulated the experiences of Black women. When recounting the history of slavery, memorializers employed Tubman and Truth as historical representations of the triumph and tenacity of formerly enslaved women. African American clubwomen commemorated freedom through the culture of recognition that acknowledged their own ingenuity in dire circumstances, including in establishing settlement homes and reliable networks of care for elder adults, the most vulnerable people in their communities. Multiracial memorial efforts like Tubman's in Auburn demonstrate the malleability of memorial brands in representing community ideals and intentional celebrations of African American women. The symbolism of Sojourner Truth and Harriet Tubman continues to resonate with new generations of memorializers in the twenty-first century who herald their historical legacies with named and traditional memorials across the United States.

CHAPTER 3

The Three Marys

Living Named Memorials of African American Women

Living named memorials were created to honor a contemporary person of great achievement. For African American women, creating living named memorials was a public practice of citation that documented the contributions and deeds of those honored with the designation. Public memory crafters shaped their cultural landscapes by heralding those who represented the intellectual and philanthropic ideals of their organizations. Through the culture of recognition, African American clubwomen acknowledged their own achievements alongside those of their organizational namesake. Though it was not uncommon to name organizations after lesser-known figures in local communities, living memorials were most often created in honor of well-known leaders of organizations like the National Association of Colored Women (NACW) because of their visibility. The Mary Clubs, established to celebrate Mary Church Terrell, Mary B. Talbert, and Mary McLeod Bethune, are three well-chronicled examples of living memorials created during the Jim Crow era.

As the first president of the NACW, Mary Church Terrell was among the earliest to be honored with living named memorials. Born during the Civil War in 1863, Mary Eliza Church came of age in Memphis, Tennessee, a city filled with the pitfalls and triumphs of the Reconstruction Era. A member of a wealthy, elite African American family, she was educated at Antioch and Oberlin Colleges, where she earned degrees in 1884. She then worked as a teacher at Wilberforce University and later at M Street High School (renamed Dunbar) in Washington, DC. There, she met Robert H. Terrell, and they married in 1891. In addition to her career as an educator, Terrell was heavily involved in developing the African American clubwomen's movement, including her role in founding the Colored Women's League

of Washington, DC, in 1892. As an intellectual, writer, and philanthropist, Terrell was committed to creating spaces for African American women to organize, socialize, and contribute to their local communities.

In 1896, she was elected the first president of the newly formed NACW. During her tenure from 1896 to 1901, Terrell managed the establishment of new clubs, settlement homes, social welfare programs, kindergartens, and childcare facilities under the central organizational umbrella of the NACW. Her leadership was also instrumental in establishing a national network of named memorials that promoted the public memory of African American women. By the turn of the century, the NACW was the largest African American organization in the nation and effectively provided an encompassing entity for African American women's social and civic labor, which substantially expanded their roles in the public sphere.[1]

Structural inequalities upheld by White supremacy made many of the public programs supported by reforms of the Progressive Era inaccessible to African American communities. As intercessors, the NACW worked ardently to provide social welfare services for those who were orphaned, ill, impoverished, and homeless while also advancing the educational, health care, and social interests of African Americans. Beverly Jones argues that "the very existence of the NACW embodied the major strategy of Mary Church Terrell: an organization of Black women, young and educated, organized for the avowed purpose of race elevation."[2] Terrell's exceptional leadership was transnational; she addressed audiences abroad at the 1904 International Congress of Women in Berlin, Germany. Having lived through World Wars I and II, she continued to be a vocal advocate of international peace and domestic civil rights. She died just two months after the 1954 US Supreme Court decision in the landmark case *Brown v. Board of Education*.[3]

Terrell's successful leadership and national presence embodied the ideals of African American clubwomen and inspired living memorials in every region of the United States. In the early to mid-twentieth century, Mary Church Terrell Clubs were established in locales like Berkeley, California; Shreveport, Louisiana; Philadelphia, Pennsylvania; and Jackson, Mississippi.[4] Among the most distinct Terrell Clubs, the club in Milwaukee, Wisconsin, organized in 1933 was focused on providing a political platform to discuss African American issues. President and founder Bernice N. Copeland (Lindsay) was a respected clubwoman in Wisconsin who helped to facilitate the dynamic agenda of the organization.[5] Copeland wrote to Terrell, saying that she and fifteen other "wide awake" young women had been so "impressed with the work of the [NACW] and its possibilities" they decided to name their organization in Terrell's honor "because we want to contribute to the onward march of humanity as you have."[6] African

FIGURE 9. Members of the Mary Church Terrell Club in Des Moines, Iowa, stand beside a portrait of their namesake, circa 1970s. Dora Mackay Papers, Iowa Women's Archives, University of Iowa Libraries.

American women were aware of the activities of national leaders like Terrell through state meetings, newsletters, and social gatherings. An appeal that memorials like Phillis Wheatley clubs did not offer members was the opportunity to write to their organizational namesake with the expectation of hearing back from them.

Copeland believed African Americans needed to know "how to read and write to achieve better understanding of the many problems they face," so

she led the Terrell Club in creating programs like the "Three-R School," an adult educational program to increase literacy and to "help adult newcomers from the south, mainly in adjusting to northern city life."[7] Copeland was often sought after to deliver keynote addresses at churches and to attend the NACW's regional and state meetings.[8] She also led the organization of Terrell Club symposiums to discuss race relations and regularly collaborated with other Black clubwomen through the Wisconsin State Association of Colored Women.[9]

Copeland's most popular initiative was the annual "Mayor of Bronzeville" election. Bronzeville, a term popularized in the early twentieth-century Midwest to describe segregated Black neighborhoods, signaled that the election would be centered around African American candidates and issues.[10] While the mayor of Bronzeville was not an officially elected public servant of Milwaukee, the winner was expected to raise awareness of the political interests of African Americans. In highly gerrymandered voting districts designed to diminish the political power of an African American voting bloc, the election sponsored by the Terrell Club empowered local residents to vote for leaders focused specifically on their communities.[11] Moreover, it provided space for African American women to hold senior leadership roles in the political process and enjoy a respected public platform to address issues important to them.

In 1937, Copeland presided over the first "election" of six candidates at Mount Calvary Baptist Church, later stating that "many people there came away with a new enthusiasm and realization of the power within them for Race betterment." Thousands of voters cast their ballots to elect Richard E. Lewis "as the first mayor of Bronzeville by a margin of 1,587 votes over his nearest opponent."[12] The distinguished designation of mayor onto Black leaders was highly regarded and functioned as the foundation of Black political representation in Milwaukee until Black citizens were officially elected to city and state offices. Mayors often addressed their constituents at church programs and special "Mayor of Bronzeville" events while also leading community initiatives, such as the 1939 census count to determine if public reports of African American populations were accurate.[13] The Terrell Club presented mayors with a key of Bronzeville, and its members were regularly selected to become part of their cabinet, or administrative team. The ceremony around the competition became so popular that Mary Church Terrell herself was "wishing she were able to attend."[14]

Terrell Club members used their organizational and philanthropic skill sets to benefit the mayor's cabinet, open to men and women, consisting of "all the officials usually found in an American metropolis," including "chief of police, commissioner of health, school board, corporation counsels, and

others."[15] Some elections were fundraisers whose proceeds were "to be used to care for the aged and for other social work among needy Milwaukee negroes."[16] In 1945, over ten thousand people paid five cents each to cast their votes for the candidates, including Helen Reid, the first woman to run for the position. Though Reid lost in a landslide to J. Anthony Josey, her representation as a candidate was a substantial step in the political representation of African American women.[17]

A decade later, the political process that had been started by the Terrell Club helped to support the campaign of one of its members, Mary Ellen Shadd, for Milwaukee Common (City) Council. Shadd's brother Lawrence Brady, who was the mayor of Bronzeville at the time, served as campaign manager in her bid to represent the Sixth Ward of Milwaukee. While thousands of African Americans had participated in the Bronzeville election, "less than 500 persons out of a possible 25,000" were registered to vote in the ward.[18] Shadd worked to register new voters and remained in the race through the primary but, ultimately, did not win the election.

Despite Shadd's loss, Vel Phillips, running for Ward Two, became the first African American and first woman elected to Milwaukee's Common Council.[19] Though there is no evidence the Terrell Club was directly involved in Phillips's success, it did help to establish a significant political infrastructure that spoke to the distinct needs of African Americans and gave women of Milwaukee the support to participate in the political process as viable candidates. The club empowered women to run for elected offices as equals to men in a time when many Black women in the nation were disenfranchised or politically disempowered. The organization continued to advocate for women's voices in politics throughout the mid-twentieth century, including through its participation and sponsorship in the 1970 Urban Affairs Conference, which brought "women face to face with the 70s and the impact they can have on the quality of life in the community."[20] The political motivations of the organizers in Milwaukee aligned with Terrell's memorial brand of civic leadership. Their commitment to political engagement and empowerment benefited generations of Black Milwaukeeans through the legacy of Mary Church Terrell.

African American women were also inspired to create living named memorials to celebrate Mary B. Talbert's national leadership and reputation. Notably, in Cleveland, Ohio, the Mary B. Talbert Hospital was opened in 1925 to serve "black women only."[21] Most named memorials of Talbert were clubs, however, organized in the 1920s and 1930s in locations like Portsmouth, Ohio; Gary, Indiana; and Lincoln, Nebraska.[22]

Their namesake, Mary Morris Burnett, was born on September 17, 1866, in Oberlin, Ohio. By the time she was sixteen, she had graduated from

high school and was enrolled in Oberlin College, from which she graduated in 1886. She began her education career as a teacher and served as the principal of Union High School until her marriage in 1891 to William Herbert Talbert. The couple moved to Buffalo, New York, and founded the Michigan Avenue Baptist Church, where she trained Sunday school teachers, played the organ, and established the Christian Culture Club. Talbert thrived as an adept collaborator with African American women both within and outside of her church ministries. She not only played a crucial role in creating the Phyllis Wheatley Club in 1899 and the Empire (New York) Federation of Colored Women's Clubs in 1911, but she also was a state representative body in the NACW. Talbert served as president of the Empire Federation from 1912 to 1916, followed by a two-term presidency of the NACW from 1916 to 1920.[23]

A deft memorializer, Talbert had a hallmark achievement with her role in preserving Frederick Douglass's Washington, DC, home as the first traditional African American public history site in the United States. African American clubwomen were excited about supporting the Douglass legacy work as well and connected Talbert's memorial brand with his. In Helena, Montana, the Mary Talbert Art Club hosted a "Frederick Douglass and Lincoln Memorial Program" in February 1923. The memorial program featured a special presentation of "Fathers of the Negro Race and Club Movement among Negro Women" along with an oration of the "Frederick Douglas [sic] Memorial Proclamation Issued by Mrs. Mary B. Talbert."[24] Talbert Clubs were particularly fond of their namesake's role as a memorializer, which Talbert employed effectively for Harriet Tubman's commemoration in Auburn, New York.

As president of the NACW during World War I, Talbert established herself as an international voice of African American issues through her work with the International Council of Women, the Young Men's Christian Association, and the Red Cross. She was a founding member of the National Association for the Advancement of Colored People (NAACP) and an organizational leader noted for her antilynching crusade. After contracting a blood clot in her heart, Talbert died at fifty-seven in 1923.[25]

Just a year earlier, in 1922, one of the most documented Mary B. Talbert Clubs was formed in Richmond, Indiana. Having worked with Talbert during her NACW presidency, founder Gertrude Carter and the twelve inaugural members were inspired to name their new club for their "leisure time" in her honor.[26] Living named memorials provided opportunities for women like Carter to express their gratitude for their namesake's leadership in African American communities. Members upheld the culture of recognition by showing their admiration for Talbert and her connection

FREDERICK DOUGLASS
Anti-Slavery Orator, Publicist and Journalist.
Nominated for the "Hall of Fame."

FREDERICK DOUGLASS MEMORIAL HOME, ANACOSTIA, D. C.

MRS. MARY B. TALBERT
Of Buffalo, N. Y., Life Member, Trustee Board
Douglass Home. Under her administration and direction the Douglass Home was redeemed.

FIGURE 10. Memorializer Mary Burnett Talbert was heralded for her preservation leadership for the Frederick Douglass Memorial Home, one of the reasons that living named memorials were created in her honor in the early twentieth century. Collection of the Smithsonian National Museum of African American History and Culture.

with the NACW as well as acknowledging their own club's activities in contributing to their local communities. With green and white as their official colors, the Talbert Club members were intent on living up to their slogan, "Read, Study and Be Informed." Club secretary and Historian Committee cochairperson Lucille Richardson likely wrote the brief history of the organization that declared the club "happy in its work of—Lifting as We Climb."[27] They expanded the popular motto of the NACW, adding

> O Step by Step we reach the heights,
> Our forces to combine.
> We'll work for right with all our might,
> Lifting as we climb.

As part of a robust community of named memorial organizations that included the Sally W. Stewart, Sojourner Truth, Madame C. J. Walker, and Home Culture Clubs, their motto aligned with their desire to benefit African Americans in Richmond and the surrounding areas.[28]

Though philanthropy was the central purpose of the Talbert Club, it was also a space for social engagement and recreation. Each week, a hostess held an organizational meeting in their home, an honor for those selected and an endeavor taken on with the utmost care. Tasked with providing refreshments, an atmosphere of comfort and productivity, and adequate seating, meeting hostesses were critically important to running the organization.

These meetings served as a venue where women discussed important service projects, planned major events, and socialized in a safe and culturally affirming space. Meeting hostesses were always thanked for providing delicious refreshments or meals, in the club records as well as in Richmond's local newspaper, the *Palladium-Item*. Through the culture of recognition, this type of documentation regularly commended women for their contributions both within organizations and publicly through media outlets. The Talbert Club was careful to list every person who participated as a committee member or attendee, and the *Palladium-Item* did the same, while also reporting on newly elected club officers and special events like its "Founder's Day."[29]

Once members had settled in the hostess's home, meetings were opened by "devotional leaders" who read Bible passages, led hymns, and said "club prayers," noted in one gathering's minutes as delivered by member Beatrice Tommie Holland. The religious rituals that began meetings reflected the Christian beliefs that spurred the activities of NACW organizations. The clubwomen's implementation of their faith undergirded their interactions, setting the tone for detailed discussions of club correspondence. Members heard community project requests and thank yous from those affected by visits to the ill and gifts of comfort. They also received updates from the Sick Cards and Flowers Committee, such as "Mrs. Boner is improving" and "Mrs. Edna Hamlet and Mrs. Bertha Garrete [are] in Reid Memorial Hospital."[30]

In addition to attesting to her dedication to community service, Talbert's memorial brand reflected her experiences as an educator. Members prioritized giving scholarships to students, including a "cash award" for high school girls "having the highest scholastic standing." In one meeting, a "Mr. McConnell" was celebrated for being an invited speaker at Richmond High School. A recipient of the Mary B. Talbert Scholarship, McConnell became the "first and youngest Negro to be hired in the state of Michigan as a parole officer."[31] Members relished in knowing that their financial contributions were helping young people break barriers and contribute to the Richmond community.

In honor of Talbert's legacy work for the Frederick Douglass Home, the club made supporting its operation another priority of their financial expenditures and activities.[32] Each February, the club celebrated "Douglass Day," a commemorative program that included speeches such as "Life of Mary B. Talbert" and "Our Clubwomen," connecting Frederick Douglass's public memory with Talbert's legacy work in enshrining his home in Washington, DC.[33] After Talbert's death in 1923, club members hosted a "sacred program" in her honor at Gertrude Carter's "artistically decorated" home that featured the official club colors of green and white in both the

decorations and the luncheon served to guests. Somber solos, poetic recitations, and papers titled "Life Works of Mary B. Talbert" and "Restoration of Frederick Douglas' [*sic*] Home" rounded out the program attended by at least forty guests.[34]

The Talbert Club's staunch support of the NACW and their state federation also reflected their namesake's memorial brand. The club budgeted to send executive board members to the annual meeting of the Indiana State Federation of Colored Women's Clubs. One year, delegate Ada Ware gave "a very splendid report" about her experience, filled with all the exciting details for those who were unable to attend. Ware was cognizant of Talbert Club's monetary sacrifice to sponsor her trip as representative to the state convention. With expenditures totaling $34.21, she also suggested "ways of raising money" to refill the club's treasury. Club finances were also used for special recognitions, including Lucille Richardson's fifty-year service as Talbert Club secretary, with members in giving a "rising vote of thanks" collected a fifty-cent "tax" to purchase an appreciation gift. On other occasions, meeting attendees had the chance to win a "mystery box" or "mystery prize" purchased with club funds.[35]

The culture of recognition extended to special "Guest Day" meetings, when the Talbert Club held commemoration programs or provided a platform for guests like Mrs. Fred Reeve to share the exciting details of a mission trip she took to Kenya.[36] Special guests, like Doda Cole Norman, the "dramatic specialist" of the NACW, were treated with fanfare and also typically featured in the *Palladium-Item*. Women of the Talbert Club coordinated community programs, such as comedy shows, plays, holiday bazaars, "lawn socials," radio broadcasts, an annual carnival, and a circus filled with "gaily bedecked booths, a clown band," and "a number of vaudeville stunts."[37] They sponsored events like the Halloween ward party held for "35 male patients of the Richmond State hospital" and an annual dinner where husbands were invited for an evening of delicious food, "games and impromptu talks."[38]

As part of its own legacy, the club established the Mary B. Talbert Junior Girls in the late 1950s.[39] The club regularly celebrated student achievement and sponsored essay contests, but the Junior Girls was a special opportunity for seasoned clubwomen to invest in Black girls' education and social upbringing that aligned with their values.[40] In 1962, Junior Girls president Beverly Oxendine traveled to the NACW's biennial convention in Washington, DC, to deliver her prize winning oration, "Youth's Dedication to the Elimination of Flaws in American Democracy Is Genuine." Oxendine's achievement was met with high praise from the Richmond community and was an esteemed reflection of the Talbert Club impact.[41] For Junior Girls

like Oxendine and for the members of the Mary Talbert Junior Women's Club in Raleigh, North Carolina (founded in 1946), the club was not a living named memorial.[42] Rather, the legacy of the organizations' origins continued the decades of public memory crafting inspired by the founders, even if newer members could not meet the club's namesake.

Young African American women could meet Mary McLeod Bethune, however, when many of the organizations named in her honor were founded. While there is sporadic evidence suggesting that Bethune Clubs were in existence as early as the 1920s, documented sources indicate that most were organized beginning in the early 1930s, including clubs in Marked Tree, Arkansas; Wheeling, West Virginia; and Fort Wayne, Indiana.[43] Just a decade later, in the 1940s, living named memorials of Bethune existed all over the nation. Black women who established Bethune Clubs were inspired by her dynamic memorial brand of leadership, education, and politics.

Born in 1875 as the fifteenth of seventeen children to formerly enslaved parents in rural Mayesville, South Carolina, Mary McLeod Bethune received a scholarship to attend the Scotia Seminary for Negro Girls, which transformed her life. Her educational experiences propelled her life's mission to provide positive learning opportunities for young people. In 1904, she founded the Daytona Literacy and Industrial Training School for Negro Girls with just $1.50. She worked tirelessly to maintain the school and was successful both in securing the finances needed to keep the school running and in expanding the school into a coed high school, and then a junior college. By 1924, the school merged with Cookman Institute and was renamed Bethune-Cookman College.

While working to build up her school, Bethune gained a national reputation as a proficient educator, esteemed clubwoman, and respected social advocate. She began her NACW involvement with local clubs in Daytona and then served as president of the Florida Federation of Colored Women's Clubs from 1917 to 1925. In 1925, she was elected president of the NACW. A visionary, Bethune supervised the purchase of the building for NACW's first headquarters, marking "the first time that a national black organization was designed to function in Washington, D.C."[44] Bethune's leadership and desire to create platforms for the distinct issues Black women faced made her the "acknowledged representative of America's black women."[45]

When the NACW's structure shifted to focus on the inner workings of the organization, Bethune saw a need for a national political body. She manifested her vision in the creation of the National Council of Negro Women (NCNW), which became one of the most influential political African American organizations of the twentieth century. Historian Joyce Hanson argues that the "depth and breadth of her political activities" were

focused on "changing social, economic, and political institutions that shaped collective opinion."[46] Bethune's national prominence also facilitated a lifelong friendship and political alliance with Eleanor Roosevelt. Her appointment as director of the Negro Division of the National Youth Administration (NYA) made her the only woman on President Franklin Roosevelt's "Black Cabinet" and ensured that African Americans received federal assistance and relief from New Deal programs. Bethune went on to advise four additional US presidents.

With a keen appreciation for the Black past, Bethune served as the first woman president of the Association for the Study of Negro Life and History and contributed to the establishment of the World Center for Women's Archives and the National Archives for Black Women's History in 1939. At the time of her death in 1955, she was one of the most influential African Americans in the nation. Bethune's outstanding leadership had spanned five decades. Her life illustrates the heights of triumph and achievement possible for African American women in the midst of racism and sexism.

In Wilson, North Carolina, African American women renamed their organization to establish a living named memorial of Bethune. The Federated Club of Wilson, founded in 1917, was reorganized as the Mary McLeod Bethune Civic Club in 1937. Member Norma Darden, who became friends with Bethune when she worked as a teacher in the early days of the Bethune Training School, led the campaign for the renaming. Club members were so impressed with a speech Bethune had delivered years before at the annual conference of the North Carolina Federation of Colored Women's Clubs that Darden's idea was met with much enthusiasm.[47] Reflecting Bethune's memorial brand, the organization prioritized the care and educational success of students at the Kinston Training School for Negro Girls. Members directed plays and concerts through the dramatic and glee clubs they sponsored and annually gave "personal gifts to be distributed" for Christmas.[48] In addition, they extended their philanthropy to their community by gifting baskets to those who were "sick and shut-in" and catalyzed the creation of Wilson County's first public "Negro Library."[49] Active in the North Carolina Federation of Colored Women's Clubs, the Bethune Civic Club also helped sponsor the annual state meeting in 1959.[50]

Similarly inspired by a Bethune speech, women in Phoenix, Arizona, established the Mary Bethune League in December 1938. "A group of wideawake [socially conscious] young matrons [who] decided to organize themselves into a club" joined the Phoenix City Federation of Colored Women, where they were embraced by seasoned clubwomen of the region. Bethune League member Hazel Farmer expressed to the *Chicago Defender* that "all federated club women are delighted with the forward move on the

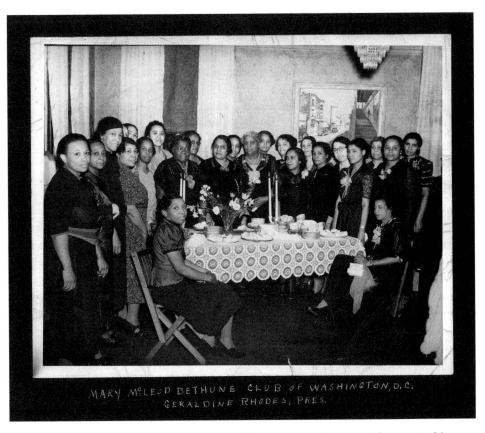

MARY McLEOD BETHUNE CLUB OF WASHINGTON, D.C.
GERALDINE RHODES, PRES.

FIGURE 11. Namesakes often visited living named memorials created in their honor. Here Mary McLeod Bethune (standing sixth from the left) attends an event with the Washington, DC, Bethune Club in the early twentieth century. Mary McLeod Bethune Papers, Bethune-Cookman University Archives, Bethune-Cookman University, Daytona Beach, FL.

part of these talented young women and welcome them into the fold."[51] One of the Bethune League's main goals was to purchase property to establish a community center and settlement house as the "Mary Bethune Residence and Recreation Center for Colored Women and Girls."[52]

The *Arizona Republic* reported that the organization's efforts were "supported generously by colored and whites alike," especially because of "the vital need" of such a community space for Black women.[53] The members hosted a wide variety of fundraisers to meet their financial goal, including holding musical banquets, selling chitterling dinners, and celebrating their annual "Silver Tea."[54] In alignment with Bethune's memorial brand, the organization also made it a priority to support Black children's educational

and recreational activities, including sponsoring a junior division of their organization named the Deroloc Club.[55] In 1951, they hosted a "Tacky Party" where raffle prizes and awards for the tackiest outfits were given to the "young, middle_age [sic] and oldsters," who attended the joyful community event.[56]

In addition to her prominence as a clubwoman, Bethune inspired living named memorials through her work in the NYA. In November 1936, Bethune was hosted at a reception in Washington, DC, where she spoke about her official duties as an NYA special advisor as well as about her club work for the NACW. So inspired by Bethune's words, Mrs. Rhodes suggested that the women present form a new club named after Bethune. Before the end of the reception, they had chosen officers and officially established the Bethune Club.[57] Encouraged to memorialize Bethune in Quoddy, Maine, young Black men being trained through the NYA formed the Dr. Bethune Technical Club "in honor of the outstanding and distinguished work . . . being done by Mrs. Mary McLeod Bethune."[58]

In Detroit, Michigan, the Mary Bethune Club was established in February of 1940 with the purpose of raising "the standards of Negro Womanhood in America—educationally, morally and socially" and to help plan arrangements for Bethune's participation in the "Seventy-Five Years of Negro Progress Exposition."[59] Members included local women and could boast of having international members from across the Great Lakes in Windsor, Ontario. In the Northwest, the Bethune Sewing Circle of Portland, Oregon, prepared pieces to display at the annual meeting of the Oregon Association of Colored Women's Clubs in 1935.[60]

Some Bethune living named memorials were associated with African American branches of the Young Women's Christian Association (YWCA), such as the one in Summit, New Jersey.[61] In Altoona, Pennsylvania, the Mary Bethune Study Club was organized in 1945 and grew to thirty members by 1952. The club held organizational meetings and events at the YWCA building while also hosting cultural events, such as the 1948 art exhibit that featured Ann Sawyer Berkley's "series of water colors illustrating 12 Negro spirituals."[62] The Mary Bethune Business and Professional Women's Club, consisting of members from East Saint Louis, Illinois, and St. Louis, Missouri, helped to reestablish their local African American branch of the YWCA in 1941.[63]

The African American Y branches in High Point, North Carolina, and Alexandria, Louisiana, however, were both named for Bethune.[64] Renamed in 1946, the Bethune YWCA in Alexandria was a vibrant part of the community and focused much of its activity on providing services for Black children.[65] The clubwomen hosted concerts while also supplying "ping-pong

tables, miniature bowling, table games, and craft equipment for children and teenagers."[66] Their programs became quite popular, the *Alexandria Daily Town Talk* reporting in August 1956 that "a total of 963 persons, mostly teenagers, participated in recreational and educational activities at the Bethune Branch."[67]

In 1950, Bethune visited High Point to celebrate its fifth anniversary and helped unveil a portrait of YWCA branch founder Maybelle Nixon. "An overflow audience" welcomed Bethune graciously for the anniversary program, which included special receptions and "The Story of Mary McLeod Bethune," a "dramatic story in pantomime" centered around her life and notable achievements.[68] Because most YWCA branches were named after Phillis Wheatley, Bethune branches were unique not only in number but because they were able to welcome their namesake to meet members and engage in community programming. The *High Point Enterprise* published that Bethune "expressed her sincere gratitude for the desire of the local organization to take her name for so noble an institution."[69] Bethune's memorialization embodied the culture of recognition through celebratory programs such as the one in High Point that recognized both her and local leader Nixon for their enduring philanthropic contributions. Like Wheatley's memorialization, the integration of Bethune named memorials in High Point and Alexandria with their White YWCA counterparts in the 1970s prompted the named memorials to be dropped.[70]

The Three Marys in Des Moines

In a rare occurrence, the Mary Church Terrell Club, Mary B. Talbert Club, and Mary McLeod Bethune Club were all established as living named memorials in Des Moines, Iowa. The city was a special hub of memorialization, where all three namesakes visited the organizations named in their honor. At the nexus of this convergence was memorializer Sue M. Wilson Brown. Married to prominent attorney Samuel Joe Brown, she was one of the most influential African American public historians of the early twentieth century. An ardent civil rights activist, community philanthropist, and organizational architect, Brown was regularly championed through the culture of recognition by African American newspapers like the *Chicago Defender*, *Broad Ax*, and *Iowa State Bystander*, which deemed her one of the "most intellectual members of the colored race in the United States."[71] As a civil rights activist, she had filed a 1907 lawsuit against the Des Moines Pure Food Show management and the J. H. Bell Coffee Company for refusing her service at a food show because of her race.[72] Though she lost her case that was appealed up to the US Supreme Court, she remained outspoken

FIGURE 12. Civic leader and memorializer Sue Wilson Brown helped found the Mary Church Terrell Club, Mary B. Talbert Club, and Mary McLeod Bethune Club in Des Moines, Iowa. Her portrait is featured on the front page of the *Broad Ax. Broad Ax*, August 30, 1924. Chronicling America, Library of Congress.

on social justice issues as a Black leader in the Republican party and as president of the Des Moines League of Colored Women Voters.[73]

Brown and her husband helped found the Des Moines chapter of the NAACP, and both served as president, making her one of the first women in the national organization to head a local branch. As an eloquent vocalist and orator, she was highly regarded in the Des Moines St. Paul AME Church, where she attended and hosted programs.[74] In addition to serving as International Grand Matron of the Masonic sorority Order of the Eastern Star, Brown authored the organization's first published history, *The History of the Order of the Eastern Star among Colored People*, in 1925.[75] Yet, chief among her internationally acclaimed political, civic, and social endeavors was her longstanding affiliation with the NACW. A contemporary of Terrell, Talbert, and Bethune, she served on the national executive board, as president of the State and Central (Region) Federations, and as "a delegate to the [1930] International Council of Women" Convention in Vienna, Austria.[76]

Arguably, Brown's most notable endeavor in the NACW was her fervent attention to the preservation of the Frederick Douglass Home. She was appointed chairman and trustee of the Frederick Douglass Memorial and Historical Association, working alongside NACW leadership for several years to open the home to the public.[77] Her substantial efforts resulted in her being awarded the "Frederick Douglas [sic] memorial trophy" in 1939 "as the person in Iowa who had given greatest service to the Negro race."[78]

Brown's memorialization work extended to Booker T. Washington after his death in 1915. She commissioned a "life sized oil portrait" of him from acclaimed artist Henry Tanner and led the campaign for clubwomen to raise the money needed for the prestigious commission.[79] The portrait had been unveiled for the first time at the sixteenth annual Iowa State Federation convention but was celebrated with much fanfare during Mary B. Talbert's visit to the city in the summer of 1917.[80] Talbert was treated with such prestige that the *Iowa Bystander* described her visit as a "royal reception." Escorted by the Browns, Talbert attended an exclusive reception hosted by Iowa governor W. L. Harding for the unveiling of Washington's portrait in the Iowa Hall of History gallery. Talbert continued her tour of the city with several more public appearances, including delivering a speech at St. Paul AME Church.

Afterward, she attended a special reception held by the Mary B. Talbert Club.[81] It was indeed a special moment for the African Americans of Des Moines to see the woman for whom their organization was named. The Talbert Club reception gave its members an opportunity to personally celebrate and interact with their namesake. For founders of the organization, like Brown, the club served as a statement about the significance of Talbert's continued work as a national leader on behalf of African Americans all over the nation.

At times, Brown hosted club meetings at her home, where members participated in citizenship classes and discussed "the political questions as they affect women."[82] Reflecting Talbert's memorial brand, members grappled with understanding how African American women's activism could expand citizenship rights for their communities during Jim Crow.[83] Since they fueled much of their efforts into community philanthropy, occasions to celebrate socially were greatly prized—especially with the woman who inspired them. Talbert visited Des Moines on several other occasions and interacted with the clubwomen.[84] In 1920, she gave "one of the most forceful lectures ever given in the city" to an enthusiastic crowd of three hundred. Per tradition, Talbert's "lecture tour" was largely hosted by Brown and members of the Talbert Club, with a slew of receptions, luncheons, and dinners.[85]

In 1915, Sue Brown hosted Mary Church Terrell, who was treated as a celebrity on a small tour of speaking engagements, dinners, and receptions. The highlight of her visit was the "splendid program" that featured the Terrell Club's presentation of "a beautiful bouquet of American Beauty roses" at a reception hosted by the Iowa State Federated Colored Women's Clubs.[86] Terrell was well aware of the club's existence, since Maude Thompson had written to her about "the club named [in her] honor" in 1907. Thompson goes on, "We trust the club may some day be worthy of your appreciation."[87] Indeed, it was. Living named memorials like the Terrell Club often corresponded with namesakes to inform them of their activities and invite them to special events.[88]

In Des Moines, the Mary Terrell Literary Club, founded in March of 1906, was the first and only literary club in the city named for an African American woman.[89] Meetings hosted in members' homes often consisted of "lessons" where attendees read and discussed the writings of Black intellectual leaders, such as Booker T. Washington, or classical literature, such as "Enid and Geraint." In the early 1910s, members presented poems, songs, and orations at the annual City Literary Convention, including "Evolution of Progress" by founding member Gertrude Hyde.[90] Hyde became so proficient in her craft that in 1913 she won second place in the oratorical contest with her paper "The Negro Soldier."[91]

A social organization, too, the Terrell Club spent some meetings listening to music on a Victrola, while other meetings focused on recognizing individual women, such as the one at "the home of Mrs. Coleen Jones" that was "the scene of an evening company . . . in honor of Mrs. Edyth Strawthers." A well-known member of the Terrell Club, Strawthers had also "won honors" in the Des Moines Oratorical Contest in 1913.[92] Some of the organization's larger meetings consisted of special presentations for members. Topics like "Benefits of Manual Training" or "Interior decoration, 'Lamps and Lighting'" were sometimes held at venues like the local drugstore.[93]

During World War I, the Terrell Club expanded their efforts to aid soldiers at Fort Des Moines (later Camp Dodge), the only Officer Training School in the country for African Americans.[94] Participants in the program became "the first group of colored commissioned officers in the United States army ever issued by our government." Sue Brown, with the help of the Terrell Club, arranged programming and special events for the soldiers. The *Iowa Bystander* heralded the clubwomen in 1918 for being "very active in making it pleasant during the summer for the students at the Officers [*sic*] Training School" and "foremost in cheering the sick boys at Fort Des Moines."[95]

Sue Brown maintained her involvement with the Terrell and Talbert organizations and in 1938 helped found the Mary McLeod Bethune Club living named memorial to which she "was made honorary president."[96] Though short-lived, the Bethune Club's main purpose was to coordinate the regional conference of the Central Association of Colored Women that was held in Des Moines in July 1938.[97] Their first public event was hosting a luncheon for Bethune during her visit to the city. Afterward, Bethune "spent two busy days" visiting local NYA projects and attending a Federation "business conference," where she "highly commended the progress of the work done through the projects in Iowa."[98] Bethune's powerful memorial brand resonated with the women who appreciated her political work on behalf of African American communities.

So much of Iowa's presence as a distinctive hub of living named memorials was influenced by the talent and tenacity of Sue Brown. She, like other African American memorializers across the United States, was proud of Terrell's, Talbert's, and Bethune's transnational leadership. Creating living named memorials embodied clubwomen's desire to support the prominent figures' efforts in the interests of African American people, which exemplified the "Lifting as We Climb" motto that aligned with their faith and service activities. Exchanging correspondence, collaborating, and meeting namesakes was a distinct feature of these types of memorials.

For the many women who had no opportunity for such personal interaction, their legacy work was tied to crafting the public memory of their namesakes' achievements, symbolic of their own aspirations for leadership in their communities. The NACW was the most substantial purveyor of living named memorials in the late nineteenth and twentieth centuries. Chief among this cadre of African American women's commemoration were Mary Church Terrell, Mary Burnett Talbert, and Mary McLeod Bethune, the elected leaders of the national organization whose legacies continue to endure in the twenty-first century.

Claiming Public Space

The Landscape of Named Memorials

In Tyler, Texas, the African American community had a strong tradition of creating named memorials dating as far back as the 1890s, though they were primarily of Black men. Emmett Scott High School, T. J. Austin Elementary School, and (Paul) Dunbar School were among seven schools named for African Americans from the 1890s to the 1950s. It was not until 1959 that the town added its first African American woman to this list when Mamie G. Griffin Elementary School was named to honor the longtime educator and principal in celebration of her forty-seven years of service.[1] Two years later, the memorialization of Ella Reid placed another African American woman in Tyler's public history landscape.

The story of Ella Reid's commemoration illustrates the common practice of creating named memorials in segregated African American communities during the Jim Crow era. Despite the often unfavorable environmental conditions of segregated housing, these communities were able to wield an insulated sphere of influence to take ownership of their neighborhoods through public history named memorials for schools, libraries, public housing, and community centers. The Ella Reid, Ida B. Wells, and Celia Dial Saxon named memorials demonstrate how segregated communities during the Jim Crow era collaborated with White government bureaucracies to celebrate the legacies of Black women. Their ability to claim space reflected how the culture of recognition was used to shape the physical and cultural landscape in African American neighborhoods throughout the twentieth century.

Segregation laws and racist customs restricted African American use of the local Carnegie Public Library in Tyler, Texas. African American teachers were reportedly forced to check out books through the janitor and pick

them up at the back door of the library. Despite being told about these policies in 1945, the Carnegie Foundation, which funded the library, dismissed the issue, relegating it to a local matter. Like many African Americans during Jim Crow, the Tyler community banded together to create their own lending services. Black women, including librarian Willie Mae Kelley, were integral to the inception of the Negro Public Library (NPL), which was first organized in the basement of Bethlehem Baptist Church in 1941.[2] By 1950, the Tyler City Commission had designated a permanent building for the NPL in an African American neighborhood. In a November 8, 1961, letter to Casey Fannin, the Tyler city manager, P. R. Robinett and Kelley requested on behalf of the Negro Public Library Board that the library's name be changed to the Ella Reid Public Library. Speaking on behalf of "the entire Negro population" of Tyler, they explained that Reid "has pass [sic] on some years ago, yet her life work cannot be forgotton [sic] by those whom she served and gave a ray of sunshine and hope as she spent her days with us here on earth."[3]

Ella Reid provided midwifery and health care services, which made her well known and highly respected. "She was employed by many Tyler families" and helped to support the Tyler Colored Day Nursery.[4] The *Tyler Morning Telegraph* describes her as a "pioneer Tyler resident" and highlights that "her daughter served as principal at Emmett Scott Junior High School," which made the family even more appreciated in the community.[5] At the time of her death in 1955, Reid was the oldest living member of St. John the Baptist Episcopal Church, having taken her First Communion in 1893.[6] Her life's work meant so much to her neighbors that she was memorialized six years after her death. In fact, head librarian Kelley recorded in her circulation report that many "calls and Congradulations [sic]" were given in support of the library name change.[7]

Because the NPL also served as a community center for clubwomen's activities, local residents saw it fitting to name the public building in honor of an African American woman. Though available records do not document exactly why Reid was chosen to be memorialized, it is evident that her impact in Tyler was enduring. African American women's clubs utilized the NPL for organizational meetings, special events, and celebrating their achievements through the culture of recognition. Some of their events featured special guests from around the state, like Willie Burke Anderson, a teacher at Booker T. Washington High School in Dallas, Texas. Others featured nationally known guests, like Toki Schalk Johnson, a society reporter for the nationally distributed *Pittsburgh Courier*. In October 1951, Johnson was a guest at Delta Sigma Theta Sorority's annual festival, where more than 150 guests were in attendance.[8] The local chapter of the sorority

also sponsored a Saturday morning "Story Hour" for children at the Ella Reid Public Library.[9]

As well as assisting the library by giving and soliciting book donations, the clubwomen contributed decorative items, such as "the mirror given the library for use in the ladies rest room."[10] Kelley, a keenly innovative librarian, used these gifts and her skills as a public memory crafter to cultivate a special space for women. She applied the culture of recognition to establish a memorial to both Ella Reid and the local African American women, working in tandem with them to coordinate donations, secure new books, and host community programs.

Kelley provided opportunities for patrons of all ages to learn about Black history and benefit from the resources the library had to offer. To further bolster the libraries offerings, she regularly requested materials from libraries near and far, including Northwestern University in Illinois.[11] She planned special programs, such as "Children Book Week," story hours, the "Summer Reading Program," and Negro History Week.[12] Kelley was intentional in obtaining and making books available to students for "summer study," such as *Young People of West Africa* (1961) by Charles R. Joy and *Careers in Research Science* (1961) by Theodore Wachs Jr.[13] Black teachers like Mattye Van Potter collaborated with Kelley to teach children about using the space and to issue them their own personal library cards.[14] Though she continued to serve as head librarian for almost another decade after establishing the Ella Reid named memorial, Kelley's enthusiasm and efficiency could not stop the permanent changes that came with integration.

The Tyler City Commission had funded the Ella Reid Public Library from its earliest days, but a request for relocation to a more central site led to an unexpected result. In 1968, the city commission decided to no longer fund the library since most patrons were taking advantage of the newly integrated Carnegie Library. That same year, the Ella Reid Library closed, with its staff and board incorporated into the larger Carnegie Board and Library structure.[15] Wille Mae Kelley did not make the move; after twenty-one years of exemplary service, she decided to retire.[16]

Much like the Phillis Wheatley branches of the Young Women's Christian Association (YWCA) in the mid-twentieth century, integration in Tyler meant the erasure of valued named memorials. While the integration of Carnegie could be seen as symbolic of African American progress through access to better facilities, it was also the cause of an erosion of public facilities controlled by and catering specifically to African American patrons. Despite its constraints, Jim Crow had provided opportunities for African Americans to have ownership over their community spaces. Kelley's only limits to obtaining resources for Black children and coordinating community programs with clubwomen were the parameters she had set for

herself. She could plan and implement as many Black history programs as she wished and host as many organizations as time and space would allow.

The integration of the Carnegie Library, however, resulted in shifted priorities for acquiring new books about and by African Americans and forced previous programs to move to private spaces.[17] In 1969, the Tyler chapter of Delta Sigma Theta held its Negro History Week activities "in the home of Mrs. J. O. Perpener," where members discussed "the circulation of [African American history] brochures, purchased for library use."[18] A year earlier, this programming and distribution of pamphlets would likely have happened at the Ella Reid Public Library. Much more than a lending service for the African Americans of Tyler, the library had been a space of their own, designed by Black women like Kelley to celebrate their accomplishments and to support the educational pursuits of upcoming generations. But as public spaces became more integrated, named memorials of African American women were in many instances eliminated.

Though the changing landscape of African American communities in the mid-twentieth century was tenuous, some named memorials of Black women endured. While the civil rights movement prompted the restructuring of many African American neighborhoods, some fixtures, like public housing, maintained their named memorials well into the twenty-first century. The housing projects named after Ida B. Wells and Celia D. Saxon in Chicago, Illinois, and Columbia, South Carolina, respectively, offer two distinct examples. The creation of both of these named memorials were the result of sustained grassroots efforts from local communities to publicly commemorate the legacies of Black women. But the public perception and physical conditions of the two public housing facilities drastically changed over the course of the twentieth century.

Though Ida Bell Wells-Barnett was born on July 16, 1862, in Holly Springs, Mississippi, her imprint in Chicago was indelible, and African Americans of this city have memorialized her since she began living there in the nineteenth century. Though Wells was born enslaved on a plantation, by age three, she was emancipated. She came of age during the Reconstruction Era and benefited from the first public schools established to educate African Americans in the South. She and her siblings, sometimes accompanied by their mother, attended the nearby Shaw University (now Rust College). At just sixteen, she lost both her parents to a yellow fever epidemic in 1878. A year later she moved to Memphis, Tennessee, earned her teacher certification, and began teaching in the Shelby County School District to help support her family.

In Memphis, Wells became a vocal advocate of African American civil rights. Refusing to move from the first-class ladies' coach car to the segregated car for African Americans, she sued the Chesapeake and Ohio

Railroad after she was forced off the train in 1884. She won her case, but the decision was overturned by the Tennessee State Supreme Court as Jim Crow laws began encroaching on the citizenship rights of African Americans across the nation. Wells also expressed her civil rights activism through writing articles published in local and national African American newspapers. By 1899, she was an owner and editor of Memphis's *Free Speech and Headlight* and eventually was able to support herself financially as a journalist and a groundbreaking investigative reporter.[19]

In March 1892, Wells's life trajectory changed forever when three of her friends were lynched. Thomas Moss, Calvin McDowell, and Henry Stewart were successful African American grocers with a thriving business. Jealous of their success, a competing White grocer led the state-sanctioned charge to jail, shoot, and hang the three Black men. Incensed by the brutal and unjust nature of the lynching of her friends and other African Americans across the nation, she wrote an editorial that eventually became "Southern Horrors: Lynch Law in All Its Phases." The piece gained Wells a national and international audience, but after receiving death threats from White people in Memphis, she moved to New York before settling in Chicago. There, she married Ferdinand Barnett in 1895. Wells-Barnett left a lasting mark on the city through her suffrage advocacy, community organizing, and unrelenting activism toward gaining equality and justice for African Americans. She helped establish the Ida B. Wells Club, the Negro Fellowship League, and the Alpha Suffrage Club, the first suffrage club for African American women in Illinois and among the first in the nation.

Her popularity continued to grow as a nationally renowned activist. She helped establish the National Association for the Advancement of Colored People in the 1910s and, in the 1920s, was a featured speaker at Universal Negro Improvement Association meetings. Wells-Barnett was well connected with prominent Black people and liberal White people across the country and abroad, which prompted the creation of the London Anti-Lynching Committee in England. While her outspoken and bold personality made her unpopular at times within these elite circles, she never stopped being a "crusader for justice." In her autobiography, she explains, "Eternal vigilance is the price of liberty, and it does seem to me that notwithstanding all these social agencies and activities there is not that vigilance which should be exercised in the preservation of our rights."[20] It was her vigilance that made her the most famous antilynching advocate in American history and one of the most admired clubwomen of the era. After her death in 1931, Chicagoans embraced her as one of their most important leaders and have kept her public memory alive since.[21]

The African American women of the Ida B. Wells Club were at the forefront of crafting her public memory. Founded in 1893, the Wells Club

not only was the first Black women's club in Chicago but also was one of the earliest documented living named memorials of an African American woman. Historian Wanda A. Hendricks contends that it was "known as the mother of the women's clubs in Illinois," which "placed African American women squarely in the reform movement in the Midwest and served as a model for many newly created associations."[22] Its community activism and advocacy made it central to African American political and social activities in Chicago, and through the 1930s, the Wells Club maintained its prominence.

For this reason, when the Chicago Housing Authority (CHA) decided to build a public housing project for Black Chicagoans, the Wells Club was poised to become a boisterous public advocate. The South Parkway Garden Apartments were scheduled to be built "diagonally across the street" from where Ida B. Wells-Barnett lived at 3624 Grand Boulevard (now Martin Luther King Jr. Drive). Intrigued by this close proximity, the Wells Club met and—through a unanimous vote—decided to launch an "intensive campaign" to name the new public housing the Ida B. Wells Homes. Wells-Barnett's youngest child, Alfreda Barnett Duster, recalls the process that led up to the naming: "The Ida B. Wells Club and the Federation [of Women's Clubs], the YMCA and other groups, somehow got this idea that it should not be named just for anything, but it should have a name that was significant in the community. Several names were proposed and the overwhelming response in letters to the Chicago Housing Authority was that it be named the Ida B. Wells Homes."[23] The club's request was swiftly embraced; they petitioned the CHA in January of 1939, and by April of the same year, the housing community was renamed.

It was common for Black clubwomen to combine their community activism with legacy work, and the Wells Club was no exception. Represented by President Ida K. Brown, the club was included in each phase of building the new housing development, from the groundbreaking ceremonies to the dedication.[24] CHA commissioner Robert R. Taylor proclaimed, "It is singularly appropriate . . . to name this project as a memorial to a woman who more than half a century ago began to wage an uncomprising [sic] fight for these principles."[25]

In the midst of the Great Depression, the Wells Homes signaled that the federal government recognized the need for quality housing for African Americans. As more and more Black migrants and immigrants moved to urban centers in the Midwest, like Chicago, housing became increasingly difficult to provide. The quality dwellings of settlement houses had helped ease the transition for new residents for decades, yet they were not sufficient to house the ever-increasing influx of people moving to the city. The alternatives were unsafe tenements and kitchenettes in an overcrowded area

deemed the "Black Belt" to demark its segregated identity. The area was reportedly overcrowded by "50,000 more than experts say the area could adequately house," while rent was "considerably higher, comparatively, than those that must be paid by members of other racial groups."[26] Public housing on a massive scale was the solution that Black lobbyists and elected officials devised to remedy what was described as "one of the worst slum areas of the country." The Wells Homes were built on forty-seven acres that held 1,662 units with an average of $14.08 monthly rent. They were the first and largest public housing for African Americans in Chicago and cost over $8.7 million to construct.[27]

The *New York Star and Amsterdam News* declared the Wells Homes to be the "Largest of Its Kind for Negroes In the World." The Black press understood that while the housing development represented African American progress, it also demonstrated the intentional efforts of the US government to invest in the wellbeing of African American communities. Wells-Barnett's name being attached to the new homes bolstered the magnitude of the project, since her memorial brand exemplified the ongoing fight for Black liberation. Meredith Johns of the *Chicago Defender* boasted that the Wells Homes "commemorate a leader who walked most of her way alone and who braved countless threats and jears [sic]—many of them hurled by her own people—in order that the American Negro might also be served justice."[28]

In addition to named memorials, Wells-Barnett's public memory was often promoted and commemorated through community events. The twenty-fifth anniversary of the Wells Homes was celebrated with a two-day festival in July 1966, designated as "Wells Day" through an official proclamation from Mayor Richard J. Daley. By then, the public housing development had grown to 2,836 apartment units, which were built in large high-rises that towered "over the original 2- and 3-story homes" constructed in the 1930s.[29] Chicagoans from elected city officials to then current and former residents celebrated the sustainment and expansion of the government's promise to provide adequate housing for African Americans. The festival was a momentous celebration for "Wellstown," a popular colloquialism of the neighborhood homes. With a packed schedule of events that included a parade, craft displays, swimming exhibition, talent show, fashion show, vendor booths, historical pageants, and essay contest, Wells Day was a time to celebrate Black life. Wells-Barnett's legacy was central to all the festival events, and she was heralded through the culture of recognition as a reflection of the triumph of Black Chicagoans.[30] The continuing community pride in the homes bearing Wells-Barnett's name demonstrated the success of the CHA's investment.

By the late twentieth century, though, the Wells Homes no longer symbolized Black progress but rather became synonymous with poverty,

FIGURE 13. Children enter the Ida B. Wells Homes Community Center for school in the public building named memorial created by the Chicago Housing Authority. Photo by Jack Delano, April 1942. Farm Security Administration Photograph Collection, Library of Congress.

violence, and urban blight. The Wells Homes, built to eradicate the "slums" in Black neighborhoods, had themselves become asbestos-laden living quarters for some of the city's poorest and most underemployed residents.[31] The units ranged from the original "neat and poor and clean" townhouses to the three- or four-story walkups to the seven-story expansion buildings that the *Chicago Tribune* described as "vertical visions of hell."[32] Journalist Bill Granger, whose father had helped build the Wells Homes in the 1930s, reported extensively on the quality of life for residents. In the 1990s, he and two homicide detectives investigated a murder in one of the dilapidated structures featuring elevators Granger called "death traps" and graffitied hallways that "smelled of urine and human waste." It was a typical windy winter in Chicago, yet the residents they visited sat in the living room with the windows open and wore summertime clothing because tenants were unable to regulate the temperature in their individual units and often became extremely overheated.[33]

The scene depicted in Granger's reporting—paired with the reality of life in the homes—completely shifted the positionality of what once represented the pinnacle of African American public housing. The symbolism of the

Wells Homes had changed, becoming illustrative of the enduring inequality and systemic injustice toward African Americans in the United States. The CHA, in line with other city housing bureaucracies, had long drifted from their priority of providing quality housing for underemployed and impoverished residents. Historian Rhonda Williams argues, "The novelty of highrise buildings, in particular, began to fade, and in general public housing became the bane of cities. . . . Public housing became controversial, a problem, and home to 'problem' families."[34] Like other metropolitan housing bureaucracies, the CHA largely abandoned their previous efforts to provide quality public housing over the course of the twentieth century.[35]

At the turn of the century, the Wells Homes were one of the most uninhabitable and unsafe places to live in the nation, prompting the CHA to close and demolish them. By 2002, the last of the Wells Homes had been torn down, effectively ending its six decades as one of the most longstanding named memorials of an African American woman from the Jim Crow era. A new, mixed-income housing development called Oakwood Shores was built to replace Wellstown, but much of the area where the Wells Homes stood remains "a vacant lot."[36]

Certainly, the Wells Club could not have imagined this to be the future of an enterprise they had championed and supported. In 1989, journalist Daniel Ruth described the homes as "a landmark representing the hopes and fears of its namesake. . . . What would Ida B. Wells think of the Ida B. Wells Homes?" A haunting question indeed. She might take solace in knowing that the Black community fostered in the Wells Homes has endured. However negative and abhorrent the reports of the Wells Homes, former residents have maintained an affection for their community. Each year, the "39ers" (a moniker referencing the street boundaries of the housing) host a reunion of the Ida B. Wells Homes, where they can "rejoice" in their community, which has remained vibrant even without the physical housing. Reunion organizer Michelle James voices, "We have no place to go back to. . . . Instead, we have each other. This is what we have to hold on to."[37] While the Wells Homes are no longer homes, they continue to define a community bound by a lasting named memorial.

The replacement of the Wells Homes, her most prominently attached named memorial, prompted new opportunities to commemorate Wells-Barnett's legacy. Her home in Chicago was listed as a National Historic Landmark in 1974, and the Ida B. Wells-Barnett Museum was developed in her hometown of Holly Springs, Mississippi, in the late 1990s.[38] As descendant memorializers, the Wells-Barnett family created the Ida B. Wells Memorial Foundation and has been a central part of crafting her public memory through publications and archival preservation. Alfreda Barnett Duster and her granddaughter Michelle Duster, the great granddaughter

of Wells-Barnett, have been at the forefront of these commemorations to recreate named memorials of Wells and expand traditional commemorations in Chicago and beyond.[39]

Michelle Duster once noted, "I want people to remember Ida B. Wells the woman, not Ida B. Wells the housing community. . . . I think who she was as a woman got lost when it was attached to the housing projects."[40] In 2008, she organized the Ida B. Wells Commemorative Art Committee to erect a sculpture in the historic African American neighborhood of Bronzeville in South Chicago. Their successful fundraising campaign resulted in the Light of Truth Ida B. Wells National Monument, an interpretive public art sculpture, unveiled in June 2021.[41] The Chicago City Council has also supported descendant and community memorialization efforts with a prominent renaming of the downtown street Congress Parkway to Ida B. Wells Drive in 2019. Despite the changing Southside neighborhood no longer being the locale of the once renowned Wells Homes, Wells-Barnett's legacy remains the most extensive commemoration of an African American in Illinois.

The public memorialization of Celia Dial Saxon in Columbia, South Carolina, experienced similar transitions from the Jim Crow era to the late twentieth century and into the new millennium. Although Saxon's named memorials were not as nationally visible as the Wells Homes, they have maintained their significance in the capital of South Carolina for over ninety years. Additionally, Saxon's public housing named memorial, Saxon Homes, endured into the twenty-first century, outlasting and expanding beyond that of Ida B. Wells.

Celia Dial was born during slavery, in 1857. By the age of twelve, she had benefited from the first public schools created in the South. She excelled in her studies at Howard School, and by 1874, she was one of the first African Americans to attend classes at South Carolina College (now University of South Carolina) in pursuit of her teaching certification at the South Carolina State Normal School for Teachers. After graduating in 1877, Dial went back to teach at Howard School and remained there for over thirty years. Later in her career, after marriage to Thomas Saxon and the birth of their two daughters, she taught social studies at Columbia's first African American high school, named for Booker T. Washington.[42]

In addition to her exemplary career as a professional educator, Saxon was one of South Carolina's most notable clubwomen and played an active role in the national clubwomen's movement. Saxon helped establish the South Carolina Federation of Colored Women's Clubs in 1909, worked to create the first African American library in the city, and served as president of the Columbia Branch of the Phyllis Wheatley YWCA. As a delegate from the South Carolina Federation, Saxon attended the 1924 national meeting of

the National Association of Colored Women (NACW) in Chicago, where fellow educator and colleague Mary McLeod Bethune was elected president.[43] Saxon continued to support the NACW and Bethune's presidency by agreeing to serve as chair of the newly formed Illiteracy Department in 1926, affirming that "the work of the national must be carried on and each one of us must try and do our part."[44]

Throughout her life, Saxon was committed to doing her part by helping to organize and lead events like the Negro Race Conference of 1907, where Black South Carolinians were given a statewide platform to address their social and economic concerns with the all-White power structure during the height of the Jim Crow era. In her collaborations with White philanthropists and local government officials, Saxon was strategic in garnering the funding needed for projects benefiting local African American communities. In 1917, she was instrumental in establishing the Fairwold Home for Delinquent Girls, the first and only public facility in the city that served young Black girls who were more often orphaned than delinquent.

During her summers, she used her expansive knowledge of the education field to train African American teachers across the state. Saxon was greatly admired for her teaching career and community philanthropy. She was elected at least once to serve on the Executive Committee for the National Association of Teachers in Colored Schools and held the office of treasurer of the Palmetto Teacher Association, an organization for African American educators, for almost a decade. The *Palmetto Leader* declared that she was "the best master of exchequer in our state. . . . Money in her hands is as safe as a 'New York Exchange' placed in a vault."[45] As one of the most respected African American women in South Carolina, Saxon was awarded a gold medal from the Columbia Public School Board for her esteemed performance as an educator and community leader. Upon her death in 1935, her body was laid in state at Booker T. Washington High School, where hundreds paid their respects to the woman they deemed the beloved "Mother Saxon."

In 1930, five years before her death, the public school board had transferred Blossom Street School from White children to African American children and renamed it Celia Dial Saxon School, the "highest honor the city school board [could] confer."[46] Education Superintendent A. C. Flora noted that Saxon "has been an exceptional teacher in many respects . . . and has an attendance record that has not been equalled."[47] *The State* reported, Saxon "has set an example of dependability and devotion to duty worthy of emulation not only to members of her own race, but to White people as well. . . . White and colored citizens alike should view with approval the action of the school board."[48] Saxon's attendance record along with her

MRS. CELIA DIAL SAXON, A. M.,
Columbia, S. C. Treasurer of The Palmetto State Teachers
Association.

FIGURE 14. Celia Dial Saxon featured on the front page of the *Palmetto Leader* five years before the creation of the Celia Dial Saxon School in Columbia, South Carolina. *Palmetto Leader*, March 28, 1925, South Carolina Historical Newspapers.

distinction as a race leader and clubwoman made her named memorial brand a commendation that all Columbians could celebrate. The school renaming never faced contestation in Columbia or elsewhere. Rather, it received exuberant praise from Columbians, moving across the color line in local media, and was reported by national African American newspapers such as the *Pittsburgh Courier*.

Though the Saxon Elementary named memorial was used to claim ownership of the newly designated African American school, it did not survive the changing landscape of the post–Jim Crow South. In 1968, Saxon Elementary closed and students were moved to a newer building without Saxon's name. The "Ward One" African American community, where Saxon Elementary had once stood, was restructured by urban renewal, the expansion of the University of South Carolina, and integration of public schools in the late 1960s and early 1970s. The dismantling of Jim Crow segregation coupled with the redevelopment plans for downtown Columbia resulted in the erasure of the esteemed named memorial.

Still, Celia Dial Saxon's public memory remained alive in Columbia. In 1952, seventeen years after her death, the Columbia Housing Authority authorized another named memorial in her honor: a $4 million African American public housing project. Although the chairmen of the housing authority disclosed "that a number of names were considered before a decision was reached," the African American Advisory Committee to the housing authority decided to bestow the honorary named memorial for Saxon.[49] Unable to hold formal leadership positions in the government public housing agency, the committee had advocated on behalf of African Americans and collaborated with the all-White agency to replace the impoverished slums where many African Americans lived in inadequate housing.

The committee's advocacy work continued as the housing authority began the project to replace a neighborhood filled with dilapidated housing with new garden-style apartments to be called Saxon Homes.[50] Each of the four hundred apartments was fitted with "a gas range, gas water, and space heater, electric refrigerator, electric light, and modern bathrooms."[51] Many of the African American families moving into Saxon Homes would experience indoor plumbing and electricity for the first time. Like the naming of Celia Dial Saxon School, the homes bearing her name had faced no public contestation. Saxon possessed an untarnished reputation, and her memorial brand was multiracially embraced. The advisory committee's recommendation had been immediately approved and praised by the housing authority.[52]

In 1954, the construction of Saxon Homes was completed and celebrated with a dedication ceremony. The atmosphere at the dedication was full of jubilance as the bands of Booker T. Washington and C. A. Johnson High Schools played, followed by performances from the Allen University Choir and the Benedict College Octet. Elected government officials, including Mayor J. Macfie Anderson, city council members, members of the South Carolina Legislature, and housing authority leaders were all in attendance. When Cornell Allen Johnson delivered his "Dedicatory Tribute," he emphasized that Saxon's "outstanding virtue, if indeed one is to be picked out was her interest in people, especially the underprivileged."[53] Because the

purpose of Saxon Homes was to help impoverished African American families, Johnson's role in establishing the named memorial was a high honor indeed. Before the end of the program, Saxon's daughters, Mary Ray and Julia, unveiled a large bronze plaque. It reads, "Saxon Homes, erected A. D. 1952 by the Housing Authority of the City of Columbia, S. C. . . . Named in honor of Celia D. Saxon, leader in education, social work and religion."[54] Saxon Homes remained a meaningful named memorial that utilized Saxon as a symbol of African American progress. Despite the sweeping changes in downtown Columbia that began in the mid-twentieth century, Saxon Homes retained its community presence.

By the late 1990s, the modernized garden apartments that housed four hundred families in the 1950s had endured decades of weathering without any substantial updates. After a local tour of the structures, US Secretary of Housing and Urban Development Andrew Cuomo granted the Columbia Housing Authority federal funding to demolish the existing public housing and completely rebuild. With the assistance of US Representative James E. Clyburn (serving the sixth district of South Carolina), the housing authority secured a federal grant of over $26 million to begin their project in 1999.[55] By the end of the redevelopment, the project had received $66 million in funding, and Saxon Homes had been transformed into the Celia Saxon Neighborhood. It consisted of a "mixed community of owner-occupied, single-family homes, rental townhouses and apartments for low-income families, as well as senior cottages." While some residents were permanently displaced, others were able to move back into the new neighborhood beginning in 2004.[56]

The revitalization of the neighborhood reflects not only a continuation of Saxon's public memory but also a transformation that showcases how the culture of recognition manifests for twenty-first century memorializers. Unlike the previous Saxon Homes, several named memorials in the neighborhood included her first name as well, including Celia Saxon Street, the Celia Saxon Health Center, Celia Saxon Apartments, and Celia Saxon Shopping Center.[57] The new neighborhood is a symbol of "renaissance" for blighted public housing and represents modern, reconceptualized public housing in the twenty-first century.[58] The Columbia Housing Authority has embraced Saxon's memorial brand of African American progress to illustrate that modern public housing provides access not only to quality homes but also to affordable health care, financial services, fresh groceries, and safe recreational areas.

Two miles away, the Celia Dial Saxon School that was demolished in 1974 also underwent a renaissance in the twenty-first century. When the University of South Carolina began expanding its campus into the Ward One neighborhood, residents could do little to forestall the urban renewal

and university growth that dominated the cityscape. By 2000, the neighborhood that had been well known to Saxon and her students was completely unrecognizable to the residents who had been uprooted. However, the public memory of the community—its people, churches, businesses, schools, and homes—saw a resurgence that coincided with Saxon's memorialization. Known for their fervent motto, "We are not done with the old Ward One," African American memorializers were determined to celebrate their former neighborhood.

The Ward One Organization, founded by Beatrice Richardson in 1991, was created to acknowledge the existence of the neighborhood destroyed by urban renewal and to reconnect displaced residents with one another. In addition to hosting a biennial reunion, the organization began to collect artifacts from former residents of the neighborhood in hopes of creating a permanent museum. The memorializers extended their public history efforts to revive the memory of Saxon, garnering the support of University of South Carolina historian Bobby Donaldson and local preservation organization Historic Columbia.[59] Their collaborative efforts in 2008 resulted in the erection of a historical marker commemorating both Saxon and Saxon School.[60] This traditional memorial of Saxon embodies the legacy of the African American community she helped to shape a century earlier.

The changing structure of segregated community spaces necessitated changes in cultural landmarks that African Americans used to claim ownership over their neighborhoods. Named memorials were essential to commemorating namesakes through the culture of recognition and exemplifying the ideals that aligned with local residents. For the women in Tyler, Texas, the Ella Reid Library represented their club work and local philanthropy, while the public housing named memorials of Wells and Saxon tied African American progress to their lifetimes of service and civic engagement. Though the Wells and Saxon named memorials outlived the Reid Library, they, too, underwent permanent changes that reflected newer ideals of the communities. Integration and urban renewal affected the ability of memorializers to sustain and influence public named memorials, which at times resulted in complete erasure. Memorializers adept at embracing the adaptability of named memorials allowed some, such as Saxon Homes, to change over time and evolve in meaning for local communities. Other memorial brands, like the Wells Homes, were seemingly irretrievable and needed to be revamped in a different memorial medium. The commemoration of Ella Reid, Ida B. Wells-Barnett, and Celia Dial Saxon continues to have a powerful presence in the public memory of those influenced by how these women shaped the physical and cultural landscapes of African American communities during the Jim Crow era.

The National, State, and Local Stages

Ushering in the Golden Age of African American Women's Memorialization

CHAPTER 5

Mary McLeod Bethune and a
New Era of Commemoration

On July 10, 1974, the National Park Service marked a tremendous moment in its history as the National Council of Negro Women (NCNW) unveiled the Mary McLeod Bethune Memorial statue in Lincoln Park, Washington, DC. Fourteen years of congressional lobbying, extensive fundraising, creative collaborations, and meticulous planning by the NCNW had finally culminated in the memorial of the prominent educator and leader. This was an occasion of great significance. The Bethune Memorial was not only the first and only statue of an African American, it was also the first and only statue of a woman to be erected in Washington, DC.

On the morning of July 10, Bethune's birthday, an enthusiastic crowd of "more than 18,000" listened to national and local dignitaries deliver inspirational remarks.[1] Robert Berks, the sculptor, was publicly thanked for his creativity and steadfastness. Walter Washington, the first African American mayor of Washington, DC, presented a city proclamation declaring July 10 Mary McLeod Bethune Day. Congresswoman Shirley Chisholm, the first African American woman elected to Congress, commended Dorothy Height, president of the NCNW, for her "stick-to-itiveness" in her leadership to create the memorial.[2] Secretary of the Interior Rogers C. B. Morton expressed his personal "gratitude" to the NCNW for the organization's "contribution to the National Park system" and delivered an official message on behalf of President Richard Nixon, who stated, "It is highly appropriate . . . that we memorialize the life and achievements of Mary McLeod Bethune."[3]

Actress Cicely Tyson then delivered a powerfully moving rendition of Bethune's "My Last Will and Testament," published after her death in

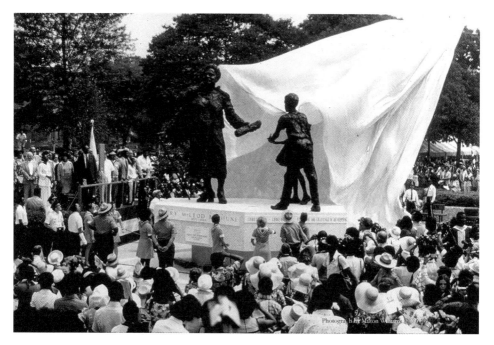

FIGURE 15. The National Council of Negro Women hosted the Mary McLeod Bethune statue unveiling ceremony in Lincoln Park, July 1974. Collection of the Smithsonian National Museum of African American History and Culture, Gift of Milton Williams Archives, © Milton Williams.

1955 in *Ebony* magazine. The crowd watched with awe as Tyson brought Bethune's words to life, eloquently explaining that although Bethune had little to leave in "worldly possessions," her desire was to leave "distilled principles and policies" representative of the essence of her "life's work."[4] Actor Roscoe Lee Brown read from the address Frederick Douglass gave at the unveiling of the Freedmen's Memorial, dedicated in Lincoln Park over a century earlier. Brown replaced Abraham Lincoln's name with Bethune's in the speech, declaring, "On this day in this place in this speech, man becomes woman."[5] The Freedmen's monument, often referred to as the kneeling slave statue, was for some a display of Black people in subjugation. In contrast, Bethune being exalted as a national treasure represented her memorial brand of liberation and progress through the sacrifice and dedication of African Americans and not White saviors.[6]

Height then echoed Brown's sentiments in her remarks when she proclaimed, "This memorial converges two very important streams in American life; a long overdue recognition that black people, brown people, red people, yellow people, have problems, but that there is a

Black heritage and contribution that has been made. And the second stream is a tremendous new awakening and recognition of the contribution of women in society. Who could bring them better together than a woman who is also Black, knowing the meaning of double jeopardy?"[7] Height's comments highlighted the distinctive experiences and contributions of African Americans to the nation and articulated the intersectional contours of the racialized and gendered identity of African American women. Though Height was Bethune's "handpicked successor," she was not alone in recognizing the significance of memorializing Bethune through the culture of recognition as a tribute to Black women everywhere.[8]

As Height pulled the light blue fabric off the gigantic memorial, Secretary Morton's and Mayor Washington's exuberant applause and cheers thundered throughout Lincoln Park. The jubilance in the atmosphere as the Bethune-Cookman College Choir led the singing of "Lift Every Voice and Sing" was as powerful as the sight of the large bronze statue. Weighing almost four thousand pounds on a pedestal six feet from the ground, the memorial features Bethune at the gargantuan height of twelve feet, passing her "legacy" to nine-foot boy and girl statues.[9] In addition to an engraved plaque mounted on the front of the memorial that credits the NCNW for erecting the monument, portions of "My Last Will and Testament" surround the colossal structure, including "I Leave You Love," "I Leave You Hope," "I Leave You Faith," and "I Leave You Finally A Responsibility to Our Young People."

After taking in the breadth of the Bethune monument, thousands walked from Lincoln Park to the steps of Capitol Hill in the "People's Parade of Dedication," organized in collaboration with Bayard Rustin, who had coordinated the seminal March on Washington a decade earlier.[10] This "Celebration March" featured African American organizations from all over the nation "to inspire rededication to the legacy of Mary Bethune and the highest principles of a democratic society." Multiple generations gathered to mark the momentous occasion of African American pride as the commemorative celebrations continued with receptions across the city and culminated in "A Salute to Women Banquet."[11] The celebrations continued for two more days with symposiums, concerts, and African American heritage festivals.

The three days of star-studded festivities embodied sheer joy from the passionate persistence of the NCNW efforts to create the first and only memorial statue of an African American in the nation's capital. Through the culture of recognition, Bethune's national commemoration acknowledged the significant contributions and achievements of

African Americans in the United States. The prominent establishment manifested a new type of memorialization for African American women, ushering in a golden age for traditional public history memorials created in their honor.

While the process for erecting the statue began in 1959, Bethune's memorial trail started much earlier, first with named memorials, and before her death, with the establishment of the Mary McLeod Bethune Foundation. In the early 1950s, Bethune began contemplating how her legacy would live on through the NCNW and Bethune-Cookman College. As a visionary, Bethune wielded her skills as a public memory crafter to establish her own institution to preserve her life's work. She confided in fellow memorializer Sue Bailey Thurman: "I am converting my own home into 'The Mary McLeod Bethune Foundation' and setting it up so that it will be a shrine after I am gone where thousands and thousands of young people and old ones too might come and get a peep into the things that surround my life. . . . I am turning over these three lots upon which my house stands and the house and the contents thereof to the foundation."[12] Bethune also conveyed her vision that the foundation was to facilitate interracial collaboration in domestic and global affairs and serve as a source of endowed funding for scholarships and the college's operations.

Bethune's establishment of her own foundation was an ingenious effort that served as a precedent for preserving collections of African American women at a time when many larger archival repositories deemed them insignificant. Historian Ashley Robertson Preston argues that Bethune's "gifting her home and all of its contents and personal papers, valued at $40,000, to the new established organization" was an endeavor "very much ahead of her time."[13] Additional funding came from wealthy donors and an accumulation of smaller donations that ranged from two to ten dollars. The foundation's motto was "Brick upon Brick," exemplifying how Bethune's "vision toward justice and honor for all people" would be built "gift upon gift."[14] The organizing efforts were successful, and the foundation officially launched in March 1953 with a dedication ceremony in Daytona Beach, where her home was officially transferred to the organization.[15]

Bethune's vision of memorialization did not begin or end with her own legacy through the establishment of her foundation; her memorial brand is evocative of African American women broadly. Her work with Carter G. Woodson and the Association for the Study of Negro Life and History in the 1920s, along with her participation in building the World Center for Women's Archives demonstrates her keen attention to

celebrating and documenting the Black past. She foresaw the importance of creating a distinct repository for preserving Black women's history as a central element to crafting their public memory and commemorations. She collaborated closely with memorializers like Thurman, whose mother donated a thousand dollars as inaugural funding for the "National Negro Women's Museum," intended to serve as an archive and museum for African American women across the nation. Under Thurman's leadership, the NCNW established June 30, 1946, as "National Archive Day" to educate chapters and community organizations about the efforts to preserve and celebrate the lives of African American women. The organization's collaborative legacy work was the origin of what would later become the Bethune Museum and the National Archives for Black Women's History in Washington, DC. However, the NCNW's ideas about memorialization did not manifest until several decades after Bethune's death.

Bethune and Thurman's vision for these traditional memorials was catalyzed by the Emancipation Proclamation centennial celebration that occurred in 1963. The NCNW decided to mark the occasion by unveiling a statue in Washington, DC, to honor Bethune as a founder of the organization, exemplar of women's achievements, and symbol of African American progress. In 1959, the NCNW, presided over by Dorothy Height, began conceptualizing the plans. Preparations for the centennial memorial focused on erecting a statue of Bethune and establishing an archival museum similar to the original concept Bethune and Thurman had formed of a national museum of Negro women. The museum was to have an archival repository, a training center "for the community leadership of women," a center for adult and continuing education, and a multipurpose room for community collaborations.[16]

The Bethune statue was to be erected in Lincoln Park, as sanctioned by the federal government. The NCNW acknowledged that "the unfinished tasks of American democracy remain," and its leadership viewed the Bethune statue as a progression toward equality and justice. The organization of Black women believed she represented "the significant contribution to all that is finest and best in America made by such a distinguished Negro American as Mary McLeod Bethune."[17] Such a public commemoration in alignment with the Emancipation Proclamation would showcase—through the symbolism of Bethune—the dual acknowledgment of the past and of the ongoing struggle for Black liberation.

Though the designation did not come with federal funding, congressional approval in a joint resolution and the support of President

Eisenhower to erect a memorial statue in Lincoln Park in June 1960 had the NCNW off to a promising start.[18] The bipartisan decision was the first time that federal approval had been granted for a traditional commemorative memorial of an African American in the capital city. The NCNW organizers used this momentum to select one of the nation's most celebrated sculpture artists, Robert Berks, and began a nationwide fundraising campaign.[19] Chapters immediately began hosting commemorative events to solicit funds for their vision.

In June 1962, the NCNW hosted a large fundraiser, "Art Exhibition in Commemoration of Mary McLeod Bethune," held at New York University, with the sales from artists Mordechai Avniel and Sol Nodel going to the Bethune Memorial Fund.[20] The art exhibition was also the debut of *"This Is Our Day": The Story of Mary McLeod Bethune*, an album created by a cappella octet Voices, Inc. The memorial record contained gospel, Negro spirituals, poetry, comedy, and a historical narrative of Bethune's life. Celebrated writers James Weldon Johnson, Langston Hughes, and Paul Lawrence Dunbar assisted NCNW and Voices, Inc. to create a one-of-a-kind memorial tribute "in words and music" that was sold at the exhibition and through local NCNW chapters for a profit margin of "70 cents per record."[21] The album showcased Bethune's favorite songs and uplifting words to encapsulate her life's work. And through the support of well-known African Americans, the NCNW promoted her national memorial brand in a widely accessible entertainment medium.

Even with successful fundraising events, album sales, chapter assistance, and private philanthropic donations, raising their goal of $350,000 in the midst of the civil rights movement proved too cumbersome a task for them to complete in three years. Height reflected in official correspondence that "NCNW's involvement in the movement for civil and human rights took precedence [because the] temper of the times left no other course."[22] Indeed, NCNW's collaboration with civil rights organizations, such as the National Association for the Advancement of Colored People and the Southern Christian Leadership Conference, and its support of protests, like the March on Washington in August 1963, became the primary focus of the organization's time and resources.

When the NCNW missed their fundraising deadline in 1963 due to competing interests and the escalating energy of the civil rights movement, it began rethinking the memorialization strategy. Members conceptualized an innovative plan to continue to promote the ideals of the envisioned national museum while shifting all their financial resources to erecting the Bethune statue. While resources were too limited to also build the museum, its ideals were readily incorporated through

the commemorative programs "The Bethune Legacy—NCNW Program Priorities in the 70's," the "1974 Black Women's Institute: Bethune Memorial Symposia," and the "Youth Symposium." These programs featured African American scholars, celebrities, and government officials who reflected the scholarship, research, political activism, and community outreach that was to be actualized through the African American women's museum.[23]

Over the next decade, the NCNW created opportunities to reach their fundraising goals and keep Bethune's public memory relevant. In 1965, New York mayor Robert Wagner commemorated "the tenth anniversary of the death of Mrs. Bethune," from May 18 through June 17, as the Mary McLeod Bethune Memorial Month. NCNW chapters used this memorial month to bring national awareness to their continued efforts.[24] The NCNW chapter in New York hosted the Summer Art Festival at Blumstein's Department Store in Harlem, where students exhibited their art and "distinguished artists from around the world" sold their work for the benefit of the Bethune memorial fund.[25] Though Washington, DC, housed the official national headquarters of the NCNW, Bethune had founded the organization in New York. As a result, New York communities and city government were particularly receptive to supporting her national memorial.

In the 1970s, the NCNW continued to successfully raise money and national awareness about the Bethune memorial. By 1971, the organization had raised sufficient funds to break ground at Lincoln Park. While some NCNW members traveled to Washington, DC, for the groundbreaking ceremony, other chapters recognized the moment through local celebrations. In Houston, Mayor Louie Welch issued a proclamation to declare May 30, 1971, as Dr. Mary McLeod Bethune Memorial Fund Day as he "urge[d] all citizens to join . . . in supporting the Houston Section of the National Council of Negro Women, Inc., in its efforts to raise $2,000 toward the cost of building the memorial monument to Dr. Bethune."[26] Local declarations crafted Bethune's public memory and made her national memorialization relevant to interested parties outside of Washington, DC.

The Lincoln Park groundbreaking ceremony held on June 19, 1971, brought a new energy to the decadelong fundraising and compelled other African American organizations to support the NCNW's legacy work. In Florida, the chapters of Alpha Kappa Alpha Sorority at Stetson University and Bethune-Cookman College came together to hold a "Silver Tea" to "honor a great lady" and send their proceeds to the NCNW.[27] The young men of the Howard D. Woodson High School Choir of Washington, DC, embarked on a concert tour through the capital city, Virginia, North

FIGURES 16A & B. National Council of Negro Women donation tin used for fund raising for the Mary McLeod Bethune statue in Washington, DC, circa early 1960s. Collection of the Smithsonian National Museum of African American History and Culture.

Carolina, and South Carolina to raise funds for the memorial as well. The Woodson Choir personified Bethune's lifelong commitment to young people and education.[28] In Seattle, Washington, the Pan African Foundation asked to collaborate with their local NCNW chapter to prominently display a small replica of the Bethune statue at a "Black Pavilion" dedicated to showcasing the contributions of African Americans to the nation.[29]

As fundraising efforts reached a national audience, so did concern about the money being used for the memorial. Few members were completely against the memorial, but some wrote to the NCNW leadership to express their discontent. In a letter to Congresswoman Chisholm, the honorary chair of the Bethune Memorial Fund Committee, Kaaren Klingol, thought it was "gross hypocrisy for the Nixon administration and Congress to 'authorize a plan' to build the memorial, but refuse to help with the costs," especially "at this time, when so many black children are undernourished and starving and black youths in ghettos are desperately in need of better education, jobs, and hope."[30]

Because clubwomen provided a number of social welfare resources to their underserved African American communities, some feared that already strained budgets would suffer. Some women who wrote to Height agreed that a more tangible use of the money in "a living monument dedicated to the teachings and ideals of Mary Bethune would be far more fitting."[31] Others wrote to the NCNW to suggest different uses for the raised funds, such as "help[ing] feed people in Mississippi," establishing "cooperative farms," or "building a hospital." Agnes Maucher understood the memorial would be "no doubt a beautiful statue, but what good will that do for the folks who need bread, medical assistance, learning, etc.?," while David M. Sherr of Santa Monica, California, wrote that he was "appalled to think that you [NCNW] are in the process of wasting good money on a 'monument' when people are ill fed—ill housed and ill clothed." [32] The anxieties expressed by those who wrote in opposition to making the substantial monetary commitment needed to erect the statue revealed the very real limitations of creating such a memorial. Mary Isabel Knox, who felt that Bethune's legacy was being misappropriated, wrote, "Anybody who knows who she was, and what she did for sufferers, knows that she is a memorial in herself."[33] Bethune's national memorial brand carried a powerful symbolism, but could that outweigh the ever-present needs of African American communities?

Dorothy Height and the NCNW leadership chose to persist in their legacy work since many African American communities had supported the organization's vision for the national memorial by contributing penny and dollar donations for over a decade. Height was a shrewd strategist and

her extensive knowledge of the political landscape informed the NCNW's decision to move forward with their commemorative plans. Because the Bethune statue represented African American women through the culture of recognition, this was uncharted territory on the national stage of commemoration. For the first time, a century after the Emancipation Proclamation and on the heels of the civil rights movement's major legislative victories, African American women were being recognized by the federal government through a traditional public memorial. By conceptualizing and funding the establishment of the Bethune statue, Height's leadership and NCNW memorializers provided the foundation for the emergence of using traditional mediums for African American women memorials.

Bethune's national memorial brand posited an African American woman as the central figure to connect the past, present, and future histories of Black people in America. Height explained that "the memorial to come is not simply a statue, but tangible evidence that black people have achieved greatness and that our government recognizes this truth—the black child needs this as well as the necessities of life."[34] The "tangible evidence" left by traditional memorials was meant to shape public space outside of African American communities while also preserving the rich life and culture that resided within them. Bethune was the perfect exemplar of this type of memorialization, being an exceptional American citizen who had shaken off all the societal roles prescribed to both women and African Americans to become a successful educator, savvy philanthropist, and one of the most powerful political women in United States history.

Alex Haley's autobiography and subsequent miniseries, *Roots: The Saga of an American Family*, helped invigorate public interests in traditional public memorials like the Bethune statue. Along with the momentum of the civil rights movement and the emergence of the Black Power movement, Haley's popularity coincided with the desire for a national monument in Washington, DC. As literary scholar Stephanie Athey explains, "*Roots* knowingly draws on the scholarly currents of the 1970s, and by popularizing academic work in revisionist history, the novel fueled a largescale, nonacademic quest for 'roots.'"[35] At the same time, the Black Studies movement's successful establishment of programs and departments in academic institutions opened up new avenues to educate public audiences. Public history sites were valued as accessible spaces to preserve, disseminate, and connect African American history to local communities.[36] African American commemoration campaigns like the NCNW's utilized the popularity of *Roots* and the increasing awareness of Black studies scholarship in the mid-twentieth century to galvanize community support and engage government

agencies for the creation of traditional memorials—museums, statues, historic sites, and parks.[37]

The erection of the Bethune Memorial defined the educator's moniker in African American public history. The triumph of the fourteen-year campaign of the NCNW opened a new pathway for the legacy work yet to complete. Shortly after the statue was unveiled in the summer of 1974, NCNW members turned their efforts to the next phase of Bethune's memorialization by establishing the Bethune Museum and the National Archives for Black Women's History. The NCNW had long been collecting documents to create the archive. Members initially turned to collaborate with the World Center for Women's Archives in the late 1930s and early 1940s, and when that endeavor was unsuccessful, they began developing independent plans for the National Negro Women's Museum. Thurman and other organizational archivists steadfastly collected archival materials for several decades while using public symposiums to sustain their earlier visions for an African American women's museum.[38]

NCNW leaders employed 1318 Vermont Avenue Northwest in the Logan Circle neighborhood of Washington, DC, the townhouse that had served as Bethune's home and the official organizational headquarters from 1941 to 1966. The home was a point of pride for the NCNW, because less than two years after Bethune had acquired the property, she purchased it outright with its fundraising campaign that included a $10,000 on-the-spot contribution she had deftly procured.[39] Operations at the home had come to a halt when a 1966 basement fire forced the NCNW headquarters to relocate. After the incident, Bethune's home on Vermont Avenue had remained unused for eleven years.

The year 1975, however, marked a turning point for Bethune's DC home and archival plans. The success and acclaimed reception of the Bethune statue a year earlier propelled the organization's efforts to establish a museum and archive to celebrate African American women. Bethune's home was first listed on the 1975 Register of National Historic Sites in Washington, DC, preceding the NCNW's new memorial campaign, the Bethune Historical and Development Project.[40] Unlike with the Bethune statue, new public funding was available for the NCNW's vision. With funds received from the Institute of Museum Services, the National Endowment for the Humanities, and the National Historical Publications and Records Commission, the NCNW enjoyed a much shorter window for implementing their memorial plans.[41]

On November 11, 1979, the NCNW officially opened the Mary McLeod Bethune Memorial Museum and the National Archives for Black Women's

History. A crowded room of NCNW members, some wearing ornate corsages made with crisp purple ribbon, stood in the front room of the home for the occasion. Historian Bettye Collier-Thomas, the first executive director, presided over the ceremony, and Dorothy Height delivered the keynote address.[42] The opening ceremonies were followed by the NCNW's hosting the first National Scholarly Research Conference on Black Women in America, reportedly attended by "2,000 historians and scholars."[43]

The Bethune Museum and Archives (BMA) was the physical culmination of African American women's history, the realization of the NCNW's original vision for the "National Negro Women's Museum." The National Archives for Black Women's History documents and preserves the multilayered histories of African American women for future generations. Collier-Thomas stated, "The achievements and contributions of black women in America have been ignored by scholars, and the council [NCNW] is determined to remedy that neglect."[44] By memorializing Bethune, African American women, and their history, the NCNW created a national public history site like none other before or after. Collier-Thomas called attention to the culture of recognition ingrained in the BMA, remarking that it operated as a "functional, alive institution," where "we not only seek to honor Mrs. Bethune . . . we're honoring black women and black people also."[45]

With "a small group of historians and archivists," Collier-Thomas worked in the first years of the museum to process manuscript collections and curate exhibits. During those years, operations and site sustainment was achieved through grants, volunteers, and organizational allocations from the NCNW. Yet maintaining sufficient funds to carry out the work of the BMA was a difficult task. To relieve some of the financial burden, the NCNW decided to seek federal aid by collaborating with the National Park Service (NPS). Their collaboration was successful in making Bethune the second African American woman to have a NPS Historic Site created in her honor (Maggie Lena Walker of Richmond, Virginia, was the first). While partnering with NPS marked another milestone in African American women's public history, it also revealed the limitations of public partnerships with government agencies.

The first African American deputy director of the NPS, Ira Hutchinson, was one of the most vocal opponents to Bethune's inclusion in the NPS.[46] At a hearing of the House Subcommittee on Public Lands and National Parks on April 22, 1982, Hutchinson represented the US Department of the Interior. He urged representatives to vote down establishing the BMA as a national historic site because the NPS "recommend[ed] against the enactment of this legislation." Along with conveying an "overall budgetary

FIGURE 17. The Mary Mcleod Bethune (National) Council (of Negro Women) House National Park Service Historic Site. 1318 Vermont Avenue Northwest, Washington, DC. Photo by Jack Boucher. Historic American Buildings Survey, Library of Congress.

restraint" in the federal agency, Hutchinson testified that "the National Park has done no study of this particular site to determine if indeed it is nationally significant. In addition, we cannot commit limited National Park Service funds and staff to complete such a study in the near future."[47]

Hutchinson's comments were unexpected and "set off a barrage of questioning from subcommittee members . . . followed by passionate testimony in favor of the measure by private citizens and public officials."[48] Dorothy Height, president of the NCNW, and Vincent deForest of the Afro-American Institute for Historic Preservation Planning and Development Corporation were among the private citizens who testified in favor of the bill. California representative Phillip Burton reflected the collective sentiment of supporters when he exclaimed, "There can be no doubt in the world that Mary McLeod Bethune qualifies on all counts to be commemorated in the national park system."[49]

Supporters of the designations prevailed, with the subcommittee going against Hutchinson's recommendation. On October 15, 1982, Congress established the Mary McLeod Bethune National Council House as an NPS Historic Site, changing its name from the Bethune Memorial Museum and Archives. The secretary of the interior, "acting through the National Park Service," was authorized to enter into a cooperative agreement with the NCNW to run the site.[50] Because the Council House use was only partially managed by NPS employees, NCNW leadership maintained control over the day-to-day operations and received $100,000 in 1983 for expenditures.[51] Nevertheless, the NCNW was still tasked with raising operating funds to equal the contributions of the NPS on a "fifty-fifty matching basis."[52] Neither Collier-Thomas nor the NCNW leadership anticipated the continued financial struggle to operate the Council House after garnering such a substantial federal partnership.

In 1985, the NCNW encountered another unexpected obstacle when leadership of the NPS yet again questioned the legitimacy of continuing to fund the Council House and of recognizing Bethune as a figure of national significance. On July 18, 1985, Mary Lou Grier, the first woman appointed as deputy director of the NPS, testified at the hearing of the House Subcommittee on National Parks and Recreation that the federal agency did not support the bill requesting an appropriation to fund the Council House annually. Grier acknowledged that the 1982 legislation made the Bethune Council House a National Historic Site but disagreed that the cooperative agreement between the NPS and NCNW should be a "vehicle for funding." She pointed out that "when the initial bill was introduced, the Park Service testified in opposition to it from the history side of it—the significance."[53]

As Hutchinson had done three years prior, Grier maintained that the Council House was a drain on the agency's budget and Bethune was an understudied person of uncertain historical importance. She also agreed that "the achievements of black women throughout our history" were already a part of the NPS in the Women's Rights National Historical Park in Seneca Falls, New York, the Maggie L. Walker National Historic Site, and "a number of sites that are dedicated to black women and men."[54] Grier's testimony indicated the NPS saw the Council House as repetitive of the work it was already doing and did not see the need for any more historic sites centered around African American women's history.

Executive Director Collier-Thomas vehemently disagreed with Grier's mangled facts and assertions. "First of all," Collier-Thomas declared, "the Bethune Council House is a national historic site, unless we have all misunderstood the legislation. . . . There are eight black historic sites in this nation and one other one honors a black woman." In regards to Grier's comments on the national park for women's rights, Collier-Thomas insisted, "They do not do any in-depth interpretation on black women" on the site.[55] Indeed, since 1954, of the two hundred historic sites in the NPS, less than five percent had been sites "dedicated to memorializing the black experience in America." As the only two NPS historic sites honoring African American women, the Bethune Council House and Maggie Walker Home represented less than one percent of all NPS units in 1985—a percentage that has not changed even in 2024.[56]

Grier's comments about the NPS being "'unable to validate her [Bethune's] achievements.'. . . touched off a national letter-writing campaign to press lawmakers to support the subsidy legislation currently in the House."[57] Jet reported that the NPS "spends less than one percent of its budget on its Black federal facilities," which made its declaration even more egregious to the nationwide cadre of Bethune memorializers.[58]

Public media and community response to Grier's testimony revealed the widespread support for memorializing Bethune along with the antipathy aimed at NPS and Ronald Reagan's administration for attempting to derail the commemoration. Fervently against the expansion of the NPS, political scientist John Freemuth argues that the Reagan administration was a "politicizing" force in the NPS by its use of "presidential appointment to locate key park policy decisions in the hands of Assistant Secretaries and Secretaries of Interior."[59] Grier, as a "Washington outsider," had been directly appointed to her position by Secretary of the Interior James Watt in 1982 and tasked with representing the larger policies of Reaganomics. Beyond fiscal conservatism, the NPS's skepticism toward Bethune's validity

as a worthy figure of commemoration offers insight into its perception of memorializing African American women.

The pushback to Grier's testimony from elected officials and their constituents was not enough to obtain the full $200,000 annual appropriation requested by Collier-Thomas on behalf of the Council House. Congress did pass an amendment to the 1982 public law, appropriating up to $100,000 for 1987, with an incremental $10,000 added for the next two years.[60] In 1989, when reauthorization of appropriation drew near, Collier-Thomas and Height held Community Mobilization Day to proactively "gather support for the reauthorization of congressional funding."[61] However, their funding reauthorization bill was amended to fully "authorize the National Park Service to acquire and manage" the Council House, in lieu of the cooperative agreement. For the third time, the NPS's testimony to Congress remained in firm opposition to Council House funding. And for the third time, both houses voted against NPS recommendations.[62]

Congress's zealous support for Bethune's memorialization made the Council House a fully incorporated NPS unit in 1991, relieving the NCNW of the growing financial obligations to maintain the museum and archives. The cooperative agreement authorized in 1982 was amended to place the care of the financial obligations, maintenance, and interpretation of the site on the NPS. The NCNW continued to be an active partner but was no longer responsible for matching financial contributions. While the journey for the Council House to be fully financed and maintained by the NPS was arduous, public support for Bethune's legacy was unrelenting. Over twenty-five years later, the Council House remains one of only two NPS historic sites centered around the legacy of an African American woman.

Still, how African American women were publicly commemorated in traditional memorials was profoundly changed by the commitment of the NCNW to memorialize Mary McLeod Bethune. Her living memorials and her vision to memorialize herself through her foundation set the tone for the eventual establishment of the federally sanctioned statue and house museum in the nation's capital. Bethune's triumphant memorial brand was the powerful symbol of African American womanhood that could withstand over a decade of ardent fundraising and an onslaught of bureaucratical barriers from the NPS. As a result, the racialized and gendered history experienced by African American women was legitimized through the federal government, deeming them as figures of national importance and noteworthy contributors to the nation.

The unveiling of Bethune's bold, bronze statue near Capitol Hill marked a national shift in the way that African American women *could* be publicly memorialized. The inclusion of the Bethune Memorial and the Council

House in the NPS coincided with national interests in African American history and marked a peak in the evolution of its public history. Though grossly underrepresented among the public history sites of women and African American men, African American women's public history flourished in the last decades of the twentieth century. Hurdling seemingly insurmountable odds, African American women epitomized character, activism, and service through the national commemoration of Mary McLeod Bethune, one of the most importantly memorialized women of the twentieth century, inspiring a new era of memorial parks, house museums, and historical markers highlighting African American women across the nation.

CHAPTER 6

From Murdering Voodoo Madam to Mother of Civil Rights

The emergence of the Black Studies movement and the Black Panther Party in California in the late 1960s and early 1970s influenced the evolution of African American women's memorialization. Home to some of the first protests demanding Black studies departments on college campuses, San Francisco State College (now University) sparked an interest in African American history. College students and community organizers worked in concert to facilitate the establishment of educational programs that explored the Black past. Historian Peniel Joseph argues that "San Francisco State would become a launching pad for Black Power on college campuses."[1]

As Black student unions galvanized college students across the country, memorializers embraced the empowering rhetoric of the Black Power movement to promote African American public history. The discourse of the Black Power and Black Studies movements irrevocably linked knowledge of the Black past to ongoing liberation struggles; being empowered with African American history was often seen as the first step to obtaining social justice. Perry A. Hall asserts that "the Black Studies movement was the instrumental mission to link processes of knowledge construction to processes of social change." Members of the San Francisco Negro Historical and Cultural Society (the Society), capitalizing on the momentum of the movements, collaborated with community activists and local professors to create public history venues of knowledge in the Bay Area.[2] The African American memorializers of the Society were so successful in their endeavors that they established some of the first traditional African American public history sites in the nation.[3]

In 1955, the Negro Historical Society merged with the Negro Cultural Society to form the San Francisco Negro Historical and Cultural Society and combine their resources. The Society was instrumental in documenting and teaching African American history in the Bay Area through their heritage programs, which included concerts, reading groups, research projects, and lectures. The Society's membership consisted of community leaders, social justice activists, philanthropists, scholars, and educated professionals who were strategic in their organizational structure and operations. Its mission was "to correct distortions about Negro life and history; to present an accurate account of the contribution of the Negro people to world culture and history; [and] to instill pride in Negro youth for their heritage."[4] The Society worked to create permanent fixtures in San Francisco to establish visible recognition of African American contributions to the region. It created walking tours marking significant sites and events, hosted Black history cruises, and lobbied to rename public buildings and spaces after Black pioneers.[5]

Among its notable initiatives, the Society's memorialization of Mary Ellen Pleasant established the first traditional public history memorial of an African American woman in the West. Still today, Pleasant is one of the most enigmatic and visible figures in California's history and throughout the western region of the United States. Her memorial brand of activism represents civil rights, Black achievement, and social mobility in a diverse, multicultural West. Despite amassing an astonishing amount of wealth, power, and influence as an African American woman in the nineteenth century, a flurry of negative rumors surrounded her legacy. However, African American women public memory crafters worked diligently as part of the San Francisco Negro Historical and Cultural Society to recast Pleasant's public persona. Through the culture of recognition, they reclaimed distorted historical narratives as a way to celebrate their own legacies of overcoming oppression.

Mary Ellen Pleasant was born on August 19, 1814. The details of her early life remain obscure. It is known that she came of age in the Northeast and was educated in Nantucket, Massachusetts, while working at Quaker Mary Hussey's dry goods store. There, she learned valuable business skills and was exposed to notable abolitionists, like William Lloyd Garrison, while visiting Boston. She later married abolitionist and Cuban planter Alexander Smith, and the couple worked together to help free enslaved people through the Underground Railroad liberation network. After Smith's death, her estimated worth was $45,000, which she used to continue supporting abolitionist causes. In the late 1840s, she married John James Pleasant.

By 1852, the couple had moved to San Francisco, California. In the 1850s and 1860s, Pleasant flourished as a savvy entrepreneur and was successful in opening several restaurants, laundries, and boardinghouses. Her businesses catered to the growing population of miners and migrants coming to San Francisco. Her entrepreneurship allowed her to employ African American men and women in her businesses and eventually act as a de facto employment agency. She supplied San Francisco business owners with employees while also providing consistent economic opportunities for the city's growing African American population. Her profits helped to establish the Bank of California and build an elaborate mansion on the corner of Octavia and Bush Streets. Pleasant's ever-growing business portfolio meant that she wielded considerable influence among the political and business elite of the city.[6]

Pleasant remained committed to the abolitionist movement and securing equal rights for African Americans throughout her life. She worked with other Black abolitionists, such as Mary Ann Shadd Cary and Martin Delaney, and helped fund John Brown's raid on Harpers Ferry in the late 1850s. In 1863, she advocated for the legal right for African Americans to testify in court, suing the North Beach and Mission Railroad Company for their discrimination against her when she was refused entry onto a streetcar in 1868. Though she was awarded a $500 settlement, her verdict was eventually overturned. Undeterred, she remained vigilant in the fight for African American freedom and civil rights. Yet, it was not until decades after her death that Pleasant was celebrated as the "Mother of Civil Rights in California."

Toward the end of Pleasant's life, the widow of former business partner Thomas Bell exercised her influence to publicly shame and dismantle Pleasant's reputation. National and local newspapers in the 1880s published reports of Pleasant, who they mockingly referred to as a "mammy," voodoo queen, and brothel madam. Despite contesting these reports, Pleasant's reputation had been tarnished, and she was unable to recover financially or socially. At the time of her death in 1904, she was virtually penniless.[7]

Half a century later, public memory crafters Elena Albert and Sue Bailey Thurman were paramount to transforming Pleasant's reputation by crafting a civil rights memorial brand that heralded her as a significant figure among African Americans contributing to California. As deft public historians, Albert and Thurman helped nurture an appreciation for Pleasant's life and attached her legacy to the civil rights movement.

Albert was a regular presence in the Black Arts and Black Studies movements in the Bay Area. Self-taught, Albert was known as an "authority on

Negro history" and regularly attended community events of commemoration.[8] She served as the Society's director of research and program director and often lectured on behalf of the organization. Her creative genius was responsible for establishing the Society's annual Black history cruise, and her public presentations of African American history "captivated her audience."[9] Albert was thorough and organized, often using "visual aids, copies of manuscripts, newspaper clippings are [sic] drawings and photographs" in her presentations. In the 1960s and 1970s, she was selected as the keynote speaker for programs for a wide range of groups, including the American Association of University Women, Women's Club of St. James AME Zion Church, Sonoma Valley Historical Society, and San Francisco YWCA.[10] Some of Albert's most widely reported events of 1968 were her collaborations with local priests, the San Francisco State College of Women, and the Black Cultural Arts School for a Black Madonna art exhibit and lecture series.[11]

Albert's legacy work with Mary Ellen Pleasant began in the 1960s when she went to "collect historical objects from the wrecked building" that had once been an elaborate mansion. In 1964, unable to preserve Pleasant's home (then being used as a children's home and a thrift store, with plans to be converted into a dental school), Albert went to salvage mementos, recounting: "That was a mansion! I've a tiny piece of embossed wall paper from one of the drawing rooms. We climbed thru the broken window of the carriage house; then up a ladder into the first story. I went alone up that handsome stair case into every room on every floor."[12] She also collected a large marble slab that once rested above the front door and used it to create a grave marker for Pleasant.[13]

Albert's artifact preservation supported the Society's principle of creating positive public images and representations of African Americans.[14] She was also motivated to uphold the tenet of embracing the beauty of Black culture, which she first heard through Marcus Garvey's directive: "Up ye mighty race, you could do what ye will," because "that made us look at ourself. And we are handsome, we are pretty, we are beautiful, we are lovely."[15] Through the rubble of Pleasant's former home and murky reputation, Albert saw the beauty and created a series of public history events in her honor.

Elena Albert coordinated the Society's first major event celebrating Pleasant's legacy. In February 1965, the Society commemorated Pleasant's life with a memorial service and gravestone dedication that began at Bethel AME Church and ended at the Tulocay Cemetery in Napa, California, with "more than 100" in attendance.[16] The marble slab Albert had recovered from Pleasant's home was engraved with the following:

MARY ELLEN PLEASANT
MOTHER OF CIVIL RIGHTS IN CALIFORNIA
1817–1904
"SHE WAS A FRIEND OF JOHN BROWN"
SAN FRANCISCO AFRICAN AMERICAN HISTORICAL
AND CULTURAL SOCIETY[17]

The program ended with Society member Alan Williams unveiling his original sculpture and the president Frances Albrier laying the ceremonial wreath atop Pleasant's grave. The keynote address, "The Significance of Mrs. Mary Ellen Pleasant," was delivered by memorializer Sue Bailey Thurman.[18]

Thurman was a formally trained scholar who had earned degrees from Spelman and Oberlin Colleges and accumulated a host of honorary doctorates throughout her life. Well known in Black elite circles as a "noted clubwoman" and the wife to famed theologian Howard Thurman, she stood tall on her own extraordinary accomplishments. As a contemporary of Mary McCleod Bethune, Thurman was as an international diplomat and an afficionado of African American history, crucial roles in the success of the earliest years of the National Council of Negro Women (NCNW), established in 1935.[19] She created the Museum and Archives Department of the NCNW and was the first editor of the organization's official periodical, the *Afro-American Woman's Journal.* She promoted the culture of recognition as editor of *The Historical Cookbook of the American Negro*, one of the NCNW's most popular publications. A culmination of fifteen years of Thurman's research, the cookbook contained recipes and historical profiles of African Americans, such as pomander balls for Phillis Wheatley and cracklin' bread for Harriet Tubman. As a public historian, Thurman was ever conscious of producing "a palatable approach to history" for her vast audience of African American readers.[20]

In Boston, Thurman was a founder of the Museum of Afro-American History. Her historical research led to the inclusion of the first African American public history sites on the city's Freedom Trail.[21] Known for collecting Black artifacts and mementos, she also contributed to the Harriet Tubman Museum in Auburn, New York. By the time she and her husband moved to San Francisco in the 1940s, Sue Thurman was already one of the nation's leading public historians. A dedicated scholar of African American history, Thurman applied her skill set to research and document the history of Black Californians.

For seven years, Thurman traveled across the state of California to do research in libraries and conduct oral history interviews for her 1952 publication, *Pioneers of Negro Origin in California.* Priced at one dollar, Thurman's

work was widely acclaimed by African American readers.[22] Several months after the book's release, she was publicly celebrated alongside "twenty-five descendants of the '49ers" for her contribution to California's Black history. The most publicly noted feature of her research was the newly coined moniker, "Mother of the Civil Rights Movement," that accompanied Mary Ellen Pleasant's biography.[23] This designation was critical for reconstructing Pleasant's public legacy. During a time when the only published works about Pleasant relegated her to a murdering voodoo madam, Thurman's recharacterization shifted the historical narrative significantly. Through the 1965 graveside memorial service, where Thurman delivered her keynote address, she had helped make Pleasant's civil rights record public knowledge.

Elena Albert and Sue Bailey Thurman continued their work to expand Pleasant's public memory throughout the 1970s, including contributing to the Society's 1974 publication of *A Walking Tour of the Black Presence in San Francisco*. Albert regularly conducted African American history walking tours in the city, while Thurman, using "her influence to champion the cause of Black civil rights in California," wrote about Pleasant in the walking tour site descriptions.[24] As memorializers and public memory crafters, both women became liaisons between their research of African American history and the local communities interested in learning about the Black past. Their public programming created intellectual and physical venues to celebrate African American women.

Though money for their endeavors was limited, Albert and Thurman were skilled in financing their programs. Albert explains, "It takes time to raise the money, by dinners, programs of music and contributions from organizations."[25] Both women successfully navigated obtaining public and private financial resources through government agencies and nonprofit organizations to continue their preservation and promotion of African American history. Thurman had more national visibility in African American public history as a distinguished race woman and a recognized "leader in the national movement to establish museums of Negro history in America,"[26] while Albert was effective in disseminating Pleasant's historical narrative to the Bay Area community. Society members recall that Albert "was such a hard worker" and though "she never had much money I can think of no one who made a greater contribution to the society than Mrs. Albert. . . . She just opened up so many doors.[27]

Albert and Thurman's public history presence was so effective that by February 1976 the Society was able to install a permanent historical marker in front of Pleasant's mansion at 1661 Octavia Street in the Fillmore neighborhood. The Society collaborated with the San Francisco Redevelopment Agency and the Western Addition Project Area Committee to designate

FIGURE 18. At the Mary Ellen Pleasant Park dedication, Sue Bailey Thurman stands near the five eucalyptus trees that comprise the park. San Francisco Redevelopment Agency Records, San Francisco Public Library.

the space in front of the home, consisting of a row of towering eucalyptus trees, as Mary Ellen Pleasant Memorial Park.[28] The center of the circular, marble historical marker embedded in the sidewalk reads,

> MOTHER OF CIVIL RIGHTS IN CALIFORNIA. SHE SUPPORTED THE WEST-
> ERN TERMINUS OF THE UNDERGROUND RAILWAY FOR FUGITIVE SLAVES,
> 1850–1865. THIS LEGENDARY PIONEER ONCE LIVED ON THIS SITE AND
> PLANTED THESE SIX TREES. PLACED BY THE SAN FRANCISCO AFRICAN
> AMERICAN HISTORICAL AND CULTURAL SOCIETY.

Because Pleasant herself planted the blue gum eucalyptus trees, she bestowed upon them "an important historical association," preventing their being cut

FIGURE 19. Group photo of the San Francisco African American Historical and Cultural Society at the Mary Ellen Pleasant Park dedication. San Francisco Redevelopment Agency Records, San Francisco Public Library.

down under protection of the San Francisco Urban Forestry Ordinance.[29] The society's designation of the location led to "the Mary Ellen Pleasant Trees" becoming official landmarks of the city and a notable addition to the National Park Service's Underground Railroad Network to Freedom.[30] Despite being the smallest park in San Francisco, it still looms large in the twenty-first century as one of the few traditional public history memorials for African American women in the West.

Though Albert and Thurman made great strides in the Bay Area's conception of Mary Ellen Pleasant, the national narrative of her life remained salacious. One particular reader, Jesse Warr III, was repulsed by the article "Black Madam: Prostitution, Intrigue, Blackmail and Murder Helped

Mammy Pleasant Gain Control of San Francisco during Rough Boister-ous Days in 1880s" in *Ebony*'s November 1978 issue.[31] His disdain was likely linked to Albert and Thurman's two-decades-long public memory crafting. In addition, Warr was a contributing member of the San Francisco African American Historical and Cultural Society, serving as the organization's lead interviewer and transcriber of the "Oral History Project: Afro-Americans in San Francisco prior to World War II," one of several collaborations with the San Francisco Public Library.[32]

In the article, "first printed in April of 1954 and reprinted in November of 1978," author Clyde Murdock characterizes Pleasant as "America's most fabulous Black madam."[33] Working "above the law," Pleasant, Murdock claims, "forced the most influential men in the west to dance to her evil tune or be wrecked." Murdock reduces San Francisco to a "wild, wild west" caricature filled with men and women devoid of morality, seeking glut-tonous fortunes and leading lives of ill repute. Relying heavily on Helen Holdredge's *Mammy Pleasant's Partner* (1954) as his main source, Murdock distinguishes Pleasant's style as a madam by highlighting the "quadroon girls" and "watered-down version of voodoo" she used to lure elite clientele, ranging from wealthy businessmen to local politicians.[34] He argues that she wielded voodoo and "black magic" to bewitch enslaved African Americans, blackmail and manipulate benefactors, and sell newborn babies to amass the fortune she used to help John Brown in his raid. Of all Murdock's lewd depictions of Pleasant's atrocities, murder is by far the most egregious. He suggests that as an accomplice and perpetrator, Pleasant was involved with several murders and died with her reputation and finances in ruin, only to be buried in "an untended grave" surrounded by weeds and decay.

Jesse Warr sprang into action, naming himself "acting chair" of the Mary Ellen Pleasant Defense Committee. He wrote to *Ebony* expressing his disbelief and disappointment in Murdock's article, with the magazine's editors publishing the letter in the February 1979 issue. Warr argues that Murdock's fiery historical account "slanders not only the long-dead Mrs. Pleasant but San Francisco's early Black pioneers as well." He chides *Ebony* for publishing the story without checking its validity and asks the editors, "Do we need our own press to join a chorus that distorts and demeans our heritage?"[35] As one of the most popular African American magazines of the twentieth century, *Ebony* had been a venue for Black empowerment and culture. As historian James West claims, the magazine's "vast circulation, pass-on readership, and public visibility helped it surpass [other Black] periodicals to emerge as one of the nation's most powerful disseminators of popular black history."[36] By publishing Murdock's article, Warr felt that *Ebony* had betrayed its faithful African American supporters.

In response to Warr's outcry, an *Ebony* editor admitted that he "called our attention to some of the pitfalls of printing old stories" and promised to investigate Pleasant's life with thorough research and a more accurate historical narrative of her life. The piece was to be written by *Ebony* editor and historian Lerone Bennett Jr., who also was "upset by the racist sources of the original story."[37] While others made their careers as historians in academia, Bennett used his position as senior editor at *Ebony* to engage the public in the Black past. *Before the Mayflower* (1969), his first and "most famous" book, was followed by a series of books and encyclopedias on the span of African American history from ancient Africa to the twentieth-century United States.[38] Fascinated with the overarching stories of African Americans, which he referred to as "the odyssey of a people," Bennett was committed to researching and documenting African American history in a way that anyone and everyone could understand and access.[39] Historian Pero Dagbovie describes Bennett as the "Philosopher and Popularizer of Black History." Indeed, Bennett, through his continuous publications with *Ebony*, had "popularized African American history" in the "formative years of the Black Studies Movement" and was the ideal public memory crafter to recast Pleasant to a national audience.[40]

In April 1979, just a couple months after Warr's letter appeared, Bennett published a two-part series. He had conducted extensive research into Pleasant, utilizing research materials from Jesse Warr and Sue Bailey Thurman. His articles became the most thorough scholarly account of Pleasant's life at that time. Adding depth and complexity to her life, Bennett refuses to "speak patronizingly of 'Mammy' or 'Mammy Pleasant'" because, he reflects, she "was a mother to thousands . . . but she was nobody's mammy. . . . Her name was Mary Ellen Pleasant. *Mrs.* Mary Ellen Pleasant."[41] With Black women often disrespected by racist White people using terms for familial relationships to show their contempt, such as "Aunt" and "Mammy," Bennett pays homage to those who had endured these insults for centuries. His writing tone is somber and sentimental, unlike Murdock's in portraying the racy "Black madam."

Since Bennett was able to reach a national audience, his work became an integral part of Pleasant's legacy. And his articles about Pleasant became part of a large body of work produced by the astute crafter of African American public history. Bennett's commitment to making Black history accessible allowed him to expand the legacy work that Elena Albert and Sue Bailey Thurman had accomplished throughout California.

Despite the many fictional, degrading, and even scholarly accounts written of Pleasant's life in the late twentieth and early twenty-first centuries, none have acknowledged the significance of African American women in

shaping (and reshaping) her public memory and memorialization.[42] While some rumors of her alleged voodoo powers still linger, public historians Albert and Thurman set the tone for recasting Pleasant's memorial brand. Jesse Warr III and Lerone Bennett Jr. built on the women's legacy work by creating a national forum that distributed Pleasant's life story to a much wider audience. As the sun set on the lives of Albert and Thurman in the 1980s and 1990s, respectively, another African American woman began celebrating Pleasant's public legacy.[43]

In the twenty-first century, Susheel Bibbs, a dynamic performer and captivating writer, has been at the forefront of teaching communities about Pleasant's life. A formally trained and critically acclaimed classical singer, Bibbs has written several newsletters, brochures, and books to educate public audiences about Pleasant. Perhaps her most riveting work was writing, producing, and starring in the performance documentaries "Meet Mary Pleasant: Mother of Civil Rights in CA" and "The Legacy of Mary Ellen Pleasant," which aired on California's Public Broadcasting Service station KVIE.[44] Though Bibbs did not collaborate directly with the Society to create her materials, it championed her work. The Society's chief librarian, Amy Holloway, commended Bibbs for her "work to communicate the truth about Mary Ellen Pleasant in her own works," telling the artist that the Society was "excited about your research, your musical, and your upcoming book."[45] As a public memory crafter, Bibbs has also carried on the tradition of holding memorial services at Pleasant's grave site and continues to perform and educate public audiences about the lives of African American women.

The work of African American public memory crafters has culminated in a solid foundation for Mary Ellen Pleasant's commemorative presence. In 2005, the San Francisco Board of Supervisors adopted a resolution declaring February 10, 2005, "Mary Ellen Pleasant Day." Lauded for her achievements as one of California's "first freedom fighters" and as a civil rights and women's rights advocate, she was also declared "an important entrepreneur and institution" that helped to build the city of San Francisco.[46] There is no mention of voodoo nor of Pleasant's alleged status as a madam or murderer. The declaration of Mary Ellen Pleasant Day has magnified her public notoriety. While African Americans in San Francisco had recognized and understood Pleasant's significance over half a century earlier, her public memorialization has made her a known national figure. She remains still the most prominently memorialized African American woman in California.

The Madam Walker Theatre
From Urban Life to Legacy Center

Indiana Avenue in downtown Indianapolis was a vibrant gathering space for African Americans for much of the twentieth century. Saturday nights on "the Avenue" were full of the melodic harmonies of brass horns and sultry voices bellowing out the blues and scatting jazz. The floors of the Sunset Terrace Dance Hall and the Walker Ballroom held sturdy beneath the feet of dancers moving swiftly to the jitterbug, lindy hop, and big apple, and then slowly to the Walker sway. Young people dressed in their finest outfits were "looking and preening" to "see and be seen" in front of the Walker Theatre, a towering landmark on the busy street. While some went on to pay their twenty-five cents to see a touring stage show or the latest movie, others met with schoolmates from Crispus Attucks High School at the Coffee Pot, where they ate, socialized, and maybe even caught a glimpse of entertainers like Paul Robeson or Ethel Waters. After a full night of performances, musicians like Duke Ellington and Count Basie left the bustling street just as another set of musicians rose to fill the avenue with the joyful sounds of gospel.[1]

Decades later, the vibrancy of culture on Indiana Avenue that permeated through its African American businesses and patrons had dwindled to just one major building, the Madam C. J. Walker Theatre. From its opening in 1927, the Walker Theatre has remained a distinct memorial of an African American woman and a dynamic nucleus of economic empowerment. Walker, the first self-made woman millionaire in the United States, owns a memorial brand that is not only evocative of her business prowess and success but is also representative of African American cultural heritage in the everchanging city of Indianapolis.

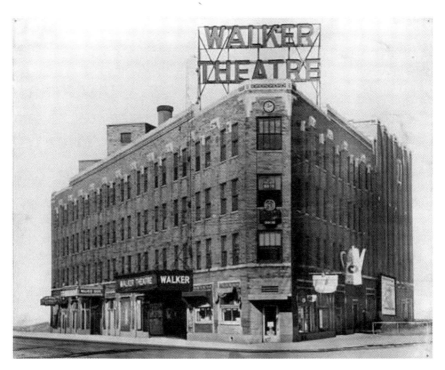

FIGURE 20. The Madam C. J. Walker Theatre in the early twentieth century. Madam C. J. Walker Collection, Indiana Historical Society.

Madam C. J. Walker was born Sarah Breedlove on December 23, 1867. Her parents, Owen and Minerva Breedlove, were enslaved on a plantation in the Louisiana delta. Four of the Breedlove's six children were born enslaved, and Sarah was the first of two children born into freedom. By seven, Sarah and her siblings were orphaned. At fourteen, Sarah married her first husband, Moses McWilliams, with whom she adopted daughter A'Lelia. After Moses's death in the late 1880s, Sarah moved to St. Louis with A'Lelia and worked as a laundress, which allowed her to work in her own space at her own pace, unlike most African American domestic workers held to rigid schedules inside White households. Though working as a laundrywoman gave Sarah autonomy over her labor, she still struggled financially.[2]

To increase her monthly income, she began selling Annie Turnbo Malone's hair care products. Malone, an enormously successful entrepreneur, had developed and begun selling her products under the name Poro in the 1890s. By the early 1900s, she had expanded her business by providing women like Sarah the opportunity to sell Poro products to earn money for themselves. Sarah continued selling Malone's products after she moved

to Denver, Colorado, in 1905. Less than a year later, she married Charles Joseph Walker and added the social title "Madam" to her name. Charles, who worked in the newspaper industry, was a skilled public relations guru. The couple collaborated, marketing and selling a new line of hair care products under the brand Madam C. J. Walker.[3]

Walker's elegant new name appeared in bold and persuasive advertisements in "farm journals, and religious periodicals," as well as in popular national African American newspapers, such as the *Chicago Defender* and the *New York Age*.[4] Though Malone sold a similar product by the same name beginning in 1900, Walker maintained that she had been working on her formula since she lived in St. Louis, when she received instructions in a dream.[5] Regardless of how Walker developed her formula, African American women all over the country embraced her products. They began selling and purchasing them as part of the growing beauty culture among American women in the early twentieth century. In several years, she had earned almost $11,000 (equivalent to $200,000 today).[6] By 1912, her business had grown so large that she "employed 1,600 agents and was making $1,000 per week."[7]

Walker's success continued, and the Madam C. J. Walker Manufacturing Company grew even larger after she moved to Indianapolis in 1910. Walker made the Indiana capital city her headquarters, foreseeing the benefits of establishing her business in a thriving African American community with impressive transportation infrastructure. Known as the "Crossroads of America," Indianapolis boasted one of the nation's newest highway systems and eight major railways that connected to every region in the United States. The Walker Manufacturing Company indeed thrived there, annually grossing over $100,000 as one of the many Black-owned businesses on Indiana Avenue in the 1910s. Historian Emma Lou Thornbrough argues, "Walker Manufacturing Company of Indianapolis [was] by far the most widely known and financially successful black-owned business in Indiana."[8]

Walker was also recognized as a dynamic addition to the National Negro Business League (NNBL), formed in 1900 by Booker T. Washington to economically empower African Americans. Yet NNBL annual conventions were dominated by men such that few women had opportunities to present their ideas in public forums.[9] That aspect of the organization changed at the 1912 NNBL convention when Madam Walker proclaimed to the crowd, "I am in a business that is a credit to the womanhood of our race." By 1914, her positionality as an entrepreneur, shaped by her race and gender, had compelled the NNBL to herald her as "the foremost business woman of our race."[10]

Markedly savvy, Walker used her influence and wealth to empower other African American women by hiring "former maids, farm laborers, and

school teachers to fill jobs at all levels, from factory worker to national sales agent."[11] She extended her generosity to philanthropic contributions by regularly donating to African American projects, organizations, and social welfare causes.[12] She was a member of Bethel AME Church and regularly donated to Black women's clubs, like the Phyllis Wheatley Young Women Christian Association.[13] Walker's economic ventures and philanthropy were still flourishing when she died unexpectedly in 1919 at fifty-one years old.[14]

Following her death, the Walker Theatre named memorial became a symbol of Black entrepreneurship and provided a venue for her legacy and for other Black professionals. Though Walker's business and charitable endeavors led to national visibility, Indianapolis became the central space for her public memorialization. She owned the luxurious Villa Lewaro, her mansion in Irvington, New York, and an elaborate Harlem brownstone, the fusion of two existing townhouses.[15] Described as having "a double-size living room stretching the full width of the second (main) floor," Walker's Harlem home had three bathrooms, a billiard room, and a retail storefront that she operated. After her death, Walker's daughter, A'Lelia, created a "literary salon" in the 1920s and leased the home to New York City in the 1930s for health clinics. A decade after A'Lelia's death in 1931, the city demolished the townhome.[16] The preservation needed to maintain Villa Lewaro would have been a gargantuan task for memorializers in the 1920s, decades before federal and state funding was available to African Americans for such a large feat, or even for the lesser goal of preserving the Harlem brownstone. Therefore, Indiana Avenue in Indianapolis became the ideal location for Walker's public memorialization.

As the first building in Indianapolis solely owned and operated by African Americans, the Walker Theatre was a beacon of Black business throughout the Midwest. Violet Reynolds, Walker's personal secretary, later recalled, "In those days, it [Indiana Avenue] was about the only place in town where black professionals could set up shop."[17] The blocks of Indiana Avenue were lined with business storefronts and brick buildings, from doctor and lawyer offices, funeral homes, tailors, nightclubs, restaurants, and grocery stores to the iconic Madam Walker Theatre. Black-owned businesses drew African American consumers from all over the city, despite their living in segregated pockets across Indianapolis. The magnetic energy of Indiana Avenue was the nexus of Black culture for much of the twentieth century. From 1927 to the late 1970s, the Walker Theatre building thrived as a central location for African American gatherings, performances, and small business office space.[18]

The famed theatre's origins began when Walker was overcharged for a movie ticket at a White-operated theater because of her race. Reynolds

recounts, "One time we went to the old Isis Theatre on Illinois Street. The sign on the window said tickets were 25 cents apiece, but the woman told us we'd have to pay 60 cents apiece."[19] Walker responded to the blatant discrimination by vowing to create a space where African Americans could enjoy entertainment "without the insult of rear entrances and dirty balconies."[20] Madam Walker's ability to funnel her energy into creating a safe space for African American entertainment and leisure benefited several generations for almost a century. Though she did not live to see her vision materialize, A'Lelia was determined to carry out her mother's wishes. She worked with longtime lawyer and family friend Freeman B. Ransom to purchase the land and build the Walker Theatre in the 1920s.

Upon completion in 1927, the Walker building at 617 Indiana Avenue resembled "today's shopping malls with a drugstore, a beauty salon, a beauty school, a restaurant, professional offices, a ballroom, and a . . . theater."[21] Described as "a city within a building," its triangular architecture shapes the exterior of the four-story, 48,000-square-foot building. A large marquee faces Indiana Avenue above the box office. The building contained a 950-seat midsize theatre and a ballroom on the first and fourth floors, respectively. The second and third floors housed commercial office space, separating the two large spaces.[22]

From its inception, the Walker Theatre demonstrated the ingenuity of African American entrepreneurship to thrive within the constraints of institutionalized race, gender, and class barriers. Though it has always heralded the extraordinary accomplishments and meaningful contributions of Madam Walker, its ability to evoke the culture of recognition among other Black business owners waned over time. Segregation had largely relegated the financial and social resources of African Americans in Indianapolis to Indiana Avenue. However, integration offered new opportunities for African Americans to extend their economic capital by living and establishing businesses in other areas of the city. By the late 1970s, the Walker building, along with other African American businesses on Indiana Avenue, was in disrepair and unable to operate at its highest potential. The fading economic vitality of the avenue forced many businesses to close or move to other locales. The central cultural and economic heartbeat of Black Indianapolis that had thrived for half a century slowly dismantled.

African American memorializers refused, however, to let the Walker Theatre die. In October 1978, James Browning of Browning Day Pollak Associates independently assessed the deteriorating "Walker Building" with the guidance of local community members Judy Waugh and Francine Smith. Their foundational understanding of the space, which they candidly shared with Browning, was that it "long served as a symbol of success to the

black community." Though dilapidated buildings in a struggling economy surrounded the Walker Theatre, it was still a steward of hope. The symbolism that Walker's legacy evoked through the moniker of the building was foundational to spurring community members to envision extending its utility beyond business.

In 1979, memorializers formed the Madam Walker Urban Life Center (ULC). Gloria Gibson-Hudson characterized their revitalization efforts as "the Walker Theatre renaissance," which endeavored "to revive the tradition of excellence established by Madam C. J. Walker and thereby help restore 'the Avenue' to its former brilliance."[23] The ULC was focused on preserving the legacy of Walker and reigniting the culture of recognition for African American economic empowerment in Indianapolis as federally sponsored urban renewal threatened to erase the history of the city's most important cultural icon.

Urban renewal in city centers and African American neighborhoods (often one and the same) during the mid- to late twentieth century resulted in the restructuring of neighborhoods and local economies. Beginning in the 1950s, federal, state, and local government agencies poured funding into modernizing cities. This restructuring of cityscapes brought new economic innovations, expanded university and college campuses, and improved roadways in cities across the nation while simultaneously displacing African American communities and irreparably destroying existing neighborhoods with new infrastructure. African American communities like that of Indiana Avenue were often the most vulnerable to being demolished or permanently restructured.[24]

The unstoppable "renewal" efforts were imminent in the area of the Walker Theatre when memorializers chose to name their preservation organization the Madam Walker Urban Life Center. Beyond the symbolic significance of their memorialization, they also understood their efforts to be a "catalyst for generating temporary and permanent employment opportunities for the revitalizing of a deteriorating neighborhood."[25] The restoration of the building was intended to be central to Black urban life in addition to driving the revitalization of Indiana Avenue through the 1980s. As "the last standing architectural remnant of the Avenue's once-bustling nightlife culture," it continues today to represent both the past prosperity and history of the area and Walker's economic memorial brand.[26]

Ironically, it was because urban renewal was destroying Indiana Avenue that ULC memorializers were able to save the Walker Theatre. They garnered social and political support for their legacy work by taking advantage of the nostalgic ties that bound African Americans to the once-thriving street. In addition, the timing of their preservation efforts meant they could receive

a wide variety of private grants and public government funding that was simply unavailable to African American memorializers just a decade earlier.

The inaugural ULC Board also transitioned the Walker Theatre from a named memorial to a traditional memorial with their decision to embrace Violet Reynold's suggestion to "construct a memorial room" for Madam Walker.[27] Deemed "a monument to black business," the building called for the ULC to set the goals of promoting the cultural and commercial benefits of its central location while also establishing within it "a suitable memorial area for the great pioneer business woman . . . as a symbol for all Indianapolis and all persons visiting" the city.[28]

In 1979, the ULC's decadelong journey to fully restore and reopen the Walker building began with the support of the Lilly Endowment, headquartered in Indianapolis and one of the nation's largest private philanthropic foundations. Like other African American memorializers, the ULC's leaders recognized the need to forge meaningful partnerships with organizations such as Lilly if they were ever going to finance their monumental vision of reopening an expansive building in much need of repair. They found early support in Charles Blair, Lilly's senior program officer, who approved the initial funding that catalyzed the restoration of the Walker building.[29]

Several consultants definitively demonstrated the value of investing in the multimillion-dollar memorial project, including Avery Brooks, an actor and theatrical scholar who stated in a letter to Blair, "Its important historical significance, its physical structure, and its attractive geographical location are, in my mind, three of the more powerful reasons for its restoration/ rehabilitation/rebirth as an influential institution of the Indianapolis community."[30] The ULC was supported in emphasizing that renovating the Walker Theatre was not only significant to Walker's legacy and Indianapolis's Black public history but also integral to the growth of the local economy.

Carl Anderson of Media Associates asserted that "the significance of Madame Walker's pioneering business efforts reaches far beyond Indianapolis and impacts on the lives of all 30 million Black citizens of this nation." By highlighting the national significance of the memorial efforts, Anderson illustrated that the Walker Theatre's revitalization as the Black cultural and economic mecca of Indianapolis was similar to other "main stems" of African American community, such as Lenox Avenue in Harlem, U Street in Washington, DC, and Central Avenue in Los Angeles.[31] The Lilly Endowment approved the grant request and continues today to be an enthusiastic philanthropic partner to the Walker Theatre.

The endowment's support positioned the Madame Walker Urban Life Center to acquire additional and much more substantial funding, including a $1.5 million Economic Development Administration grant in 1981. Hiring

Kenneth "Kenny" Morgan as the first executive director of the ULC (who served until 1987), the organization launched their renovation plan.[32] At a 1982 "Walker Building Renovation Party," it announced the project's three phases: "emergency repairs such as roof replacement," "restoration of the ballroom, offices, and commercial space, as well as exterior refurbishing," and "restoration of the Walker Theatre."[33]

Morgan expressed the duality of their efforts in both the "restoration of the building and rebirth of the area."[34] The ULC's efforts coincided with other public history projects to celebrate Walker's legacy in Indianapolis, including the production of documentaries to debut on the Public Broadcasting Service.[35] Part of the Walker renaissance took place in the cultural events in the city, including when Alex Haley and descendant A'Lelia P. Bundles, a media scholar and historian, together visited the Indiana Historical Society in 1983.[36] These projects kept Walker's public memory alive, maintained the relevancy of the multiyear endeavor, and allowed the ULC to receive millions in federal funding. By the grand reopening, the ULC reportedly had received $3.5 million dollars in public funding from the Economic Development Administration in the US Department of Commerce, the City of Indianapolis Community Development Block, the Division of Historic Preservation in the Indiana Department of National Resources, and a host of local charities like the Junior League of Indianapolis and The Coalition of 100 Black Women.[37]

The ULC also relied on collaborations with state institutions to sustain their momentum throughout the mid-1980s. In addition to gaining the support of the Indiana Historical Society's executive director as a new member of the ULC Board of Directors in 1984, the ULC partnered with the Indiana State Museum to promote Walker's public memory. Reynolds, Walker's secretary, was featured as a speaker in the museum's exhibition *Achievers against the Odds: Storytellers of the Black Experience*.[38] As a public memory crafter, Reynolds often discussed her experience working with the businesswoman, which began when she was sixteen in 1914 and went until Walker's death just five years later. Her continued presence at the Walker Manufacturing Company for sixty-eight years was valued by the ULC and fundamental to its public programming, fundraising efforts, and community engagement.

The successful completion of the fourth-floor renovations in 1984, which included the "Casino Ballroom and Lounge," was a significant marker of the ULC's progress, prompting the Historic Landmarks Foundation of Indiana to honor its legacy work with the 1985 Historic Preservation Award for Adaptive Use.[39] The ULC's largest celebration, however, was reopening the Walker Theatre in October 1988. Characterized as the "the crowning

FIGURE 21. Members of the Madam Walker Urban Life Center, including memorializers Violet Reynolds and Kenneth Morgan (left) standing in front of the development plans for the Madam C. J. Walker Theatre in July 1983. Indianapolis Recorder Collection, Indiana Historical Society.

achievement of the building's renovation," the rededication ceremony of the Walker Theatre was a star-studded event. *Jet* reported that "search lights crisscrossed the sky, celebrities in stretch limousines pulled up for the grand reopening as hundreds outside craned their necks to catch a glimpse of the stars," including Alex Haley, Gregory Hines, Roscoe Lee Brown, and Isaac Hayes.[40] Hayes remarked, "It's hard to describe the feeling you get when you think about all the greats who have performed here. . . . And the fact that it was founded by a black woman is just the greatest thing in the world."[41] The celebrity endorsement of the theatre and the significance of Madam Walker's legacy resonated with African Americans across the nation, as well as with several donors who made "an additional corporate pledge of $325,000."[42]

The culmination of the theater, ballroom, memorial room, and office space at the center of Walker's memorialization in the 1980s has manifested into a one-of-a-kind commemoration of an African American woman, maintaining its multifaceted relevance even in the twenty-first century. At

the theatre opening, executive director Josephine Weathers proclaimed, "It was unheard of for a black woman, or woman of any race, to achieve the level of prominence she [Walker] did."[43] Walker's grand achievements, business acumen, and ingenuity in providing a leisure space for African American joy and pleasure embedded her into the Indianapolis community irrevocably.[44] The Walker Theatre provided an intimate connection with Black culture from the Great Depression through the civil rights movement as "an oasis for escape" for generations of Black patrons. And as the only remaining Black-owned business on Indiana Avenue, the Walker Theatre is a distinct economic, social, and cultural center.

Following the 1988 gala, the Walker Theatre launched "Freedom: A Lens on Black America and the Third World," a weeklong film festival that incorporated a variety of themes of African American history. By including films like *Buck and the Preacher*, *Mandela*, *Men of Bronze*, and *Cry Freedom*, along with Julie Dash's *Four Women* and *Illusions*, which was followed by the panel "Black Women Filmmakers Explore Artistic Freedom," the event showcased the wide scope of Black history as well as the importance of having a public history site as a safe space for scholarly and community exploration.

Debuting at the film festival was Stanley Nelson's *Two Dollars and a Dream*, a documentary about Walker herself.[45] This film by Nelson and his sister Jill was a continuation of the close and longstanding working relationship between the Walker and Ransom families. Both their father and grandfather, Willard and Freeman Ransom, respectively, worked for the Walker Manufacturing Company, which paralleled the siblings' memorialization efforts. Freeman B. Ransom, general counsel and manager of the company, had a dynamic working relationship with Walker during her lifetime, and he continued to work for the company for almost forty years after her death. His son, Willard B. Ransom, also worked as a lawyer and went on to help kick off the work of the Madam Walker ULC, serving as an inaugural board member. The legacy work of the Ransom family and other memorializers enabled the Walker Theatre to evoke a culture of recognition among Black business owners and supporters of Black economic empowerment that was broader than that of clubwomen and their namesakes. The ability of the ULC to utilize urban renewal efforts—that in most instances dismantled Black communities—was central to its success in preserving the Walker Theatre.

Though the ULC achieved revitalizing the iconic building, it was less impactful in shifting the Black economic structure of Indiana Avenue. Unlike the ULC, many revitalization projects on the avenue did not have access to the multimillion-dollar capital necessary for major renovations.

And even a new generation of potential entrepreneurs still faced a divergent market of African American patrons. Determined to maintain the inertia that the ULC had sparked, Charles Blair and Kenny Morgan went on to lead the Business Opportunity Systems (BOS) initiative as another pathway to stimulate the Black economy in Indianapolis.[46] Blair, who founded BOS, explained that the company was established "as a companion piece to the Center . . . to ensure jobs for Blacks . . . to make sure that Blacks got a piece of the Indiana Avenue pie."[47] But the Walker Theatre's role as a beacon of urban renewal that benefited African Americans began waning in the 1990s. The ULC's dual purpose in promoting economic development and Walker's legacy slowly shifted to mainly focus on memorialization.

By 1998, the organization had changed its name to the Madam Walker Theatre Center. Its name change reflected a new era of Walker's memorialization in Indiana and beyond. Her business memorial brand had remained prominent, leading to her induction into the Junior Achievement National Business Hall of Fame several years earlier.[48] In January 1998, Walker became a part of the US Postal Service's Black Heritage Series as the twenty-first figure in its commemorative project (Harriet Tubman was the first honored in the series in 1978), the growing reach of her national legacy grounded always in her memorial presence in the Indianapolis landmark.[49]

By the twenty-first century, Walker's public memory and commemoration had invigorated two decades of historic projects and organizations, such as the Indiana Historical Society's expansion of its archives and publications documenting the African American experience in the state. While this growth did not in turn stimulate Black economic empowerment through the urban renewal of Indiana Avenue, it did manifest in a new robust field of Indiana African American history, with archival collections like "Black Women In the Middle West" and several public documentaries, including *Indiana Avenue: Street of Dreams*.[50] As a performing arts center, the Walker Theatre has also carried on the musical legacy of jazz on Indiana Avenue, which at one time had "25 jazz clubs in a four-block area."[51]

As a descendant memorializer, A'Lelia Walker, Madam Walker's daughter, created the iconic focal point of Indiana Avenue, which has been an economic and cultural embodiment of her mother's public legacy for much of the twentieth century. Madam Walker's great-great granddaughter A'Lelia Bundles has also been an instrumental descendant memorializer and prominent public memory crafter for the last several decades. Bundles's 2001 *On Her Own Ground: The Life and Times of Madam C. J. Walker* was "the first comprehensive biography of Walker." In addition to her scholarly publications on Walker, Bundles has continued to champion the efforts of her foremother's memorialization in Indiana and beyond, magnifying Walker's

legacy to the world through highly visible productions, from Netflix's *Self Made: Inspired by the Life of Madam C. J. Walker* (2020) to Mattel's Madam C. J. Walker Barbie (2022) from their Inspiring Women Series.[52] Bundles's eloquence and tenacious commitment to excellence have both kept Walker's public memory relevant and amplified her name recognition.

In October 2023, A'Lelia Bundles joined the center's executive leadership in the Madam Walker Memorial Way street dedication and has contributed to future plans at the center. Following a period of renovation that had begun in 2018 with $15.3 million dollars from the Lilly Foundation, the organization changed its name to the Madam Walker Legacy Center, with the mission of "ensuring that the significance of Madam CJ Walker, Indiana Avenue, and African American cultural arts are not forgotten."[53] The newly announced development strategy furthers this vision, with plans for creating a rooftop event space by the 2027 centennial anniversary of the building, once again reflecting its role "as the anchor of a revitalized Indiana Avenue Cultural District."[54]

The Madam Walker Legacy Center is the only public history site in the United States centered around an African American woman's legacy that simultaneously promotes economic empowerment, performing arts, community collaboration, and African American cultural heritage. Mary McLeod Bethune proclaimed that Walker "was the clearest demonstration I know of a Negro woman's ability recorded in history. . . . She has gone, but her work still lives, and shall live as an inspiration, to not only her race, but to the world."[55] A century after Madam C. J. Walker's death, Bethune's words remain true.

CHAPTER 8

The Charlotte Hawkins Brown Site
State-Funded Memorialization

As part of the United States bicentennial celebration in 1976, the Association for the Study of Afro-American Life and History launched the National Historical Marker project "To Look Back to Heritage, To Evaluate Today, and To Assess Potential for Tomorrow."[1] Akin to grave site markers donned with "an ebony bronze plaque, depicting the head of an Afro-American looking appropriately 'forward and backward,'" the nearly one hundred memorials were placed in every region of the nation.[2] One such marker was placed at the grave site of North Carolina education activist Charlotte Hawkins Brown on the campus of Palmer Memorial Institute (PMI) in rural Sedalia. Brown's marker was among approximately 80 percent of the memorials placed in the South and approximately 5 percent of the memorials of women.[3]

The large percentage of southern memorials aligns with there being more traditional public history sites in the South honoring African American women than in any other region of the United States. The vast underrepresentation of women among the most notable African Americans is not surprising, given the national context of traditional memorialization in the 1970s. What *was* quite remarkable is that Brown's memorialization in the 1980s became the first and only time in United States history that a state has fully funded the establishment and ongoing operations of an African American woman's public history site. North Carolina remains a frontrunner in this respect. To date, the Charlotte Hawkins Brown Museum is the only historic site of an African American and a woman among the North Carolina State Historic Sites, the state's preservation agency.

Charlotte Eugenia Hawkins Brown was born on June 11, 1883, in Henderson, North Carolina.[4] At seven, she moved with her family to Cambridge,

Massachusetts, and continued her education through the State Normal School in Salem. Upon graduating in 1901, Brown began teaching African American children in rural Sedalia, North Carolina, through a job with the American Missionary Association. Fifty children from all over Guilford County packed into a tiny, dilapidated church house to attend school. Brown made an indelible mark on the lives of her students, often spending her own salary on school supplies and clothing. When the missionary association decided to defund Brown's school, local parents and community members convinced her to remain in Sedalia and open another school. Her decision to stay transformed her life and those of several generations influenced by her lifelong commitment to education and philanthropy.

In 1902, Brown opened the Alice Freeman Palmer Memorial Institute with fifteen acres of community-donated land and a building. The school's namesake had funded Brown's education at the State Normal School, and Brown was able to garner donations in Freeman's honor after her benefactor's death. Brown was exceedingly adept at raising money for Palmer Institute over her fifty-year career as an educator and administrator. She modeled and publicized Palmer as a vocational school similar to Booker T. Washington's Tuskegee Institute as a strategy to receive White philanthropic donations. Though funding was always an issue, Brown's strategy was successful. She maintained and expanded Palmer Institute from just one building in 1902 to an entire campus complete with a dining hall, student dormitories, teacher cottages, an athletic field, and several classroom buildings by the 1940s.

Brown's educational leadership made her a mentor to generations of educators and "an important force in developing black education in North Carolina." She helped to establish the North Carolina Teachers Association and served as the organization's president and vice president in the 1930s.[5] Her etiquette book, *The Correct Thing to Do—to Say—to Wear* (1941), reflected her own impeccable style and insistence on good manners. Instilling strict behavioral expectations was a means to help students navigate through the social and class barriers as well as to protect them from the violent realities of the Jim Crow era. According to Carolyn Denard, *The Correct Thing* "became the bible of manners for generations of students at Palmer Institute and became the primer for African American youth at other schools who wanted to behave properly."[6]

Brown was married in 1911 to Edward Brown and, in 1923, to John W. Moses, but she lived most of her life as a single woman. Though she gave birth to no children of her own, she raised several nieces and nephews and became the surrogate mother to many of her young students who lived on campus. Her dedication to the African American community extended into

her prominence in the national women's club movement. After helping establish the North Carolina State Federation of Negro Women's Clubs in 1909, Brown was so beloved and efficient that she was elected president for over two decades. She collaborated with other nationally known clubwomen and memorializers, including Mary Church Terrell and Mary McLeod Bethune, as she toured the country giving lectures and raising money for African American philanthropic causes. Like her contemporaries, Brown used her national platform as a social and political education activist to provide African American youth with quality educational opportunities. When Brown died in January 1961, she was buried on the Palmer Memorial Institute campus beside her home, known as Canary Cottage.[7]

The public legacies of Charlotte Hawkins Brown and PMI are intertwined. Brown lived on the PMI campus along with students and faculty. PMI stayed open for ten years after Brown's death, but the absence of her deft ability to secure the finances needed to maintain the school left an already strained budget impossible to maintain. When the school closed in 1971, alumni and locals alike were dismayed to see the school in ruins. Alumnus Elworth Smith attributed the school's closing as "ultimately a casualty of integration" after "more and more educational opportunities became available to blacks" in the mid-twentieth century. PMI's last president, Charles W. Bundridge, expressed "deep sadness" at seeing the once-thriving school, where he had spent seventeen years of his career, "vacant, idle, useless and a magnet for vandals who seem intent on tearing it down."[8] In the decade that the school had sat empty and in disrepair, attempts by Bundridge and nearby Bennett College, which became the owner of the campus, to secure state or federal funds to rehabilitate the property and use it for other educational purposes were unsuccessful. Unable to care for the property, Bennett College sold the campus in 1980 to the American Muslim Mission to open a teacher college.[9]

Even while the school was not operational, PMI alumni and former faculty annually visited Brown's grave site to celebrate her legacy throughout the 1970s. Bethany United Church of Christ, a de facto part of campus across the street, hosted a "special program" to commemorate Brown's birthday. Attendees would "recount memories . . . and listen to music that she [Brown] enjoyed" at a program that consisted of "reading different excerpts from old activity books, singing of the Palmer alma mater, scripture readings, two solo songs and placing of wreaths on Brown's grave."[10] These grave site ceremonies not only promoted Brown's public memory, but they became the precursor to establishing a distinct traditional memorial.

Memorializers Marie Gibbs and Maria Cole, who was Brown's niece and wife of pioneering African American entertainer Nat King Cole, were

leaders in her commemoration. Cole, raised by Brown at PMI, maintained her friendship with Gibbs, who she had met as a student. When the duo visited Brown's grave in 1982, they were dismayed to see the site surrounded by overgrown "crabgrass and weeds."[11] Even after Bennett College's transfer of the property to the American Muslim Mission, the campus remained uncared for and empty. Cole in particular "became very intent that something should be done to make Dr. Hawkins' grave and homeplace a historic site," and she and Gibbs "were determined not to let Dr. Brown's accomplishments go unrecognized."[12]

In solidarity with Maria Cole, Gibbs began to solicit support from PMI alumni, who came together in 1983 to form the Charlotte Hawkins Brown Historical Foundation (CHBHF), "a memorial to the dreams, the life, and the works of Dr. Charlotte Hawkins Brown."[13] Cole and Brown's other niece, Charlotte Hawkins Sullivan, were named honorary chairpersons. African American scholars, including John Hope Franklin, Maya Angelou, Lerone Bennett Jr., and A'Lelia Bundles, served on the CHBHF Advisory Council.[14] While the coalition of supporters bolstered the visibility of their legacy work, Cole and Gibbs as memorializers knew they needed major financial funding to restore PMI's large campus and fulfill their greater goal of commemorating Brown.

The fruitful fundraising campaign that ensued certainly evoked Brown's legacy. As a school in the Jim Crow South, PMI had received limited financial support from the state, which left Brown to constantly raise money to maintain and expand the operations of the school. Vina Wadlington Webb recalled praying for Dr. Brown's fundraising trips. She and her classmates "would write letters and pray over them. Oh, how we would pray! I remember how proud I was when I got my first five dollars."[15] The spirit and ingenuity of their efforts as students fueled the nationwide network of PMI alumni to develop a substantial private fund for commemorating Brown and the campus. As one alum noted, "The support groups want to raise funds for the development of the site, but we also want to celebrate black history."[16] Most of the PMI alumni had witnessed Brown's nationally recognized achievements and understood that her legacy was significant beyond the histories of African Americans in North Carolina.

The enthusiastic support of alumni undergirded the early efforts of the CHBHF. But as African American preservationists, the organization recognized that for the longevity of the site, it had to be sustained by more than private donations from alumni. The CHBHF garnered public funding from the state with the help of North Carolina senator William "Bill" Martin.[17] As the only African American in the senate, freshman Senator Martin prioritized galvanizing political support to fund the creation of the

FIGURE 22. Maria Cole, the niece of Charlotte Hawkins Brown who helped catalyze the educator's memorialization, stands at Brown's grave site in the 1980s. Charlotte Hawkins Brown Museum Records, North Carolina Historic Sites.

Charlotte Hawkins Brown Memorial Site.[18] He collaborated with North Carolina representative Henry McKinley "Mickey" Michaux Jr., a PMI alum, to gain support for state appropriations.[19] Their advocacy infused the CHBHF's commemorative efforts very early in the process of funding its vision. Because of Martin's efforts—just a year after Cole and Gibbs began their campaign to preserve Brown's legacy—the North Carolina General Assembly appropriated $67,377 to research the histories of Brown and

PMI and develop plans for site preservation.[20] Both Martin and Michaux continued to collaborate with the CHBHF as its primary advocates for state funding throughout the rest of their tenure in the general assembly.[21]

Memorializers in the CHBHF and the PMI alumni network strengthened statewide support for Brown's commemoration. Project director Annette Gibbs explained, "We plan to tell the overall history of North Carolina's black cities; to cover all geographical areas as it pertains to that story."[22] To solicit social and financial support for the memorial site, the CHBHF launched the inaugural Black History Commemorative Banquet in February 1984. The fundraising event featured an exhibition of Brown that emphasized "the role of education as a factor in the development of the culture and history" of North Carolina.[23] Brown's memorialization being tied to the preservation of the PMI campus provided a distinct opportunity to showcase the history of African American education.[24]

That same year, Governor James B. Hunt, Jr. officially designated June 11, Brown's birthday, as "Dr. Charlotte Hawkins Brown Day."[25] The annual "Community Memorial Service" began across the street from the PMI campus at Bethany United Church of Christ and ended with a processional to Brown's grave site near her campus home. There, a ceremonial wreath was placed as those gathered shared "memories of Dr. Brown and her favorite music." The surrounding community remained committed to commemorating Brown because of the impact of her legacy on several generations of local residents. Involving Sedalia organizations and the nearby Greensboro's historically Black colleges and universities, Bennett College and North Carolina Agricultural and Technical (A&T) State University, only increased excitement for the site's establishment and reinforced the already robust network of support for Brown's memorialization.

The political support of Bill Martin and Mickey Michaux was essential to the success of the CHBHF. It supported the legislators' internal efforts to sponsor and pass bills for the site by recruiting other members of the North Carolina General Assembly to their cause. In addition to conducting "mailings and phone calls" to state legislators, the CHBHF collaborated with the North Carolina Department of Cultural Resources to provide them with an "exhibit, open house and sumptuous reception," where the memorializers lobbied for their backing. In 1985 and 1986, the general assembly appropriated an additional $250,000 and $417,000, respectively, for "site acquisition and initial stabilization."[26]

In the interim of raising social, financial, and political support for Brown's memorial, the Muhammad Mosque No. 2, Inc., which operated under Imam Sidney Sharif's leadership, had purchased PMI to establish the American Muslim Teacher College (AMTC), a religious college to

train Black teachers for the Nation of Islam's Clara Muhammad Schools.[27] Though the mosque's goal of establishing AMTC proved unsuccessful, it also meant that PMI alumni were able to reclaim the campus through the CHBHF and the appropriations from the state legislature. The memorializers conveyed that their negotiations with the "American Muslims" for the forty-acre campus "were very 'sketchy' at times" and "progressed slowly."[28] Indeed, it took two years for the final sale to be completed, which delayed the site opening by several months.[29] Even after the final acquisition of the property, Imam Sharif maintained his support of the site's development.[30] Both organizations sought to revitalize the African American educational impact of the campus as a living homage to Charlotte Hawkins Brown. Ultimately, the ability of the CHBHF to acquire public funding made the vision a long-term solution for its memorialization goals.

With the appropriations from the mid-1980s, the CHBHF and the North Carolina Department of Cultural Resources purchased the forty acres comprising the PMI campus.[31] In addition to Canary Cottage, the campus consisted of over ten extant buildings, including student dormitories, faculty housing, classrooms, the dining hall, and the Tea House, or the student canteen. The Teacher's Cottage next to Brown's home was transformed into a "Visitors' Center with exhibits, a viewing room, and gift shop."[32] Other preserved areas on the campus include Brown's grave site and meditation altar, along with the multipurpose athletic field where the fifty-five-thousand-gallon and five-hundred-foot-high water tower bearing "Palmer Memorial Institute" can be seen from miles away.[33]

While the CHBHF was able to establish the memorial with funding from the state, their continued partnership meant the foundation was beholden to the ebbs and flows of the political system. One member explained, "We have always been a little uncertain about when it [additional funding] would happen."[34] For instance, the initial memorial plans outlined in a $1.5 million budget had to be recalculated for the public funding received from the North Carolina General Assembly. Undeterred by the necessary adjustments, Annette Gibbs maintained, "We're glad to get what we can and every penny will go to good use."[35]

During the multiyear process of site acquisition and development in the mid-1980s, the CHBHF maintained its memorialization momentum by hosting events such as their annual Black history banquet, the "Black Folk Heritage Tour," and the Black History Awareness Conference, which was sponsored in collaboration with the North Carolina Department of Cultural Resources.[36] Widespread participation and positive press for each cultural event encouraged members to continue pushing to make their memorial vision a reality.[37]

From the start, Marie Gibbs, like others in the CHBHF, had been "wait-ing, wishing, dreaming," about Brown and PMI's memorialization.[38] Gibbs was instrumental in these efforts, setting "in motion a movement and endeavor." Besides championing her legacy work, for which "the hours were never too long, the personal sacrifices were never too great, the obstacles were never believed to be insurmountable," the CHBHF declared that "because of her efforts, North Carolina is a better State, America will be a better nation."[39] When Gibbs died the year before the site opened, the members of the foundation were deeply saddened and challenged "to con-tinue with the same fervor and persistence that were her trademarks."[40] With her daughter, Annette Gibbs, working as her successor, the CHBHF did indeed persist with their memorialization of Brown.

On the afternoon of November 7, 1987, the Charlotte Hawkins Brown Memorial State Historical Site was dedicated on the front lawn of PMI. The nexus of Brown's educational memorial brand was "to preserve Palmer Memorial Institute as a memorial to Dr. Charlotte Hawkins Brown."[41] Though the CHBHF named and dedicated the site for Brown instead of PMI, the memorializers irrevocably tied their legacies together as exemplars of Black educational excellence. The foundation's mission of "Promoting and Preserving North Carolina's Proud Heritage of Black History and Edu-cation" was exemplified in its establishment of the first and only memorial of a woman and of an African American in the state.[42]

The fall site dedication was so well attended that there was a "standing-room only crowd," many of them enthusiastic PMI alumni. In addition to the members of the CHBHF, celebrities, including Alex Haley, and elected officials were present.[43] "The one thing that's certain is Charlotte Hawkins Brown is smiling down at the proceedings here today," declared Lieutenant Governor Robert "Bob" Jordan.[44] Renowned historian John Hope Franklin, serving as the keynote speaker, was followed by a medley performance of Brown's favorite spirituals.[45] As Representative Michaux recited the "Palmer Creed" during his speech, "the well-dressed crowd of Palmerites" joined in with nostalgic zeal.[46] After "the ribbon-cutting ceremony," guests were ush-ered into a reception at the dining hall and offered tours of Brown's Canary Cottage. The opening of the Charlotte Hawkins Brown Memorial State Historic Site was a major event that caught the attention of the national Black press. *Jet* featured the dedication in their "Society World: Cocktail Chitchat" section, noting, "This is North Carolina's first state-owned and state-operated site devoted to a Black and a female," a fact that remains true in the twenty-first century.[47]

The Brown Memorial dedication displayed the CHBHF's effective public fundraising efforts, which opened up a new source of private funding from

FIGURE 23. This historical maker is located at the Charlotte Hawkins Brown Museum in Sedalia, North Carolina. Photo by A. Russell, 2021.

corporations like the Z. Smith Reynolds Foundation and RJR Nabisco, which gave thousands to the site in 1988.[48] Local public schools Sedalia Elementary School and Greensboro Day School also donated the same year, raising $150 and $342.50, respectively, for the memorial site.[49]

The ongoing support of North Carolinians also contributed to the CHB-HF's favorable outcome of lobbying to the state's transportation board for the renaming of the highway stretching in front of the site.[50] In April 1988, the Charlotte Hawkins Brown Memorial Highway, a five-mile section of US 70, was established as a named memorial. At the dedication ceremony, Governor James Martin proclaimed, "Indeed, it is fitting and proper" that Brown, a "Leader. Champion of the disadvantaged. Mentor. Inspirer of youth. Visionary. A woman of undaunted faith," have the highway named in her honor.[51] Martin pledged continued public funding for the restoration of and maintenance of the site. Congressman Howard Coble, a Republican representative from North Carolina, read these remarks: "This is a truly fitting tribute [of Brown's] lifelong dedication and devotion to educating black children of Sedalia and eastern Guilford County," a statement made

on behalf of "President Ronald Reagan expressing his regrets that he and his wife, Nancy," were not at the ceremony.[52] The bipartisan support for Brown's memorial that began in 1983 in the general assembly had grown substantially over the five years to solicit the public support of the highest elected official in the nation. Brown's educational memorial brand made politicians amenable to heralding her virtue while posturing North Carolina as a leader in promoting the significance of African American public history.

Working closely with the Department of Cultural Resources, the CHBHF employed Brown's memorialization as a conduit to disseminate scholarly discussions of the Black past. During Black History Month, they offered free programming at the site to create a major hub of activity. Events such as a "Black crafts exhibit," a "seminar on black business," a discussion on "Blacks in politics," and an essay contest attracted church, student, and family groups from all over the state.[53] On the one-year anniversary of the site's opening, in November 1988, the CHBHF debuted their first annual African American Heritage Festival, "Preserving Black History in North Carolina."[54] Memorializer Annette Gibbs promoted the event by publicizing that representatives from African American historical organizations would be present at the festival to educate audiences, appearing along with "living history presentations" and historian John Hope Franklin.[55]

The CHBHF also offered free public programs to emphasize the Brown Memorial Site as the only state-funded site commemorating an African American and a woman. Its African American Heritage Festival served as a means to promote a race and gender consciousness in ninth- and tenth-grade girls through the "Seminar for Minority Teen Women."[56] In addition to enjoying the festival, the girls were taught leadership skills needed for different career paths while parents were offered a workshop about college admissions and financial aid.[57] The CHBHF used this seminar—and other programs, such as etiquette classes—as "one way in which [they brought] to light the aims and objectives Dr. Brown had for education."[58]

Brown's memorial brand was a historical symbol that garnered substantial funding, and her memorializers were so effective in trumpeting her public memory that any attempt to tarnish her legacy was squelched. In her April 1993 article "Skin-Tone Biases Survive from Antebellum Period," *Greensboro News and Record* staff writer Robin Adams claimed Brown was a colorist:

"In the early part of the 20th century, Sedalia's Palmer Institute denied admission to dark-skinned black people. Founder Charlotte Hawkins Brown thought it best if her students had a white ancestor or two in the family."[59] Besides the claim having no substantial evidence for support, it also cast a disparaging elitism on Brown and her memorializers. To make matters worse, an editorial from Michael Robinson, who had previously

admired Brown, found her "evidently an ignorant, uppity, hypocritical, bigoted, educated fool," having read Adams's article a week earlier.[60]

These egregious claims of Brown's so-called discrimination had not surfaced before or during the decade of legacy work that resulted in the state memorial, which, had they, might have negatively affected the CHBHF's fundraising efforts. In the early 1990s, ongoing sustainability funding was at stake. Memorial site manager Jeanne Lanier Rudd and historian Charles Wadelington quickly organized to publicly repudiate Adams's article. "Highly disturbed," Rudd wrote to the editor of the *Greensboro News and Record* requesting that the newspaper print a retraction and reveal the source of Adams's claims in her "article containing such derogatory comments" about the "honored and respected" Brown.[61] Outraged PMI alumni, including Thomas Drexel and Richard Skeete Jr., expressed they were "surprised and disturbed" and that "such inflammatory, irresponsible reporting is blatantly reprehensible!"[62] Their collective outrage was rooted in not only the fallacy of the claims but also the potential of tarnishing the symbolism of the Brown Memorial Site.

The newspaper did not publish a retraction. However, it did publish responses to Adams's article leading up to its editorial printed on May 15, 1993, "Palmer Institute Didn't Discriminate against Some Blacks," which featured an "Editor's Note" revealing Adams's source (a misquoted book) and vehement letters from Frances Crump, Richard Skeete Jr., and Jeanne Lanier Rudd.[63] Crump, who wrote that she was a "dark-skinned female" and never faced discrimination at school, invited Adams to come to PMI's alumni weekend to be educated and enlightened about Brown and her institution. Skeete explained that PMI students, who "came from the islands, Africa, and at least 23 states," had been empowered by Brown, who used her "blackness to motivate, mold and challenge those with whom she came in contact," while Rudd highlighted that there was "no historical evidence to support Adams' unfortunate statement."[64]

Days later, in a Department of Cultural Resources letter entitled "Justice Sought for Dr. Brown," Wadelington declared: "The good news is that the harm done to Dr. Brown's reputation by Adams' article is not permanent because the stature, esteem, and prestige of such a positive black role model cannot be blemished long by such blunderous remarks."[65] The swift efforts to preserve the sanctity of Brown's public memory demonstrate how valuable her symbolism was in creating the memorial site, which just a few years after opening became the largest and most visited African American site in North Carolina.[66]

Much of the continued success of Brown's memorial has been attained through the ongoing support of PMI alumni and former faculty. Oral

FIGURE 24. The Charlotte Hawkins Brown Museum is preserved on the campus of Palmer Memorial Institute, as depicted on this illustrated map. Brown's home, Canary Cottage, is in the front center of the map. Charlotte Hawkins Brown Museum Records, North Carolina Historic Sites.

histories from affiliates like Charlotte Hawkins Sullivan, Brown's niece, and Ruth Totton, once a teacher at PMI and a CHBHF historian, were used to restore the features of the campus to their former glory.[67] Totten recalled "lamps, the piano, the paint schemes of the walls," and "the mirror" in which Brown used to check her appearance before leaving her home, Canary Cottage, where she hosted guests, who included Eleanor Roosevelt.[68] Since many of Brown's furnishings had been distributed to family and friends after her death, Totton and the vast networks of family, alumni, and former faculty were instrumental in recreating the house as it was during Brown's life.[69] In preparation for the 2002 centennial anniversary of PMI's founding, Canary Cottage was revamped for the Black History Month celebration.[70]

Connecting scholars and community members through programming that promotes Brown's legacy and African American education remains central to the activities of the site in the modern day. While the CHBHF was enormously successful in its legacy work, it was not without limitations. The foundation, like other African American organizations in the late twentieth century, benefited from access to local, state, and federal preservation funding that supported their memorialization plans. Though the CHBHF deftly parlayed their political capital into establishing a lasting state-funded memorial, it was also subject to the whims of election cycles, appropriations, and the power of public opinion. Still, Brown's memorial brand as an education activist is so compelling that bipartisan support has never been an obstacle.

Preserving an entire campus in honor of Brown remains a distinct memorialization, but the colossal feat also illustrates the power of African American women memorials in shaping public memory in southern landscapes. Ironically, the continuous communication over the last thirty years about the Brown Memorial Site being the first and only North Carolina State Historic Site of an African American and a woman has perhaps prevented the inclusion of any additional such state-funded sites.[71]

The CHBHF's limitations also show up in its preservation efforts, as not all the PMI buildings could be restored to their former utility like Canary Cottage has been. In 2022, its campus buildings were listed on the National Trust for Historic Preservation's "Most Endangered Historic Places."[72] With this designation comes considerable funding to preserve and update the internal structures of the former dormitory and classroom buildings for eventual use by the local community. The Charlotte Hawkins Brown Museum Operation Revitalization serves as the latest impetus for educating African American youth that began over a century ago with a one-room schoolhouse in Sedalia, North Carolina.

TABLE 8.1. North Carolina General Assembly Appropriations for the Charlotte Hawkins Brown Site from 1983 to 1991

Year	Description of appropriation use	Amount (US$)
1983	Original planning	67,377
1985	Operating expenses	250,000
1986	Land purchase	417,000
1988	Capital improvement planning	50,000
1989	Site improvement funds	482,000
1991	Annual operating budget	158,000
Total		1,424,377

Source: *Charlotte Hawkins Brown Historical Foundation, Inc., Newsletter,* vol. 1, no. 1 (August 1991)

TABLE 8.2. Private and Additional State Funding for the Charlotte Hawkins Brown Site as of 1991

Organization	Funding use description	Amount (US$)
Z. Smith Reynolds Foundation	Operations	50,000
A. J. Fletcher Foundation	Marketing	10,000
NC General Assembly	At Risk Youth Program	11,000
RJR Nabisco	Annual banquet support	5,000
PMI National Alumni	Canary Cottage	1,000
Fund raising and small grants		30,000
Total		107,000

Source: *Charlotte Hawkins Brown Historical Foundation, Inc., Newsletter*, vol. 1, no. 1 (August 1991)

CHAPTER 9

Celia Mann, Modjeska Simkins, and Historic Columbia

Reimagining House Museums in the Twenty-First Century

At the time the National Historical Preservation Act of 1966 was signed into law, the Harriet Tubman Home (Auburn, NY) and the Mary McLeod Bethune Foundation Home (Daytona Beach, FL) were the only two house museums of African American women in the United States. They were sustained by internal community resources like most other local preservation efforts across the nation.[1] The Historical Preservation Act and the seminal commissioned report *With Heritage So Rich* opened a new avenue of public support despite the conspicuous lack of any mention of African American site preservation.[2] Pioneering African American public historians saw the new preservation and civil rights legislation of the 1960s as an opportunity to preserve and disseminate the Black past using public funding. Within a decade, their efforts had made the Maggie Lena Walker Home in Richmond, Virginia, the first National Park Service Historic Site of an African American woman. Its inclusion on the National Register of Historic Places reverberated across the United States, helping to more widely establish the house museum—a home transformed into an interpretive space to disseminate historical knowledge to the public—as a traditional memorial venue for African American women in the mid- to late twentieth century.

As named memorials of settlement houses, like the Phillis Wheatley Home, began to decline in popularity, house museums were adopted as a new way to cultivate safe community spaces and craft the public memory of African American women. Establishing house museums as venues of memorialization was a strategy used by memorializers in Black communities to save homes, often threatened by urban renewal, as well as to provide new opportunities for the dissemination of Black history. Public historian

Kenneth Turino asserts that in the twenty-first century "there is a loud call now for reinventing the house museum, to do away with velvet rope tours, make them less static and more a vital part of their community."[3] Innovative house museums like the (Celia) Mann-Simons Cottage and the Modjeska Monteith Simkins Home in the capital of South Carolina have maintained community connections since their intellectual conception and continue to propel the venue through the twenty-first century with modern interpretations of memorialization.

Until 2015, Columbia was enlisted in a half-century debate over the removal of the Confederate flag from the grounds of the South Carolina State House. Just a mile north from the contested space are two house museums centered around the legacies of African American women that commemorate the Black experience from the antebellum era to the civil rights movement.[4] By centering African American women in these traditional public history sites, the memorializers highlight the women's distinct racialized and gendered experiences and provide visitors with a powerful lens for understanding the complexity of African American history. Past and renewed efforts of local African American preservation groups, paired with Historic Columbia's commitment to Black public history, have driven the memorialization of women in Columbia, making it the southern city that contains the greatest number of traditional memorials of African American women in the nation.

Saving Celia Mann's home, which was under threat of demolition in the 1970s, was the first major push to establish a traditional memorial in Columbia. Family oral histories have provided much of what is known about Mann's early life. Even with new archival discoveries, much of the detail of her enslavement and emancipation remains unknown. Born in 1799, Celia Mann reportedly walked herself out of enslavement in Charleston, South Carolina, to freedom in Columbia by the 1830s. The matriarch of her family, she was said to have journeyed on foot for over one hundred miles to create a new life for herself and her children. She married Benjamin Delane and lived with him in Columbia as early as 1837. The couple acquired property at 1901 Richland Street and had four daughters. Three of their children—Dinah Collins, Julia Ann McMellen, and Nancy Smith—moved to Boston, while Agnes Jackson remained in Columbia, living with them at their Richland Street home.[5] Celia Mann had a notable community presence as an esteemed midwife and a founding member of Calvary Baptist Church, one of the first African American churches in the city. The *Daily Phoenix* describes her as a "respected colored" woman and nurse who "was present at the birth of many of our citizens."[6] Mann's life as a health care provider and property owner in the antebellum era made

her a part of the small free, Black middleclass population in South Carolina. She was highly regarded as a woman of faith who demonstrated the possibilities of Black social and economic mobility within the constrained social structure in which she had once been enslaved.[7]

After Mann's death in September 1867, her daughter Agnes Jackson inherited a block of land and property assets in downtown Columbia.[8] Jackson's sons John, Thomas, and Charles Simons were prominent religious and fraternal leaders whose entrepreneurial pursuits made them well respected. The brothers expanded the real estate on the property to include a lunch counter and convenience store. After Agnes's death in 1907, the Simonses' businesses ebbed and flowed, but the Richland Street home was maintained.[9] Bernice Conners, raised by Charles Simons, Celia Mann's grandson, was the last descendant to live in the home. In 1970, it was purchased by the Columbia Housing Authority for $20,000. After being acquired, the home stood unused and in disrepair. Conners recalled that the home was ransacked and the marble taken from the parlor fireplace, while an oak tree Charles had planted in the front yard was unceremoniously removed in the early 1970s. Made aware of its historic value, the Columbia Housing Authority partnered with the South Carolina Department of Archives and History to place the property on the National Register of Historic Places in 1973 and transferred the deed to the South Carolina Historic Preservation Commission.[10]

Bernice Conners and African American community advocates came together in 1975 to form the Center for the Study and Preservation of Black History, Art and Folklore (the Center) to save the family home. The Center promoted the humanities as conduits for the public to learn about the significance of Black cultural and historical experiences through its coalition of members who leveraged their influence to garner public and private resources as Black civic leaders. The group collaborated with local preservation organization Richland County Historic Preservation Commission (later renamed Historic Columbia Foundation) to discuss fundraising efforts.[11] The Center's president, Reverend I. DeQuincey Newman, represented the interests of African American constituents at planning meetings.[12] Public historian Susan Orr posits, "When a house becomes a museum its function changes from one of domesticity to one which suits the current political issues that are meaningful to those pursuing preservation."[13] Such was the case with the Center's efforts.

Celia Mann's life story was inspiring and a widely untold aspect of African American history. As the central figure of the home, Mann allowed visitors to connect her life with the history of slavery, free antebellum Black communities, and Black entrepreneurs. She was described as a "tough"

woman who was "resourceful." And her "home stands as a monument and inspiration for those who believe in the rights of individuals."[14] Mann's drive to free herself and become a midwife and property owner in the South distinguished her historical narrative from popular understandings of women's experiences. The Center's efforts as public memory crafters galvanized support around Mann's unique life story. Definitively, "the life and legacy of Celia Mann shows how one woman went from Charleston slave to Columbia landowner" and reshaped public discourse about the contours of race and gender in South Carolina history.[15]

Much like the Charlotte Hawkins Brown Historic Foundation, the Center's members recognized they needed a combination of partnerships, both private and public funding, to raise the initial $120,000 required to preserve the home.[16] The preservation group named the first African American house museum in Columbia the Mann-Simons Cottage, an acknowledgment of Celia Mann and the Simons brothers. Despite the dual named memorial, the Simons were a limited aspect of the home's historical interpretation until the 2010s. To establish a community space that would promote South Carolina's Black history statewide, the Center employed Celia Mann's story to publicize their efforts. The strategy to amplify African American women's history brought success in acquiring private and public funding from federal, state, and local bureaucracies.

Local African American organizations, including Delta Sigma Theta Sorority and First Calvary Baptist Church, contributed hundreds of dollars to the restoration.[17] Small fundraisers were also held to raise money for the site, such as a Scrabble tournament hosted by the "Friends of Mann-Simons Historical Cottage" in 1978.[18] Larger donations came from government grants and nonprofit organizations, including the South Carolina Humanities Council, United Black Fund of the Midlands, US Department of the Interior, City of Columbia Community Development Department, and South Carolina Bicentennial Commission. Just a few years after it formed, the Center had raised $90,000, but it failed to reach its goal of $120,000, which it had deemed necessary for complete renovation.[19]

Despite their $30,000 deficit, the Mann-Simons Cottage successfully opened to the public in 1978. Bernice Conner's oral histories and recollections of her uncle Charles's stories comprised the home's public narrative.[20] While archeological evidence necessitated a new interpretive plan for the site decades later, Conner's memories were essential to crafting the foundational exhibitions of the home and Celia Mann's legacy. At twenty-seven years old, the tenacious and astute CeCe Byers was selected as the museum's first executive director—and the only fulltime employee. Byers had previously worked with the National Archives and was president of the City Museum

project in Washington, DC. She had worked closely with the Center for the Study and Preservation of Black History, Art and Folklore to promote the Mann-Simons Cottage as a leader in disseminating Black history in South Carolina.

As a pathfinding African American public historian, Byers was among the first Black museum professionals in the nation. She was determined to establish the Mann-Simons Cottage as "a center for black history" in South Carolina and the nation.[21] In a 1979 interview, she stated: "The museum can function in almost any way that the community is willing to support. . . . It's not a place where you just come to see all these charming and lovely old things but rather a place where there's a lot by way of social, political, and economic discussions relating directly to historic preservation and its implications for the black community, and basically, in terms of black history . . . a resource for black history."[22]

As the only fulltime staff, Byers faced a large undertaking. She depended on volunteers to help give tours and programs while she struggled to meet budgetary demands.[23] However, Byers's efforts were not in vain. Much like the Madam Walker Theatre Center and the Charlotte Hawkins Brown Memorial State Historic Site, the Mann-Simons Cottage became the African American community's destination of choice to commemorate its cultural heritage and promote unity for the ongoing freedom struggle.

The annual Jubilee Festival, a cultural heritage block party, associated the museum's moniker with Black history in Columbia. The inaugural festival was held during the opening of the home to the public in May of 1978, a manifestation of the Center's initial conception.[24] The festival opened with a performance from the US Command 282nd Army Band followed by musical performances from the Sweet Desolation String Band and Ebenezer First Baptist Church Mass Choir. In addition to a tour of the Mann-Simons Cottage, children received free silk screen prints of animals from the Riverbanks Zoo and through other festival vendors could make craft souvenirs from quilting to Catawba pottery.[25]

Though the Jubilee Festival brought positive visibility, by the 1980s, the site had stopped operating autonomously under the Center's leadership. To sustain its operational structure with consistent funding, it was fully incorporated into the house museum cluster of Historic Columbia Foundation (HCF) as one of four historic house museums then under the local preservation organization's management.[26] HCF was established similarly to the Center in that community advocates had come together to save a historically significant house, the Robert Mills Home, from demolition in 1961. Within two decades, they had more than tripled their acquisitions and gained national notoriety. As an all-White preservation group, HCF

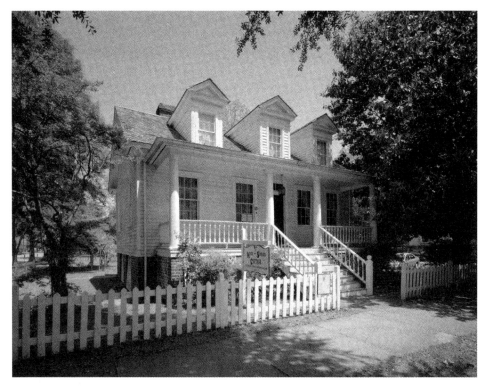

FIGURE 25. The (Celia) Mann-Simons House Museum in 1999. South Caroliniana Library, University of South Carolina, Columbia, SC.

had greater access to capital and public funding, which enabled it to build a robust infrastructure of preservation management.

The limited resources of the local African American community, a reflection of structural inequity dating back centuries, simply could not support the Center's vision. Still, its members were successful in demonstrating the historical significance and value of preserving the stories of Celia Mann and her descendants. The merger, in turn, gave HCF the opportunity to expand its traditional repertoire of histories centering all-White narratives to managing a site that specifically represented African American history and culture. Adding the Mann-Simons Cottage to the Robert Mills House, Hampton-Preston Mansion, and Woodrow Wilson Home helped HCF catalyze the growth and influence that made it a substantial "presence in preservation battles large and small."[27]

Described as a "shrine of freedom to the African American community," the site compelled the HCF to embrace the Center's vision for maintaining the space.[28] The foundation prominently advertised the annual Jubilee

Festival as an event "to honor the memory of Celia Mann and her family."[29] By the 1990s, festival celebrations had expanded to include Pan-Africanist presentations, like "African Traditions in Childbirth" and "Auset African Sisterhood." One year, there was a free screening of the Civil War film *Glory* accompanied by a reenactment troupe of the African American 54th Massachusetts Infantry central to the film's story.[30] Some years, the festival expanded to two or three days and included performances from celebrated Black organizations, such as the World Champion Double Dutch Forces. And a wide array of jazz, African, and gospel music performances were always included in the day's program.[31] An expanded musical focus in 1999 grew the block party to include the gala "Ragtime, Blues, Jazz: A Progression."[32]

By the twenty-first century, the Jubilee Festival had gained national acclaim and was featured in *Ebony* magazine's "Travel Guide" as a notable African American celebration in the United States.[33] In 2000, the "African-American Heritage Sites Tour" featuring nearby locations was developed as an activity for that year's festival but eventually became a regular tour offered by Historic Columbia.[34] Including other African American historic sites as part of the Jubilee Festival manifested in a memorialization of the "30 Most Significant African Americans in Columbia and Richland County" for the Mann-Simon Cottage's thirtieth anniversary in 2008.[35] A year later, the neighboring Modjeska Simkins house museum was added to the celebration, as well as an oral history contest.[36] Staunch in their commitment to make the Mann-Simons Cottage culturally relevant, Historic Columbia hosted public events such as the panel on "Preservation Matters: The Future of Historic African American Sites in Columbia."[37]

In addition to the Jubilee Festival, the Mann-Simons Cottage became the destination for other Black heritage events in the city. During Black History Month, the house museum was opened to the community with free tours. In 1995, the Richland County Alumnae Chapter of Delta Sigma Theta Sorority, Inc., longtime supporters of the site, hosted a Juneteenth festival. Although celebrating the emancipation of African Americans was the historical focus of the festival, a health fair and voter registration drive addressed contemporary needs of the community.[38] The Mann-Simons site and Mann's legacy became intertwined with community uplift and the celebration of Pan-Africanist heritage. For instance, the Wisteria Garden Club helped create a "medicinal and culinary herb garden in honor of the cottage's famous resident and midwife, Celia Mann" to increase the utility of the community space.[39] Like the Juneteenth festival, the garden commemorated the Black past through Celia Mann's legacy while also addressing modern-day issues relevant to African American communities.

First Calvary Baptist Church, Second Calvary Baptist Church, and Zion Baptist Church, which all grew out of the religious meetings in Mann's basement, maintained close ties to the museum. In 2002, the cohort donated $1,500 to erect the historical marker that now rests on the front lawn of the home. This public memorial made Celia Mann the first African American woman in Columbia, South Carolina, to have a historical marker erected in her honor, though 5 percent of the city's historical markers were memorials of African Americans.[40] Also new in the early 2000s was the Celia Mann Award, introduced by HCF to recognize the preservation efforts of individuals, neighborhood associations, and community organizations, like the Center for the Study and Preservation of Black History, Art and Folklore.[41]

Alongside community involvement, archaeological research brought about a new historical narrative for the site. Beginning in 1998, archaeologists Chris Clement and Mona Grunden began an archeological dig to prevent overlooking or damaging any artifacts in a new landscaping project. Their astute examination drastically reshaped the museum's historical interpretation.[42] As more evidence of the property's past was dug up, the narrative of Celia Mann shifted. Over a decade of research culminated in a 2011 publication revealing that the home in which the museum had operated since 1978 had actually been built three years after Mann's death. Mann had lived in another structure on the property that her daughter Agnes had built that predated the Mann-Simons Cottage.[43]

To incorporate the additional buildings that the archaeology study unearthed, HCF erected "ghost structures" (that look similar to white PVC pipes) outlining the Simonses' lunch counter and grocery store, outhouse, and two houses built by Mann's descendants.[44] The building outlines were developed into an outdoor museum exhibition, making it the first in South Carolina and among the first in the nation.[45] While the additional history shifted the narrative of the museum from Mann's entrepreneurial pursuits to those of her family, the site remains rooted in her legacy. The additional structures necessitated the name change from the Mann-Simons Cottage to the Mann-Simons Site. Beginning in 2015, the interior home exhibitions were refashioned in a new interpretive plan that features pieces from the sixty thousand artifacts found in the archaeological study, new research about Celia Mann's relationship with Ben Delane, and expanded analysis on Charles Simons and Bernice Conners.[46]

Historic Columbia director Robin Waites remarked that the cottage "used to be set up as a traditional historic house museum. . . . We've really flipped that around, so it's really more of a 21st century museum."[47] This type of ongoing transformation of the interpretive narrative, along with the interior and exterior site exhibitions, makes the Mann-Simons Site a

national leader in modern house museum design. With its cutting-edge design, the site has also created a national platform for Celia Mann's legacy and the significance of house museums of African American women.

In 2016, Steve Benjamin, the mayor of Columbia, noted, "The Mann-Simons family story is the story of so many chapters in Columbia's history."[48] Locally, the city has continued to embrace the site and support celebrating the legacy of Celia Mann. Celia Smith, Mann's fourth-generational descendant, remarked, "I think that she [Celia] wants her story to be told . . . what she was able to accomplish, that says a lot. And a black woman at that . . . Throughout our family history there are lots of strong black women."[49] Smith's commentary, heard in the interior exhibition, promotes the distinctive perspectives of Black women. As the anchor of the narrative, Mann remains the moniker of the site as a beacon of Black history, resilience, and achievement. Just as the founders of the site intended, the home they saved in the 1970s continues to be a community gathering space used to promote cultural heritage and relevance of the African American experience through the lens of Celia Mann.

Around the corner from the Mann-Simons Site, the Modjeska Monteith Simkins House also disseminates African American history through a woman's interpretive narrative. Located at 2025 Marion Street, the house museum highlights Simkin's activism during the long civil rights movement, showing another distinct aspect of African American women's memorialization.

Mary Modjeska Monteith Simkins was born on December 5, 1899, the first child of Rachel and Henry Monteith, in Columbia, South Carolina. Her mother instilled a deep passion for education in her daughter at an early age, teaching her and encouraging her thirst for knowledge. Mary excelled in mathematics, and after graduating from the historically Black Benedict College in 1921, she began teaching at the segregated Booker T. Washington High School. She worked there with an accomplished Black faculty (that included Celia Dial Saxon) until she married Andrew Whitfield Simkins in 1929.

From 1931 to 1942, Simkins worked with the South Carolina Tuberculosis Association as the first director of Negro Work. She believed access to adequate health care to be a fundamental human and civil right and began her lifelong dedication to social justice for African Americans. In the 1930s, Simkins began working with the Civil Welfare League, a group that advocated for fair treatment from the government and law enforcement. She also began serving as state meeting organizer with the Columbia branch of the National Association for the Advancement of Colored People (NAACP). Displeased with her fervent public advocacy for social justice

and civil rights, the South Carolina Tuberculosis Association terminated her position in 1942.[50]

Undeterred, Simkins became even more active in civil rights. She was elected state secretary of the South Carolina NAACP and became heavily involved in civil rights legal cases in the state. In the 1950s, Simkins assisted with *Briggs v. Elliott*, the first of five cases in the landmark *Brown v. Board of Education* decision that legally ended segregation in public schools. Simkins regularly housed Thurgood Marshall, the lead NAACP lawyer on the case, during his visits to South Carolina and helped him organize community members in Clarendon County who were central to the case. In addition to the NAACP, she worked with "more than fifty progressive reform organizations over a period of six decades," including the Southern Negro Youth Congress, Southern Conference for Human Welfare, and National Negro Congress. Her unrelenting advocacy for justice made her widely known as the "Matriarch of the South Carolina Civil Rights Movement."[51] Her biographer, Barbara Woods, attests that Simkins "was a steadfast, persistent, and courageous activist in the struggle for human rights in the United States."[52]

Several years before her death, Simkins was a featured speaker in Columbia's public schools and a figure in the *South Carolina African-American Role Models* calendar.[53] She was also the subject of an hourlong documentary about her civil rights activism, produced by South Carolina's public broadcasting station, ETV. *Making a Way out of No Way* aired nationwide in February 1990, proclaiming, "The name Modjeska Monteith Simkins evokes images of a fearless, aggressive soldier fighting on the front lines of the civil rights movement."[54] Her public memory became definitively tied to the legacy of the African American liberation struggle in the twentieth century. In 1991, E. W. Cromartie, Columbia city councilman, declared December 5 as "Mary Modjeska Monteith Simkins Day," in honor of her ninety-second birthday. That same year, the South Carolina Women's Consortium presented the first Modjeska Simkins Award in honor of "an outstanding citizen who has worked to improve the quality of life for all people in South Carolina."[55] Simkins's life story became a featured aspect of popular historical narratives about South Carolina women and social justice.[56]

In 1992, the year of Simkins's death, her official portrait, commissioned by the South Carolina Legislative Black Caucus, was hung in the state house.[57] Earlier that year, public historian Catherine Fleming Bruce had begun a documentary project, *A Perfect Equality: Conflicts and Achievements of Historic Black Columbia*, for which she interviewed Simkins about the legacy of her home as a human rights center. Simkins had remarked, "I'm not worrying about that. That's for future generations to think about."[58] Though Simkins did not live to see Bruce's documentary, she left a lasting

mark on the preservationist that led to the establishment of her home as a public history site and a center for justice.

Transitioning Simkin's home into a house museum began several years after her death. Listed on the National Register in 1994, the home remained empty and unused after her passing. Bruce found that Simkins's home had been overrun with garbage and squatters who were homeless in the years following her death.[59] Deeply disturbed by what she had seen, Bruce established the Modjeska Monteith Simkins House Restoration Project and, through her role as director of the Collaborative for Community Trust (CCT), stopped the City of Columbia from demolishing the home.[60] CCT board members included South Carolina representative Alma Byrd and University of South Carolina professor and chair of the African American Studies Department Cleveland Sellers.[61] The board worked under Bruce's leadership to create a lasting public history site intended to be a living embodiment of Simkins's activist spirit. Bruce and the CCT regarded Simkins's home as "more than a house and more than a place of history. . . . We envision the collaborative working here."[62] Their intention was "to use the home as a center for social change activities and a place to display Simkins memorabilia."[63]

With its vision in place, the CCT began fundraising to save, restore, and renovate the home. The organization raised $20,000 of their $180,000 goal in several months. With the help of the Columbia Housing Authority, Historic Columbia Foundation, Historic Charleston Foundation, National Trust for Historic Preservation, South Carolina State Historic Preservation Office, and the City of Columbia, the CCT raised $60,000 and was able to conduct small tours of the home.[64] In the spring of 1997, the CCT revamped its proposal plan by increasing the goal to $325,000, but funding stalled. Dismayed at their slowed progress, at least one CCT member blamed it on the political climate in South Carolina. Board member Ernest Wiggins stated, "I think that to hold up and want to memorialize the efforts of a civil rights worker may strike some people as being a little too hot right now to pursue."[65] Other groups, however, continued to see the value in their legacy work. In October 1997, the Women in Law of the University of South Carolina Law School held a yard sale fundraiser for the Simkins Home. The group's advisor, Pam Robinson, commented that no other project in the organization's history had "galvanized the group as much as this one. . . . Modjeska Simkins did so much to influence civil rights legislation and equality of opportunity for women, so all this fund raising is truly a labor of love for us."[66]

During this period of fundraising and incremental renovations, the CCT sporadically opened the home to the public for special events and private

FIGURE 26. Memorializer Catherine Fleming Bruce seated in the living room of the Modjeska Simkins Home in 2006. Photo by Mary Ann Chastain. Associated Press.

tours.[67] The site officially opened in April 2001 as the Modjeska Monteith Simkins Center for Justice, Ethics and Human Rights.[68] The home functioned as both a museum and public forum for civil rights and political advocacy, fulfilling the CCT's vision for honoring Simkins's legacy. The first national political candidate to utilize the space was Joe Lieberman during his 2004 Democratic presidential campaign. Lieberman unveiled his anti-poverty program as part of his political platform at the Simkins Home to symbolize his commitment and recognition of civil rights issues.[69] Albert E. Jabs remarked in *The State*, "When the national political parties descend on our beautiful South Carolina, they need to see the singular respect and dignity we repose on our distinguished civil rights leaders."[70] Other events, such as the "Six Who Dared" exhibition about *Brown v. Board of Education*, centered Simkins's civil rights activism. Also, the fortieth anniversary of the Freedom Riders was commemorated at the Simkins House with the James Earl Chaney Foundation.[71]

Despite the national recognition these events brought, funding remained an issue. Bruce and the CCT raised over $300,000 but still struggled to

maintain the site. In one area newspaper, Bruce appealed, "Historic preservation funds aren't what we wish they were. We're calling on the public to help."[72] Mayor Bob Coble publicly acknowledged that "African American historic buildings are a very strong part of our historic community and tourist venues" but that they did not generate the continuous stream of resources necessary to maintain the site long-term.[73]

Ultimately, issues with funding led to the transition of the site's management. Bruce and the CCT, behind in payments on a 2003 bank loan for $51,000, were in jeopardy of losing the Simkins home to foreclosure.[74] Bruce stated, "The purchase, restoration and operation of a historic site is a gargantuan task, even more so with a paucity of staff support and resources."[75] While the CCT had been successful in securing the foundational funding needed to acquire and open the home as a functioning community activist center, the "gargantuan task" of sustaining operations and creating exhibitions was an issue that continues to plague African American museums unable to secure consistent public funding.

In an op-ed, local resident Kevin Fisher accused Bruce of mishandling money she received to restore the home and the Columbia City Council of mishandling taxpayer dollars. Fisher was not the only person dissatisfied with Bruce's performance. Discontent local government and other involved or interested community members led to the CCT handing the management of the site to HCF in 2007.[76] Bruce responded to Fisher's accusations by first noting, "Had the Collaborative [CCT] not stepped up 12 years ago, the Simkins House would not be here today." She explained that no financial decisions had been made without the guidance and consent of the board of directors. Even in the absence of "developers or [a] well-financed institution," Bruce expressed her "hope that other ordinary people will continue to step out on faith to preserve history in their communities."[77] Indeed, she and the CCT had saved the Simkins home from disrepair and begun a movement of memorialization for a new generation of activists.

HCF extended the foundational legacy work of Bruce and the CCT by adding the Simkins House to its organization. The group's operational support, consistent public funding, and prior success in managing the Mann-Simons Cottage made it an ideal candidate for sustaining the public history project. Blue Cross Blue Shield paid the overdue bank loan, purchased the home outright, and helped renovate the adjacent carriage house (where Thurgood Marshall had stayed during visits for the *Briggs v. Elliott* case). Additionally, the City of Columbia pledged an annual $60,000 for site maintenance, staff, and programming.[78] The HCF also secured funding from the federal government, including a $150,000 appropriation in 2010 for restoration work through Congressman James E. Clyburn.[79]

While the site's operation shifted from the Collaborative for Community Trust to Historic Columbia Foundation, the purpose and function of the community-centered space did not. The South Carolina Progressive Network, headquartered in the Simkins home since 2009, established the Modjeska Simkins School for Human Rights to teach "Modjeska-style" community organizing and strategies for local activism. The network annually commemorates Simkins's legacy by celebrating her December birthday.[80] Other community organizations, like the Midlands Transit Riders Association, have used the space to advocate for local labor issues. Historic Columbia (renamed in 2017) continues to utilize the home for public history programs, including the annual Jubilee Festival, Archaeology Day, and scheduled school tours.[81] To further the museum's historical impact, it launched the award-winning "Scholar-in-Residence" program to provide housing for a doctoral student conducting research at nearby archival repositories.[82]

The 2010s became a renaissance season for Historic Columbia's house museums. Expanded public support from Columbia municipalities along with federal allocations like the National Park Service's African American Civil Rights Grant Program have provided needed resources to undertake substantial revisions of the interpretive plans and interactive exhibition design. Tours such as "Walking in the Footsteps of Entrepreneurs, Activists, and Educators" and "Journey to Freedom" have made the local history of African American women in Columbia relevant to a national audience.[83] The Mann-Simons Site has received several prestigious awards, including the National Council on Public History's 2017 Outstanding Public History Project Award, while the interior exhibition "Modjeska Monteith Simkins: An Advocate of the People" is accessible both in person and as a free virtual tour. Because the majority of African American house museums are centered around the legacies of men, the Mann-Simons Site and Modjeska Simkins Home stand out as distinct memorials that illustrate history through the experiences of women.

As house museums rose in prominence as an African American public history medium in the late twentieth century, they became visible representations used to foster public memory of the Black past. Choosing house museums as a venue to disseminate Black history, memorializers are centering women in cities across the nation. Promoting the legacies of African American women was an intentional choice that has had a lasting impact on the national public history landscape, but particularly in the South where these traditional memorials are most plentiful. Not only have they saved dilapidated structures whose absence would have resulted in an enduring

void, but they have also created a venue of memorialization that provides a community space for celebration, remembrance, social services, and activism.

Memorializers like Bernice Conners and Catherine Fleming Bruce were successful in galvanizing support to save and establish house museums in the late twentieth century, but the lack of a sturdy operational structure prevented lasting autonomous management. Community preservation groups, like the Center for the Study and Preservation of Black History, Art and Folklore, held fast to their commemorative visions but also saw the benefit of partnering with organizations like Historic Columbia, whose wealth of knowledge and access to a steady stream of public and private funding provided consistent staffing and the resources to revitalize exhibitions. On the other hand, sole operators like CeCe Byers and Catherine Fleming Bruce were tasked with the entire responsibility of designing and implementing short- and long-term plans. Regardless of the circumstances, the extraordinary ability of memorializers to realize their visions of spaces that promote public memory and communal gathering encourages continued growth and relevance for house museums of African American women in the twenty-first century.

Conclusion

The memorial trail of Maggie Lena Walker, the first woman bank president in the United States, illustrates how African American women's public history evolved from the early twentieth century to the early twenty-first century. Walker's public commemoration began in 1936 with a named memorial for the African American high school in Richmond, Virginia. In the 1970s, her memorialization expanded when she became the first African American woman honored with a National Park Service (NPS) Historic Site. In 2017, a full-body, bronze statue of Walker was unveiled near her NPS house museum in Richmond. These commemorations reflect the three distinct phases of African American public history in the United States.

Born in 1867, Maggie Lena Walker was an African American activist who positively affected the African American community in Richmond through her organizing efforts and philanthropy.[1] Referred to as "Little Africa," "Harlem of the South," and "Black Wall Street," the Jackson Ward neighborhood was a space of refuge and opportunity for collective resistance to the social, economic, and political constraints of the oppressive Jim Crow regime for the many middleclass professionals and property owners who lived there.[2] With a strong background in "accounting and sales," Walker was a foundational leader in the Independent Order of St. Luke (IOSL), a fraternal organization and mutual benefit society.[3] By 1899, she had been elected its president and collaborated with other African American women as they "helped to found a school for delinquent girls, raised money for scholarships, supported women's suffrage, denounced the theft of the vote from black men, and spoke out against lynching."[4] Walker was guided by what historian Elsa Barkley Brown describes as "womanist consciousness," a combination of activism and ideology used to build institutions in Black

communities while recognizing the distinct circumstances that intersections of race and gender create for Black women.[5]

Under Walker's leadership, the IOSL expanded its mission and propelled her to the positions of president of the St. Luke Penny Savings Bank and chairman of the board of the St. Luke Bank and Trust Company. The first woman of any race in the United States to become a bank president, Walker championed African American financial empowerment. Her mantra was, "Let us put our money together; let us use our money; Let us put our money out as usury among ourselves, and reap the benefit ourselves."[6] Her community activism was well respected by an interracial cadre of supporters. By the time of her death in 1934, as Walker's obituary in the *Richmond Times-Dispatch* highlighted, she was "honored by Governors" and "was as much respected by the white race as she was venerated by her own."[7]

Four years after her death, Maggie Walker High School was opened in 1938 to "relieve the crowded conditions" at Armstrong High School, which had been the only high school for African Americans in Richmond since 1865, when it was established by the Freedmen's Bureau.[8] Funded by the Public Works Administration (PWA), the school became the first to be named after an African American woman and the first in the city to be led by an African American principal.[9] The Maggie Walker High School named memorial was not only an acknowledgment of Walker's significant achievements, but her memorial brand was also a symbol of progress and educational opportunity for African Americans.[10]

The circumstances calling for the preservation of Walker's home came in the 1970s as urban renewal threatened to destroy it and other cultural spaces in the Jackson Ward neighborhood. With the leadership of memorializer Mozelle Sallee, the Maggie Lena Walker Historical Foundation was founded in 1974.[11] In less than a year, it had successfully partnered with the Virginia Historic Landmarks Commission to designate the Jackson Ward Historic District and Walker's home as state landmarks.[12] By 1976, both were listed on the National Register of Historic Places. In addition, the Richmond City Council provided grants to the Walker Historical Foundation to help preserve and restore the home.[13] On November 10, 1978, President Jimmy Carter signed into law the National Parks and Recreation Act of 1978, officially making the Maggie Lena Walker Home a National Park Service Historic Site. As a national site, Walker's home carries on the tradition of preserving Black history through an African American woman.

Walker's memorial brand continues to symbolize community progress and serves as an exemplar of African American public history trends. As a national debate was sparked in 2017 by the removal of Confederate statues in Charlottesville, Virginia, a bronze statue of Maggie Lena Walker was

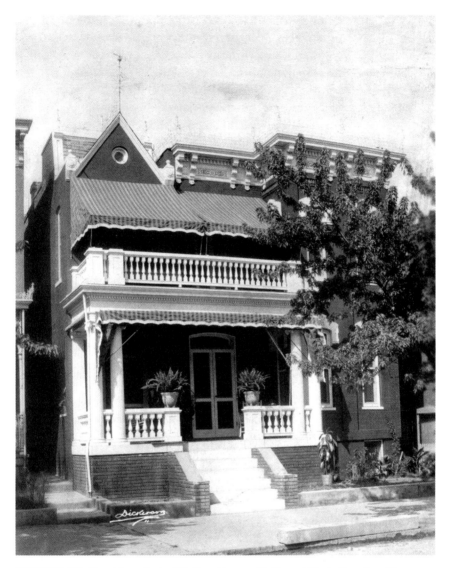

FIGURE 27. The Maggie L. Walker Home National Park Service Historic Site, 110½ East Leigh Street, Richmond, Virginia. Maggie L. Walker Papers, National Park Service.

being unveiled less than a hundred miles away in Richmond, the former capital of the Confederacy. An enthusiastic crowd gathered for the occasion held on Walker's 153rd birthday, July 17, 2017.[14] The first two decades of the twenty-first century opened a new era of African American traditional memorials in public spaces not only as a contestation of public space but

also as a perpetuation of the traditions of the culture of recognition that began in the late nineteenth century. The hypervisibility of a memorial trailblazer like Walker contrasts with the prevailing underrepresentation of African American women memorials in the United States. Walker remains only one of three who have National Park Service units centered around their legacies. At the same time, her memorial trail highlights public history traditions that have not yet been included within the scope of scholarly analysis of African American commemoration.

The dichotomy of sites seen and unseen in African American public history traditions are evident in other memorial trails—multiple memorials of the same person—that continue to expand in the twenty-first century. Mary McLeod Bethune's commemoration, for example, has once again altered the national landscape of African American women's memorialization. The opportunity to expand Bethune's memorial trail came as Florida's elected officials decided unanimously to replace the statue of the "obscure Confederate general" Edmund Kirby Smith, who had represented the state in the US Capitol since 1922.[15] Through the National Statuary Hall Collection, each state chooses two people who symbolize significant aspects of their history to be represented by enormous marble statues that line the hallways of the US Capitol rotunda and visitor center. Florida's July 2022 removal of Smith's statue to replace it with a newly commissioned eleven-foot-high, six-thousand-pound statue of Bethune made a powerful statement about the people deemed worthy to grace the halls of the national legislature. As the first and only African American to represent a state, Bethune has opened up a new arena of commemoration in Washington, DC, that reverberates across the nation.

In 2021, the Wisconsin State Capitol and Executive Residence Board authorized a bipartisan approval to erect on the grounds of the state legislature in Milwaukee a statue of Vel Phillips, the first African American judge in Wisconsin. It is slated to be the first of its kind in the state.[16] In Maryland, bronze statues of Frederick Douglass and Harriet Tubman were installed in the state house's Old House Chamber in 2020. The traditional memorials were a response that followed the controversial monument removal of Supreme Court Justice Roger B. Taney, who ruled that Black people could not be US citizens in the seminal Dred Scott case of 1857.[17] The installation of the Bethune, Phillips, and Tubman statues shows that African American commemorations are now experiencing a season of expansion into public spaces previously held by White memorials now considered inaccurate or controversial representations of the past. And multicultural community memorializers with decision-making power have effectively advocated that

memorials of African American women be central to reconceptualizing public space.

Harriet Tubman's memorial brand has extended the impact of her legacy as a representation of the recovery and acknowledgment of African American women's history. In addition to Tubman's statue in the Maryland State House, her memorial trail has expanded significantly in the twenty-first century. Her most notable traditional memorials are the NPS historic parks created in her honor in Auburn, New York, and Cambridge, Maryland. A myriad of public monuments featuring Tubman statues, including in Battle Creek, Michigan; South Bend, Indiana; Boston, Massachusetts; Harlem, New York; Newark, New Jersey; and Pomona, California, were erected across the United States in the 2010s. Though Tubman's debut on the twenty-dollar bill continues to be in political limbo, the federal designation would make her the first African American and woman to be commemorated on US paper currency. In the meantime, the feature of African American women on US currency has progressed in other ways. The specially minted commemorative coin of a Black woman as "Lady Liberty" on the front of a 24k gold coin was released by the US Mint in 2017—though distribution has been limited. However, with the recent addition of the American Women Quarters Program, the US Mint commemorates four "pioneering" African American women—Maya Angelou, Bessie Coleman, Pauli Murray, and Ida B. Wells—on newly minted quarters from 2022 to 2025.[18]

Pathfinding African American women politicians like Shirley Chisholm and Barbara Jordan have begun to be recognized in traditional public history memorials as well. Congresswoman Chisolm, the first African American woman to campaign for the US presidency and to serve as an elected US representative of New York, was commemorated with the designation of the Shirley Chisholm State Park in 2019 and is being honored with a commissioned public art piece scheduled to be unveiled by the She Built NYC organization, both in Brooklyn.[19] Texas Congresswoman Barbara Jordan was commemorated with two statues installed in 2002 and 2009 at the Austin-Bergstrom International Airport and on the campus of the University of Texas at Austin, respectively, while an additional outdoor artwork commemoration was commissioned in 2019 by the City of Houston's Mayor's Office.[20]

Recovered histories and the expansion of published scholarship on African American women has inspired the establishment of new memorials and has created an intellectual atmosphere for memorializers to operate with enhanced knowledge of how race, gender, and class impact the African American experience. Those who have previously been marginalized in

popular historical narratives are now being acknowledged through traditional memorials, such as the 2006 Harriet Wilson statue in Milford, New Hampshire, and the 2019 Cathay Williams bust in Leavenworth, Kansas.[21] Fannie Lou Hamer, a working-class civil rights activist, has been memorialized in Mississippi with a statue and memorial park dedicated to her legacy.[22]

The Colored Girls Museum expands African American women's memorialization in the twenty-first century by celebrating the legacies of lesser-known people. In 2015, Vashti DuBois founded the museum in her home in Philadelphia, Pennsylvania, to celebrate the ordinary extraordinary Black woman.

DuBois proclaims these words of pride: "In spite of everything, the Colored Girl continues to demonstrate her connectedness, her willingness to create from a place of love, to use that love to sustain others, to bind family and community together, to use our bodies to imagine, to protect, to comfort, to grieve and to fight."[23] The Colored Girls Museum is representative of African American women broadly whose history has not been widely commemorated in named or traditional memorials. Talented artists fill the museum with unique and phenomenal works of art that highlight underexplored aspects of African American women's lived experiences. The Colored Girls Museum is a bold statement about new ways to commemorate African American women outside of the typical memorials that celebrate women like Mary McLeod Bethune, whose public achievements loom large.

While historic sites and museums have been central traditional venues of public history, the internet has emerged as the most significant new medium. Posts on Facebook, Instagram, and Twitter and commemorative art on Google Doodles have become a significant means for memorializing the legacies of African American women. With these free platforms, memorializers of all ages can promote public memory. Social media, digital humanities projects, and other multimedia web-based platforms have transformed how people disseminate knowledge and learn about African American women.

In addition to the global reach of virtual commemoration, the impact of communities advocating to change the composition of public history landscapes has also influenced inaugural traditional memorials of Black women in other Western nations. In 2016, the United Kingdom unveiled the Mary Seacole statue in London near the Houses of Parliament. This tribute to Seacole, an acclaimed nurse of the nineteenth century who overcame challenges to provide medical services to British soldiers in the Crimean War, is the product of twelve years of planning and fundraising by memorializers.[24]

FIGURE 28. Founder Vashti DuBois on the porch of The Colored Girls Museum. Courtesy of The Colored Girls Museum, Philadelphia, PA.

In Copenhagen, the capital city of Denmark, the Mary Thomas statue was unveiled in 2018 as the first public monument to a Black woman in the country that showcases the resilience of the Black communities affected by the country's role in enslavement and exploitation in its Caribbean colonies. The statute, titled *I Am Queen Mary*, lauds Thomas's legacy as the leader of the 1878 plantation uprising in Danish-colonized St. Croix.[25] In October 2021, memorializers in Cardiff, Wales, working to foster recognition of women's contributions through public history memorials, unveiled a monument of Betty Campbell, a beloved community advocate and the first Black head teacher in Wales. It is the first statue created to honor the legacy of a specific woman and a person of African descent in Wales.[26] The public commemoration of Black women in European communities reveals the impact of expanding commemorations in the twenty-first century that are reflecting the lives and contributions of women everywhere.

While other Western nations are experiencing these traditional memorials of Black women for the first time, memorializers in the United States continue to explore aspects of the Black diasporic experience through creating distinct memorials of African American women. The Harriet Barber House in Hopkins, South Carolina, provides a memorial venue outside of the more prevalent sites of enslavement to underscore African American contributions and connections to agricultural and environmental histories. Through the lens of an African American woman, this traditional memorial commemorates the rural experiences of communities on Black-owned land.

Harriet Barber was born enslaved in Lower Richland, South Carolina. After being emancipated at the end of the Civil War, she and her husband, Samuel Barber, used their agricultural skills to run a farm in the same area. In 1872, the couple participated in the South Carolina Land Commission land redistribution program, designed to provide opportunities for land ownership and economic empowerment to formerly enslaved African Americans in the state. The Barbers' lot of land consisted of forty-two and a half acres on which they built a house, dug a well, and farmed cotton and corn using multicrop production practices. They were so successful in cultivating crops they were able to purchase their land outright in just seven years. In 1879, Harriet made the final payment to the Land Commission and received the title for their lot. The Barber House is located in rural Hopkins at 116 Barberville Loop, about fourteen miles south of the capital city of Columbia. The legacy of the Barbers has endured beyond their deaths in the 1890s through their descendants, who have lived on their land for almost a hundred and fifty years. Notably, the Barber land is the only surviving African American—owned property received from the South Carolina Land Commission.[27]

Figure 29. The Harriet Barber House in Hopkins, South Carolina, in the mid-twentieth century. Courtesy of the Harriet Barber House, Hopkins, SC.

Though both Barbers owned and built up the land, the traditional memorial was named for Harriet. It was an intentional decision to memorialize the African American woman because, as descendant Ulysses Barber explained, "She really was the one who did the business of the place."[28] Similar to other African American house museums, the family oral histories passed down several generations formed the foundational basis of the site's interpretive narrative. Additionally, a collection of "yellowed documents, handwritten notes and pictures that document four generations of preachers, teachers and farmers" has been carefully preserved by family members like Ulysses. Though he did not have the financial resources to restore the home, he was able to publicize its history and develop a memorial brand for rural and agricultural African American history distinct from the familiar plantation narratives. Ulysses told *The State* in 1990, "The future of the house is uncertain. Ragged and uninhabited, it would take a grant or some other special funding to restore it." To further pursue his vision, he established the Harriet Barber House Restoration Foundation and collaborated with the African American Heritage Council and the South Carolina Department of Archives and History to recognize the home as a state site of historical

significance. As a result of his efforts, the Barber House was listed on the National Register of Historic Sites in 1986 and incorporated into the Historic Homes Tour of Lower Richland as early as 1990.[29] In the twenty-first century, however, the Barber House opened as a fully operational public history site.[30]

After Ulysses's death in 2004, his daughters, Marie Adams, Mary Kirkland, and Carrie White, and his niece Deborah Scott Brooks, made his dream a reality. White explained, "It's just so important as blacks to know, to have a sense of history of themselves. . . . I think that's what we've lost because of our ancestors being taken from their homes."[31] As descendants and astute African American memorializers, they developed a strategy to sustain the house museum through collaborative partnerships that would provide the funding needed for their preservation efforts. In 2006, they secured a $25,000 grant from the Richland County Conservation Commission, followed by an additional $37,500 in 2007.[32] Adams, a founder and chairwoman of the South East Rural Community Outreach, helped garner public funding from Richland County by using Harriet Barber's memorial brand to promote the rural area's historical tourism. Richland County councilwoman Bernice Scott was an important ally in obtaining local and state appropriations for the site, including $167,250 in 2007 and $250,000 in 2008.[33] In 2010, the descendant memorializers added another traditional memorial to the site when they erected a historical marker in front of the Barber House.[34]

The Barber House has come to represent an unconventional aspect of American history through Harriet and Samuel's land ownership during Reconstruction among a host of public and private plantation homes that populate the area as tourist attractions. Inventive programming, including African American Heritage Day, Memorial Day, the Strong Threads Program, and the "Richland's International Flavors" festival has increasingly made the site a distinct disseminator of African American history to local communities.[35] The Barber Home memorial brand has become so established in the Lower Richland community that its Memorial Day celebrations have become a central community venue to commemorate the holiday, whose attractions have included the "Moving Wall" replica of the national Vietnam Veterans Memorial in Washington, DC.[36] Its decadelong tradition of annual Juneteenth celebrations that began in 2014 offer community barbeques, African American historical reenactments, and free tours of the home.[37] The programming has been expanded still further by partnering with the annual Swampfest sponsored by the nearby Congaree National Park, where several family members have appeared in the visitor video and

regular programming that educates guests on the rural and agricultural history of African Americans in the region. The environmental history of the site has also been recognized, with the Columbia Tree and Appearance Commission commending the Barber House for the dawn redwoods located on the property.[38] Manifesting yet another distinct layer of African American women's public memorialization, Harriet Barber's legacy is certain to influence how sites depict Black agricultural and environmental history.

The memorialization of African American women has been strategic, political, and socially subversive. However, the resistance to erasure generated by memorial efforts has only been a byproduct of the intrinsic desire to acknowledge and celebrate women in Black communities. Memorializers in the twenty-first century are a part of a generational continuum of African American clubwomen and historical societies who established memorials and crafted public memory to intentionally celebrate lives and legacies by claiming space and shaping the cultural landscape of commemoration. New generations of professionally trained memorializers are directing and staffing public history sites across the nation. In the National Park Service, 102-year-old Betty Reid Soskin has gained notoriety as the "oldest active ranger." An interpretive ranger at the Rosie the Riveter World War II Home Front National Historical Park in Richmond, California, Soskin emphasizes the significance of African American women to the war effort in her role. Her ability to incorporate the contributions of African American women into the site narrative that had previously diminished or overlooked them speaks to the perpetual deftness with which public memory crafters in the twenty-first century reshape those dominant histories. In a 2021 *New York Times* article, Soskin affirmed, "When I became a ranger . . . I was taking back my own history."[39] Like Soskin, African American memorializers are recovering histories and reckoning with erasure in false or misleading public representations of the past.

Mapping the legacies of African American women in the United States draws on the same diasporic, Pan-Africanist commemorative practices evoked by #SAYHERNAME in crafting public memory. Memorializers center their own ideals and aspirations each time they establish a public memorial that centers and celebrates Black women legacies.

Notes

Introduction

1. Vigil-Fowler, "'Two Strikes—A Lady and Colored.'"
2. Gamble, "Physicians," 2, 489; Huner, "Justina Ford."
3. Robert Fink, "Five Points."
4. Lohse, *Justina Ford: Medical Pioneer*; Tollette, *Justina Lorena Ford, M.D.*
5. *Colorado Experience*, "Justina Ford, M.D."
6. Geraldine R. Stepp, "Project History Dr. Justina Ford House," Justina Ford Medical Society Collection, Blair-Caldwell Library, Denver (hereafter cited as Ford Papers); "The Dr. Justina Ford Project Community History Project," Ford Papers.
7. Evelyn C. White, "How Paul Stewart Mines Lost 'Gold' with a Tape Recorder," *Smithsonian*, August 1989, 62–63.
8. Paul Wilbur Stewart, Sr. funeral program, "This Man Made a Difference," Paul Stewart Collection, Blair-Caldwell Library, Denver.
9. Eileen Ogintz, "Historian of the Western Blacks: Paul Stewart, Uncovering a Rich, Forgotten Heritage in Denver," *Washington Post*, March 1, 1989.
10. John Wideman, "West of the Rockies: The Brief Saga of Deadwood Dick, Aunt Clara Brown and Today's Black Pioneers Who've Sought Greater Horizons and Found Them," *Black Enterprise* 7, June 1977, 161.
11. "Clayton's Museum: Black In West," *New Pittsburgh Courier*, July 23, 1977; White, "How Paul Stewart Mines Lost 'Gold,'" 59–60.
12. White, 60.
13. "Clayton's Museum," 17.
14. "The Dr. Justina L. Ford House Committee," Ford Papers. The members of the committee were Jimmy BrownSmith, Dr. Leroy Graham, Zepha Grant, Esper Gullatt, Ottawa Harris, Joe Mangrum, Patricia Mayberry, Charleszine Nelson, Steve Shepard, Geraldine Stepp, Paul Stewart, and Irving Watts.

15. Stepp, "Project History Dr. Justina Ford House," Ford Papers.

16. Ruffins, "Mythos, Memory, and History."

17. Hamilton, *Booker T. Washington in American Memory*; Rocksborough-Smith, *Black Public History in Chicago*; Wilson, *Negro Building*; Bouknight, "Black Museology."

18. Intersectionality, coined by legal scholar Kimberlé Crenshaw, is the simultaneous expression of multiple categories of analysis. Race, gender, class, and region work in concert to create distinct experiences for African American women in their lives and public memorialization.

19. Tagger, "Interpreting African American Women's History," 17; Savage, *African American Historic Places*; Curtis, *Black Heritage Sites*.

20. Monument Lab, *National Monument Audit*. Martin Luther King Jr. and Frederick Douglass are the other two African Americans represented in the findings.

Chapter 1. The Phillis Wheatley Brand

1. Carretta, *Biography of a Genius*, 1–200; Shields, "Wheatley, Phillis," 3, 345–47; Jamison, "Analysis of Selected Poetry," 408–16; Frund, "Wheatley, a Public Intellectual," 35–52.

2. Gates and McKay, *Norton Anthology*, 167.

3. Higginbotham, *Righteous Discontent*, 185–229.

4. *Phillis, Phyllis, Philis, Phylis*, and *Phyliss* were all common spellings used in newspapers and organizational records. *Phyllis* was the earliest spelling used by NACW organizations in the 1890s and later in 1930 when they established the Wheatley Department. *Phillis* and *Phyllis* were the two most common spellings. Variations in spelling did not have any specific significance; the name may have been misspelled by newspaper journalists and editors. No evidence suggests that one spelling was more or less prevalent in different regions of the United States. Rather, a spelling was a matter of preference for each organization, journalist, and newspaper. In this work, I use the specific spelling used in each organizational record, newspaper, or other source.

5. Many of these records do not date back past the early twentieth century, so the internal structures of the earliest Wheatley organizations are mostly unknown. The club records that do exist provide a pathway to understanding the earlier iterations of Wheatley organizations that operated in the late 1880s through the 1890s. Newspaper records digitized on web-based platforms offer the deepest insight into the Wheatley brand. They document meetings, officer elections, special events, community collaborations, and at times, ideological and political views of the clubwomen. They also are essential in documenting the locales of Wheatley organizations, from small towns to major cities. In some instances, newspapers document the organizations' establishment, activities, and decline. In other instances, only one or two references to an organization are documented, which I use as an indication of the existence of an organization in a specific location.

6. "In Woman's Realm," *St. Paul Daily Globe*, July 29, 1982.

7. "Phillis Wheatley Club: A Concert for the Benefit of the Children's Building," *St. Paul Daily Globe*, July 31, 1892; "A Charming Concert: The Phillis Wheatley Concert and Fete," *St. Paul Daily Globe*, August 4, 1892.

8. National Association of Colored Women's Clubs Inc. (NACWC), "A History of the Club Movement among the Colored Women of the United States of America," 1902, reel 1, 72–73, Records of the National Association of Colored Women's Clubs, 1895–1992, Bethesda, MD (hereafter cited as NACWC Records).

9. *Holt County Sentinel*, March 29, 1895.

10. The following note is a selection of the widespread newspaper coverage throughout 1895: "A President of Color: An Afro-American Club of Clever Negro Women," *Anaconda Standard*, February 8, 1895; "A Colored Woman's Club," *Madisonian*, May 18, 1895; "A Colored Woman's Club," *Topeka State Journal*, February 20, 1895; "Negro Women: The Members Are Ambitious and Untiring Workers; Well Organized In New Orleans; An Afro-American Club That is Devoted to the Cause of Elevating the Negro Race," *Pioche Weekly Record*, March 7, 1895; B. W. Jones, "Mary Church Terrell," 28.

11. B. W. Jones, "Mary Church Terrell," 28.

12. NACWC, "History of the Club Movement," 58–60, 122, NACWC Records.

13. "A McKinley Club Organized," *Cleveland Gazette*, April 25, 1896; Lerner, "Early Community Work," 161; Knupfer, "If You Can't Push," 222; Kimani, "Mothers of the City," 1–90.

14. Knupfer, "If You Can't Push," 222; Kimani, "Mothers of the City," 5; B. W. Jones, "Mary Church Terrell," 29. Elizabeth Lindsay Davis proclaimed the Wheatley Home of Chicago, established in 1908, to be the first of its kind, as shown in the National Association of Colored Women (NACW) Minutes of July 1935, p. 35.

15. "Progress among Colored Women: How They Are Solving Economic in Chicago; Improvement in Home Life," *Denver Star*, December 12, 1914.

16. "Call of the Phyllis Wheatly Club," *Nashville Globe*, September 20, 1907; "Phyllis Wheatley Club," *Nashville Globe*, September 18, 1908; "Phyllis Wheatley Club's Record Cannot Be Excelled and Is Seldom Equalled: Thirteen Years of Continued Efforts for the Poor," *Nashville Globe*, January 31, 1908.

17. "Phyllis Wheatley Club," *Nashville Globe*, June 21, 1907.

18. "Phyllis Wheatley Club's Record Cannot be Excelled," *Nashville Globe*.

19. "Phyllis Wheatley Club Incorporated," *Franklin's Paper, The Statesman*, September 4, 1909.

20. "Annual Shower Planned for Phyllis Wheatley Home," *Detroit Tribune*, November 25, 1933; Lerner, "Early Community Work," 162; Carby, "Policing the Black Woman's Body," 738–55.

21. Keaton and Segura, *Our Stories*, 52–53.

22. "Wheatley Place Dots," *Dallas Express*, April 3, 1920; "Wheatley Place,"

Dallas Express, January 15, 1921; "Wheatley Place Art Club Entertains," *Dallas Express*, January 8, 1921; "Wheatley Place Clippings," *Dallas Express*, May 22, 1920.

23. *Washington Post*, June 14, 1906; "Good Club of Colored Women," *Daily Gate and Constitution*, April 2, 1919; *Bystander*, August 15, 1919.

24. "Weatherly to Speak," *Lincoln Star*, January 13, 1934; *Negro Star*, May 27, 1921; *Nashville Globe*, June 21, 1908; *Greenville News*, November 14, 1923; *Detroit Tribune*, June 8, 1940; Records of the Phyllis Wheatley Community Center, n.d., Minnesota Historical Society.

25. C. J. Savage, "'In the Interest of the Colored Boys,'" 515.

26. *Broad Ax*, Feb 3, 1900.

27. *St. Paul Daily Globe*, March 20, 1905.

28. *Colored American*, November 17, 1900.

29. *Iowa Bystander*, March 15, 1907; "Another Iowa Girl Makes Good," *Iowa Bystander*, June 6, 1913. Brown was also active in the founding of the Mary Church Terrell and Mary B. Talbert Clubs in Des Moines. Honoring the living and past legacies of African Americans was an integral part of her long career of public service.

30. "Lyceum Pays Tribute to Phillis Wheatley," *Iowa Bystander*, February 4, 1910.

31. "Philis Wheatley Club Concerts Successfully," *Cleveland Gazette*, May 6, 1893.

32. *Iowa State Bystander*, March 28, 1913.

33. Johnson, "'Drill into Us,'" 533, 558.

34. *Chicago Defender*, April 3, 1932; "Phyllis Wheatley Art Club," *Kansas City Sun*, January 30, 1915.

35. *Appeal*, March 4, 1899.

36. Washington, *Medical Apartheid*, 189–215.

37. W. E. B. Du Bois to Phillis Wheatley Club, February 14, 1925, W. E. B. Du Bois Papers (MS 312), Special Collections and University Archives, University of Massachusetts Amherst Libraries (hereafter cited as Du Bois Papers).

38. Booker T. Washington Junior High pageant program, "Mrs. Terrell Wrote Pageant to Inspire School Children," Phillis Wheatley Pageant, n.d., Mary Church Terrell Papers, 1932–1933, Manuscripts Division, Library of Congress (hereafter cited as Terrell Papers).

39. Phillis Wheatley Pageant, Terrell Papers.

40. "Historical Pageant-Play Based on the Life of Phyllis Wheatley," n.d., 1–2, Terrell Papers; K. C. Smith, "Constructing a Shared History," 43; Gere, *Intimate Practices*, 237.

41. Flyer, "Phillis Wheatley Day," June 12, 1932, Terrell Papers.

42. "Story of Phillis Wheatley Poems: Learned Critics Discuss Slave Girl's Literary Work; Views of Many Notables," *Denver Star,* October 16, 1915; "Poems of First Negro Author," *Statesman*, May 21, 1910.

43. Osceola F. Gordon, "Alabama's Appreciation of Literature," *Christian Recorder*, June 16, 1887.

44. "The Day of Freedom," *Colored American*, February 2, 1901.

45. "Women's Part in War Efforts Highlight of Week's Broadcast: Workers Here and Abroad to Be Heard," *Baltimore Afro-American*, March 20, 1943; "Unusual Air Program Planned by National Urban League via CBS," *Pittsburgh Courier*, March 13, 1943.

46. "WCAO to Carry Wheatley Story: Dramatic Program to Be Aired Tues. Night," *Baltimore Afro-American*, January 22, 1949; "CBS to Air 'Wheatley' Saga in Honor of Negro History Week," *Michigan Chronicle*, January 22, 1949; "Story of Phillis Wheatley on CBS," *Weekly Review*, January 21, 1949; Horne, *Race Woman*, 104.

47. "Muriel Smith to Do Phillis Wheatley Act," *Philadelphia Tribune*, January 22, 1949; "Broadcast to Observe Negro History Week: Muriel Smith to Portray the Role of Phillis Wheatley," *New Journal and Guide*, January 22, 1949.

48. Prepared radio typescript from the Columbia Broadcasting System, "The Story of Phillis Wheatley," January 1949, Papers of Shirley Graham Du Bois, 1865–1998, MC 476, box 34, Schlesinger Library, Harvard Radcliffe Institute.

49. Horne, *Race Woman*, 89; Graham, *Story of Phillis Wheatley*, 13–160.

50. Snow, review of *Story of Phillis Wheatley*, 1920.

51. Bair, "Universal Negro Improvement," 3, 273.

52. R. A. Hill, *Marcus Garvey*, 11, 440–41.

53. R. A. Hill, 11, 442.

54. Bandele, *Black Star*, 117; H. Vinton Plummer, "UNIA Convention Notes," August 31, 1921, Universal Negro Improvement Association Records, Stuart A. Rose Manuscript, Archives, and Rare Book Library, Emory University.

55. R. A. Hill, *Marcus Garvey*, 4, 719, 942; William H. Ferris, "Garvey's Meteoric Rise To Fame and Power; And the Trial That Led to the Gates of Atlanta," *Pittsburgh Courier*, February 21, 1925.

56. Roscoe Conkling Bruce to American Fund for Public Service, April 21, 1926, American Fund for Public Service Records, New York Public Library (hereafter cited as American Fund Records); Memorandum, Phillis Wheatley Publishing Company, n.d., Du Bois Papers.

57. Gatewood, *Aristocrats of Color*, 340; Bruce to Kelly Miller, July 13, 1926, Kelly Miller Family Papers, Stuart A. Rose Manuscript, Archives, and Rare Book Library, Emory University (hereafter cited as Miller Papers).

58. Memorandum, Phillis Wheatley Publishing Company, 1926, Du Bois Papers; Bruce to Miller, December 21, 1925, Miller Papers. Other board members included Coralie Franklin Cook, Jessie R. Fauset, Charles S. Johnson, Kelly Miller, Helen L. Watts, Laura Wheeler, and W. T. B. Williams.

59. "Social Progress," 107.

60. *Crisis*, March 1926, 256.

61. Charles L. Skinner to American Fund, April 22, 1926, American Fund Records; Bruce to American Fund, April 21, 1926, American Fund Records.

62. Bruce to American Fund for Public Service, April 21, 1926, American Fund Records; Memorandum, Phillis Wheatley Publishing Company, n.d., Du Bois Papers (underlining in the original has been changed to italics here).

63. R. J. Baker to Bruce, April 28, 1926, Du Bois Papers.

64. "Varied Background Aided Businessman in Rise to Top," *Michigan Chronicle*, October 21, 1961.

65. *Detroit Tribune*, July 2, 1938.

66. *Detroit Tribune*, August 6, 1938.

67. Bettie Ellington, "Westside Detroit, 'Booker T. Washington Trade Association,'" *Michigan Chronicle*, February 11, 1939.

68. *Detroit Tribune*, September 9, 1939; *Indianapolis Recorder*, August 19, 1939.

69. *Daily Standard*, November 2, 1928; *Advocate*, December 12, 1907; *Advocate*, May 30, 1901.

70. NACW Minutes, July 11–18, 1930, reel 1, p. 42, NACWC Records; Phillis Wheatley Department of the NACW, October 21, 1938, reel 9, NACWC Records.

71. NACW Minutes, 1941, p. 62, NACWC Records.

72. NACW Minutes, 1937, p. 35, NACWC Records.

73. "Phyllis Wheatley Department or Junior N.A.C.W.," reel 11, NACWC Records; "NACW Phyllis Wheatley Young Adults Department," reel 19, NACWC Records.

74. "W. C. T. U. Meeting," *Harrisburg Telegraph,* November 26, 1906.

75. Rita Robbins, newspaper clipping in scrapbook, "YWCA Observes Its 33rd Anniversary: Phyllis Wheatley Branch Here Started on 'Shoestring,'" n.d., box 114, Richmond YWCA Records, M 177, Special Collections and Archives, James Branch Cabell Library, Virginia Commonwealth University (hereafter cited as Richmond YWCA Records).

76. YWCA of Asheville, "Historical Panels": "Empowering Women," "Phyllis Wheatley Branch," "Eliminating Racism at the YWCA."

77. YWCA Seattle, King, Snohomish. "History: A Journey."

78. Newspaper clipping in scrapbook, "Who Is Founder?," 1952, box 177, Richmond YWCA Records.

79. "YWCA Observes Its 33rd Anniversary,'" Richmond YWCA Records.

80. "Indianapolis YWCA," box 4, folder 21, Bernice Walker Papers, William H. Smith Library, Indiana Historical Society.

81. "Colored Y. W. C. A. Home Dedication: Exercises Open Next Sunday at New Building for Girls and Women," *Evening Star*, December 12, 1920.

82. Simmons, *Crescent City Girls*, 178.

83. Simmons, 191.

84. "Y. W. C. A. Program for This Week," *Albuquerque Journal*, March 5, 1933; "Girl Reserve Group Program for Week," *Albuquerque Journal*, April 9, 1933; "Girl Reserves," *Albuquerque Journal*, November 24, 1935; "Y. W. C. A. Clubs Will Entertain at State Meet, Saturday Session Closes at Mountain Lodge," *Albuquerque Journal*, April 24, 1936. The Albuquerque YWCA divided its youth into different racial and ethnic groups, identified by names like El Club Progresivo, Sokeyne, and Oku-Po.

85. "Phyllis Wheatley Group Elects," *Albuquerque Journal*, September 22, 1929; "Society," *Albuquerque Journal*, March 10, 1933; "High School Girls from Several Cities to Join In Reserve Club State Convention," *Albuquerque Journal*, April 14, 1937; "Girl Reserves Activities," *Albuquerque Journal*, January 27, 1928; "Girl Reserves Activities," *Albuquerque Journal*, February 22, 1928; "Girl Reserve Clubs Dates for Cabin Outings Announced," *Albuquerque Journal*, June 12, 1934.

86. "Unusual Feature of High Jinks Given by Young Colored Girls," *Albuquerque Journal*, April 7, 1927; "Girl Reserves Activities," *Albuquerque Journal*, November 27, 1927; "Girl Reserves," *Albuquerque Journal*, December 8, 1935; "Y. W. C. A. Girl Reserve Clubs," *Albuquerque Journal*, February 11, 1938; Y. W. C. A. Girl Reserve Clubs," *Albuquerque Journal*, April 7, 1940; "National Y. W. C. A. Program Observed Locally Tuesday, Inter-Racial Theme Keynote Injected in Public Meeting," *Albuquerque Journal*, March 8, 1942.

87. "Big Sister Club Plans Carnival as Nursery Benefit," *Albuquerque Journal*, May 30, 1942; "National Y. W. C. A. Program Observed."

88. "Memorial Tree Planted: Y. W. C. A. Exercises Do Honor to Phyllis Wheatley, Poet," *Evening Star*, April 23, 1922.

89. Scrapbook, 1952, box 177, Richmond YWCA Archives.

90. YWCA of Asheville, "Eliminating Racism at the YWCA"; Hannah Frisch, "Tuesday History: Thelma Caldwell Calls Out the YWCA's Shortcomings," *Mountain Express,* August 1, 2017.

91. "20 Black Women Poets to Honor Phillis Wheatley," *New York Times,* November 2, 1973; "Wheatley: Women Poets Honor America's First Black Woman of Letters at Mississippi Festival," *Ebony,* March 1974, 94–96; "Wheatley Festival Honors First Published US Black: JSC Event November 4–7 Features 20 Women Poets," *Clarion-Ledger*, September 30, 1973. The Institute for the Study of the History, Life, and Culture of Black People at Jackson State University in Mississippi is now named the Margaret Walker Alexander National Research Center in honor of Walker's extraordinary commitment to Black studies and her exemplary career as an author.

92. Margaret Walker to Lucille Clifton, July 10, 1973, box 55, folder 12, Lucille Clifton Papers, Stuart A. Rose Manuscript, Archives, and Rare Book Library, Emory University (hereafter cited as Clifton Papers).

93. Phillis Wheatley Poetry Festival program, November 4–7, 1973, Clifton Papers.

94. Wheatley Poetry Festival program, Clifton Papers.

95. "Jackson State Honors Poetess with Festival," *Jet*, November 29, 1973.

96. Margaret Walker, Journal 093, Margaret Walker Personal Papers, series 2, Margaret Walker Alexander National Research Center, Jackson State University.

97. Charles H. Rowell, "Poetry, History, and Humanism: An Interview with Margaret Walker," *Black World*, December 1975, 5; C. J. Brown, *Song of My Life*, 3–104.

98. Rowell and Ward, "Ancestral Memories," 128, 145.

99. Charlayne Hunter, "Poets Extol a Sister's Unfettered Soul," *New York Times*, November 9, 1973; Rhodes, *Jackson State University*, 1974.

100. M. Walker, "Black Women Writers," 37.

101. M. Walker, 39.

102. A. Walker, *Our Mothers' Gardens*, 96.

103. Gates, *Trials of Wheatley*, 9–94.

104. Jeffers, *Age of Phillis*.

Chapter 2. Commemorating Freedom

1. Painter, "Truth, Sojourner," 3, 259–62; Painter, *Sojourner: A Life*, 3–287.

2. D. G. White, *Ar'n't I a Woman?*, 12.

3. "An Appeal to Colored People: Contributions Much Needed to Support the Sojourner Truth Home," *Washington Post*, August 4, 1896; Horace D. Slatter, "What Negroes Are Doing," *Birmingham News*, January 4, 1914.

4. Beasley, *Negro Trail Blazers*, 226.

5. "Sojourner Club Elects President," *Los Angeles Times*, July 12, 1928.

6. *Los Angeles Times*, February 12, 1909.

7. Flamming, *Bound for Freedom*, 400; "Sojourner Truth Industrial Home," *Los Angeles Times*, May 20, 1913; "Sojourner Truth Home," *Los Angeles Times*, May 11, 1913; "Colored Girls' Home: Sojourners' Women's Club Makes Provision for Workers and House Is Purchased, With Every Comfort," *Los Angeles Times*, May 19, 1911; Beasley, *Negro Trail Blazers*, 227. Historian Douglas Flamming notes that the press referred to the home as the Sojourner Truth Home, Sojourner Truth Industrial Home, Sojourner Industrial Home, and Sojourner Truth Home for Working Girls.

8. Boyd, "Black Angeleno Women," 64–65.

9. Beasley, *Negro Trail Blazers*, 228; Flamming, *Bound for Freedom*, 139; *History of the California State Federation of Colored Women's Clubs, Inc.* (n.p.: [CSFCWC?], [1953?]), 8, 28; "Los Angeles Society," *Pittsburgh Courier*, August 13, 1927; De Graaf, "Race, Sex, and Region," 307. The Fannie Wall Children's Home in Oakland was the California Federation's central project in Northern California throughout the early twentieth century.

10. "Colored Clubs Open Convention: California Federation Gathers at First A. M. Church for Annual Session," *Oakland Tribune*, July 27, 1915.

11. Beasley, *Negro Trail Blazers*, 1–317; Cheryl Tillman, "First African American Teacher in Los Angeles," *Los Angeles Sentinel*, March 3, 2011.

12. "Calif. Federation's Landmark," *Chicago Defender*, December 10, 1938; Eloise Bibb Thompson, "Club Women Aid Reform; 45,000 in National Body; Splendid Work of National Association of Colored Women's Clubs Shown at Ninth Biennial Meeting of Wilberforce, Ohio," *Chicago Defender*, October 24, 1914.

13. "Pleasing Signs of the Times: Los Angeles Women in Politics," *Chicago Defender*, August 22, 1914.

14. "For Racial Advancement," *Los Angeles Times*, November 8, 1916.

15. Marie Dorothy, "Los Angeles Society," *Pittsburgh Courier*, October 8, 1927.

16. Marie Dorothy Bout, "Los Angeles Society," *Pittsburgh Courier*, February 4, 1928; Thelma G. Hardon, "California News: Los Angeles," *Chicago Defender*, July 9, 1932.

17. "Former House of Noted Woman to House Girls: Urban League to Open Home for Delinquent Girls in October," *Philadelphia Tribune*, August 7, 1915; Hicks, *Talk with You*, 191–92. The Sojourner Truth Club in Seattle was formed in 1918 with the central purpose of establishing a home for single and unwed Black women, which they were able to do by 1920.

18. "Richmond," *Chicago Defender*, April 16, 1938.

19. Minutes of the Sojourner Truth Club, November 21, 1923, box 1, folder 2, Sojourner Truth Club Records, 1922–75, M 540, Indiana Historical Society William Henry Smith Memorial Library, Indianapolis (hereafter cited as Truth Records); Minutes of the Truth Club, July 15, 1925, Truth Records; "History and Constitution of the Truth Club," n.d., box 1, folder 1, Truth Records; Thankyou cards and correspondence, ca. 1931, box 2, folder 4, Truth Records; "Receipts," ca. 1935 and 1940, box 2, folder 6, Truth Records.

20. Larson, "Tubman, Harriet," 3, 266; Clinton, *Road to Freedom*, 3–226; Sernett, *Myth, Memory, and History*, 1–319; Lowry, *Imagining a Life*, 3–378.

21. "Afro-American Notes," *Times Union*, July 10, 1911; "To Befriend Harriet Tubman, Empire State Federation of Women's Clubs Takes Up Case," *New York Age*, July 13, 1911.

22. "Investigates Harriet Tubman's Condition, President of State Federation Makes Report and Recommendations," *New York Age*, August 3, 1911.

23. "Afro-American Notes," *Brooklyn Daily Eagle*, August 9, 1911; "Afro-American Notes," *Brooklyn Daily Eagle*, March 21, 1912.

24. "Brooklyn," *New York Age*, July 13, 1911.

25. *New York Age*, February 22, 1912.

26. "Harriet Tubman Needs Federation Money, Dr. James Edward Mason Investigates and Tells of Findings," *New York Age*, February 8, 1912.

27. "Harriet Tubman Is a Shadow of Former Self," *New York Age*, February 27, 1913.

28. "Tubman Memorial Services," *New York Age,* April 17, 1913.

29. "Empire State Federation of Women's Clubs," *New York Age*, March 21, 1912; "Tubman Memorial Services," *New York Age*, April 3, 1913.

30. "Tubman Memorial Services," *New York Age*.

31. "Empire Federation Convenes," *New York Age*, July 22, 1909.

32. "The White Rose Industrial Association Presents," *New York Age*, March 28, 1907; "Afro-American Notes," *Brooklyn Daily Eagle*, May 29, 1911; *Brooklyn Daily Eagle*, June 25, 1911; "Marie Jackson Stuart Dies in Hospital," *New York Amsterdam News*, September 16, 1925.

33. "Buffalo Briefs," *New York Age*, June 8, 1911.

34. *Crisis,* September 1913; Berrett, "Golden Anniversary," 75–78; "Directors for Exposition Features," *Indianapolis Recorder*, October 11, 1913; *New York Tribune*, May 6, 1917. According to W. E. B. Du Bois, "The Historical Pageant of the Negro Race" had a 350-person ensemble and was "a great scenic production of the history of the black race."

35. "Delegates Meet at the White Rose Home," *New York Age*, September 3, 1908; "Women's Day in Orange," *New York Age*, June 28, 1906; "Douglass Night in Brooklyn," *New York Age*, March 3, 1910.

36. "Afro-American Notes," Brooklyn Daily Eagle, February 8, 1909; "Japanese Fete: Given at White Rose Home for Working Girls a Perfect Success," New York Age, September 5, 1907; "The White Rose Industrial Association Presents," New York Age; "Grand Benefit in Aid of the Douglass Home," New York Age, April 23, 1908; "Empire Federation Convenes," New York Age.

37. "Federation Meets Today, State Branch of the National Association of Colored Women," *Buffalo Morning Express*, July 4, 1913; "Among Women's Organizations, Colored Women's Convention," *Buffalo Evening News*, July 5, 1913; "Colored Women Elect Officers for State Body," *Buffalo Sunday Morning News*, July 6, 1913.

38. "Women Wanted to Boycott Age," *New York Age*, July 9, 1914; "Harriet Tubman Night at Salem," *New York Age*, July 9, 1914.

39. "High Tribute Paid to Harriet Tubman as Memorial Tablet Is Unveiled in Her Honor," *Advertiser-Journal*, June 13, 1914, Harriet Tubman Binder Collection, Seymour Library, Auburn, New York (hereafter cited as Tubman Binder); "For Tubman Memorial," *Auburn Citizen*, June 9, 1914, Tubman Binder.

40. "High Tribute Paid to Harriet Tubman as Memorial Tablet is Unveiled in Her Honor," *Advertiser-Journal*, June 13, 1914.

41. "Fine Memorial Is Erected to Negro Heroine," *Democrat and Chronicle*, July 8, 1914.

42. "Sculptures You Ought to Know About," *Baltimore Afro-American*, March 19, 1932.

43. "The Tubman Monument Question of Location," *New York Age*, March 25, 1915.

44. "Harriet Tubman Monument Benefit," *New York Age*, September 3, 1914; "The Tubman Monument Question of Location"; Rosell, *Fort Hill Cemetery*, 106.

45. "News of Greater New York," *New York Age*, April 29, 1915.

46. "Auburn, N.Y.," *New York Age*, July 8, 1915; "Monument Unveiled to Harriet Tubman," *New York Age*, July 15, 1915.

47. "Manhattan Y. W. C. A. Notes," *Chicago Defender*, March 6, 1920.

48. "A Harmonious Convention," *New York Age*, July 23, 1927; "Empire State Federation Has Meeting Here," *Democrat and Chronicle*, December 17, 1927; "Industrial School for Negro Women Planned near Auburn," *Democrat and Chronicle*, July 17, 1927; "Auburn Buildings Will Be Remodeled for Home

and School for Negro Women," *Press and Sun-Bulletin*, July 31, 1927; "Local Women Elected Directors of Harriet Tubman Home in Auburn," *New York Age*, November 23, 1929; "The Federation's Program," *New York Age*, August 27, 1932.

49. "New York Clubwomen to Hold Their Annual Convention in Ithica [*sic*]," *New York Age*, July 3, 1937; "Monument Unveiled to Harriet Tubman, Who Devoted Life to Anti-Slavery Cause," *Pittsburgh Courier*, August 7, 1937.

50. "Monument over Harriet Tubman Grave Unveiled," *Citizen-Advertiser*, July 8, 1937, Tubman Binder.

51. "Report of Unmarked Historic Site or Building," n.d., New York Division of Archives and History.

52. Personal photo of marker, October 28, 2019, in the author's possession.

53. "SS Harriet Tubman to Memorialize Abolitionist," *Chicago Defender*, April 15, 1944; "SS Tubman to Be Launched Memorial Day," *Chicago Defender*, May 27, 1944; "SS Harriet Tubman Launched," *Chicago Defender*, June 10, 1944.

54. Harry S. McAlpin, "Georgia Women Lead Bond Drive," *Jackson Advocate*, September 9, 1944; Venice Tipton Spraggs, "Women in the National Picture," *Chicago Defender*, June 10, 1944; "Nat'l Negro Insurances Allocate $1,000,000 in Harriet Tubman Drive," *Chicago Defender*, July 22, 1944; "To Launch Liberty Ship Named for Negro Woman," *New York Age*, May 20, 1944.

55. Toki Schalk, "Liberty Ship Harriet Tubman Is Launched with Impressive Ceremonies in Portland," *Pittsburgh Courier*, June 10, 1944.

56. Schalk, "Liberty Ship Harriet Tubman Is Launched," *Pittsburgh Courier*; Venice Tipton Spraggs, "Women in the National Picture," *Chicago Defender*, June 17, 1944; Photograph album of Eva Stewart Northrup, Harriet Tubman Collection, Smithsonian National Museum of African American History and Culture, Gift of Charles L. Blockson.

57. Schalk, "Liberty Ship Harriet Tubman Is Launched."

58. City of South Portland, "Proclamation #4—13/14," April 7, 2014; *Citizen-Advisor*, June 3, 1944; Vivian Abdur-Rahim and Sadie Young to Maxine Beecher, March 12, 2014, Harriet Tubman Historical Society, Stone Mountain, GA.

59. "Tubman Home to Be Restored, Dedicated," *Syracuse Herald Journal*, April 12, 1953.

60. "Harriet Tubman Home Is Rebuilt as Shrine," *Chicago Defender*, April 11, 1953; "Pilgrimage to Harriet Tubman Home Set for Aug. 1," *Syracuse Herald Journal*, July 22, 1957.

61. "Women's Clubs Aid Tubman Home," *Syracuse Herald Journal*, December 21, 1952.

62. Harriet Tubman Boosters, *Harriet Tubman Boosters Newsletter*; "Pilgrimage to Tubman Home Set," *Syracuse Herald*, September 12, 1954; "Tubman Club Hold Tea on Dec. 30," *Syracuse Herald Journal*, October 1, 1956; "Tubman Unit Holds Picnic," *Syracuse Herald*, August 17, 1957; "Tubman Boosters Meet at Auburn," *Syracuse Herald*, December 8, 1957; "Harriet Tubman Boosters Meet," *Auburn Citizen-Advertiser*, January 17, 1963.

63. "Tubman Unit Holds Picnic"; "Tubman Boosters Meet at Auburn"; "AME Zion Connection to Meet in Auburn, New York," *Jackson Advocate*, June 22, 1957; "Tubman Group Plans Activities," *Post-Standard*, September 17, 1961; "Tubman Boosters Hear about Trip," *Auburn Citizen*, March 22, 1963.

64. "Pilgrimage Set: Second Annual Pilgrimage to Harriet Tubman Home and Shrine," *Detroit Tribune*, September 25, 1954; *Detroit Tribune*, May 5, 1953; "Tubman Pilgrimage Next Month," *Syracuse Herald Journal*, September 18, 1955; "Mrs. Sibley Bid to Tubman Home Rites," *Syracuse Herald Journal*, April 26, 1953; "Auburn—At Pilgrimage," *Syracuse Herald Journal*, October 18, 1955; "Harriet Tubman Home to Be Restored as Museum," *Baltimore Afro-American*, April 7, 1953.

65. "Tubman Pilgrimage Scheduled Oct. 14," *Tribune*, September 24, 1955; "Pilgrimage Set by AME Zion Group Friday," *Elmira Advertiser*, October 13, 1955; "Pilgrimage to Harriet Tubman Home Set for Aug. 1," *Syracuse Herald Journal*, July 22, 1957.

66. "Pilgrimage to Tubman Home Set."

67. "Tubman Guild Planning Solidarity," *Pittsburgh Post-Gazette,* February 23, 1962.

68. Cole and Redcross, *African Americans of Sewickley Valley*, 56; Smoot, "Self Help and Institution Building," 1–477, quotations on pp. 128, 130; Debbie Norrell, "100 Years of the Harriet Tubman Guild," *Pittsburgh Courier*, August 28, 2015.

69. Margaret Yeats, "The Harriett Tubmans Keep Up Welfare Work: Monthly Meeting Reveals Much Good in the Interest of the Unfortunate," *Pittsburgh Courier*, February 16, 1935.

70. Smoot, "Self Help and Institution Building," 137; "Tubman Guild Keeps Up Busy Schedule despite Hot Days," *Pittsburgh Courier*, July 13, 1935; "Harriett Tubman Guild Holds Board Meeting," *Pittsburgh Courier*, September 7, 1935; "Tubman Guild Holds Interesting Meeting," *Pittsburgh Courier*, January 12, 1935; Jane Shaw, "Harriet Tubman Guild Shows Its Love in Service to Others," *Pittsburgh Post-Gazette*, December 1, 1972.

71. "Frances Harpers Have Glorious President's Day," *Pittsburgh Courier*, September 16, 1939; Smoot, "Self Help and Institution Building," 128.

72. Smoot, 130; "Explanation!," *Pittsburgh Courier*, May 12, 1934; "Tubman Guild Planning Solidarity."

73. "Brown and Jones," *Pittsburgh Press*, February 8, 1934; "Harriett-Tubman Charter Unites City-Co. Chapters," *Pittsburgh Courier*, March 24, 1934; Smoot, "Self Help and Institution Building," 145; J. H. Roy, "Harriett Tubman Board Meets," *Pittsburgh Courier*, October 12, 1935; "Guild Conducts AllDay Session," *Pittsburgh Courier*, June 23, 1934.

74. American Philatelic Society, *Black Heritage Series*; US Postal Service, *African Americans on Stamps*.

Chapter 3. The Three Marys

1. Hendricks, *Gender, Race, and Politics*, 22.

2. B. W. Jones, "Mary Church Terrell," 30; Shaw, "Black Club Women," 11–25.

3. B. W. Jones, "Terrell, Mary Eliza Church," 3; 233–34; Quigley, *Just Another Southern Town*, 3–240; Salem, "National Association," 2, 429–36.

4. *Chicago Defender*, November 30, 1940; *Chicago Defender*, April 8, 1922; *Chicago Defender*, March 2, 1940; *Philadelphia Tribune*, March 22, 1913. In Berkeley, the Terrell Club was socially oriented with a focus on music and put on special programs for enlisted African American men and World War II veterans. The Shreveport Terrell Club was founded in April of 1922 and stayed active throughout the 1940s.

5. Copeland was married to Ulysses S. Lindsay and was lauded for her contributions to the Black community in Milwaukee, particularly for her work with the Terrell Club, Delta Sigma Theta Sorority, and the YWCA. In 1967, a street was named in her honor, as well as Lindsay Park years later. The memorialization of national figures often prompted the memorialization of local figures, a common occurrence with Black women promoting the culture of recognition.

6. Bernice Copeland to Mary Church Terrell, December 4, 1933, Mary Church Terrell Papers, Library of Congress (hereafter cited as Terrell Papers).

7. "Women's Clubs Really Do Things That Are Worth While," *Holland Evening Sentinel*, July 23, 1960; "Milaukee Welfare Worker Builds Better Race Relations For City," *Chicago Daily Defender*, May 25, 1959.

8. "Negro Women Pick Delegates to Central Meet," *Journal Times*, June 27, 1934; "Many Reservations Made for Banquet," *News-Record*, March 25, 1933; "Neenah Society," *Post-Crescent*, March 29, 1933; "Negro Problem Theme of Talk for Federation: Baptist Church to Be Host to Clubs Thursday," *Journal Times*, October 29, 1936; "Plan Program for Local Observance of World Day of Prayer Next Friday," *Post-Crescent*, February 10, 1937.

9. "Milwaukee News," *Chicago Defender*, February 16, 1946.

10. Like Milwaukee, the cities of Indianapolis and Chicago also had Bronzeville neighborhoods. Chicago's is probably the most documented and well known.

11. Genevieve G. McBride and Stephen Byers, "The First Mayor of Black Milwaukee: J. Anthony Josey," *Wisconsin Magazine of History* 91, no. 2 (Winter 2007–8): 4–7.

12. "Milwaukee Bronzeville Contest Gets Under Way," *Chicago Defender*, November 27, 1937; "Milwaukee Club Lauds Bob Miller," *Chicago Defender*, December 4, 1937; "Richard E. Lewis Is Bronzeville Mayor," *Chicago Defender*, December 25, 1937.

13. "State Association of Colored Women to Convene in Racine for 3 Days," *Journal Times*, June 22, 1939; "Mayor-Bronzeville Council Holds Meeting; Officers Are Appointed," *Journal Times*, September 1, 1939; "Attorney to Speak,"

Journal Times, September 17, 1939; "Milwaukee Man Will Be Speaker," *Sheboygan Press*, April 9, 1943.

14. "Typovision," *Chicago Defender*, February 15, 1941.

15. "Milwaukee's 'Mayor' Picks His Cabinet," *Chicago Defender*, May 10, 1941; "Lewis Now at Helm as Mayor over 'City,'" *Chicago Defender*, January 15, 1938.

16. "City Negroes Elect Mayor For Charity," *Portage Daily Register*, November 15, 1945.

17. "Milwaukee News," *Chicago Defender*, September 1, 1945; V. C. Bevenue, "Milwaukee News," *Chicago Defender*, December 1, 1945; McBride and Byers, "The First Mayor," 2–15. Though Josey was not the "first" Mayor of Bronzeville as this article asserts, he regularly participated and collaborated with Bernice Copeland (Lindsay) and other members of the Mary Church Terrell Club.

18. Audrey Weaver, "Milwaukee Mother in Race for City Council Seat," *Chicago Defender*, February 11, 1956.

19. Carol Cohen, "Vel Phillips: Making History in Milwaukee," *Wisconsin Magazine of History* 99, no. 2 (Winter 2015–16): 46, 53.

20. "Deputy Director of Women's Bureau to Keynote Urban Affairs Parley on Apr. 8," *Wisconsin Jewish Chronicle*, March 13, 1970.

21. Morton, *And Sin No More*, 88.

22. "Lincoln Club Honored," *Lincoln State Journal*, June 29, 1928; "To Present Prizes to Local Students," *Portsmouth Times*, June 13, 1931; Millender, *Gary's Central Business*, 63.

23. L. S. Williams, "Talbert, Mary Morris Burnett," 3, 209–11; L. S. Williams, *Strangers in Paradise*, 1–193; Nahal and Matthews, "Niagara Movement," 65–83.

24. "Memorial Program St. James Church," *Helena Daily Independent*, February 11, 1923.

25. L. S. Williams, "Talbert, Mary Morris Burnett," 3, 209–11; L. S. Williams, *Strangers in Paradise*, 1–193; Nahal and Matthews, "Niagara Movement," 65–83.

26. Minutes from Mary B. Talbert record book, 1953–61, p. 290, box 2, folder 1, M 495, Alta M. Jett Collection, 1916–86, Indiana Historical Society William Henry Smith Memorial Library (hereafter cited as Jett Collection); Mary B. Talbert Club booklet, 1963–64, box 2, folder 2, Jett Collection.

27. Minutes from Talbert record book, 1953–61, p. 293, Jett Collection.

28. "Colored's Women's Clubs Arranging Benefit Banquet," *Palladium-Item*, November 10, 1927; "Richmond Woman Is Given State Office," *Palladium-Item*, July 8, 1928; "Townsend Branch," *Palladium-Item*, April 11, 1933; "News Briefs," *Palladium-Item*, March 28, 1951. Sally W. Stewart was president of the NACW from 1928 to 1933.

29. "Officers Elected," *Palladium-Item*, September 10, 1027; "Mary B. Talbert Club Has Election," *Palladium-Item*, December 10, 1954; "21 Women Attend Opening Meeting of Talbert Club," *Palladium-Item*, October 15, 1958; "Founder's Day Observed by Mary B. Talbert Club," *Palladium-Item*, April 24, 1974.

30. Minutes from Talbert record book, 1953–61, p. 203, Jett Collection;

"Program of Talbert Club Is Announced," *Palladium-Item*, August 16, 1924; Talbert Club booklet, 1966–67, box 2, folder 2, Jett Collection.

31. Minutes from Talbert record book, 1953–61, pp. 161–63, box 2, folder 1, Jett Collection.

32. "Townsend Tag Day Plans Progressing," *Palladium-Item*, October 2, 1925; "35 Hear Miami Senior Discuss Freedom," *Palladium-Item*, March 29, 1953.

33. Minutes from Talbert record book, 1953–61, pp. 275–76, Jett Collection; "Talbert Club Memorial Program Announced," *Palladium-Item*, February 18, 1925.

34. "Memorial Meeting Held for Mary B. Talbert," *Palladium-Item*, December 1, 1924.

35. Minutes from Talbert record book, 1953–61, p. 204, Jett Collection; "Chicken Supper Monday," *Palladium-Item*, January 31, 1924; "Impressive Graduation Exercise Are Conducted," *Palladium-Item*, May 28, 1932; "Mary B. Talbert Club Hears Talk about Civil War," *Palladium-Item*, March 17, 1961; "Mary B. Talbert Club Hears about State Convention," *Palladium-Item*, July 23, 1959; "Founder's Day Observed by Mary B. Talbert Club," *Palladium-Item*, April 24, 1974.

36. "Short News of City, Mrs. Benson Hostess," *Palladium-Item*, August 11, 1923; "Mary B. Talbert Club Hears about Life in Kenya," *Palladium-Item*, March 1, 1964.

37. "Talbert Club Circus Has Many Attractions," *Palladium-Item*, October 25, 1923; "Talbert Club to Present Three-Act Comedy Tonight," *Palladium-Item*, June 25, 1925; Mrs. M. C. Robbins, "News of Colored Folk in and about Muncie," *Muncie Evening Press*, August 19, 1925; "Mary B. Talbert Club to Give Xmas Bazaar," *Palladium-Item*, December 9, 1925; "Mary B. Talbert Club to Hold Bazaar," *Palladium-Item*, April 16, 1930; "Lawn Social Tuesday," *Palladium-Item*, July 6, 1931; "Townsend Center," *Palladium-Item*, June 5, 1933; "Mary Talbert Club to Sponsor Radio 'Broadcast' Friday," *Palladium-Item*, January 3, 1934.

38. "Mary B. Talbert Club Gives Party for Ward Patients," *Palladium-Item*, November 3, 1958; "Talbert Club Dinner Enjoyed at Home of Mrs. Estella Carter," *Palladium-Item*, October 28, 1927; "Club Dinner Friday," *Palladium-Item*, December 29, 1932.

39. "Girls Form New Junior Mary B. Talbert Club," *Palladium-Item*, March 13, 1958.

40. "Talbert Club Recognition Rite Held for Students," *Palladium-Item*, June 26, 1949; "Talbert Club Host to 21 Students Here," *Palladium-Item*, June 17, 1955.

41. Minutes from Talbert record book, 1953–61, Oct 1, 1959, p. 203–6, Jett Collection; "The Junior Mary B. Talbert Club," *Palladium-Item*, July 13, 1958.

42. "Fiftieth Anniversary Convention of the North Carolina Federation of Negro Women's Clubs" program booklet, 1959, box 2, folder 2, Jett Collection; "Mary B. Talbert Federated Club," *Rocky Mount Telegram*, October 30, 1983.

There was also a Mary B. Talbert Junior Federated Club for girls in Rocky Mount, North Carolina, an offspring of a Talbert Club organized in 1916.

43. "Bethune Club Celebrates 2d Anniversary," *Chicago Defender*, December 16, 1933; "Wheeling," *Baltimore Afro-American*, March 28, 1931; "Fort Wayne, Ind.," *Chicago Defender*, August 13, 1932.

44. E. M. Smith, "Bethune, Mary McLeod," 1, 99.

45. Hine and Thompson, *Shining Thread*, 251–52.

46. Hanson, *Mary McLeod Bethune*, 3.

47. "Federated Club Started in 1917," *Wilson Daily Times*, July 2, 1976.

48. "Special Program," *Wilson Daily Times*, April 24, 1948; "Among Our Clubs Wilson," *Federation Journal*, April 1949.

49. "Wilson County Has Negro Library," *Wilson Daily Times*, April 14, 1948; "Among Our Clubs Wilson"; "A Place of Their Own," *Wilson Daily Times*, February 24, 2006.

50. "Among Our Clubs Wilson"; "Wilson Clubs," *Federation Journal*, April 1954; "Meet Slated Here By Women's Clubs," *Wilson Daily Times*, May 1, 1959; "Negro Women's Clubs Open Meet," *Wilson Daily Times*, May 14, 1959.

51. Hazel Farmer, "Arizona Adds New Blood to Its Club Life: The Mary Bethune Club Becomes a Member of Phoenix Federation," *Chicago Defender*, December 17, 1938; Rebecca Stiles Taylor, "Activities of Women's National Organizations," *Chicago Defender*, June 24, 1939.

52. "Colored Group to Seek Funds," *Arizona Republic*, March 13, 1943; "Colored Center Campaign Opens," *Arizona Republic*, March 17, 1943; "Bethune Group Meets," *Arizona Republic*, October 22, 1944.

53. "Recreation Center Campaign," *Arizona Republic*, April 20, 1943; "Ministry Student to Speak at Church," *Arizona Republic*, December 7, 1946.

54. "Music Banquet Set for Friday," *Arizona Republic*, January 27, 1950; "Mary Bethune League Will Give Tea Sunday," *Arizona Sun*, February 14, 1947; "Mary Bethune League," *Arizona Sun*, April 24, 1953; "The Mary Bethune League," *Arizona Tribune*, April 29, 1960; "Notice!," *Arizona Sun*, November 2, 1960.

55. "Registration Set at Youth Center," *Arizona Republic*, January 14, 1944; "Deroloc Club," *Arizona Sun*, July 1, 1949; "Violin Concert Set at School," *Arizona Republic*, July 16, 1944.

56. "Mary Bethune League Plans 'Tacky Party,'" *Arizona Sun*, October 19, 1951.

57. Jeanette Carter, "News of the Heart of the Nation: Washington, D.C.," *Chicago Defender*, November 7, 1936.

58. "NYA Youths Form First Bethune Club," *Chicago Defender*, June 14, 1941; "Quoddy Village Spreads Democracy Under 'VV,'" *Pittsburgh Courier*, July 4, 1942; "U. S. Commissioner of Education Is Visitor at Quoddy," *Bangor Daily News*, August 1, 1941; "NYA Defense Training Center," *Chicago Defender*, December 6, 1941. For more on Quoddy NYA projects, see Federal Security Agency, *Final Report of the National Youth Administration*, iii-236.

59. "Women Organize Mary Bethune Club," *Detroit Tribune*, March 2, 1940; "Didja Know? . . . ," *Detroit Tribune*, April 20, 1940.

60. "Portland News," *Northwest Enterprise*, October 17, 1935; "Portland News: Williams Ave. Y.W.C.A.," *Northwest Enterprise*, November 1, 1934; "Portland News," *Northwest Enterprise*, May 2, 1935.

61. "A Typical Month at Summit Y. W. C. A. Shows Full Program," *Summit Herald*, May 16, 1946; "YWCA to Hear of Work in China at Twilight Tea," *Summit Herald*, November 22, 1945.

62. Barbara Pendleton, "Altoona," *Pittsburgh Courier*, October 18, 1952; "Noted Artist to Exhibit Works Here under Auspices of Y Club," *Altoona Mirror*, October 13, 1948.

63. "Mary Bethune Club Pledges YWCA Support," *Chicago Defender*, March 8, 1941; "Mary Gladden Head of Mary Bethune Club," *Chicago Defender*, October 5, 1940.

64. "News of Interests to Colored People: YWCA Honors Founder," *High Point Enterprise*, March 1, 1950; "YWCA Building to Open Today," *High Point Enterprise*, November 6, 1944.

65. Cleo Joffrion, "Bethune YWCA Plans Move to New Facilities," *Alexandria Daily Town Talk*, May 26, 1974.

66. "Colored Singer," *Alexandria Daily Town Talk*, January 27, 1947; Moon, "Alexandria YWCA," 71.

67. "United Fund: It's A Fact!," *Alexandria Daily Town Talk*, November 8, 1956.

68. "News of Interests to Colored People: YWCA Honors Founder," *High Point Enterprise*, March 1, 1950; "YWCA Presenting Mrs. Bethune Tomorrow," *High Point Enterprise*, January 27, 1946; "Large Crowd Hears Noted Negro Leader," *High Point Enterprise*, January 29, 1946.

69. "Large Crowd Hears Noted Negro Leader."

70. Alice Owens, "Celebrating a Century," *Greensboro News and Record*, February 21, 2020; Joffrion, "Bethune YWCA Plans Move."

71. "Mrs. S. Joe Brown," *Broad Ax*, August 8, 1924; "All Phases of Activities Chronicled," *Chicago Defender*, May 4, 1935; Lufkin, "Black Des Moines," 62.

72. "Supreme Court Will Decide," *Keokuk Daily Gate City*, June 10, 1909; "For Rehearing of Case," *Fairfield Journal*, January 12, 1910; "Joe Brown Loses 'Color Line' Suit," *Des Moines Daily News*, December 27, 1907; "Court Rules against Colored Woman," *Waterloo Weekly Courier*, February 18, 1910.

73. "Politics to Boil at Suff Meeting," *Marshalltown Times-Republican*, September 25, 1919; "Johnson on State Meeting Program," *Muscatine Journal*, June 23, 1909; "Colored Voters to Have Rally," *Keokuk Daily Gate City*, October 28, 1920.

74. "Methodist (Maxwell)," *Ames Daily Tribune*, February 15, 1929; "Negro Club Is Now Planned," *Des Moines Daily News*, October 24, 1917; "Central's Pres. Pinch Hits for African Missionary," *Chicago Defender*, January 28, 1939.

75. "A New History of the Order of the Eastern Star," *Broad Ax*, March 14, 1925; "Mrs. S. Joe Brown, of Des Moines, Iowa," *Broad Ax*, August 30, 1934; "Mrs. S. Joe Brown Addresses the International Conference at Pittsburgh, Pennsylvania," *Broad Ax*, August 23, 1924.

76. "The Meeting of the National Association of Colored Woman's Clubs at Wilberforce, Ohio," *Broad Ax*, August 15, 1914; "News Briefs," *Jefferson Herald*, May 15, 1930; "Prominent Women Off to Quinquennial Convention," *Chicago Defender*, May 17, 1930; "Iowans Remain in Des Moines for Regional," *Chicago Defender*, July 30, 1938.

77. Rebecca Stiles Taylor, "True Story of Fifty Years of Lifting and Climbing," *Chicago Defender*, May 6, 1950; "City Locals," *Iowa Bystander*, October 5, 1917; "Meeting of National Association at Denver, Colo.," *Iowa Bystander*, July 5, 1918; Associated Negro Press, "Home of Frederick Douglass Is Opened To Public," *Iowa Bystander*, March 17, 1921; "Mrs. Brown Is Trustee," *Des Moines Daily News*, July 22, 1920; "Mrs. Brown Given Ovation at Douglass Celebration," *Iowa Bystander*, February 21, 1919.

78. "Mrs. S. Joe Brown, Des Moines, Dies," *Daily Hawk-Eye Gazette*, November 29, 1941.

79. "Mrs. S. Joe Brown," *Broad Ax*, August 9, 1924. Over one hundred years later, the portrait remains one of the most recognizable images of Washington and is heralded as one of Tanner's greatest works of art.

80. "Iowa Federation of Colored Women Hold Most Interesting Session in History or [*sic*] Organization," *Iowa Bystander*, June 1, 1917.

81. "Mrs. Talbert Given Royal Reception by Des Moines Citizens," *Iowa Bystander*, June 1, 1917; Lufkin, "Brown, Samuel Joe and Sue M. Brown," 61–63; Jack Lufkin, "Henry Tanner and Booker T. Washington: Iowa Story Behind the Portrait," *Palimpsest* 72, no. 1 (Spring 1991): 18–19.

82. "Mrs. S. Joe Brown," *Iowa Bystander*, August 3, 1917; "Who's Who in Des Moines Locals," *Iowa Bystander*, November 18, 1920; "Locals," *Iowa Bystander*, December 9, 1920.

83. "Mrs. Brown Thanks Contributors," *Iowa Bystander*, July 30, 1920; "Locals," *Iowa Bystander*, July 30, 1920; "City Locals," *Iowa Bystander*, February 7, 1919; "Mrs. Brown Given Ovation at Douglass Celebration."

84. "St Paul Bugetarian," *Iowa Bystander*, June 14, 1918; "Negro Club Woman Speaks in City," *Des Moines Daily News*, June 19, 1918.

85. "Mrs. Talbert Delivers Forceful Address to Enthusiastic Audience," *Iowa Bystander*, January 23, 1920.

86. *Iowa State Bystander*, June 11, 1915.

87. Maude Thompson to Terrell, January 26, 1907, Terrell Papers.

88. Unknown clubwoman to Terrell, January 6, 1926, Terrell Papers; Gertrude Rush to Terrell, May 15, 1915, Terrell Papers.

89. "City News," *Iowa State Bystander*, March 29, 1907; Mary Church Terrell Club scrapbook, Iowa Association of Colored Women Convention program, July 1979, p. 15, Dora E. Mackay Papers, University of Iowa Special Collections.

90. "The City Convention," *Iowa State Bystander*, June 2, 1911.

91. "Negro Cop Wins City Oratorical Honors," *Des Moines Daily News*, July 1, 1913.

92. *Iowa State Bystander*, June 4, 1915; "Negro Cop Wins City Oratorical Honors."

93. "The City Convention," *Iowa State Bystander*, June 11, 1915; *Iowa State Bystander*, August 4, 1916; *Iowa State Bystander*, November 18, 1920.

94. "Negro Club Is Now Planned"; "Extension of Camp Mothers' Work Planned," *Des Moines Daily News*, June 28, 1918.

95. *Iowa State Bystander*, December 20, 1918; *Iowa State Bystander*, April 25, 1919.

96. "Iowa Women Form a Mary Bethune Club," *Chicago Defender*, May 7, 1938.

97. "Myrtle Foster Cook Issues Call for Central Ass'n," *Chicago Defender*, March 19, 1938. The Central Association of Colored Women consisted of representatives from Virginia, Kentucky, Ohio, Michigan, Illinois, Indiana, Wisconsin, Minnesota, Iowa, Missouri, Kansas, and Nebraska.

98. "Des Moines Open Its Doors to N. Y. A. National Director," *Chicago Defender*, May 7, 1938.

Chapter 4. Claiming Public Space

1. Atkins, *Remembering When*, 23.

2. Robert Glover, "Smith County Blacks Have Rich, Full Past," *Tyler Morning Telegraph*, February 5, 1997.

3. P. R. Robinett and Willie Mae Kelley to Casey Fannin, November 8, 1961, box 1, folder 1, Ella Reid Public Library Records, 1941–69, Historical Society of Pennsylvania, Philadelphia (hereafter cited as Reid Records).

4. "Ella Reid Funeral to Be Held Thursday," *Tyler Morning Telegraph*, May 26, 1955; "Tyler Nursery Does Big Job," *Tyler Morning Telegraph*, October 31, 1950.

5. "Board Wishes Library Named 'Ella Reid,'" *Tyler Morning Telegraph*, November 9, 1961.

6. "Ella Reid Funeral to Be Held Thursday."

7. "Circulation Report," November 1961, box 1, folder 2, Reid Records.

8. "Report for October 1951," box 1, folder 10, Reid Records.

9. "Holidays Slated by 'Story Hour,'" *Tyler Courier-Times*, December 13, 1964.

10. "Report for March, 1952," box 1, folder 1, Reid Records.

11. Kelley to Mary L. Hilton, November 10, 1952, box 1, folder 2, Reid Records.

12. "Annual Report of Circulations 1961," box 1, folder 3, Reid Records; "Circulation Report February 1963," box 1, folder 1, Reid Records; "City Libraries Give Reports," *Tyler Courier-Times*, July 15, 1962.

13. "Report for May 1962," box 1, folder 1, Reid Records.

14. "City Library Report Given," *Tyler Morning Telegraph*, October 17, 1962; "Libraries Report on Circulations," *Tyler Morning Telegraph*, February 20, 1963.

15. Atkins, *Remembering When*, 53–55; Sarah H. Harper, "Reid Library Serves Tyler's Black Citizens," *Tyler Morning Telegraph*, January 1, 2000; Knott, "One Collection, Two Contexts," 55.

16. "Commission Meet Slated Here Today," *Tyler Morning Telegraph*, January 3, 1969.

17. "Carnegie Library Expands Listings," *Tyler Courier-Times*, January 10, 1971; "Carnegie Adds 36 Selections," *Tyler Courier-Times*, November 29, 1970.

18. "Special Program Given at Meeting," *Tyler Morning Telegraph*, February 25, 1969.

19. Hendricks, "Wells-Barnett," 3, 337–40; Bay, *To Tell the Truth*, 3–328; Giddings, *Ida: A Sword*, 1–660; Schechter, *Wells-Barnett and American Reform*, 1–253; M. I. Thompson, *Wells-Barnett: An Exploratory Study*, xiii-280; Duster, *Ida B. the Queen*, 1–148.

20. Wells, *Crusade for Justice*, 415.

21. Hendricks, "Wells-Barnett," 3, 337–40.

22. Hendricks, *Gender, Race, and Politics*, 17.

23. Greenlee, "Alfreda Duster: Oral History," 133. Duster goes on to explain that despite her mother's full name being Ida B. Wells-Barnett at the time of her death in 1931, the naming committee decided to condense her name without the hyphen.

24. "Lay Ida B. Wells Homes Cornerstone," *Chicago Defender*, June 21, 1941; "Picket Line Mars Housing Project's Dedication: Strife Hounds Wells Unit Up to Very Last," *Chicago Defender*, November 2, 1940.

25. "'City In City' Honors Ida B. Wells," *Chicago Defender*, January 9, 1954; Sterling, afterword to *Memphis Diary*, 196; "Want Project Named after Ida B. Wells," *Chicago Defender*, January 28, 1939; "South Park Housing Project Named for Ida B. Wells, Noted Journalist," *Chicago Defender*, April 22, 1939; Lerner, "Early Community Work," 161.

26. "Chicago Builds New Homes for 1,662 Negro Families," *Cincinnati Enquirer*, January 14, 1941.

27. McMillen, "Public Housing in Chicago," 152, 153; University of Chicago Law Review, "Public Housing in Illinois," 306. The total cost was $8,769,000. The estimated total cost per unit was $5,305 versus $6,350 for the Jane Addams Houses, $5,645 for the Julia Lathrop Homes, and $5,728 for the Trumbull Park Homes.

28. "Chicago Home Project Open: Development Largest of Its Kind for Negroes in the World," *New York Star and Amsterdam News*, January 25, 1941; "'City In City' Honors Ida B. Wells."

29. "Wells Homes Mark 25th Year," *Chicago Tribune*, July 31, 1966.

30. "2-Day Fete Will Mark 25th Year of Wells Homes," *Chicago Defender*, July 20, 1966; "A Nostalgic Look at Ida Wells Homes," *Chicago Defender*, July 12, 1966.

31. Jerry Thornton, "Asbestos Still Fouls CHA Units," *Chicago Tribune*, April 20, 1987.

32. Bill Granger, "Homicide Cop," *Chicago Tribune Magazine*, February 10, 1980; Leanita McClain, "Six Success Stories from 'The Projects,'" *Chicago Tribune*, May 24, 1981.

33. Bill Granger, "Much Has Changed since Projects Were Built," *Daily Herald*, June 6, 1995.

34. R. Y. Williams, *Politics of Public Housing*, 126.

35. Daniel Ruth, "'Wells' on PBS Tells Life Story of Chicago Hero," *Chicago Sun-Times*, December 19, 1989.

36. Lolly Bowean, "A Sense of Community Remains," *Chicago Tribune*, September 8, 2019. New construction in some of the lot began in 2021.

37. Bowean, "A Sense of Community Remains."

38. Ida B. Wells-Barnett Museum, "Ida B. Wells-Barnett Museum"; Belinda Stewart Architects, PA, "Ida B. Wells-Barnett Museum and Cultural Center."

39. Duster, *Ida B. the Queen*, 1–148.

40. Angela Terrell, "Black Landmarks," *Washington Post*, August 3, 1974; Caryn Rousseau, "Sculpture Honoring Wells to Be Built in Chicago," Associated Press, December 28, 2011; Amanda Murphy, "Ida B. Wells Monument to Come to Bronzeville," *Columbia Chronicle*, November 21, 2011.

41. Lolly Bowean, "After Social Media Push, Organizers Raise Enough to Pay for Ida B. Wells-Barnett Monument," *Chicago Tribune*, July 17, 2018; Clark, "Bronze Statue Honoring Ida B. Wells"; Associated Press, "A Monument to Journalist, Civil Rights Activist Ida B. Wells Is Unveiled in Chicago," *NPR News*, July 1, 2021, https://www.npr.org/2021/07/01/1012203967/ida-b-wells-new-monument-unveiled-in-chicago; Astrid Kayembe, "Ida B. Wells Statue Unveiled in Downtown Memphis," *Memphis Commercial Appeal*, July 16, 2021, https://www.commercialappeal.com/story/news/local/2021/07/16/ida-b-wells-statue-memphis-lugar-bronze-foundry/7956770002/. The full-body statue of Ida B. Wells was unveiled at the Ida B. Wells Plaza in downtown Memphis, Tennessee, in July 2021.

42. Russell, "'In Them She Built Monuments,'" 383–410. Portions of this chapter's analysis have been published by the author in an expanded biography of Celia Dial Saxon.

43. Nettie George Speedy, "Mrs. Bethune of Florida Elected to Lead Women's Clubs," *Chicago Defender*, August 16, 1924.

44. C. D. Saxon to Mary McLeod Bethune, September 22, 1926, reel 6, 14, Records of the National Association of Colored Women's Clubs, 1895–1992, part 1, Bethesda, MD (hereafter cited as NACWC Records).

45. "Welcome! Teachers of the Palmetto Association: State Teachers in Annual Session," *Palmetto Leader*, March 28 1925.

46. "Five Thousand Negroes Enrolled," *State*, Sept 7, 1930.

47. "School Named for Negro Woman: Celia Saxon Honored by City Board,"

State, September 11, 1930; "South Carolina Teacher Honored," *Pittsburgh Courier*, September 20, 1930.

48. "Negro Teacher Honored," *State*, September 13, 1930.

49. "'Saxon Homes' Will Be Name of Seegars Park Area Project," *State*, March 14, 1952; "Saxon Homes Will Cost $2,487,347," *State*, March 15, 1952; "Saxon Homes to Be Dedicated Today," *State*, May 16, 1954; "Saxon Homes, 400-Unit Project for Negroes, Is Dedicated Here," *State*, May 17, 1954.

50. "Saxon Homes to Be Dedicated Sunday," *State*, May 11, 1954.

51. W. R. Bowman, "Saxon Homes Opened Wednesday; Adm. Chase Makes Statements," *Palmetto Leader*, April 18, 1953.

52. Regular meeting minutes of the Columbia Housing Authority, March 1952, Public Housing Scrapbook Collection.

53. "Saxon Homes to Be Dedicated Today."

54. "Saxon Homes, 400-Unit Project For Negroes, Is Dedicated Here"; "Saxon Homes to Be Dedicated Today."

55. Chuck Crumbo, "Battle for Property: Woman Vows to Keep Her Home, Memories," *State*, May 14, 2001; "Twenty Decision in the Past 20 Years Shaped Columbia for the Future," *State*, September 6, 2001.

56. "Water Fun Coming to Celia Saxon Community—Federal Grant Will Pay for Spray Pool, Educational Area at Harden Street Development," *State*, May 4, 2007.

57. City of Columbia, Richland County, Resolution R-2007-067, City of Columbia Utilities and Engineering Department, January 9, 2008; Columbia Housing Authority, "Transformation Plan Draft," City of Columbia, 2012; Real Property Research Group, "Market Feasibility Analysis, The Point at Elmwood Apartments, Columbia, Richland County, South Carolina," January 23, 2018; WLTX, "Columbia Housing Selling Shopping Center." The Columbia Housing Authority sold the Celia Saxon Shopping Center in 2021, which resulted in a name change. The AllSouth Federal Credit Union branch located in the shopping center, however, is still named for Celia Saxon.

58. Gina Smith, "Renaissance: Celia Saxon Neighborhood," *State*, June 15, 2006.

59. McDuffie, "Ward One Community."

60. Larry Wood, "Educator's Papers Shed Light on Reconstruction Era," *University of South Carolina Times*, October 9, 2008; Carolyn Click, "'A Grand and Noble Woman'—Saxon Was One of Few Black Women to Graduate USC after Civil War," *State*, October 12, 2008; Historic Columbia Foundation, "Celia Saxon School Honored," *Columbia Star*, September 19, 2008; "A List of the New Historic Markers," *State*, February 8, 2009; Joey Holleman, "Black History Markers to Spread Knowledge—Little-Known Facts Are 'Eye-Opening,' Columbia Official Says," *State*, February 8, 2009. Civil rights historian Bobby Donaldson, professor in the Department of History at University of South Carolina and founding director of the university's Center for Civil Rights History and Research, catalyzed the historic preservation of the Ward One community

and worked closely with the Historic Columbia Foundation and Ward One Organization to erect the historical marker.

Chapter 5. Mary McLeod Bethune and a New Era of Commemoration

1. "Bethune Memorial Is First Black Statue in the U. S. Capital," *Jet*, August 1, 1974, 12.

2. "Mary McLeod Bethune Memorial Dedication Schedule of Activities," July 10–12, 1974, series 8, box 6, folder 84, National Council of Negro Women Collection, Nation Archives for Black Women's History, Washington, DC (hereafter cited as NCNW Records); "Mary McLeod Bethune—Dedication—Lincoln Park," audio recording transcript, July 10, 1974, p. 15, series 15, box 5, folder 86, NCNW Records.

3. "Mary McLeod Bethune—Dedication—Lincoln Park," p. 25, NCNW Records.

4. Mary McLeod Bethune, "My Last Will and Testament," *Ebony*, August 1955, 107–10; "Mary McLeod Bethune—Dedication—Lincoln Park," p. 11, NCNW Records.

5. "Mary McLeod Bethune—Dedication—Lincoln Park," p. 7, NCNW Records.

6. K. Savage, *Standing Soldiers*, 89–128.

7. "Mary McLeod Bethune—Dedication—Lincoln Park," p. 19, NCNW Records.

8. Hanson, *Black Women's Political Activism*, 201.

9. US Department of the Interior, National Park Service, *A Monument to a Monument*, 10–11; Daugherty, "Lifting the Veil," 259–63; Woodley, "'Ma Is in the Park,'" 494–95.

10. Roger Baldwin to Bayard Rustin, December 1, 1970, series 8, box 1, folder 2, NCNW Records.

11. "Mary McLeod Bethune Memorial Dedication Schedule of Activities," July 10–12, 1974, NCNW Records.

12. Mary McLeod Bethune to Sue Baily Thurman, September 25, 1952, series 6, folder 001390-011-0798, Mary McLeod Bethune Papers: Bethune Foundation Collection, Part 2, Mary McLeod Foundation Archive, Bethune-Cookman College, Daytona Beach (hereafter cited as Bethune Papers).

13. Robertson, *Mary McLeod Bethune in Florida*, 55, 57.

14. "Brick upon Brick," [ca. 1950s], series 6, folder 001395-015-0415, Bethune Papers, Part 4.

15. Unsigned "Articles of Incorporation of Mary McLeod Bethune Foundation," January 1953, series 6, folder 001395-015-0415, Bethune Papers, Part 4.

16. Memorandum, "Summary of the Proposed Bethune Memorial Educational Center," August 3, 1962, series 8, box 7, folder 13, NCNW Records.

17. "Summary of the Proposed Bethune Memorial Educational Center," NCNW Records.

18. Joint Resolution Authorizing the Erection in the District of Columbia of a Memorial to Mary McLeod Bethune, Pub. L. No. 86–484, 74Stat.154 (1960); "Congressional Resolution for Memorial to Mary McLeod Bethune," *Atlanta Daily World*, June 4, 1960; "Ike Signs Bill Authorizing a 'Mary Bethune' Memorial," *New York Recorder*, June 11, 1960.

19. Daugherty, "Lifting the Veil," 258. Robert Berks was a celebrated national artist of the time; he also sculpted a bust of Abraham Lincoln that still resides in Ford's Theatre.

20. NCNW, "Art Exhibition in Commemoration of Mary McLeod Bethune," press release, ca. June 1962, series 8, box 1, folder 3, NCNW Records; "Donor Premiere," program, June 10, 1962, series 8, box 1, folder 3, NCNW Records.

21. "Donor Premiere," NCNW Records; "This Is Our Day," brochure, n.d., series 8, box 15, folder 3, NCNW Records; "Voices, Inc. Vocal/Dramatic Theatre presented by National Council of Negro Women, Inc.," [ca. 1960s], series 8, box 15, folder 3, NCNW Records.

22. Dorothy Height to Mary Knox, February 17, 1971, series 8, box 5, folder 5, NCNW Records.

23. Planning memorandum, "1974 Black Women's Institute—Bethune Memorial Symposia," [ca. 1974], series 8, box 14, folder 1, NCNW Records; "Mary McLeod Bethune Memorial Dedication Schedule of Activities," NCNW Records; Mary McLeod Bethune Commemoration Celebration, program, 1971, NCNW Records.

24. "Bethune Commemoration Month Proclaimed," press release, n.d., series 8, box 3, folder 10, NCNW Records.

25. "Special Preview of a Summer Art Festival in Harlem Sponsored by the National Council of Negro Women, Inc.," program, June 1965, series 8, box 3, folder 10, NCNW Records.

26. "Dr. Mary McLeod Bethune Memorial Fund Day," proclamation, May 18, 1971, series 8, box 3, folder 13, NCNW Records.

27. Sophie Pinkney et al. to NCNW, December 1, 1971, series 8, box 2, folder 1, NCNW Records; "Silver Tea," invitation, November 21, 1971, series 8, box 2, folder 1, NCNW Records; "Tea Will Benefit Memorial Fund," newspaper clipping, n.d., series 8, box 2, folder 1, NCNW Records.

28. Ruth Sykes to Mable Jordan, April 26, 1974, series 8, box 15, folder 6, NCNW Records; "Howard D. Woodson Choir Tour," program, 1974, series 8, box 15, folder 6, NCNW Records; "Howard D. Woodson Choir Singing for Mary McLeod Bethune," itinerary, May 9–13, 1974, series 8, box 15, folder 6, NCNW Records.

29. Annie M. Hall to Sykes, February 27, 1974, series 29, box 14, folder 14, NCNW Records.

30. Kaaren and David Klingol to Shirley Chisholm, May 8, 1969, series 8, box 6, folder 5, NCNW Records.

31. Hymie Cutter to NCNW, December 31, 1970, series 8, box 6, folder 5, NCNW Records.

32. Agnes W. Maucher to Height, January 6, 1971, series 8, box 6, folder 5, NCNW Records; David M. Sherr to NCNW, January 14, 1971, series 8, box 6, folder 5, NCNW Records.

33. Knox to Height, January 25, 1971, series 8, box 6, folder 5, NCNW Records.

34. Height to H. Natalie McKenzie, January 15, 1971, series 8, box 6, folder 17, NCNW Records.

35. Athey, "Poisonous Roots," 173; Curtis, *Black Heritage Sites*, v-viii.

36. For more on the Black Studies movement, see Rojas, *Black Power to Black Studies*; Dagbovie, *African American History*; Biondi, *Black Revolution on Campus*; Aldridge and Young, *Out of the Revolution*; Ford, *Black Studies*.

37. Hayward and Larouche, "Emergence of the Field," 163–72.

38. Collier-Thomas, "Towards Black Feminism," 43–66; Henry, "Promoting Historical Consciousness," 251–59.

39. Holt, *Bethune: A Biography*, 181–83. Philanthropist Marshall Field III donated $10,000 from his $11 million endowment for the Field Foundation toward the Council House headquarters after a bold and persuasive request from Bethune.

40. National Park Service, "The Council House: History of the Mary McLeod Bethune Council House National Historic Site."

41. Committee on Interior and Insular Affairs, *Authorizing Funds*, 57, 66, 88.

42. Bethune Museum opening, VHS videotape, 1979, NABWH_001_S15_SS7_F09, NCNW Records.

43. Barbara Gamarekian, "Interest Grows in Afro-American Women's History," *Alton Telegraph*, March 7, 1985.

44. "Museum of Black Women's History Grows in Capital Town House: Lecturers, Writers and a Banker," *New York Times*, March 16, 1980.

45. Leah Y. Latimer, "Bethune Home Is Center of Historical Site Debate," *Washington Post*, May 26, 1982.

46. Hutchinson went on to become a specialist in minority and women's affairs in the office of the secretary of the interior.

47. A Bill to Designate the Mary McLeod Bethune "Council House" in Washington, D. C., as a National Historic Site, and for Other Purposes, H. R. 6091, 97th Cong. (1982), 55.

48. Latimer, "Bethune Home Is Center of Historical Site Debate."

49. H. R. 6091, 68.

50. An Act to Designate the Mary McLeod Bethune Council House in Washington, District of Columbia, as a National Historic Site, and for Other Purposes, Pub. L. No. 97–329, 96 Stat. 1615 (1982).

51. Pub. L. No. 97–329.

52. Committee on Interior and Insular Affairs, *Authorizing Funds*, 27.

53. *Authorizing Funds*, 16–17, 27.

54. *Authorizing Funds*, 23, 48.

55. *Authorizing Funds*, 49.

56. *Authorizing Funds*, 64.

57. "National Park Service Exec. Stirs Furor over Bethune House Subsidy," *Jet*, August 19, 1985.

58. "National Park Service Exec. Stirs Furor over Bethune House Subsidy."

59. Freemuth, "National Parks," 281.

60. A Bill to Amend the Act of October 15, 1982, Entitled "An Act to Designate the Mary McLeod Bethune Council House in Washington, District of Columbia, as a National Historic Site, and for Other Purposes," Pub. L. No. 99–187, 99 Stat. 1181 (1985).

61. Charles Elder, "Funds Sought to Keep Bethune's Legacy Alive," *Washington Post*, April 27, 1989.

62. Committee on Energy and Natural Resources, *Miscellaneous National Parks Measures*, 66.

Chapter 6. From Murdering Voodoo Madam to Mother of Civil Rights

1. Joseph, *Waiting 'til the Midnight Hour*, 215.

2. The organization changed its name to the San Francisco African American Historical and Cultural Society in the 1970s.

3. Hall, *In the Vineyard*, 169–70.

4. "San Francisco Negro Historical and Cultural Society, Inc.," n.d., information sheet and membership form in "Oral History of the San Francisco African American Historical and Cultural Society, 1945–1986," Bancroft Library Oral History Center, University of California, Berkeley, (hereafter cited as "Oral History of SFAAHCS"), https://digitalassets.lib.berkeley.edu/rohoia/ucb/text/sanfranafricanhist00nancrich.pdf.

5. Mildred Hamilton, "How the Blacks See History," *San Francisco Examiner*, November 9, 1972; "San Francisco Negro Historical and Cultural Society, Inc.," Bancroft Library, University of California, Berkeley; "Mary Ellen Pleasant: Mother of Civil Rights in California," *Praisesinger*, July 28, 1983.

6. L. M. Hudson, *Making of "Mammy Pleasant,"* 22–23.

7. L. M. Hudson, "Pleasant, Mary Ellen," 2; 507–8; L. M. Hudson, *Making of "Mammy Pleasant,"* 1–120; Jackson, "Mary Ellen Pleasant, Nineteenth-Century Massachusetts," 312–30.

8. Michael Grieg, "Rubble of History, Mammy Pleasant's Old Home," *San Francisco Chronicle*, October 10, 1964; "Negro Composers Concert Theme," *Press Democrat*, February 4, 1968; "S. F. Arts Festival Opens," *San Francisco Chronicle*, September 25, 1968; "A Poem, Flowers, Sculpture, Boy's Poignant Memorial," *San Francisco Chronicle*, October 3, 1966; "Black Culture Lecture Series," *Oakland Post*, September 18, 1969.

9. "Negro Cultural History in California Reviewed, AAUW Program Featured," *Petaluma Argus-Courier*, April 11, 1968; "Salute to Negro Pioneer," *San Francisco Examiner*, August 19, 1968.

10. "Negro Cultural History in California Reviewed, AAUW Program Featured"; "California Negro History to Be Topic" *San Mateo Times*, September 12, 1968; "YWCA Plans Series on Influence of Black Culture on Music and Art," *San Rafael Daily Independent Journal*, September 12, 1969; "'Yours for the Cause,'" *San Mateo Times*, May 24, 1969; Charles F. Hampton, "James Herndon, Attorney at Law," interview, in "Oral History of SFAAHCS," 39; Blauner, *Black Lives, White Lives*, 310.

11. "California Negro History to Be Topic"; Toki Schalk Johnson, "On Campus," *Pittsburgh Courier*, December 21, 1968; Mildred Hamilton, "Black Madonna Art," *San Francisco Examiner*, July 3, 1968; "Black Madonna Visual Arts Show," *Sun Reporter*, December 7, 1968.

12. Elena Albert to Helen Holdredge, April 23, 1967, M43, Helen Holdredge Collection (SFH 36), San Francisco History Center, San Francisco Public Library (hereafter cited as Holdredge Collection); Grieg, "Rubble of History."

13. "History Vanishes in Wreck of Mammy Pleasant's Old San Francisco Home," *Humboldt Times*, October 10, 1964; Albert to Holdredge, April 23, 1967, Holdredge Collection.

14. "Outstanding Blacks Contributed to Early History of California," *San Mateo Times*, August 7, 1972; "Many Made Major Contributions, Interest in Black History Growing," *Los Angeles Times*, August 6, 1972.

15. Blauner, *Black Lives, White Lives*, 313.

16. "Ceremony at Grave," *Napa Valley Register*, February 13, 1965; "Remarkable Pioneer: Negroes Honor Mammy Pleasant," *San Francisco Chronicle*, February 13, 1965.

17. Mary Ellen Pleasant historical marker, Frances Albrier Papers, MS 108, African American Museum and Library at Oakland, Oakland Public Library.

18. "Memorial Services in Honor of Mary Ellen Pleasant, 1812–1904, Mother of Civil Rights in California, Friend of John Brown," program, 1965, Holdredge Collection.

19. Leslie, "'United, We Build,'" 192–218; Height, foreword to *Historical Cookbook*, vii-viii; "Mrs. Howard Thurman and Daughter, Team Charts Boston's Freedom Trails," *Pittsburgh Courier*, February 8, 1964.

20. Claire Leeds, "A Taste of History," *San Francisco Examiner*, February 8, 1959; "NCNW Succeeds in Initial Sales of Cookbook with Outline of American Negroes' History," *Jackson Advocate*, December 20, 1958; Tipton-Martin, *Jemima Code*, 74–75.

21. "Sue Bailey Thurman, Pioneering Activist, Dies at 93," *Jet*, January 20, 1997, 17; Broussard, "Strange Territory," 20–25.

22. Libby Clark, "Noted Clubwoman Is Author of New Book," *Pittsburgh Courier*, March 1, 1952; "Descendents of '49ers Share the Spotlight," *Pittsburgh*

Courier, August 9, 1952; "Book Review: Pioneers of Negro Origin in California by Sue Bailey Thurman," *Detroit Tribune*, March 8, 1952; "Largest Elks Confab Set for Los Angeles," *Pittsburgh Courier*, August 19, 1967.

23. Thurman, *Pioneers of Negro Origin*, 1–70.

24. Parker and Abajian, *A Walking Tour*, 2; Lena Baker, "Memorial Stroll: The City's Black Pioneer," *San Francisco Chronicle*, July 13, 1970.

25. Albert to Holdredge, April 23, 1967, Holdredge Collection.

26. Mildred Schroeder, "Mom, Pop—Even Stork, Degrees Are a Family Affair," *San Francisco Examiner*, June 18, 1967.

27. Hampton, "James Herndon, Attorney at Law," interview, in "Oral History of SFAAHCS," 17, 37.

28. "Mary E. Pleasant Park Dedicated," *Oakland Post*, February 15, 1976; "Smallest Park in S. F. to Be Dedicated," *Sun Reporter*, February 14, 1976; Dedication photographs, 1978, San Francisco Redevelopment Agency Records (SFH 371), San Francisco History Center, San Francisco Public Library.

29. Sullivan, *Guide to the Trees*, 11–12; City and County of San Francisco, Res. 552-07, File no. 071405 (approved October 16, 2007).

30. City of San Francisco, "Pleasant: A Life of Advocacy," 48.

31. Clyde Murdock, "Black Madam: Prostitution, Intrigue, Blackmail and Murder Helped Mammy Pleasant Gain Control of San Francisco during Rough Boisterous Days in 1880s," *Ebony*, November 1978, 53.

32. The Martin Luther King, Jr. Special Collection Project Staff to Advisory Board, August 17, 1979, San Francisco African American Historical and Cultural Society Vertical File, San Francisco Public Library; Robin Orr, "The Social Circle," *Oakland Tribune*, June 9, 1969. Albert and Thurman worked on a host of other significant programs with the Society, including the establishment of the Martin Luther King Jr. Special Collection at the San Francisco Public Library.

33. Murdock, "Black Madam," 53.

34. Murdock, "Black Madam," 53; Holdredge, *Mammy Pleasant's Partner*, vii–300.

35. Jesse Warr III, "Mammy Pleasant," *Ebony*, February 1979, 22.

36. West, Ebony *Magazine and Bennett*, 5.

37. Warr, "Mammy Pleasant," 22.

38. Bennett, *Before the Mayflower*, vii–412; Dagbovie, "History as a Core Subject," 621.

39. Editors of Ebony, *Ebony Pictorial History*, vol. 1, 1.

40. Dagbovie, "History as a Core Subject," 621; West, Ebony *Magazine and Bennett*, 31–90.

41. Lerone Bennett Jr., "A Historical Detective Story: Part I, The Mystery of Mary Ellen Pleasant: Was She a Public Benefactor or a Public Menace?," *Ebony*, April 1979, 90; Lerone Bennet, Jr., A Historical Detective Story: Part II, Mystery of Mary Ellen Pleasant," May 1979, 71 (Bennett's italics); Article drafts with notes, box 5, Lerone Bennett Jr. Papers, Stuart A. Rose Manuscript, Archives,

and Rare Book Library, Emory University, Atlanta (hereafter cited as Bennett Papers).

42. Some of the accounts of Pleasant's life include L. M. Hudson, *Making of "Mammy Pleasant"*; Bibbs, *Heritage of Power*; Bibbs, *Mother of Civil Rights*; Cliff, *Free Enterprise*; Powers, *Earthquake Weather*; Wills, *Black Fortunes*; Yates-Richard, "'In the Wake' of the 'Quake"; Papazoglakis, "'Feminist, Gun-Toting Abolitionist.'"

43. Blauner, *Black Lives, White Lives*, 315; "Sue Thurman, Widow of Noted Theologian Howard Thurman," *Los Angeles Sentinel*, February 13, 1997. Albert died in the early 1980s, and Thurman died in February 1997.

44. Bibbs, *Meet Mary Pleasant*; Bibbs, *Legacy of Mary Ellen Pleasant*; Bibbs, "Pleasant: Mother of Civil Rights in California"; Veale, "The Real History."

45. Bibbs, "Meet Mary Pleasant," 1996, *MEP Living Heritage Series*, 2, no. 1, box 5, Bennett Papers.

46. City and County of San Francisco, Res. 103-05, File no. 050159 (approved February 11, 2005); L. M. Hudson, "Lies, Secrets, and Silences," 139–40.

Chapter 7. The Madam Walker Theatre

1. Ridley, *From the Avenue*, 23–60; "Madame Walker's Aide Remembering for Others," newspaper clipping, April 8, 1984, box 10, folder 26, Ransom Family Papers, 1912–2011, M1200, William Henry Smith Memorial Library, Indiana Historical Society (hereafter cited as Ransom Papers).

2. For more on African American laundresses, see Clark-Lewis, *Living In, Living Out*; Hunter, *To 'Joy My Freedom*.

3. Bundles, *On Her Own Ground*, 15–297; Bundles, "Walker, Madam C. J.," 3, 308–13; Gill, *Beauty Shop Politics*, 1–136; Peiss, *Hope in a Jar*, 61–237.

4. Peiss, *Hope in a Jar*, 112; Bundles, *On Her Own Ground*, 96; Peiss, *Hope in a Jar*, 225.

5. Bundles, "Walker, Madam C. J.," 3, 309.

6. Bundles, *On Her Own Ground*, 107.

7. Hine, *Speak Truth to Power*, 100.

8. Thornbrough, *Indiana Blacks*, 14–15.

9. Hine, *Speak Truth to Power*, 135.

10. Bundles, *On Her Own Ground*, 135, 153.

11. Bundles, "Walker, Madam C. J.," 3, 311.

12. Freeman, *Gospel of Giving*, 1–208.

13. Bundles, *Madame Walker Theatre Center*, 7, 14.

14. Bundles, "Walker, Madam C. J.," 3, 312.

15. McBain, "Villa Lewaro Celebrates." Walker's elaborate mansion in New York, Villa Lewaro, was not preserved as a public history site until the twenty-first century. In 1977, the US Department of the Interior designated thirty-three new African American historic sites and districts as National Historic Landmarks,

Walker's mansion among them. It was not until 2018, however, that Villa Lewaro was purchased by New Voices Foundation and developed as a public history site.

16. Christopher Gray, "The Grand Mansion of an Early Black Entrepreneur," *New York Times*, April 24, 1994.

17. "Madame Walker's Aide Remembering for Others," April 8, 1984, Ransom Papers.

18. Bundles, *Madame Walker Theatre Center*, 27.

19. "Madame Walker's Aide Remembering for Others," April 8, 1984, Ransom Papers.

20. Bundles, *Madame Walker Theatre Center*, 8.

21. Bundles, *Madame Walker Theatre Center*, 7.

22. "The Walker Building Restoration Project," [ca. 1985?], information sheet, box 22, folder 4, M0649, Roselyn Comer Richardson Papers, 1900–1993, William Henry Smith Memorial Library, Indiana Historical Society (hereafter cited as Richardson Papers); Billy Rowe, "Lady and Her Historic Contributions Recognized," *New York Amsterdam News*, October 22, 1988.

23. Gibson-Hudson, "To All Classes," 63.

24. Triece, *Urban Renewal and Resistance*, 1–148; Saunders and Shackelford, *End of Black Culture*, 1–114; Wise and Clark, *Urban Transformations*, 1–229.

25. "The Walker Building Restoration Project," Richardson Papers; "Executive Director's Report For The Month of September 1988," box 16, folder 6, Ransom Papers.

26. Kyle Long, "Madame Walker's Legacy," *NUVO*, February 4, 2015.

27. "Madame Walker's Aide Remembering for Others," Ransom Papers.

28. "Articles of Amendment of the Articles of Incorporation and Code of By-Laws of the Madame Walker Building Urban Life Center, Inc.," July 13, 1979, box 15, folder 6, Ransom Papers.

29. Indiana Historical Society (hereafter cited as IHS), "Walker Building Renovation Party," *Black History News and Notes*, no. 35 (February 1989): 1.

30. Avery F. Brooks to Charles Blair, January 15, 1979, box 15, folder 15, Ransom Papers. Brooks, born and raised in Indiana, was an actor and professor of theater arts at Rutgers University.

31. Carl D. Anderson to Blair, memorandum, January 24, 1979, box 15, folder 15, Ransom Papers.

32. IHS, no title, *Black History News and Notes*, no. 7 (November 1981): 4.

33. IHS, "Walker Building Renovation Party," *Black History News and Notes*, no. 10 (August 1982): 1–2.

34. IHS, "Walker Building Renovation Party," 1–2.

35. IHS, "Film Makers Nelson and Grayson Receive Major Grants for Documentaries on Walkers and Indiana Avenue Neighborhood," *Black History News and Notes*, no. 6 (August 1981): 1–2, 11.

36. IHS, "Walker Building Renovation Party," *Black History News and Notes*, no. 14 (August 1983): 1.

37. "The Walker Building Restoration Project," Richardson Papers; "Madame

C. J. Walker Honored: The Rebirth of Walker Theatre Brings Celebs to Indianapolis," *Jet*, October 31, 1988, 53.

38. "Madame Walker's Aide Remembering for Others," Ransom Papers.

39. Kenneth Morgan, "Executive Director's Report for the months of April, May, June 1995," Ransom Family Papers. Historic Indianapolis, Inc., the Indianapolis Historic Preservation Commission, the Central Indiana Chapter of the Society of Architectural Historians, and the Indianapolis Chapter of the American Institute of Architects also presented them with the award.

40. "Madame C. J. Walker Honored: The Rebirth of Walker Theatre Brings Celebs to Indianapolis," 53.

41. Lynn Ford, "Memories Come Alive at Walker Reopening," *Indianapolis Star*, October 15, 1988.

42. Rowe, "Lady and Her Historic Contributions Recognized."

43. Anne Zidonis, "From Ironing Board to Chairman of Board," *USA Today*, October 17, 1988.

44. Gibson-Hudson, "To All Classes," 57.

45. "The Black Film Center/Archive and the Madame Walker Urban Life Center Present Freedom: A Lens on Black American and the Third World 1988 Film Festival," flyer, 1988, box 22, folder 4, Richardson Papers; Gibson-Hudson, "To All Classes," 61–63; A'Lelia P. Bundles, "Lost Women: Madam C. J. Walker—Cosmetics Tycoon," *Ms.*, July 1983, 93.

46. Annette Anderson, "The Early Days of the Avenue," *Indianapolis Recorder*, August 12, 1995.

47. Annette Anderson, "'Sellouts' Deny Blacks Slice of Avenue Pie?," *Indianapolis Recorder*, December 23, 1995.

48. "Madame Walker Inducted into Business Hall of Fame," *Indianapolis Business Journal*, March 23–29, 1992, box 10, folder 26, Ransom Family Papers; "Madam C. J. Walker to Be Inducted into National Business Hall of Fame," news release of Junior Achievement, Inc., March 4, 1992, box 10, folder 26, Ransom Papers; Thornbrough, "History of Black Women," 69.

49. IHS, "Walker Stamp Ceremony," *Black History News and Notes*, no. 71 (February 1998).

50. IHS, "Film Makers Nelson and Grayson Receive Major Grants for Documentaries on Walkers and Indiana Avenue Neighborhood"; Spears, "Makers of Local History," 2–13; Gibbs, *Indiana's African-American Heritage*, 1–243; IHS, "Index to Articles in *Black History News and Notes* (October, 1979-August, 1994)," no. 58 (November 1994); IHS, "Film Makers Nelson and Grayson Receive Major Grants for Documentaries on Walkers and Indiana Avenue Neighborhood."

51. "A Heritage Rediscovered," *Black Enterprise* 17, no. 12, (July 1987): 84.

52. Bundles, "Netflix's 'Self Made'"; Mattel, "Madam C. J. Walker Barbie"; National Archives, "'Meet' Madam C. J. Walker"; Brenda C. Siler, "Madam C. J. Walker Barbie Doll Now Available: Likeness of Successful Black Female Entrepreneur a Huge Success," *Washington Informer*, August 27, 2022.

53. Madam Walker Legacy Center, "Unveils Memorial Way, Future Plans."

54. Madam Walker Legacy Center, *Portal to Our Past*.

55. Bundles, "Lost Women: Madam C. J. Walker—Cosmetics Tycoon," 93.

Chapter 8. The Charlotte Hawkins Brown Site

1. Association for the Study of Afro-American Life and History (ASALH), "ASALH National Historic Marker Program, Memorandum," May 1, 1977, document 3, Academic organizations, 1960–77, Clarence Bacote Papers, Atlanta History Center.

2. Picott, "Editorial Comment: In Tribute," 803.

3. ASALH, "National Afro-American History Kit," 1978, box 1, folder 1, Educational Kits Collection, EPEK-112-01, Auburn Avenue Research Library on African-American Culture and History, Atlanta.

4. Brown changed her name from Lottie to Charlotte Eugenia after graduating high school.

5. Percy E. Murray, *History of the North Carolina Teachers Association*, 1984, 52, quotation on p. 22, Gelman Library, George Washington University, Black Teacher Archive, Harvard University Libraries.

6. Denard, introduction to *"Mammy,": Appeal to the Heart*, iii–xxxv.

7. Silcox-Jarrett, *One Woman's Dream*, 1–109; Wadelington and Knapp, *Brown and Palmer Memorial Institute*, xii–216.

8. Stan Swofford, "Palmer Falling into Ruin," *Greensboro Daily News*, May 11, 1975.

9. David Boul, "As Assembly Honors Her Aunt: Widow of Nat Cole Visits Guilford," *Greensboro News and Record*, June 11, 1984; "North Carolina General Warranty Deed [Bennett College to Muhammad Mosque No. 2, Inc.]," November 28, 1980, Charlotte Hawkins Brown Museum Papers, Charlotte Hawkins Brown Museum, Sedalia, NC (hereafter cited as Brown Papers).

10. "Sedalia Set for Palmer Celebration," *Daily Times-News*, June 12, 1986; Jim Scholosser, "Palmer Institute Founder Is Honored," *Greensboro News and Record*, June 11, 1986; Kim Weaver, "Service to Honor Palmer Institute Founder," *Daily Times-News*, June 10, 1989.

11. Swofford, "Palmer Falling into Ruin."

12. "Cover Story: Founder of Palmer Institute," *African American Tymes*, January 1995, vol. 2, 8; Swofford, "Palmer Falling into Ruin."

13. "Charlotte Hawkins Brown Historic Foundation Black History Banquet Program," 1991, series 6, folder 3, #142, Abraham H. Peeler Papers, Greensboro History Museum Archives (hereafter cited as Peeler Papers); "History of the Charlotte Hawkins Brown Historical Foundation, Inc.," [ca. 1988], Peeler Papers; "Support Group For Palmer School Set," *Carolina Peacemaker*, December 3, 1983; "Support Group Organized for Black History Site," *Carolina Times*, December 17, 1983, series 6, folder 3, #142, Peeler Papers. The inaugural CHBHF Board of Directors were Marie Hill Gibbs (president), Burleigh Webb (vice president), Marie Hart (corresponding secretary), Jeanne Rudd (recording secretary),

Ruth Totton (historian), and Dr. Isaac (treasurer). The CHBHF received IRS designation as a nonprofit in 1984.

14. "Charlotte Hawkins Brown Historic Site Dedication Ceremony Program Book," 1987, Peeler Papers; "Charlotte Hawkins Brown Historic Foundation Black History Banquet Program," 1991, Peeler Papers; "Charlotte Hawkins Brown Historic Foundation Fact Sheet Brochure," [ca. 1985], Peeler Papers.

15. Swofford, "Palmer Falling into Ruin."

16. Bev Smith, "Honors for First Black Historic Site Scheduled," *Carolinian*, January 31, 1985; Newspaper clippings, Bennett College Scrapbook 1987–89, Bennett College Scrapbook Collection, Thomas F. Holgate Library, Bennett College for Women, Greensboro, NC (hereafter cited as Bennett Collection).

17. Charlotte Hawkins Brown Advisory Council Meeting Outline, [ca. 1988], Peeler Papers.

18. Jim Schlosser, "Memorial to Brown Probable," *Greensboro News and Record*, July 13, 1983; Newspaper clippings, Bennett College Scrapbook 1987–89, Bennett College Collection.

19. Burns-Vann and Vann, *Sedalia and Palmer Memorial Institute*, 122.

20. Jim Scholosser, "Friends of Palmer Move Closer to Goal of Brown Memorial," *Greensboro News and Record*, July 28, 1983; General Assembly of North Carolina, Senate DRS8590, session 1983, July 1, 1983, Brown Papers.

21. "Daniel," *Daily Times-News*, February 7, 1989.

22. Wadelington and Knapp, *Brown and Palmer Memorial Institute*, 267; "Historic Site to Highlight State's Black History," *Carolina Peacemaker*, Feb 16, 1985, Bennett College Scrapbook 1990–99, Bennett Collection; Bernie Woodall, "Black Heritage Celebrated," *Greensboro News and Record*, November 5, 1989, Bennett College Scrapbook 1987–89, Bennett Collection. Annette Gibbs was Marie Gibbs's daughter and successor in the CHBHF.

23. Charlotte Hawkins Brown Historical Foundation, "CHBHF Fact Sheet," brochure, n.d., Peeler Papers.

24. "The Charlotte Hawkins Brown Historical Foundation, Inc. Black History Commemorative Banquet," February 16, 1991, Peeler Papers.

25. James B. Hunt, Jr., State of North Carolina Proclamation, "Dr. Charlotte Hawkins Brown Day," June 11, 1984, Governor's Office, Charlotte Hawkins Brown Museum. This framed proclamation hangs at the entrance of the Charlotte Hawkins Brown Museum Visitor's Center.

26. North Carolina Office of Archives and History, "Forty-First Biennial Report: The North Carolina Division of Archives and History, 1984–1986," 1987, pp. 35, 219, Division of Archives and History, North Carolina Department of Cultural Resources, North Carolina Digital State Publications Collection, State Library of North Carolina, Raleigh (hereafter cited as NC Publications); Rothell Howard, "Martin, Gist Net Funds," *Carolina Peacemaker*, July 13, 1985.

27. James S. Tinney, "Muslims to Open N. C. College for Teachers," *National Leader*, September 2, 1982; Newspaper clippings, n.d., "The American Muslim

Teacher College," advertisement; "OK's Muslim College," *Bilalian News*; "AMTC Hosts National Education Conference," *A. M. Journal*, Brown Papers.

28. "History of the Charlotte Hawkins Brown Historical Foundation, Inc.," [ca. 1988], pp. 3–4, Peeler Papers.

29. Larry G. Misenheimer to Friends of Charlotte Hawkins Brown, March 13, 1987, Peeler Papers.

30. Sidney R. Sharif to Annette Gibbs, February 22, 1988, Brown Papers.

31. Marie H. Gibbs on behalf of the Charlotte Hawkins Brown Historical Foundation, Inc., "Memorandum of Understanding," March 18, 1985, Brown Papers; William N. Martin to Theodore Williamson, Jr., March 10, 1986, Brown Papers.

32. "History of the Charlotte Hawkins Brown Historical Foundation, Inc.," [ca. 1988], p. 4, Peeler Papers.

33. Newspaper clippings, n.d., "The AMTC Campus" photo caption and "Historical Map: Palmer Memorial Institute 1902–1971 Sedalia, NC," Brown Papers; "Old Palmer Institute Plan Snagged," *Daily Times-News*, April 20, 1987; Eddie Huffman, "Legislature Approves Palmer Institute Funds," *Daily Times-News*, July 17, 1986.

34. Eddie Huffman, "Palmer Institute Historic Site behind Schedule," *Daily Times-News*, July 15, 1986.

35. "State's Plans Are Trimmed for Charlotte Brown Museum," *Daily Times-News*, September 12, 1985.

36. "Charlotte Hawkins Brown Historic Foundation Fact Sheet Brochure," [ca. 1985], Peeler Papers.

37. Dorothy P. Barnett to Annette Gibbs, June 11, 1984, Brown Papers; Eloise McKinny Johnson to Marie Gibbs, March 25, 1986, Brown Papers; Michael Roberts, "Palmer Alumni Return to Area, Promote Historic Black Institute," *Carolina Peacemaker*, February 23, 1985; Richard L. Williams, "200 Honor N. C. Black Educator," *Raleigh Times*, June 11, 1984; "School Memories," *News and Observer*, June 12, 1984.

38. Scholosser, "Friends of Palmer Move Closer to Goal of Brown Memorial"; Newspaper clippings, Bennett College Scrapbook 1982–87, Bennett Collection.

39. "Charlotte Hawkins Brown Historic Site Dedication Ceremony Program Book," 1987, Peeler Papers.

40. "History of the Charlotte Hawkins Brown Historical Foundation, Inc.," pp. 3–4, Peeler Papers.

41. "Charlotte Hawkins Brown Historic Site Dedication Ceremony Program Book," 1987, Peeler Papers.

42. Charlotte Hawkins Brown Historic Foundation, Inc., *Newsletter* 1, no. 1, 1991, Peeler Papers.

43. "Saturday Ceremonies Will Open Palmer Historic Site," *Daily Times-News*, November 6, 1987.

44. Eddie Huffman, "State Historic Site Dedicated at Sedalia," *Daily Times-News*, November 8, 1987.

45. "Charlotte Hawkins Brown Historic Site Dedication Ceremony Program Book," 1987, Peeler Papers.

46. Huffman, "State Historic Site Dedicated at Sedalia."

47. "Society World: Cocktail Chitchat," *Jet*, Oct 12, 1987, 34.

48. Alva Stewart, "The Heritage of Charlotte Hawkins Brown," *State*, February 1988; Charlotte Hawkins Brown Advisory Council Meeting Outline, [ca. 1988], Peeler Papers.

49. Eddie Huffman, "Highway Dedicated to Founder of School," *Daily Times-News*, April 23, 1988.

50. Charlotte Hawkins Brown Advisory Council Meeting Outline, [ca. 1988], Peeler Papers.

51. JanMichael Poff, ed., *Addresses and Public Papers of James Grubbs Martin, Governor of North Carolina, Volume 1, 1985–1989* (Raleigh: Division of Archives and History Department of Cultural Resources, Outer Banks History Center Monographs, 1992), 809; Huffman, "Highway Dedicated to Founder of School."

52. "Highway Dedicated to Founder of School."

53. "Alamance Scene: Sedalia Black History," *Daily Times-News*, February 3, 1988.

54. "African-American Heritage Festival to Be Held June 13," *Greensboro News and Record*, May 18, 1998; "Sedalia Set for Palmer Celebration." Subsequent festivals were held in June to commemorate Brown's birthday, June 11. The festival was held on the second Saturday in June, but if it did not fall on June 11, a separate celebration was held at the site. It also continued the tradition of the PMI alumni annual birthday celebration.

55. "Briefing: Heritage Festival," *Daily Times-News*, November 3, 1988.

56. "African-American Festival Scheduled Nov. 5," *Daily Times-News*, October 12, 1988.

57. Susan Ladd, "Charlotte Hawkins Brown Memorial Celebration Scheduled," *Greensboro News and Record*, November 2, 1988.

58. "The Correct Thing," *Charlotte Hawkins Brown Museum Newsletter* 6, no. 6, n.d., NC Publications; "Black History Observances Set," *Daily Times-News*, February 5, 1989.

59. Robin Adams, "Skin-Tone Biases Survive from Antebellum Period," *Greensboro News and Record*, April 9, 1993.

60. Michael Robinson, "Revelation about Black Educator Is Disappointing," *Greensboro News and Record*, April 20, 1993.

61. Jeanne Lanier Rudd to Editor, News and Record, April 29, 1993, Brown Papers.

62. Thomas C. Parker to Rudd, April 29, 1993; Richard Skeete, Jr. to Editor, News and Record, May 1, 1993; Julia H. Hudson to Editor, News and Record, May 4, 1993; Maxine Smith Martin to Editor, News and Record, July 8, 1993. All letters cited in this note are from Brown Papers.

63. Thomas C. Parker, "Black Educator Didn't Have Racial Preferences," *Greensboro News and Record*, May 6, 1993; Christine Jenkins Flanagan, "Skin

Tone Was Not an Issue at Palmer," *Greensboro News and Record*, May 7, 1993; Editor, "Palmer Institute Didn't Discriminate against Some Blacks," *Greensboro News and Record*, May 15, 1993. The May 15 "Editor's Note" identified that Robin Adams's "source for the material about skin-tone discrimination at Palmer Memorial Institute was the book, *The Color Complex: The Politics of Skin Color among African Americans*, by Kathy Russell, Midge Wilson and Ronald Hall."

64. Editor, "Palmer Institute Didn't Discriminate against Some Blacks."

65. Charles Wadelington, North Carolina Department of Cultural Resources, "Justice Sought for Dr. Brown," May 20, 1993, Brown Papers.

66. Melissa Manware, "Book Offers a Guided Tour of N. C. Black Historic Sites," *Greensboro News and Record*, July 26, 1992.

67. Annette Gibbs to Home Office Staff, State of North Carolina Department of Cultural Resources, "Introduction and Informal discussion with Ms. Charlotte Hawkins Sullivan," August 4, 1987, CHBMS; "Charlotte Hawkins Brown Historic Site Dedication Ceremony Program Book 1987"; "Charlotte Hawkins Brown Historic Foundation Fact Sheet Brochure," [ca. 1985], Peeler Papers.

68. Alice Thrasher, "Tribute to a Leader," *Fayetteville Observer*, Feb 7, 1988; Jim Schlosser, "Oral History Restoration," *Greensboro News and Record*, July 9, 1992.

69. Howard O. Hendricks, "Furnishings Plan for Canary Cottage," April 1993, Brown Papers.

70. "Charlotte Hawkins Brown Museum to Observe Centennial," *Carolina Comments* 50, no. 2 (2002): 21, 23–24.

71. Mark Price, "Crumbling Heritage: As African American Historical Sites Decay, Movements Emerge to Preserve Them," *Charlotte Observer*, November 26, 1995.

72. Lauren Vespoli, "Endangered Dorms at a Prestigious Former School for Black Students," *Preservation Magazine* (Summer 2022), https://savingplaces.org/stories/endangered-dorms-at-a-prestigious-former-school-for-black-students#; B. Jones, "11 Most Endangered Historic Places"; North Carolina Historic Sites, "Palmer Dormitory Revitalization."

Chapter 9. Celia Mann, Modjeska Simkins, and Historic Columbia

1. "Historic preservation was undertaken on a highly individualistic basis, usually in response to some emergency that threatened a site. The rumor of destruction would mobilize friends . . . and through the enthusiasm generated by a crisis a goal would be achieved." Whitehill, "The Right of Cities to Be Beautiful," 47.

2. Rains and Henderson, *With Heritage So Rich*, 1–230; National Historic Preservation Act of 1966, Pub. L. No. 89–665, 80 Stat. 915 (2021).

3. Kenneth C. Turino, "America Doesn't Need Another House Museum (And What About Collections?)," *History News* 64, no. 2 (Spring 2009): 12.

4. Richland County, South Carolina, "Richland County Leads Charge." Richland County, where Columbia is located, has a total of three house museums (Mann-Simons Site, Modjeska Monteith Simkins Home, and Harriet Barber Home), all traditional public history sites that commemorate legacies of African American women.

5. Celia Mann, will dated August 25, [1867], proved September 19, [1867], Court of Probate, Richland County, South Carolina, 38–39.

6. "Death of a Respected Colored Woman," *Daily Phoenix*, September 9, 1867; "Funeral Invitation," *Daily Phoenix*, September 8, 1867; "Local Items: Death of a Respected Colored Woman," *Daily Phoenix*, September 8, 1867.

7. Crockett, "Democracy of Goods," 208–37; Crockett, *History and Archaeology*, 1–89; "Under Decree in Equity," *Daily Phoenix*, February 6, 1870; "Celia Mann: Midwife and Matriarch," video, September 2023, Mann-Simons Site Collection, Historic Columbia.

8. Mann, will, 38–39.

9. Agnes Jackson, will dated May 27, 1903, proved October 22, [1907], Court of Probate, Richland County, South Carolina, 68–69.

10. Karin Burchstead, "Good As New: Mann-Simons Cottage Represents Columbia's Free Black Community," *Columbia Record*, May 18, 1978; Clark Surratt, "Home Is History—Mann-Simons Cottage Vital to Story of Bernice Conners, S. C.," *State*, February 1, 1993; Bernard V. Kearse, "The Mann-Simons House," March 16, 1973, National Register, South Carolina Department of Archives and History, Columbia.

11. "Agenda and Attachments, August 10, 1977, Richland County Historic Preservation Committee," General 1976–77, Isaiah DeQuincey Newman Papers, South Carolina Political Collections, Ernest F. Hollings Special Collections Library, University of South Carolina (hereafter cited as Newman Papers); Dawn Hinshaw, "Rivals Unite to Preserve Houses: Old Feud Waning as Groups Pull Together for 4 Columbia Sites," *State*, May 15, 1994.

12. CeCe Byers-Johnson to I. DeQuincy Newman, April 7, 1983, General 1983, Newman Papers; Correspondence from Frank L. Taylor and Newman, March 1975, General 1974–75, Newman Papers. Reverend Newman's contributions as a memorializer were instrumental. He was recognized for his work to save the site in the early 1980s with a donor plaque placed prominently in the home.

13. Orr, "Historic House Museum Sustainability," 21.

14. Francois Pierre Nel, "Free at Last, She Bought Home Celia Mann's Cottage Open for Columbia," *Charlotte Observer*, December 7, 1989.

15. "Black History Month," *State*, February 9, 2006.

16. Joe Logan, "Funds Are Sought to Restore Home," *State*, March 7, 1975.

17. Richland County Conservation Commission, "Agenda," August 10, 1977, Newman Papers.

18. "Mann-Simons Benefit Today at Prince Hall," *State*, March 29, 1978.

19. Dawn Hinshaw, "Downtown Dig Reveals Abundance of Artifacts," *State*,

May 7, 1998; Dawn Hinshaw, "Mann-Simons Cottage to Get Historic Marker," *State*, January 9, 2009; Burchstead, "Good as New."

20. Surratt, "Home is History."

21. "Preserving the Past," *Columbia Record*, December 28, 1978.

22. "CeCe Byars [*sic*] on Mann-Simons Cottage: Outtakes" (Columbia, SC: WISTV Awareness Story 112, 1979), 16mm film, Moving Image Research Collections, University of South Carolina.

23. "CeCe Byars [*sic*] on Mann-Simons Cottage—Outtakes."

24. "Landmark Restored: Cottage-Opening Jubilee Planned," *Columbia Record*, May 11, 1978.

25. Burchstead, "Good As New."

26. Dawn Hinshaw, "Rivals Unite to Preserve Houses Old Feud Waning as Groups Pull Together For 4 Columbia Sites," *State*, May 15, 1994. The Richland County Historic Preservation Commission began as a public entity designed to save historic sites in Columbia and Richland County and eventually developed into HCF in 1994. HCF was private and garnered private funds as well as received continued support from the county and state governments. Whereas public funds from the commission supported the acquisition and largescale renovations of the historic homes, HCF helped furnish, maintain, and develop educational programming. "The commission owns and operates the four historic houses, while the foundation owns most of the furnishings." In 1994, the commission disbanded, and HCF took over the properties. In 2017, HCF renamed itself Historic Columbia. In 2024, HCF manages seven historic homes.

27. John Sherrer, "Award Winner Spotlight: Historic Columbia Foundation: Connecting Communities through History," *History News* 66, no. 4 (Autumn 2011): 28. In addition to managing the Mann-Simons Site and Modjeska Simkins Home, Historic Columbia has successfully revised their museum interpretive narratives in the twenty-first century to present a multidimensional depiction of history that includes and, at times, centers African American history at each of their sites, particularly the Woodrow Wilson House and the Hampton-Preston Mansion.

28. Jon Bream, "Columbia, S. C.—Architecture Tells a Piece of the Story," *Star Tribune: Newspaper of the Twin Cities*, March 30, 1997; Danny Flanders, "Tours Cast Soft Glow of Christmases Past," *State*, December 6, 1992; Douglass Steimle, "Mann-Simons Cottage: An African-American Shrine," *Columbia Examiner*, May 9, 2009.

29. Michael Miller, "Jubilee to Explore Influence of African-American Culture," *State*, August 20, 1999; "Jubilee Celebrates the Life of Celia Mann," *State*, August 18, 2008; "Festivals Bloom in July and August," *State*, June 29, 2001.

30. Tanya Fogg Young, "Event Showcases African Culture," *State*, August 31, 2003.

31. Dawn Hinshaw, "Jubilee Festival Looks Back on Columbia's Black History," *State*, September 17, 1994; Dawn Hinshaw, "Black Culture Focus of Jubilee," *State*, October 1, 1994; Staff Report, "Festival Highlighting African-American Contributions Coming Up This Weekend," *Gamecock*, August 19, 1999.

32. "Annual Festival Celebrates Black Heritage," *Sun News*, August 20, 1999.

33. "Ebony Travel Guide: What's Happening Where!," *Ebony*, August 2006.

34. Bill Starr, "Historic Sites Tour Highlights Black History," *State*, February 6, 2000.

35. "Jubilee Celebrates Life of Celia Mann"; Warner Montgomery, "Standing on the Shoulders of Many," *Columbia Star*, August 29, 2008.

36. Douglas Steimle, "Historic Columbia Foundation to Hold Oral History Contest," *Columbia Examiner*, July 20, 2009.

37. Anita Baker, "African American Sites in Columbia Need to Be Preserved," *Columbia Star*, August 24, 2012.

38. Michelle McCullers, "Festival to Share Art, Culture African-American Creations, Performances Highlight Area's Let's Share Celebration," *State*, September 1, 1996; Bill McDonald, "Juneteenth Festival Full of Soul," *State*, June 21, 1998; B. J. Ellis, "Black History Month February Is Time to Celebrate," *State*, January 28, 1988.

39. "Herbal Essence," *State*, May 31, 1995; Chuck Crumbo, "Timeless Beauty: Historical Gardens Growing in Popularity," *State*, March 22, 1998; Res. R-2006-035, City of Columbia (Aug 16, 2006).

40. Donald Wood, "Coming Up—Historic Foundation Sets Two Events," *State*, September 9, 2002; "Close to Home," *State*, September 12, 2002; Dawn Hinshaw, "Festival Kicks Off Fund Raising for Marker, *State*, September 19, 2002; WeGOJA, *Teacher's Guide*, 97–98, 106. Mary McLeod Bethune was the first African American woman in South Carolina to have a historical marker erected.

41. "Historic Projects Honored," *State*, May 21, 2004; Shalama Jackson, "Awards to Recognize Preservation Efforts," *State*, May 7, 2005; Warner Montgomery, "Historic Columbia Awards Preservation," *Columbia Star*, June 2, 2006; Jessica Foster, "Tours to Visit Columbia's Historic Black Sites: Trolley Rides Will Be Given in February to Honor Black Heritage," *Gamecock*, January 31, 2003.

42. Dawn Hinshaw, "'Dig' Might Unearth Clues to Early Black Life in Columbia," *State*, April 17, 1998.

43. Douglas Steimle, "Celia Mann and the Mann-Simons Cottage," *Columbia Examiner*, January 7, 2011; Dawn Hinshaw, "Rewriting History of Mann-Simons Cottage—Black History Month," *State*, February 27, 2011; Crockett, "Democracy of Goods," 208–37; Crockett, *History and Archaeology*, 1–89.

44. Douglas Steimle, "Ghost Structures at Mann-Simons Site," *Columbia Examiner*, May 8, 2012.

45. "Historic Columbia Foundation Announces the Completion of the Mann-Simons Outdoor Museum," *Columbia Star*, February 15, 2013.

46. Lois Carlisle, "As Yet Untold: The Reinterpretation of the Mann-Simons Site," *Garnet & Black*, Fall 2016, 21–23; Historic Columbia, "Mann-Simons Site."

47. Matt Long, "Refurbished Mann-Simons Cottage Will Reopen to Public This Weekend," *South Carolina Radio Network*, September 16, 2016.

48. Steve Benjamin, "What One Family's Adversity and Perseverance Teach Us," *State*, September 12, 2016.

49. "Celia Smith: Reflections on Her Family's Legacy," September 2023, MPEG video, Mann-Simons Site Collection, Historic Columbia.

50. Bruce, *Sustainers*, 84; Woods, "Simkins, Mary Modjeska Monteith," 3, 115–17; Aba-Mecha, "Black Woman Activist,"1–412; Jhan Robbins, "Oral History with Modjeska Simkins," October 28, 1985, Walker Local and Family History Center, Richland County Public Library.

51. Heather B., "Columbia Women"; 159 Cong. Rec. H8215 (daily ed. June 6, 2013) (statement of Hon. James E. Clyburn).

52. Bruce, *Sustainers*, 84; Woods, "Simkins, Mary Modjeska Monteith," 3, 115–17; Aba-Mecha, "Black Woman Activist,"1–412; Jhan Robbins, "Oral History with Modjeska Simkins," October 28, 1985, Walker Local and Family History Center, Richland County Public Library.

53. Diane Lore, "Blacks Set Examples of Success: 12 to Be Featured as Role Models for Youths," *State*, November 29, 1989; Vicki Shealy, "School Districts to Celebrate Triumphs of Black Americans," *State*, Feb 1, 1990.

54. Bhakti Larry Hough, "S. C. ETV Focuses Lens on Civil Rights Warrior," *State*, February 19, 1990.

55. Lori Roberts, "'Stand Up' for Her 92nd Birthday, Simkins Gets Honors," *State*, December 5, 1991; POINT, "Do Something."

56. William Starr, "Just in Time—New Edition Expands on S. C. Women," *State*, March 17, 1991; Bodie, *South Carolina Women*, 1–170. The second edition of Bodie's *South Carolina Women* included Simkins's biography to address the limited biographies of Black women in the first edition.

57. Lee Bandy, "'She Showed Us How to Live'—Simkins' Spirit Lives, Mourners Say," *State*, April 10, 1992; "Richland House Members Will Lead to Caucuses," *State*, November 21, 1992; Nina Brook and Cindi Ross Scoppe, "Meetings to Set Tone of Session: Impact of New Lawmakers to Be Tested in Both Houses," *State*, December 6, 1992; Michelle Davis, "Artist Lifts First Black Justice from the Shadows of History," *State*, February 26, 1996.

58. Bruce, *Sustainers*, 88; Ernest Wiggins, "Blacks' Role in Columbia: Chronicled Videos Seek to Capture History Before It's Lost," *State*, February 2, 1992.

59. Joseph Stroud, "Center a Doorway to Civil-Rights History," *State*, December 15, 2002.

60. Bertram Rantin, "Group Plans to Restore Simkins' House," *State*, May 22, 1996; Jill Hanson, "The Modjeska Monteith Simkins Home," *OAH Magazine of History* 12, no. 1 (1997), 19; Bruce, *Sustainers*, 94–97.

61. Dawn Hinshaw, "Capturing History Preservation of Home Allows Civil Rights Legacy to Live On," *State*, May 26, 1997.

62. Rantin, "Group Plans to Restore Simkins' House."

63. "Home Nears Third of Goal," *State*, December 6, 1996.

64. "$20,000 Raised in Effort to Restore Simkins Home," *State*, October 16, 1996; "Home Nears Third of Goal"; Hanson, "The Modjeska Monteith Simkins Home," 19.

65. Hinshaw, "Capturing History Preservation."

66. Bill McDonald, "Yard Sale Funds to Restore Home: Simkins Residence to Become a Center," *State*, October 11, 1997.

67. Allison Askins, "Pilgrims to Retrace Slave Trade Route to Group to Arrive in Columbia Friday, March to Simkins House," *State*, August 12, 1998.

68. Warren Bolton, "Simkins Center a Worthy Tribute to Feisty, Dedicated Activist," *State*, April 3, 2001; Dawn Hinshaw, "Ceremony Marks Renovation of Civil Rights Leader's Home," *State*, April 5, 2001.

69. Lee Bandy, "Lieberman Stumps in S.C., Hits Bush on Jobs, Poverty," *State*, January 19, 2004.

70. "Refurbish Simkins' Home, Tell Her Story," *State*, April 12, 2007.

71. Gina Smith, "Medal to Commemorate Briggs' Part in Decision," *State*, May 7, 2004; "Richland County: About Town," *State*, June 7, 2004; Williesha Lakin, "'Freedom' Bus to Stop in Columbia," *State*, June 11, 2004.

72. Katrina Goggins, "Home of S. C. Civil Rights Matriarch Could Face Demolition," *Union Daily Times*, December 15, 2006.

73. Gina Smith, "Repairs Urged for Civil Rights Site," *State*, December 15, 2006.

74. Gina Smith, "Saving a Part of History—BlueCross Comes to Home's Rescue," *State*, August 7, 2007.

75. Catherine Fleming Bruce, "Simkins House Will Be Center Piece of Civil Rights Movement in Columbia," *State*, September 1, 2007.

76. Kevin Fisher, "Modjeska Simkins Deserves Better," *Free Times*, June 17, 2010.

77. Andrew Moore, "Simkins Restoration Requires Public-Private Partnership," *Free Times*, July 25, 2007.

78. "Columbia to Help Restore Modjeska Simkins House," *State*, August 17, 2007.

79. "Jim Clyburn's Earmarks," *State*, August 9, 2010.

80. ABC Columbia Site Staff, "Modjeska Simkins Birthday Party!"

81. Dy Lucas, "New Group Aims to Join Talks on Transit—Midlands Buses," *State*, April 4, 2013; "Historic Columbia Sponsors Public Archaeology Days at Modjeska Simkins Site," *Columbia Examiner*, November 13, 2012; "Historic Columbia Offers Early Adventures: Celebrating African-American Heritage," *Columbia Examiner*, January 22, 2013.

82. "Local and State," *Post and Courier*, June 16, 2013; "Historic Columbia Foundation Receives 2013 Preservation Service Award," *Carolina Panorama*, June 20, 2013; "Life of Noted Civil Rights Warrior Modjeska Simkins to Be Celebrated," *Carolina Panorama*, November 28, 2013; South Carolina Progressive Network, "About: Modjeska Simkins School."

83. Douglas Steimle, "Historic Columbia Foundation Presents 'Walking in the Footsteps,'" *Columbia Examiner*, February 11, 2011; Historic Columbia, "Journey to Freedom Tour."

Conclusion

1. E. B. Brown, "Constructing Life and Community," 28–30.

2. Marlowe, *Right Worthy Grand Mission*, xv.

3. E. B. Brown, "Constructing Life and Community," 29.

4. Hine and Thompson, *Shining Thread of Hope*, 202.

5. E. B. Brown, "Womanist Consciousness," 610–33.

6. National Park Service, "Maggie L. Walker: History & Culture."

7. "Maggie L. Walker, Negro Leader, Dies," *Richmond-Times Dispatch*, December 16, 1934; Garrette-Scott, *Banking on Freedom*, 41–111.

8. "Negro to Head School for First Time," *Richmond-Times Dispatch*, February 10, 1936.

9. "Negro to Head School For First Time"; "1,115,900 Spent by PWA in Richmond," *Richmond-Times Dispatch*, September 18, 1937.

10. Richmond Public Schools, "Armstrong High School." Armstrong was also the founder of Hampton Institute in Virginia.

11. "Walker Site Considered for Museum," *Richmond-Times Dispatch*, October 17, 1975.

12. "8 Places Named State Landmarks," *Richmond-Times Dispatch*, April 27, 1975; "Area Given Designation," *Richmond-Times Dispatch*, April 21, 1976; Raymond P. Rinehart, "Black Historic Area Gets Official Status; New Challenge Faced: A Richmond Subdivision," *Washington Post*, September 25, 1976.

13. P. W. Kaufman, *National Parks and Woman's Voice*, 228–29.

14. WTVR, "Statue of Richmond Icon."

15. Treisman, "Capitol Unveils Mary McLeod Bethune Statue"; Dr. Mary McLeod Bethune Statuary Fund, Inc., "Pride of Florida"; Rayna Song, "Mary McLeod Bethune's Statue from Florida Will Make History in the U. S. Capitol," *Tampa Bay Times*, November 11, 2021, https://www.tampabay.com/news/florida-politics/2021/11/11/mary-mcleod-bethunes-statue-from-florida-will-make-history-in-the-us-capitol/; US Representative Kathy Castor, "Rep. Castor Welcomes Bethune Statue."

16. Ben Cadigan, "Statue Honoring Vel Phillips to Be Constructed at State Capitol by 2023," *Badger Herald*, November 4, 2021, https://badgerherald.com/news/2021/11/04/statue-honoring-vel-phillips-to-be-constructed-at-state-capitol-by-2023/; Laura Schulte, "'She'd Be Proud': Statue of Trailblazer Vel Phillips Approved for Wisconsin State Capitol Grounds," *Milwaukee Journal Sentinel*, November 1, 2021, https://www.jsonline.com/story/news/local/wisconsin/2021/11/01/statue-black-woman-trailblazer-vel-phillips-approved-capitol/6233021001/.

17. Emily Opilo, "'A Room with a Different View': Maryland Unveils Statues of Harriet Tubman, Frederick Douglass in State House," *Baltimore Sun*, February 10, 2020; Brigit Katz, "Harriet Tubman and Frederick Douglass Honored with Statues in Maryland State House," *Smithsonian Magazine*, February 12, 2020; Gasca, "Statues Unveiled at Maryland State House."

18. Treisman, "Maya Angelou, Sally Ride on U. S. Coins"; US Mint, "Announces

Designs for 2022 American Women"; US Mint, "American Women Quarters™ Program"; Circulating Collectible Coin Redesign Act of 2020, Pub. L. No. 116–330, 134 Stat. 5101 (2021); US Mint, "American Liberty Coin"; A. J. Willingham, "For the First Time Ever, There Will Be a Black Lady Liberty on a Coin," *CNN*, last updated January 13, 2017, https://www.cnn.com/2017/01/13/us/lady-liberty -coin-trnd/index.html#. Other women in the 2022 American Women Quarters series are Sally Ride, Wilma Mankiller, Nina Otero-Warren, and Anna May Wong.

19. New York City Cultural Affairs, "She Built NYC"; "Shirley Chisholm Monument in NYC Marks First Public Artwork Honoring a Woman," *New York Beacon*, July 27, 2023; "New York City Mayor Adams to Revive Creation of Paused Monuments Honoring New York City Women," Targeted News Service, March 29, 2024; Nadja Sayej, "'Her Legacy Is Incredible': Behind the Shirley Chisholm 'Anti-monument,'" *Guardian*, May 21, 2019; National Park Service, "Shirley Chisholm State Park Opens."

20. City of Houston, "Public Artwork Honoring Jordan"; City of Houston, "Houston's First Sculpture Honoring Barbara Jordan"; Austin-Bergstrom International Airport, "Barbara Jordan Memorial Statue"; Robert Faires, "The Barbara Jordan Statue at UT," *Austin Chronicle*, April 24, 2009.

21. Harriet E. Wilson is the first African American to publish a novel in the United States. Cathay Williams disguised her gender to enlist and serve as a Buffalo Soldier.

22. Fannie Lou Hamer Resource Center, "Fannie Lou Hamer Statue."

23. This statement appears on a wall in the foyer of The Colored Girls Museum.

24. "Mary Seacole Statue Unveiled in London," *BBC News*, June 30, 2016, https://www.bbc.com/news/uk-england-london-36663206; Mary Seacole Trust, "Mary Seacole Statue"; Amy Fleming, "Sculptor Defends His Mary Seacole Statue: 'If She Was White, Would There Be This Resistance?,'" *Guardian*, June 21, 2016, https://www.theguardian.com/artanddesign/2016/jun/21/sculptor-defends -his-mary-seacole-statue-if-she-was-white-would-there-be-this-resistance.

25. Brigit Katz, "New Statue Immortalizes Mary Thomas, Who Led a Revolt Against Danish Colonial Rule," *Smithsonian Magazine*, April 4, 2018, https://www .smithsonianmag.com/smart-news/denmark-unveils-monument-queen-mary -thomas-who-led-revolt-against-danish-colonial-rule-180968661/; Martin Selsoe Sorensen, "Denmark Gets First Public Statue of a Black Woman, a 'Rebel Queen,'" *New York Times*, March 31, 2018.

26. Jenkins, "A Statue for the Past"; "Betty Campbell: Statue Honours Wales' First Black Head Teacher," *BBC News*, September 29, 2021, https://www.bbc.com/ news/uk-wales-58721710.

27. Historic Harriet Barber House, "Our History."

28. Michael Sponhour, "A Home for History Time Has Worn Away," *State*, February 6, 1994.

29. Loretta Neal, "Home Tour Demonstrates Life in Lower Richland of the Past," *State*, May 17, 1990.

30. Sponhour, "A Home For History Time Has Worn Away."

31. Joy Woodson, "'This Is Our Heritage'—Freed Slaves' Home Saved Richland County Funds Will Help in Restoration of 1880s Homestead in Hopkins," *State*, December 24, 2006; "Metro and State Briefly," *State*, June 6, 2007.

32. "Grants to Help Restore Landmark Schoolhouses," *State*, June 15, 2006.

33. "'We're All Connected': Group to Promote Lower Richland's Heritage Corridor," *State*, July 19, 2007; Dawn Hinshaw, "Tourism Funds Flowing to Lower Richland Area—Plan Will Push Historic Sites, *State*, July 9, 2008.

34. Joey Holleman, "New Markers Tell Story of Lower Richland," *State*, September 10, 2010.

35. "Cook's Calendar," *State*, February 10, 2010.

36. South Eastern Rural Outreach, "Lower Richland Memorial Day Celebration 2016: The Moving Wall," *One Columbia*, May 30, 2016.

37. "Juneteenth Celebration June 19–21," *Columbia Star*, June 6, 2014.

38. Megan Sexton, "Treasured Trees," *State*, December 6, 2009.

39. Jennifer Schuessler, "'America's Oldest Park Ranger' Is Only Her Latest Chapter," *New York Times*, September 20, 2021; National Park Service, "Betty Reid Soskin Biography."

Bibliography

Manuscript Collections

African American Museum and Library at Oakland, Oakland Public Library (Oakland, CA)
 California State Association of Colored Women's Clubs, Inc.
 Francis Albrier Papers
Anacostia Community Museum Archives (Washington, DC)
 Black Women: Achievements against the Odds Exhibition Records
Atlanta History Center (Atlanta, GA)
 Clarence Bacote Papers
Auburn Avenue Research Library on African-American Culture and History (Atlanta, GA)
 Educational Kits Collection
Avery Research Center for African American History and Culture (Charleston, SC)
 Phillis Wheatley Literary and Social Club Papers
Bancroft Library Oral History Center, University of California, Berkeley (Berkeley, CA)
 Community and Identity Oral Histories Individual Interviews
Blair-Caldwell African American Research Library (Denver, CO)
 Justina Ford Medical Society Collection
Minus Collection
 Paul Stewart Collection
Brooklyn Historical Society (Brooklyn, NY)
 Richetta Randolph Wallace Papers
Charlotte Hawkins Brown Museum (Sedalia, NC)
 Charlotte Hawkins Brown Museum Papers

Columbia Housing Authority (Columbia, SC)
 Public Housing Scrapbook Collection
Ernest F. Hollings Special Collections Library, University of South Carolina (Columbia, SC)
 Isaiah DeQuincey Newman Papers, 1911–1985, South Carolina Political Collections
 WIS-TV Outtakes, Moving Image Research Collections
Greensboro History Museum Archives (Greensboro, NC)
 Abraham H. Peeler Papers
Harvard University Libraries (Cambridge, MA)
 The Black Teacher Archive
Historical Society of Pennsylvania (Philadelphia, PA)
 Ella Reid Public Library (Negro Public Library) Records
Historic Columbia (Columbia, SC)
 Mann-Simons Site Collection
Indiana Historical Society William Henry Smith Memorial Library (Indianapolis, IN)
 Alta M. Jett Collection
 Bernice Walker Papers
 Black History News and Notes
 Black Women in the Middle West Project Collection
 Indianapolis Recorder Collection
 Indianapolis YWCA Collection, Phyllis Wheatley Branch
 Mary D. Yore Papers
 Ransom Family Papers
 Roselyn Comer Richardson Papers
 Sojourner Truth Club Records
 Madam C. J. Walker Collection
Iowa Women's Archives, University of Iowa Libraries
 Dora E. Mackay Papers
James Branch Cabell Library, Virginia Commonwealth University (Richmond, VA)
 Richmond YWCA Records, Phyllis Wheatley Branch
Library Company of Philadelphia (Philadelphia, PA)
 African Americana Collection
Library of Congress (Washington, DC)
 Mary Church Terrell Papers
Margaret Walker Alexander National Research Center, Jackson State University (Jackson, MS)
 Margaret Walker Alexander's Personal Journals Digital Collection
Mary McLeod Bethune Foundation Archive, Bethune-Cookman College (Daytona Beach, FL)
 Mary McLeod Bethune Foundation Collection, Part 4

Minnesota Historical Society
 Records of the Phyllis Wheatley Community Center
National Archives for Black Women's History (Washington, DC)
 National Council of Negro Women Collection
 Bethune Museum and Archives Collection
National Association of Colored Women's Clubs (Bethesda, MD)
 Records of the National Association of Colored Women's Clubs, 1895–
 1992, Part 1
New York Division of Archives and History (Albany, NY?)
New York Public Library (New York City, NY)
 American Fund for Public Service Records
North Carolina Division of Archives and History (Raleigh, NC)
Outer Banks History Center Monographs
North Carolina Historic Sites (Raleigh, NC)
 Charlotte Hawkins Brown Museum Records
San Francisco History Center, San Francisco Public Library (San Francisco, CA)
 Helen Holdredge Collection
 San Francisco African American Historical and Cultural Society Vertical
 File
 San Francisco Redevelopment Agency Records
Seymour Public Library (Auburn, NY)
 Harriet Tubman Binder Collection
Schlesinger Library on the History of Women in America (Cambridge, MA)
 Black Women Oral History Project Interviews
 Shirley Graham Papers
Schomburg Center for Research in Black Culture (New York, NY)
 Earl Conrad/Harriet Tubman Collection
 Schomburg Center for Research in Black Culture records, 1924–1979
Smithsonian National Museum of African American History and Culture
 Harriet Tubman Collection, Gift of Charles L. Blockson
 Memorabilia and Ephemera–Advertisements and Media Arts Collections
 Milton Williams Photography Collection, Gift of Milton Williams Archives
South Carolina Department of Archives and History (Columbia, SC)
National Register
South Caroliniana Library, University of South Carolina (Columbia, SC)
 Celia Dial Saxon Vertical File
State Library of North Carolina (Raleigh, NC)
 North Carolina State Publications Collection
Stuart A. Rose Manuscript, Archives, and Rare Book Library, Emory University
 (Atlanta, GA)
 Kelly Miller Family Papers
 Lerone Bennett Jr. Papers
 Lucille Clifton Papers
 Universal Negro Improvement Association Records

Thomas F. Holgate Library, Bennett College for Women (Greensboro, NC)
 Bennett College Scrapbook Collection
University of Massachusetts Amherst Libraries Special Collections (Amherst, MA)
 W. E. B. Du Bois Papers
Walker Local and Family History Center, Richland County Public Library (Columbia, SC)
 Celia Dial Saxon Vertical File
 Oral History Collection

Newspapers and Magazines

Advertiser-Journal (Auburn, New York)
Advocate (Baton Rouge, LA)
African American Tymes (Winston-Salem, NC)
Afro-American (Baltimore, MD)
Albuquerque Journal
Alexandria (LA) Daily Town Talk
Alton (IL) Telegraph
Appeal (St. Paul, MN)
Atlanta Daily World
Altoona (PA) Mirror
Ames (IA) Daily Tribune
Anaconda (MT) Standard
Arizona Republic (Phoenix)
Arizona Sun (Flagstaff)
Arizona Tribune (Phoenix)
Associated Press
Atlanta Daily World
Auburn (NY) Citizen
Augusta Chronicle
Austin Chronicle
Baltimore Afro-American
Baltimore Sun
Badger Herald (Madison, WI)
Bangor (ME) Daily News
BBC News
Bilalian News (Chicago, IL)
Black Enterprise
Black History News and Notes (Indianapolis, IN)
Black World
Birmingham News
Broad Ax (St. Paul, MN)
Brooklyn Daily Eagle

Buffalo Courier
Buffalo Rising
Bystander (Des Moines, IA)
(North) Carolina Comments
Carolina Panorama (Columbia, SC)
Carolina Peacemaker (Greensboro, NC)
Carolina Times (Durham, NC)
Carolinian (Raleigh, NC)
Cayton's Weekly (Seattle, WA)
Cincinnati Enquirer
Charlotte Observer
Chicago Defender
Chicago Sun-Times
Chicago Tribune
Christian Recorder
Citizen-Advertiser (Auburn, NY)
Clarion-Ledger (Jackson, MS)
Cleveland Gazette
CNN
Colorado Springs Gazette Telegraph
Colored American
Columbia Chronicle
Columbia Examiner
Columbia Record
Columbia Star
Crisis
Daily Gate and Constitution (Keokuk, IA)
Daily Hawk-Eye Gazette (Burlington, IA)
Daily Herald (Arlington Heights, IL)
Daily Phoenix
Daily Standard (Red Bank, NJ)
Daily Times-News (Burlington, NC)
Democrat and Chronicle (Rochester, NY)
Denver Star
Des Moines Daily News
Detroit Tribune
Ebony
Elmira (NY) Advertiser
Evening Star (Washington, DC)
Fairfield (IA) Journal
Fayetteville (NC) Observer
Federation Journal (Durham, NC)
Franklin's Paper, The Statesman (Denver, CO)
Frederick Douglass' Paper

Freedomways
Free Times (Columbia, SC)
Gamecock (Columbia, SC)
Garnet and Black (Columbia, SC)
Guardian (US Edition)
Greensboro (NC) Daily News
Greensboro (NC) News and Record
Greenville (SC) News
Harrisburg (PA) Telegraph
Helena (MT) Daily Independent
High Point (NC) Enterprise
Holland (MI) Evening Sentinel
Holt County Sentinel (Oregon, MO)
Humboldt Times (Eureka, CA)
Indianapolis Recorder
Indianapolis Star
Iowa (State) Bystander
Jackson (MS) Advocate
Jefferson (IA) Herald
Jet
Journal Times (Racine, WI)
Kansas City (MO) Sun
Keokuk (IA) Daily Gate City
Liberator
Lincoln (NE) Journal Star
Lincoln (NE) State Journal
Los Angeles Sentinel
Los Angeles Times
Madisonian (Virginia City, MT)
Marshalltown (IA) Times-Republican
Memphis Commercial Appeal
Michigan Chronicle (Detroit)
Milwaukee Journal Sentinel
Mountain Express (Asheville, NC)
Ms.
Muncie (IN) Evening Press
Muscatine (IA) Journal
Napa Valley Register
Nashville Globe
National Leader (Philadelphia, PA)
National Public Radio News
Negro Digest
New Journal and Guide (Norfolk, VA)
New Pittsburgh Courier

News and Observer (Raleigh, NC)
News and Record (Greensboro, NC)
New York Age
New York Recorder
New York Star and Amsterdam News
New York Times
New York Tribune
Northwest Enterprise (Seattle, WA)
NUVO (Indianapolis, IN)
Oakland (CA) Post
Oakland (CA) Tribune
One Columbia (SC)
Palimpsest (Des Moines, IA)
Palladium-Item (Richmond, IN)
Palmetto Leader (Columbia, SC)
Petaluma (CA) Argus-Courier
Philadelphia Tribune
Pioche (NV) Weekly Record
Pittsburgh Courier/New Pittsburgh Courier
Pittsburgh Post-Gazette
Pittsburgh Press
Port Arthur (TX) News
Portsmouth (OH) Times
Post and Courier (Charleston, SC)
Post-Crescent (Appleton, WI)
Post-Standard (Syracuse, NY)
Praisesinger (San Francisco, CA)
Preservation Magazine
Press and Sun-Bulletin (Binghamton, NY)
Press Democrat (Santa Rosa, CA)
Provincial Freeman (Windsor, Canada)
Raleigh (NC) Times
Richmond (VA) Times-Dispatch
Rocky Mountain News (Denver, CO)
Rocky Mount (NC) Telegram
Saint Paul (MN) Globe
San Francisco Chronicle
San Francisco Examiner
San Mateo (CA) Times
San Rafael (CA) Daily Independent Journal
Sheboygan (WI) Press
Smithsonian Magazine
South Carolina Radio Network
Southern Indicator (Columbia, SC)

Star Tribune: Newspaper of the Twin Cities (Minneapolis/Saint Paul, MN)
State (Columbia, SC)
Statesman (Denver, CO)
St. Paul (MN) Daily Globe
Summit Herald (Summit, NJ)
Sun News (Myrtle Beach, SC)
Sun Reporter (San Francisco)
Syracuse Herald Journal
Tampa Bay Times
Targeted News Service
Times and Democrat (Orangeburg, SC)
Topeka (KS) State Journal
Tyler (TX) Courier-Times
Tyler (TX) Morning Telegraph
Union (SC) Daily Times
University of South Carolina Times (Columbia)
USA Today
Washington (DC) Informer
Washington (DC) Post
Waterloo (IA) Weekly Courier
Wilson (NC) Daily Times
Wisconsin Jewish Chronicle
Wisconsin Magazine of History

Government Documents

Committee on Energy and Natural Resources. *Miscellaneous National Parks Measures: Hearing before the Subcommittee on Public Lands, National Parks and Forests of the Committee on Energy and Natural Resources, US Senate, One Hundred First Congress, Second Session on* [. . .] *September 20, 1990.* Washington, DC: US Government Printing Office, 1990.

Federal Security Agency: War Manpower Commission. *Final Report of the National Youth Administration Fiscal Years, 1936–1943.* Washington, DC: Government Printing Office, 1944.

House Subcommittee on National Parks and Recreation of the Committee on Interior and Insular Affairs. *Authorizing Funds for the Mary McLeod Bethune National Historic Site and Land Conveyances in the State of Maryland.* 99th Cong., 1st sess., July 18, 1985.

House Subcommittee on Public Lands and National Parks of the Committee on Interior and Insular Affairs. *Public Land Management Policy (H.R. 6091).* 97th Cong., 2nd sess., May 20, 1982.

US Department of the Interior, National Park Service. *Final General Management Plan/Environmental Impact Statement: Mary McLeod Bethune Council House National Historic Site.* Washington, DC: US Geological Survey, 2001.

US Department of the Interior, National Park Service. *General Guidelines for Identifying and Evaluating Historic Landscapes.* Washington, DC: US Geological Survey, 1999.

US Department of the Interior, National Park Service. *Historic Furnishings Report Maggie L. Walker House, Volume 1: Historical Data.* Washington, DC: US Geological Survey, 2004.

US Department of the Interior, National Park Service. *A Monument to a Monument: Mary McLeod Bethune Council House.* Washington, DC: US Department of the Interior, National Park Service, n.d.

US Library of Congress. Congressional Research Service. *National Park System: Establishing New Units,* by Carol Hardy Vincent. Open-file report, U.S. Geological Survey. Washington, DC, 2014.

Selected Books and Articles

Aba-Mecha, Barbara Woods. *See also* Woods, Barbara. "Black Woman Activist in Twentieth Century South Carolina: Modjeska Monteith Simkins." PhD diss., Emory University, 1978.

ABC Columbia Site Staff. "Modjeska Simkins Birthday Party!" *ABC Columbia,* November 23, 2015. https://www.abccolumbia.com/2015/11/23/modjeska-monteith-simkins-birthday-party/.

Alanen, Arnold R., and Robert Z. Melnick, eds. *Preserving Cultural Landscapes in America.* Baltimore: Johns Hopkins University Press, 2000.

Aldridge, Delores P., and Carlene Young, eds. *Out of the Revolution: The Development of Africana Studies.* Lanham, MD: Lexington Books, 2000.

American Philatelic Society. *Black Heritage Series.* Sidney, OH: Amos Press, 2017.

Anderson, Lisa M. *Mammies No More: The Changing Image of Black Women on Stage and Screen.* Lanham, MD: Rowman and Littlefield, 1997.

Athey, Stephanie. "Poisonous Roots and the New World Blues: Rereading Seventies Narration and Nation in Alex Haley and Gayl Jones." *Narrative* 7, no. 2 (1999): 169–93.

Atkins, Rodney Lamar. *Remembering When We Were Colored in Tyler, Texas: Volume 1.* Self-published, 2007.

Austin-Bergstrom International Airport. "Barbara Jordan Memorial Statue at the Airport." Accessed November 9, 2023. http://www.austintexas.gov/department/barbara-jordan-memorial-statue-airport.

B., Heather. "Columbia Women: A Walking Tour." *Richland Library* (blog). March 14, 2022. https://www.richlandlibrary.com/blog/2022-03-11/columbia-women-walking-tour

Bair, Barbara. "Universal Negro Improvement Association." In *Black Women in America,* 2nd ed., edited by Darlene Clark Hine, 273-274. New York: Oxford University Press, 2005.

Bandele, Ramla M. *Black Star: African American Activism in the International Political Economy.* Urbana: University of Illinois Press, 2008.

Bay, Mia. *To Tell the Truth Freely: The Life of Ida B. Wells*. New York: Hill and Wang, 2009.

Beasley, Delilah L. *The Negro Trail Blazers of California: A Compilation of Records* [. . .]. Los Angeles: Times-Mirror Printing and Binding House, 1919.

Belinda Stewart Architects, PA. "Ida B. Wells-Barnett Museum and Cultural Center of African American History Renovation." Accessed March 21, 2018. https://belindastewartarchitects.com/portfolio/ida-b-wells-barnett-museum -cultural-center-of-african-american-history-renovation/.

Bennett, Lerone, Jr. *Before the Mayflower: A History of Black America*. Chicago: Johnson, 1962.

Berrett, Joshua. "The Golden Anniversary of the Emancipation Proclamation." *Black Perspective in Music* 16, no. 1 (1988): 63–80.

Bibbs, Susheel. *Heritage of Power: Marie LaVeaux to Mary Ellen Pleasant*. Sacramento: MEP, 2012.

———. *The Legacies of Mary Ellen Pleasant: Mother of Civil Rights in California*. Sacramento: MEP, 1998.

———. *The Legacy of Mary Ellen Pleasant*. DVD. Sacramento: MEP Productions, 2007.

———. "Mary Ellen Pleasant: Mother of Civil Rights in California." Accessed August 11, 2020. http://mepleasant.com/index.html

———. *Meet Mary Pleasant: Mother of Civil Rights in CA*. DVD. Sacramento: MEP Productions, 2008.

Biondi, Martha. *The Black Revolution on Campus*. Berkeley: University of California Press, 2012.

Black, Jeremy. *Contesting History: Narratives of Public History*. London: Bloomsbury Academic, 2014.

Blain, Keisha N., and Tiffany M. Gill, eds. *To Turn The Whole World Over: Black Women and Internationalism*. Urbana: University of Illinois Press, 2019.

Blauner, Bob. *Black Lives, White Lives: Three Decades of Race Relations in America*. Berkeley: University of California Press, 1989.

Bodie, Idella. *South Carolina Women*. Orangeburg: Sandlapper, 1990.

Bouknight, Ashley. "Black Museology: Reevaluating African American Material Culture." PhD diss., Middle Tennessee State University, 2016.

Boyd, Kaitlin Therese. "The Criminalization of Black Angeleno Women: Institutionalized Racism and Sexism in Los Angeles, 1928–1938," PhD diss., University of California, Los Angeles, 2012.

Bradford, Sarah H. *Harriet: The Moses of Her People*. New York: Geo. R. Lockwood and Son, 1886.

———. *Scenes in the Life of Harriet Tubman*. Auburn, NY: W. J. Moses, 1869.

Broussard, Albert S. "Strange Territory Familiar Leadership: The Impact of World War II on San Francisco's Black Community." *California History* 65, no. 1 (1986): 18–25.

Brown, Carolyn J. *Song of My Life: A Biography of Margaret Walker*. Jackson: University Press of Mississippi, 2014.

Brown, Charlotte Hawkins. *"Mammy": An Appeal to the Heart of the South; The Correct Thing to Do—to Say—to Wear.* New York: G. K. Hall, 1995.

Brown, Elsa Barkley. "Constructing a Life and a Community: A Partial Story of Maggie Lena Walker." *Organization of American Historians Magazine of History* 7, no. 4 (1993): 28–31.

———. "Womanist Consciousness: Maggie Lena Walker and the Independent Order of Saint Luke." *Signs* 14, no. 3 (1989): 610–33.

Bruce, Catherine Fleming. *The Sustainers: Being, Building and Doing Good through Activism in the Sacred Spaces of Civil Rights, Human Rights and Social Movements.* Charleston, SC: Quality Books, 2016.

Brundage, W. Fitzhugh. *The Southern Past: A Clash of Race and Memory.* Cambridge: Belknap Press of Harvard University Press, 2005.

———, ed. Where These Memories Grow: History, Memory, and Southern Identity. Chapel Hill: University of North Carolina Press, 2000.

Bundles, A'Lelia. *Madame Walker Theatre Center: An Indianapolis Treasure.* Charleston, SC: Arcadia, 2013.

———. "Netflix's 'Self Made' Suffers from Self-Inflicted Wounds." *Andscape.* May 12, 2020. https://andscape.com/features/netflixs-self-made-suffers -from-self-inflicted-wounds/.

———. On Her Own Ground: The Life and Times of Madam C. J. Walker. New York: Washington Square Press, 2001.

———. "Walker, Madam C. J. (Sarah Breedlove)." In *Black Women in America*, 2nd ed., edited by Darlene Clark Hine, 3, 308–13. New York: Oxford University Press, 2005.

Burns, Andrea A. *From Storefront to Monument: Tracing the Public History of the Black Museum Movement.* Amherst: University of Massachusetts Press, 2013.

Burns-Vann, Tracey, and André D. Vann. *Sedalia and the Palmer Memorial Institute.* Charleston, SC: Arcadia, 2004.

Cameron, Jenks. *The National Park Service: Its History, Activities, and Organization.* New York: D. Appleton, 1922.

Carby, Hazel V. "Policing the Black Woman's Body in an Urban Context." *Critical Inquiry* 18, no. 4 (1992): 738–55.

Carretta, Vincent. *Phillis Wheatley: Biography of a Genius in Bondage.* Athens: University of Georgia Press, 2011.

Chase-Riboud, Barbara. "Slavery as a Problem in Public History: Or Sally Hemings and the 'One Drop Rule' of Public History." *Callaloo* 32, no. 3 (2009): 826–31.

City of Houston. "City Issues Nationwide Request for Qualifications for Public Artwork Honoring Barbara Jordan." Press release. August 2, 2019. https://www .houstontx.gov/culturalaffairs/20190802.html.

———. "Houston's First Sculpture Honoring Barbara Jordan Comes to Civic Art Collection." Press release. October 27, 2021. https://www.houstontx.gov/ culturalaffairs/20211027.html.

City of San Francisco. "Mary Ellen Pleasant: A Life of Advocacy." In *African*

American Citywide Historic Context Statement. Adopted February 21, 2016, 48. https://sfplanning.org/african-american-historic-context-statement#.

Clark, Kym. "Bronze Statue Honoring Ida B. Wells to Be Unveiled This Summer." *WMC Action News.* February 6, 2021. Video. https://www.wmcactionnews5.com/2021/02/06/bronze-statue-honoring-ida-b-wells-be-unveiled-this-summer/.

Clark-Lewis, Elizabeth. *Living In, Living Out: African American Domestics in Washington, D.C., 1910–1940.* Washington, DC: Smithsonian Institution, 2010.

Cliff, Michelle. *Free Enterprise: A Novel of Mary Ellen Pleasant.* San Francisco: City Lights, 1993.

Clinton, Catherine. *Harriet Tubman: The Road to Freedom.* New York: Little, Brown, 2004.

Cole, Bettie, and Autumn Redcross. *The African Americans of Sewickley Valley.* Charleston, SC: Arcadia, 2008.

Collier-Thomas, Bettye. "Towards Black Feminism: The Creation of the Bethune Museum-Archives." *Special Collections* 3, no. 3–4 (1985): 43–66.

Colorado Experience. Season 1, episode 102, "Justina Ford, M.D." Aired February 28, 2013, on Rocky Mountain PBS. http://video.rmpbs.org/video/2349544027/.

Crenshaw, Kimberlé. "Mapping the Margins: Intersectionality, Identity Politics, and Violence against Women of Color." *Stanford Law Review* 43, no. 6 (1991): 1241–99.

Crockett, Jakob D. "'A Democracy of Goods': An Archaeology of Commodity Landscapes in Columbia, South Carolina, 1870–1930." PhD diss., University of South Carolina, 2011.

———. *History and Archaeology at the Mann-Simons Site.* Columbia, SC: Historic Columbia Foundation, 2012.

Crummell, Alexander. *The Black Woman of the South: Her Neglects and Her Needs.* Cincinnati, OH: Woman's Home Missionary Society, 1883.

Curtis, Nancy C. *Black Heritage Sites: An African American Odyssey and Finder's Guide.* Chicago: American Library Association, 1996.

Dagbovie, Pero Gaglo. *African American History Reconsidered.* Urbana: University of Illinois Press, 2010.

———. "History as a Core Subject Area of African American Studies: Self Taught and Self-Proclaimed African American Historians, 1960s–1980s." *Journal of Black Studies* 37, no. 5 (2007): 602–29.

———. *What Is African American History?* Cambridge, UK: Polity Press, 2015.

Danilov, Victor J. *Women and Museums: A Comprehensive Guide.* Lanham, MD: AltaMira Press, 2005.

Daugherty, Ellen Kathleen. "Lifting the Veil of Ignorance: The Visual Culture of African American Racial Uplift." PhD diss., University of Virginia, 2004.

Davis, Elizabeth Lindsay. *The Story of the Illinois Federation of Colored Women's Clubs / The History of the Order of the Eastern Star among Colored People* (by

Mrs. S. Joe Brown), edited by Henry Louis Gates Jr. New York: G. K. Hall, 1997.

Deas-Moore, Vennie. *Columbia, South Carolina.* Charleston, SC: Arcadia, 2000.

De Graaf, Lawrence B. "Race, Sex, and Region: Black Women in the American West, 1850–1920." *Pacific Historical Review* 49, no. 2 (1980): 285–313.

Denard, Carolyn. Introduction to *"Mammy": An Appeal to the Heart of the South; The Correct Thing to Do—to Say—to Wear*, by Charlotte Hawkins Brown, iii- xxxv. New York: G. K. Hall, 1995.

Denkler, Ann. *Sustaining Identity, Recapturing Heritage: Exploring Issues of Public History, Tourism, and Race in a Southern Town.* Lanham, MD: Lexington Books, 2007.

Dilsaver, Lary M., ed. *America's National Park System: The Critical Documents.* 2nd ed. Lanham: Rowman and Littlefield, 2016.

Doss, Erika. *Memorial Mania: Public Feeling in America.* Chicago: University of Chicago Press, 2010.

Dr. Mary McLeod Bethune Statuary Fund, Inc. "The Pride of Florida: Dr. Mary McLeod Bethune Statuary Project." Accessed October 17, 2023. https://mmbstatue.org.

Dubrow, Gail Lee, and Jennifer B. Goodman, eds. *Restoring Women's History through Historic Preservation.* Baltimore: Johns Hopkins University Press, 2003.

Duster, Michelle. *Ida B. the Queen: The Extraordinary Life and Legacy of Ida B. Wells.* New York: One Signal Publishers, 2021.

Editors of Ebony, ed. *Ebony Pictorial History of Black America.* With an introduction by Lerone Bennett Jr. 3 vols. Chicago: Johnson, 1971.

Fainstein, Susan S., and Scott Campbell, eds. *Readings in Urban Theory.* Malden, MA: Blackwell, 1997.

Fannie Lou Hamer Resource Center. "Fannie Lou Hamer Statue." Accessed January 11, 2024. https://www.fannielouhamersamerica.com/fannie-lou -hamer-resource-center/statue.

Fink, Robert. "Five Points." In *Encyclopedia Britannica*, Academic ed. October 29, 2013. https://www.britannica.com/place/Five-Points.

Finney, Carolyn. *Black Faces, White Spaces: Reimagining the Relationship of African Americans to the Great Outdoors.* Chapel Hill: University of North Carolina Press, 2014.

Flamming, Douglas. *Bound for Freedom: Black Los Angeles in Jim Crow America.* Los Angeles: University of California Press, 2005.

Ford, Nick Aaron. *Black Studies: Threat or Challenge?* Port Washington, NY: Kennikat Press, 1973.

Fosler, R. Scott, and Renee A. Berger. *Public-Private Partnerships in American Cities: Seven Case Studies.* Lexington, MA: D. C. Heath, 1982.

Freeman, Tyrone McKinley. *Madame C. J. Walker's Gospel of Giving: Black Women's Philanthropy during Jim Crow.* With a foreword by A'Lelia Bundles. Champaign: University of Illinois Press, 2020.

Freemuth, John. "The National Parks: Political versus Professional Determinants of Policy." *Public Administration Review* 49, no. 3 (1989): 278–86.

Frund, Arlette. "Phillis Wheatley, a Public Intellectual." In *Toward an Intellectual History of Black Women*, edited by Mia Bay, Farah J. Griffin, Martha S. Jones, and Barbara D. Savage, 35–52. Chapel Hill: University of North Carolina Press, 2015.

Gable, Eric, Richard Handler, and Anna Lawson. "On the Uses of Relativism: Fact, Conjecture, and Black and White Histories at Colonial Williamsburg." *American Ethnologist* 19, no. 4 (1992): 791–805.

Gamble, Vanessa Northington. "Physicians." In *Black Women in America*, 2nd ed., edited by Darlene Clark Hine, 2, 489. New York: Oxford University Press, 2005.

Garrett-Scott, Shennette. *Banking on Freedom: Black Women in U.S. Finance before the New Deal*. New York: Columbia University Press, 2019.

Gasca, Noel. "Harriet Tubman and Frederick Douglass Statues Unveiled at Maryland State House." *NPR*, February 12, 2020. https://www.npr.org/local/305/2020/02/12/805279006/harriet-tubman-and-frederick-douglass-statues-unveiled-at-maryland-state-house.

Gates, Henry Louis, Jr. *The Trials of Phillis Wheatley: American's First Black Poet and Her Encounters with the Founding Fathers*. New York: Basic Civitas Books, 2003.

Gates, Henry Louis, Jr., and Nellie Y. McKay, eds. *The Norton Anthology of African American Literature*. New York: W. W. Norton, 1997.

Gardner, James B., and Peter S. LaPaglia, eds. *Public History: Essays from the Field*. Malabar, FL: Krieger, 1999.

Gatewood, Willard B. *Aristocrats of Color: The Black Elite, 1880–1920*. Fayetteville: University of Arkansas Press, 1990.

Gere, Anne Ruggles. *Intimate Practices: Literary and Cultural Work in U.S. Women's Clubs, 1880–1920*. Chicago: University of Illinois Press, 1997.

Gibbs, Wilma L., ed. *Indiana's African-American Heritage: Essays from Black History News and Notes*. Indianapolis: Indiana Historical Society, 1993.

Gibson-Hudson, Gloria J. "'To All Classes; to All Races; This House is Dedicated': The Walker Theatre Revisited." In *Indiana's African-American Heritage: Essays from Black History News and Notes*, edited by Wilma L. Gibbs, 51–64. Indianapolis: Indiana Historical Society, 1993.

Giddings, Paula J. *Ida: A Sword among Lions: Ida B. Wells and the Campaign Against Lynching*. New York: Amistad, 2008.

Gill, Tiffany M. *Beauty Shop Politics: African American Women's Activism in the Beauty Industry*. Chicago: University of Illinois Press, 2010.

Gilmore, Glenda Elizabeth. *Gender and Jim Crow: Women and the Politics of White Supremacy in North Carolina, 1896–1920*. Chapel Hill: University of North Carolina Press, 1996.

Graham, Shirley. *The Story of Phillis Wheatley*. New York: J. Messner, 1949.

Greenlee, Marcia McAdoo. "Alfreda Duster: Oral History Interview." In *The*

Black Women Oral History Project, vol. 1, edited by Ruth Edmonds Hill, 111–83. Westport, CT: Meckler, 1991.

Guy-Sheftall, Beverly, ed. *Words of Fire: An Anthology of African American Feminist Thought*. With an epilogue by Johnnetta B. Cole. New York: The New York Press, 1995.

Haley, Alex. *Roots: The Saga of an American Family*. Garden City, NY: Doubleday, 1976.

Hall, Perry A. *In the Vineyard: Working in African American Studies*. Knoxville: University of Tennessee Press, 1999.

Hamilton, Kenneth M. *Booker T. Washington in American Memory*. Chicago: University of Illinois Press, 2017.

Hanson, Joyce A. *Mary McLeod Bethune and Black Women's Political Activism*. Columbia: University of Missouri Press, 2003.

Harriet Tubman Boosters. *Harriet Tubman Boosters Newsletter*, January 2017. https://sites.google.com/view/harriettubmanboosters/newsletters.

Hayward, Jeff, and Christine Larouche. "The Emergence of the Field of African American Museums." *Public Historian* 40, no. 3 (2018), 163–72.

Height, Dorothy. Foreword to *The Historical Cookbook of the American Negro*, by the National Council of Negro Women, vii-viii. Edited by Sue Bailey Thurman. Boston: Beacon Press, 2000.

Hein, Hilde S. *The Museum in Transition: A Philosophical Perspective*. Washington: Smithsonian Institution Press, 2000.

Helsley, Alexia Jones. *Columbia, South Carolina: A History*. Charleston: History Press, 2015.

Hendricks, Wanda A. *Fannie Barrier Williams: Crossing the Borders of Region and Race*. Chicago: University of Illinois Press, 2014.

———. *Gender, Race, and Politics in the Midwest: Black Club Women in Illinois*. Bloomington: Indiana University Press, 1998.

———. "Wells-Barnett, Ida B." In *Black Women in America*, 2nd ed., edited by Darlene Clark Hine, 3, 337–40. New York: Oxford University Press, 2005.

Henry, Linda J. "Promoting Historical Consciousness: The Early Archives Committee of the National Council of Negro Women." *Signs* 7, no. 1 (1981): 251–59.

Hicks, Cheryl. *Talk with You Like A Woman: African American Women, Justice, and Reform in New York, 1890–1935*. Chapel Hill: University of North Carolina Press, 2010.

Higginbotham, Brooks. *Righteous Discontent: The Women's Movement in the Black Baptist Church, 1880–1920*. Cambridge, MA: Harvard University Press, 1994.

Hill, Robert A., ed. *The Marcus Garvey and Universal Negro Improvement Association Papers*. Berkeley: University of California Press, 1983.

Hill, Ruth Edmonds, ed. *The Black Women Oral History Project*. Vol. 1. Westport, CT: Meckler, 1991.

Hine, Darlene Clark, ed. *Black Women in America*. 2nd ed. 3 vols. New York: Oxford University Press, 2005.

———. *Speak Truth to Power: Black Professional Class in United States History*. Brooklyn, NY: Carlson, 1996.

———. *When the Truth Is Told: A History of Black Women's Culture and Community in Indiana, 1875–1950*. Indianapolis: National Council of Negro Women, Indianapolis Section, 1981.

Hine, Darlene Clark, and Kathleen Thompson. *A Shining Thread of Hope: The History of Black Women in America*. New York: Broadway Books, 1998.

Historic Columbia. "Journey to Freedom Tour." Accessed August 23, 2023. https://www.historiccolumbia.org/journey-to-freedom.

———. "Mann-Simons Site." Accessed August 23, 2023. https://www.historic columbia.org/tours/house-tours/mann-simons-site.

Historic Harriet Barber House. "Our History." Accessed January 13, 2024. https://www.harrietbarberhouse.org/bio-our-history.

Holdredge, Helen. *Mammy Pleasant's Partner*. New York: G. P. Putnam's Sons, 1954.

Holt, Rackham. *Mary McLeod Bethune: A Biography*. Garden City, NY: Doubleday, 1964.

Horne, Gerald. *Race Woman: The Lives of Shirley Graham Du Bois*. New York: New York University Press, 2000.

Horton, James Oliver, and Lois E. Horton. *Slavery and Public History: The Tough Stuff of American Memory*. New York: New Press, 2006.

Hudson, David, Marvin Bergman, and Loren Horten, eds. *The Biographical Dictionary of Iowa*. Iowa City: University of Iowa Press, 2008.

Hudson, Lynn M. "Lies, Secrets, and Silences: Writing African American Women's Biography." *Journal of Women's History* 21, no. 4 (2009): 138–40.

———. *The Making of "Mammy Pleasant": A Black Entrepreneur in Nineteenth-Century San Francisco*. Chicago: University of Illinois Press, 2003.

———. " Pleasant, Mary Ellen." In *Black Women in America*, 2nd ed., edited by Darlene Clark Hine, 2, 507–8. New York: Oxford University Press, 2005.

Hull, Gloria T., Patricia Bell Scott, and Barbara Smith, eds. *All the Women Are White, All the Blacks Are Men, but Some of Us Are Brave: Black Women's Studies*. New York: Feminist Press, 1982.

Huner, Brittany. "Justina Ford." In *Colorado Encyclopedia*. Last modified August 9, 2018. http://coloradoencyclopedia.org/article/justina-ford.

Hunter, Tera W. *To 'Joy My Freedom: Southern Black Women's Lives and Labors after the Civil War*. Cambridge: Harvard University Press, 1997.

Ida B. Wells-Barnett Museum. "Ida B. Wells-Barnett Museum: Cultural Center of African American History." Accessed March 21, 2018. http://idabwellsmuseum.org/spires-bolling-house/.

Jackson, Kellie Carter. "Mary Ellen Pleasant, Nineteenth-Century Massachusetts and California (US)." In *As If She Were Free: A Collective Biography of Women and Emancipation in the Americas*, edited by Erica L. Ball, Tatiana Seijas, Terri L. Snyder, 312–30. Cambridge: Cambridge University Press, 2020.

Jamison, Angelene. "Analysis of Selected Poetry of Phillis Wheatley." *Journal of Negro Education* 43, no. 3 (1974): 408–16.

Jeffers, Honorée Fanonne. *The Age of Phillis*. Middletown: Wesleyan University Press, 2020.

Jenkins, Lyndsey. "A Statue for the Past, Present and Future: Making Space for Betty Campbell, by Angela V. John." *Women's History Network*, October 25, 2021. https://womenshistorynetwork.org/a-statue-for-the-past-present-and-future -making-space-for-betty-campbell-by-angela-v-john/.

Johnson, Joan Marie. "'Drill into Us . . . the Rebel Tradition': The Contest over Southern Identity in Black and White Women's Clubs, South Carolina, 1898–1930." *Journal of Southern History* 66, no. 3 (2000): 525–62.

Jones, Arnita A. "Public History Now and Then." *Public Historian* 21, no. 3 (1999): 21–28.

Jones, Beverly W. "Mary Church Terrell and the National Association of Colored Women, 1896 to 1901." *Journal of Negro History* 67, no. 1 (1982): 20–33.

———. "Terrell, Mary Eliza Church." In *Black Women in America*, 2nd ed., edited by Darlene Clark Hine, 3, 233–34. New York: Oxford University Press, 2005.

Jones, Brenda. "11 Most Endangered Historic Places—2022 List Unveiled." Press release. May 4, 2022. National Trust for Historic Preservation. https:// savingplaces.org/press-center/media-resources/americas-11-most-endangered -historic-places2022-list-unveiled.

Jones, Ian, Robert R. MacDonald, and Darryl McIntyre, eds. *City Museums and City Development*. Lanham, MD: AltaMira Press, 2008.

Jones, Martha S. *All Bound Up Together: The Woman Question in African American Public Culture, 1830–1900*. Chapel Hill: University of North Carolina Press, 2007.

Joseph, Peniel E. *Waiting 'til the Midnight Hour: A Narrative History of Black Power in America*. New York: Henry Holt, 2006.

Kachun, Mitch. *Festivals of Freedom: Memory and Meaning in African American Emancipation Celebrations, 1808–1915*. Cambridge: University of Massachusetts Press, 2003.

Karenga, Maulana. "Names and Notions of Black Studies: Issues of Roots, Range, and Relevance." *Journal of Black Studies* 40, no. 1 (2009): 41–64.

Kaufman, Ned. *Place, Race, and Story: Essays on the Past and Future of Historic Preservation*. New York: Routledge, 2009.

Kaufman, Polly Welts. *National Parks and the Woman's Voice: A History*. Albuquerque: University of New Mexico Press, 2006.

Keaton, George, Jr., and Judith G. Segura, eds. *Our Stories: Black Families in Early Dallas*. Denton: University of North Texas Press, 2022.

Kimani, Abraham Carter, Sr. "Mothers of the City: The Phyllis Wheatley Club and Home, the Great Migration, and Communal Family in Black Chicago, 1910–1930." PhD diss., University of California, Los Angeles, 2012.

Knott, Cheryl. "One Collection, Two Contexts: The Ella Reid Public Library Archives." *Revue francaise d'études américaines* 1, no. 162 (2020): 51–66.

Knupfer, Anne Meis. *Toward a Tenderer Humanity and a Nobler Womanhood: African American Women's Clubs in Turn-of-the-Century Chicago*. New York: New York University Press, 1996.

———. *The Chicago Black Renaissance and Women's Activism*. Chicago: University of Illinois Press, 2006.

———. "'If You Can't Push, Pull, If You Can't Pull, Please Get Out of the Way': The Phyllis Wheatley Club and Home in Chicago, 1896 to 1920." *Journal of Negro History* 82, no. 2 (1997): 221–31.

Larson, Kate Clifford. "Tubman, Harriet." In *Black Women in America*, 2nd ed., edited by Darlene Clark Hine, 3; 262–267. New York: Oxford University Press, 2005.

Lerner, Gerda. "Early Community Work of Black Club Women." *Journal of Negro History* 59, no. 2 (1974): 158–67.

Leslie, Grace V. "'United, We Build a Free World': The Internationalism of Mary McLeod Bethune and the National Council of Negro Women." In *To Turn the Whole World Over: Black Women and Internationalism*, edited by Keisha N. Blain and Tiffany M. Gill, 192–218. Urbana: University of Illinois Press, 2019.

Lister, Ann Drayton, and Virginia Hook McCracken. *Hopkins*. Charleston, SC: Arcadia, 2009.

Lohse, Joyce B. *Justina Ford: Medical Pioneer*. Palmer Laker, CO: Filter Press, 2004.

Lowry, Beverly. *Harriet Tubman: Imagining a Life*. New York: Doubleday, 2007.

Lufkin, Jack. "Brown, Samuel Joe and Sue M. Brown." In *The Biographical Dictionary of Iowa*, edited by Marvin Bergman, David Hudson, and Loren Horton, 61–63. Iowa City: University of Iowa Press, 2008.

Lufkin, John Charles. *See also* Lufkin, Jack. "Black Des Moines: A Study of Select Negro Social Organizations in Des Moines, Iowa, 1890–1930." Master's thesis, Iowa State University, 1980.

Lumpkin, Shirley Ann. "'Natural Process': The Development of Afro-American Poetics and Poetry." PhD diss., McGill University, Montreal, 1982.

Madam Walker Legacy Center. "Madam Walker Legacy Center Unveils Memorial Way, Future Plans." Press release. October 20, 2023. https://madamwalkerlegacycenter.com/madam-walker-legacy-center-unveils-memorial-way-future-plans/.

———. *Portal to Our Past, Gateway to Our Future: Strategic Plan 2023–2027*. Indianapolis: Madam Walker Legacy Center, October 2023. https://madamwalkerlegacycenter.com/wp-content/uploads/2023/10/Madam-Walker-Legacy-Center-Strategic-Plan-1.pdf.

Majors, Monroe Alphus. *Noted Negro Women: Their Triumphs and Activities*. Chicago: Donohue and Henneberry, 1893.

Marlowe, Gertrude Woodruff. *A Right Worthy Grand Mission: Maggie Lena Walker*

and the Quest for Black Economic Empowerment. Washington, DC: Howard University Press, 2004.

Mary Seacole Trust. "Mary Seacole Statue." Accessed April 15, 2023. https://www.maryseacoletrust.org.uk/mary-seacole-statue/.

Mattel. "Madam C. J. Walker Barbie Inspiring Women Doll, Collectible Gift for 6 Years and Older," Accessed October 26, 2023. https://shop.mattel.com/products/madam-cj-walker-barbie-inspiring-women-doll-hlm19.

Maxey, Russell. *South Carolina's Historic Columbia: Yesterday and Today in Photographs.* Columbia: R. L. Bryan, 1980.

McBain, Ruth. "Villa Lewaro Celebrates a New Owner and Plans for the Future." December 19, 2018. National Trust for Historic Preservation. https://savingplaces.org/places/villa-lewaro-madam-c-j-walker-estate/updates/villa-lewaro-celebrates-a-new-owner-and-plans-for-the-future.

McCluskey, Audrey Thomas, and Elaine M. Smith, eds. *Mary McLeod Bethune: Building a Better World; Essays and Selected Documents.* Bloomington: Indiana University Press, 1999.

McDonald, Heather Lynn. "The National Register of Historic Places and African American Heritage." Master's thesis, University of Georgia, 2009.

McDuffie, Jade. "Ward One Community." 2013. http://wardone.wix.com/wardone.

McMillen, Wayne. "Public Housing in Chicago, 1946." *Social Service Review* 20, no. 2 (June 1946): 150–164.

McNulty, Robert H. and Stephen A. Kliment, eds. *Neighborhood Conservation: A Handbook of Methods and Techniques.* New York: Whitney Library of Design, 1976.

Melosi, Martin V., and Philip Scarpino, eds. *Public History and the Environment.* Malabar, FL: Krieger, 2008.

Meringolo, Denise D. *Museums, Monuments, and National Parks: Toward a New Genealogy of Public History.* Amherst: University of Massachusetts Press, 2012.

Millender, Dharathula (Dolly). *Gary's Central Business Community.* Charleston, SC: Arcadia, 2003.

Mills, Cynthia, and Pamela H. Simpson, eds. *Monuments to the Lost Cause: Women, Art, and the Landscapes of Southern Memory.* Knoxville: University of Tennessee Press, 2003.

Monument Lab. *National Monument Audit.* Philadelphia: Monument Lab/Mellon Foundation, 2021. https://monumentlab.com/monumentlab-national monumentaudit.pdf.

Moon, Krystyn. "The Alexandria YWCA, Race, and Urban (and Ethnic) Revival: The Scottish Christmas Walk, 1960s–1970s," *Journal of American Ethnic History* 35, no. 4 (Summer 2016): 59–92.

Morton, Marian J. *And Sin No More: Social Policy and Unwed Mothers in Cleveland, 1855–1990.* Columbus: Ohio State University, 1993.

Nahal, Anita, and Lopez D. Matthews Jr., "African American Women and the

Niagara Movement, 1905–1909." *Afro-Americans in New York Life and History* 32, no. 2 (2008): 65–83.

National Archives. "'Meet' Madam C. J. Walker and her IRL Great-Great-Grandchild A'lelia Bundles." Press release. May 6, 2021. https://www.archives.gov/press/press-releases/2021/nr21-42.

National Park Service. "Betty Reid Soskin Biography." Accessed July 16, 2021. https://www.nps.gov/rori/learn/historyculture/betty-reid-soskin.htm.

———. "The Council House: History of the Mary McLeod Bethune Council House National Historic Site." Accessed October 12, 2017. https://www.nps.gov/mamc/learn/historyculture/the-council-house.htm.

———. "Maggie L. Walker: History and Culture." Last updated May 27, 2021. https://www.nps.gov/mawa/learn/historyculture/index.htm.

———. "Mary McLeod Bethune Council House: National Historic Site, District of Columbia, Mary McLeod Bethune's Legacy" Last updated February 21, 2024. https://www.nps.gov/mamc/index.htm.

———. "Shirley Chisholm State Park Opens in NYC." Last updated November 8, 2019. https://www.nps.gov/articles/shirley-chisholm-state-park.htm.

New York City Cultural Affairs. "She Built NYC." Accessed April 2, 2024. https://www.nyc.gov/site/dcla/publicart/shebuiltnyc.page.

North Carolina Historic Sites. "Palmer Memorial Institute Dormitory Revitalization." Accessed October 17, 2023. https://historicsites.nc.gov/all-sites/charlotte-hawkins-brown-museum/palmer-memorial-institute-dormitory-revitalization.

Orr, Susan R. "Historic House Museum Sustainability in the 21st Century: Paths to Preservation." Master's thesis, Seton Hall University, 2011.

Painter, Nell Irvin. *Sojourner Truth: A Life, A Symbol.* New York: W. W. Norton, 1996.

———. "Truth, Sojourner." In *Black Women in America*, 2nd ed., edited by Darlene Clark Hine, 3, 259–62. New York: Oxford University Press, 2005.

Papazoglakis, Sarah. "'Feminist, Gun-Toting Abolitionist with a Bankroll': The Black Radical Philanthropy of Mary Ellen Pleasant." *New Global Studies* 12, no. 2 (2018): 235–56.

Parker, Elizabeth L., and James Abajian. *A Walking Tour of the Black Presence in San Francisco during the Nineteenth Century: A Black History Week Event.* San Francisco: San Francisco African American Historical and Cultural Society, 1974.

Peiss, Kathy. *Hope in a Jar: The Making of America's Beauty Culture.* New York: Henry Holt, 1998.

Phillips, Kendall, ed. *Framing Public Memory.* Tuscaloosa: University of Alabama Press, 2004.

Picott, J. Rupert. "Editorial Comment: In Tribute," *Negro History Bulletin* 41, no. 2 (March-April 1978): 803.

POINT. "Do Something." Last modified October 11, 1995. http://www.scpronet.com/point/9510/doit.html.

Powers, Tim. *Earthquake Weather*. New York: TOR / Tom Doherty, 1997.

Quigley, Joan. *Just Another Southern Town: Mary Church Terrell and the Struggle for Racial Justice in the Nation's Capital*. New York: Oxford University Press, 2016.

Rains, Albert, and Laurance G. Henderson. *With Heritage So Rich: A Report of a Special Committee on Historic Preservation under the Auspices of the United States Conference of Mayors with a Grant from the Ford Foundation*. New York: Random House, 1966.

Rhodes, Lelia Gaston. *Jackson State University: The First Hundred Years, 1877–1977*. Jackson: University Press of Mississippi, 1979.

Richland County, South Carolina. "Richland County Leads Charge to Celebrate Black Women, Researcher Finds." January 19, 2021. https://www.richland countysc.gov/Home/News/ArtMID/479/ArticleID/2163/Richland-County -Leads-Charge-to-Celebrate-Black-Women-Researcher-Finds.

Richmond Public Schools. "Armstrong High School: About Us: History." Accessed April 4, 2024. https://ahs.rvaschools.net/about-us/history.

Ridley, Thomas Howard, Jr. *From the Avenue: A Memoir; Life Experiences and Indiana Avenue Told from the Perspective of One Who Was There*. 2nd ed. Self-published, 2014.

Robertson, Ashley N. *Mary McLeod Bethune in Florida: Bringing Social Justice to the Sunshine State*. Charleston, SC: History Press, 2015.

Rocksborough-Smith, Ian. *Black Public History in Chicago: Civil Rights Activism from World War II into the Cold War*. Chicago: University of Illinois Press, 2018.Rojas, Fabio. *From Black Power to Black Studies: How a Radical Social Movement Became an Academic Discipline*. Baltimore: Johns Hopkins University Press, 2007.

Rosell, Lydia J. *Auburn's Fort Hill Cemetery*. Charleston, SC: Arcadia, 2001.

Rowe, George Clinton. *Our Heroes: Patriotic Poems on Men, Women and Sayings of the Negro Race*. Charleston, SC: Walker, Evans, and Cogswell, 1890.

Rowell, Charles H., and Jerry W. Ward Jr., "Ancestral Memories: The Phillis Wheatley Poetry Festival," *Freedomways* 14, no. 2 (1974), 127–45.

Ruffins, Fath Davis. "Building Homes for Black History: Museum Founders, Founding Directors, and Pioneers, 1915–95." *The Public Historian*, 40, no. 3 (2018): 13–43.

———. "Four African American Women on the National Landscape." In *Restoring Women's History through Historic Preservation*, edited by Gail Lee Dubrow and Jennifer B. Goodman, 58-80. Baltimore: Johns Hopkins University Press, 2003.

———. "'Lifting as We Climb': Black Women and the Preservation of African American History and Culture." *Gender & History* 6, no. 3 (1994): 376–96.

———. "Mythos, Memory, and History: African American Preservation Efforts, 1820–1990." In *Museums and Communities: The Politics of Public Culture*, edited by Ivan Karp, Christine Mullen Kreamer, and Steven D. Lavine, 506–611. Washington, DC: Smithsonian Institution Press, 1992.

Russell, Alexandria. "'In Them She Built Monuments': Celia Dial Saxon and American Memory." *Journal of African American History* 106, no. 3 (Summer 2021): 383–410.

Salem, Dorothy. "National Association of Colored Women." In *Black Women in America*, 2nd ed., edited by Darlene Clark Hine, 2, 429–36. New York: Oxford University Press, 2005.

Saunders, James Robert, and Renae Nadine Shackelford: *Urban Renewal and the End of Black Culture in Charlottesville, Virginia: An Oral History of Vinegar Hill*. Jefferson, NC: McFarland, 1998.

Savage, Beth L., ed. *African American Historic Places: National Register of Historic Places* (New York: Preservation Press, 1995).

Savage, Carter Julian. "'In the Interest of the Colored Boys': Christopher J. Atkinson, William T. Coleman, and the Extension of Boys' Clubs Services to African-American Communities, 1906–1931." *History of Education Quarterly* 51, no. 4 (2011): 486–518.

Savage, Kirk. *Standing Soldiers, Kneeling Slaves: Race, War, and Monument in Nineteenth-Century America*. Princeton, NJ: Princeton University Press, 1997.

Schechter, Patricia Ann. *Ida B. Wells-Barnett and American Reform, 1880–1930*. Chapel Hill: University of North Carolina, 2001.

Sernett, Milton C. *Myth, Memory, and History*. Durham, NC: Duke University Press, 2007.

Shackel, Paul A., ed. *Myth, Memory, and the Making of the American Landscape*. Gainesville: University Press of Florida, 2001.

Shaw, Stephanie J. "Black Club Women and the Creation of the National Association of Colored Women." *Journal of Women's History* 3, no. 2 (Fall 1991): 11–25.

Sherrer, John. "Award Winner Spotlight: Historic Columbia Foundation: Connecting Communities through History." *History News* 66, no. 4 (Autumn 2011): 28–29.

Sherr, Lynn, and Jurate Kazickas. *Susan B. Anthony Slept Here: A Guide to American Women's Landmarks*. New York: Times Books, 1994.

Shields, John C. "Wheatley, Phillis." In *Black Women in America*, 2nd ed., edited by Darlene Clark Hine, 344-347. New York: Oxford University Press, 2005.

Silcox-Jarrett, Diane. *Charlotte Hawkins Brown: One Woman's Dream*. Winston-Salem, NC: Bandit Books, 1995.

Simmons, LaKisha Michelle. *Crescent City Girls: The Lives of Young Black Women in Segregated New Orleans*. Chapel Hill: The University of North Carolina Press, 2015.

Singleton, Theresa A. "Commentary: Facing the Challenges of a Public African-American Archaeology." *Historical Archaeology* 31, no. 3 (1997): 146–52.

Small, Stephen. "Still Back of the Big House: Slave Cabins and Slavery in Southern Heritage Tourism." *Tourism Geographies* 15, no. 3 (2013): 405–23.

Smith, Elaine M. "Bethune, Mary McLeod." In *Black Women in America*, 2nd

ed., edited by Darlene Clark Hine, 1, 99. New York: Oxford University Press, 2005.

Smith, Katharine Capshaw. "Constructing a Shared History: Black Pageantry for Children during the Harlem Renaissance." *Children's Literature* 27 (1999): 40–63.

Smoot, Pamela Annette. "Self Help and Institution Building in Pittsburgh, Pennsylvania, 1830–1945." PhD diss., Michigan State University, 1999.

Snow, Miriam B. Review of *The Story of Phillis Wheatley*, by Shirley Graham. *Library Journal* 74, no. 22 (1949): 1920.

"Social Progress." *Opportunity* 4, no. 40 (March 1926): 106–7.

South Carolina Progressive Network. "About: Modjeska Simkins School." Accessed March 12, 2018. https://www.scpronet.com/modjeskaschool/home-2/.

Spears, Jean E. "Makers of Local History." *Makers of Local History,* June 1987. https://www.digitalindy.org/digital/api/collection/ftv/id/1349/download.

Sterling, Dorothy. Afterword to *The Memphis Diary of Ida B. Wells: An Intimate Portrait of the Activist as a Young Woman*, by Ida B. Wells-Barnett, 191–200. Edited by Miriam Decosta-Willis. Boston: Beacon Press, 1995.

Stipe, Robert E., ed. *A Richer Heritage: Historic Preservation in the Twenty-First Century.* Chapel Hill: The University of North Carolina Press, 2003.

Sullivan, Michael. *Your Guide to the Trees of San Francisco* (Birmingham: Wilderness Press, 2015.

Tagger, Barbara A. "Interpreting African American Women's History through Historic Landscapes, Structures, and Commemorative Sites." *Organization of American Historians Magazine of History* 12, no. 1 (1997): 17–19.

Taylor, Quintard, and Shirley Ann Wilson Moore, eds. *African American Women Confront the West, 1600–2000.* Norman: University of Oklahoma Press, 2003.

Thompson, Lisa B. *Beyond the Black Lady: Sexuality and the New African American Middle Class.* Chicago: University of Illinois Press, 2009.

Thompson, Mildred I. *Ida B. Wells-Barnett: An Exploratory Study of an American Black Woman, 1893–1930.* Vol. 15 of *Black Women in United States History*, edited by Darlene Clark Hine. Brooklyn, NY: Carlson, 1990.

Thornbrough, Emma Lou. "The History of Black Women in Indiana." In *Indiana's African-American Heritage: Essays from Black History News and Notes*, edited by Wilma L. Gibbs, 67–85. Indianapolis: Indiana Historical Society, 1993.

———. *Indiana Blacks in the Twentieth Century*, edited and with a final chapter by Lana Ruegamer. Bloomington: Indiana University Press, 2000.

Thorton Dill, Bonnie, and Ruth Enid Zambrana, eds. *Emerging Intersections: Race, Class, and Gender in Theory, Policy, and Practice.* New Brunswick, NJ: Rutgers University Press, 2009.

Thurman, Sue Bailey. *Pioneers of Negro Origin in California.* San Francisco: Acme, 1952.

Tipton-Martin, Toni. *The Jemima Code: Two Centuries of African American Cookbooks*. Austin: University of Texas Press, 2015.

Tollette, Wallace Yvonne. *Justina Lorena Ford, M.D.: Colorado's First Black Woman Doctor*. Denver: Western Images, 2005.

Treisman, Rachel. "Capitol Unveils Mary McLeod Bethune Statue: A Historic Milestone Years in the Making." *NPR*. Last updated July 13, 2022. https://www.npr.org/2021/10/14/1045964525/mary-mcleod-bethune-statue-us-capitol-florida-unveiling.

———. "Maya Angelou, Sally Ride and Other Trailblazing Women Will Be Featured on U.S. Coins." *NPR*, October 7, 2021. https://www.npr.org/2021/10/07/1044023494/maya-angelou-sally-ride-anna-may-wong-historical-women-quarters-us-mint.

Triece, Mary E. *Urban Renewal and Resistance: Race, Space, and the City in the Late Twentieth to the Early Twenty-First Century*. Lanham, MD: Lexington Books, 2016.

United States Mint. "American Liberty One-Tenth Ounce 2018 Gold Proof Coin." https://catalog.usmint.gov/american-liberty-one-tenth-ounce-2018-gold-proof-coin- Cultural Affairs18XF.html.

———. "American Women Quarters™ Program." Accessed October 17, 2023. https://www.usmint.gov/learn/coin-and-medal-programs/american-women-quarters.

———. "United States Mint Announces Designs for 2022 American Women Quarters™ Program Coins." Press Release. October 6, 2021. https://www.usmint.gov/news/press-releases/united-states-mint-announces-designs-for-2022-american-women-quarters-program-coins.

United States Postal Service. *African Americans on Stamps: A Celebration of African-American Heritage*, Publication 354. Washington, DC: USPS, 2004.

United States Representative Kathy Castor. "Rep. Castor Welcomes Dr. Mary McLeod Bethune Statue to Florida before Final Journey to U.S. Capitol." Press release. October 12, 2021. https://castor.house.gov/news/documentsingle.aspx?DocumentID=403716.

University of Chicago Law Review. "Public Housing in Illinois." *University of Chicago Law Review* 8, no. 2 (February 1941): 296–316.

Van Balgooy, Max A., ed. *Interpreting African American History and Culture at Museums and Historic Sites*. Lanham, MD: Rowman and Littlefield, 2015.

Veale, Liza. "The Real History behind Mary Ellen Pleasant, San Francisco's 'Voodoo Queen.'" September 9, 2015. With photograph by Olivia Cueva. KALW Public Media. MP3 audio, 9:41. https://www.kalw.org/post/real-history-behind-mary-ellen-pleasant-san-franciscos-voodoo-queen#stream/0.

Vergo, Peter, ed. *The New Museology*. London: Reaktion Books, 1989.

Vigil-Fowler, Margaret. "'Two Strikes—A Lady and Colored': Gender, Race, and the Making of the Modern Medical Profession, 1864–1941." PhD diss., University of California, San Francisco, 2018.

Wadelington, Charles W., and Richard F. Knapp. *Charlotte Hawkins Brown and Palmer Memorial Institute: What One Young African-American Woman Could Do*. Chapel Hill: University of North Carolina Press, 1999.

Walker, Alice. *In Search of Our Mothers' Gardens: Womanist Prose*. San Diego: Harvest, 1984.

Walker, Margaret. "Phillis Wheatley and Black Women Writers, 1773–1973." In *On Being Female, Black, and Free: Essays by Margaret Walker, 1932–1992*, edited by Maryemma Graham, 35-40 (Knoxville: University of Tennessee Press, 1997).

Washington, Harriet A. *Medical Apartheid: The Dark History of Medical Experimentation on Black Americans from Colonial Times to the Present*. New York: Harlem Moon, 2006.

Weedon, Chris, and Glenn Jordan. "Collective Memory: Theory and Politics." *Social Semiotics* 22, no. 2 (2012): 143–53.

WeGOJA Foundation. *A Teacher's Guide to African American Historic Places in South Carolina*, 4th ed. Hartsville, SC: WeGOJA Foundation, 2020.

Wells, Ida B. *Crusade For Justice: The Autobiography of Ida B. Wells*, edited by Alfreda M. Duster. Chicago: University of Chicago Press, 1970.

———. *The Memphis Diary of Ida B. Wells: An Intimate Portrait of the Activist as a Young Woman*, edited by Miriam DeCosta-Willis Boston: Beacon Press, 1995.

West, E. James. Ebony *Magazine and Lerone Bennett Jr.: Popular Black History in Postwar America*. Urbana: University of Illinois Press, 2020.

Wheatley, Phillis. *Memoir and Poems of Phillis Wheatley: A Native African and a Slave. Also, Poems by a Slave*. Boston: Isaac Knapp, 1838.

White, Deborah Gray. *Ar'n't I a Woman? Female Slaves in the Plantation South*. New York: W. W. Norton, 1999.

———. *Too Heavy a Load: Black Women in Defense of Themselves, 1894–1994*. New York: W. W. Norton, 1999.

Whitehill, Walter Muir. "The Right of Cities to Be Beautiful." In *With Heritage So Rich: A Report of a Special Committee on Historic Preservation under the Auspices of the United States Conference of Mayors with a Grant from the Ford Foundation*, edited by Albert Rains and Laurance G. Henderson. New York: Random House, 1966.

White, Tara Y. "History as Uplift: African American Clubwomen and Applied History." *Public Historian*, 43, no. 2 (2021): 11–19.

———. "'A Shrine of Liberty for the Unborn Generations': African American Clubwomen and the Preservation of African American Historic Sites." PhD diss., Middle Tennessee State University, 2010.

Williams, Lillian Serece. *Strangers in the Land of Paradise: The Creation of an African American Community, Buffalo, New York, 1900–1940*. Bloomington: Indiana University Press, 1999.

———. "Talbert, Mary Morris Burnett." In *Black Women in America*, 2nd ed.,

edited by Darlene Clark Hine, 3, 209–11. New York: Oxford University Press, 2005.

Williams, Rhonda Y. *The Politics of Public Housing: Black Women's Struggles against Urban Inequality*. Oxford: Oxford University Press, 2004.

Williams, Stephen L., and Catharine A. Hawks, eds. *Museum Studies: Perspectives and Innovations*. Washington, DC: Society for the Preservation of Natural History Collections, 2006.

Wills, Shomari. *Black Fortunes: The Story of the First Six African Americans Who Survived Slavery and Became Millionaires*. New York: HarperCollins, 2019.

Wilson, Mabel O. *Negro Building: Black Americans in the World of Fairs and Museums*. Berkeley: University of California Press, 2012.

Wise, Nicholas, and Julie Clark, eds. *Urban Transformations: Geographies of Renewal and Creative Change*. London: Routledge, 2017.

WLTX. "Columbia Housing Selling Celia Saxon Shopping Center for $2.5 Million." Updated March 23, 2021. Video. https://www.wltx.com/article/news/local/cha-selling-saxon-shopping-center/101-47f00fb6-c132-42b8-bfdc-6274325ec01f.

Wolcott, Victoria W. *Remaking Respectability: African American Women in Interwar Detroit*. Chapel Hill: University of North Carolina Press, 2001.

Woodley, Jenny. "'Ma Is in the Park': Memory, Identity, and the Bethune Memorial. *Journal of American Studies* 52, no. 2 (2017): 474–502.

Woods, Barbara. "Simkins, Mary Modjeska Monteith." In *Black Women in America*, 2nd ed., edited by Darlene Clark Hine, 3, 115–17. New York: Oxford University Press, 2005.

WTVR. "Statue of Richmond Icon Maggie Walker Unveiled: 'Awesome and Beautiful.'" Updated July 16, 2017. Video. https://wtvr.com/2017/07/15/maggie-walker-monument-broad-street-richmond/.

Yates-Richard, Meina. "'In the Wake' of the 'Quake: Mary Ellen Pleasant's Diasporic Hauntings." *American Studies* 58, no. 3 (2019): 37–57.

YWCA of Asheville. "Historical Panels": "Empowering Women," "Phyllis Wheatley Branch," "Eliminating Racism at the YWCA." Accessed April 27, 2018. https://www.ywcaofasheville.org/history.

YWCA Seattle, King, Snohomish. "History: A Journey to Empowering Women, Eliminating Racism." Accessed April 27, 2018. https://www.ywcaworks.org/history.

Index

women's suffrage, 38, 44, 78, 161
Woodman, Frederick, 40
Woodrow Wilson Home, 150, 210n27
Woods, Barbara, 154
Woodson, Carter G., 94
"The Work of the Juvenile Court"
(Pulliam), 40
World Center for Women's Archives,
66, 94, 101
World War I, 72

YMCA (Young Men's Christian Asso-
ciation), 61
YWCA (Young Women's Christian
Association): Bethune branches,
68–69; in New York, 46, 49; Wheat-
ley branches, 31–34, 83, 122

Zion Baptist Church, 152
Z. Smith Reynolds Foundation, 139,
143 (table)

ALEXANDRIA RUSSELL is a W. E. B. Du Bois Research Institute Fellow at Harvard University's Hutchins Center for African & African American Research, and the Interim Vice President of Education and External Engagement at the Boston Symphony Orchestra.

The University of Illinois Press
is a founding member of the
Association of University Presses.

———————————————————

Composed in 10.5/13 Adobe Garamond
with Gotham display
by Jim Proefrock
at the University of Illinois Press
Manufactured by Versa Press, Inc.

University of Illinois Press
1325 South Oak Street
Champaign, IL 61820-6903
www.press.uillinois.edu